CENTURY GIRL

100 YEARS IN THE LIFE OF DORIS EATON TRAVIS,
LAST LIVING STAR OF THE ZIEGFELD FOLLIES

LAUREN REDNISS

REGAN

An Imprint of HarperCollinsPublishers

CENTURY GIRL

CENTURY GIRL

100 YEARS

IN THE LIFE OF

DORIS EATON TRAVIS

LAST LIVING STAR OF THE

ZIEGFELD FOLLIES

BY LAUREN REDNISS

REGAN

AN IMPRINT OF HARPERCOLLINS PUBLISHERS

for my family

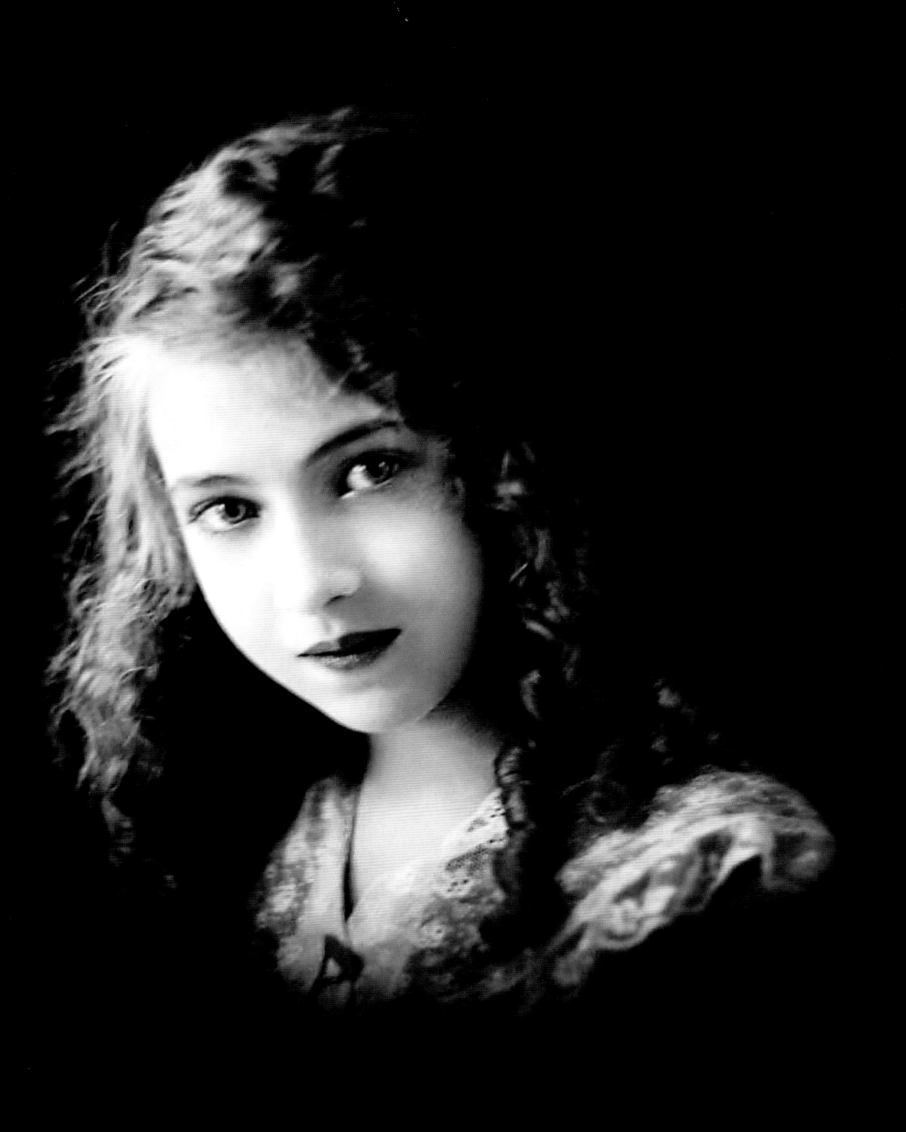

DORIS

Fourteen years old and the youngest girl in the Ziegfeld Follies, Doris Eaton made critics swoon. "Mine eyes are yet dim with the luminous beauty of a girl named Doris," wrote a Chicago reviewer. When Doris Eaton was born on March 14, 1904, the average American could expect to live 47 years. The blue-eyed child was destined to fill more than two of these life spans. She was named three weeks before New York City Mayor George McClellan dubbed the bowtie of streets between 42nd and 47th, from Broadway to Seventh Avenue, "Times Square." It was there, on the New Amsterdam Theatre stage, that she made her debut as a chorus girl in the Ziegfeld Follies of 1918. For her 100th birthday she was back on the same stage, in a black taffeta skirt and silver heels, leading a conga line of a dozen dancers. Before receiving her honorary doctorate at age 101, she starred in silent and talking pictures, performed for presidents and princesses, bantered with Babe Ruth, offended Henry Ford, outlived six siblings, wrote a newspaper column, hosted a television show, earned a Phi Beta Kappa degree in history (at 88), raised turkeys, and raced horses.

AND THAT'S JUST FOR STARTERS.

DORIS

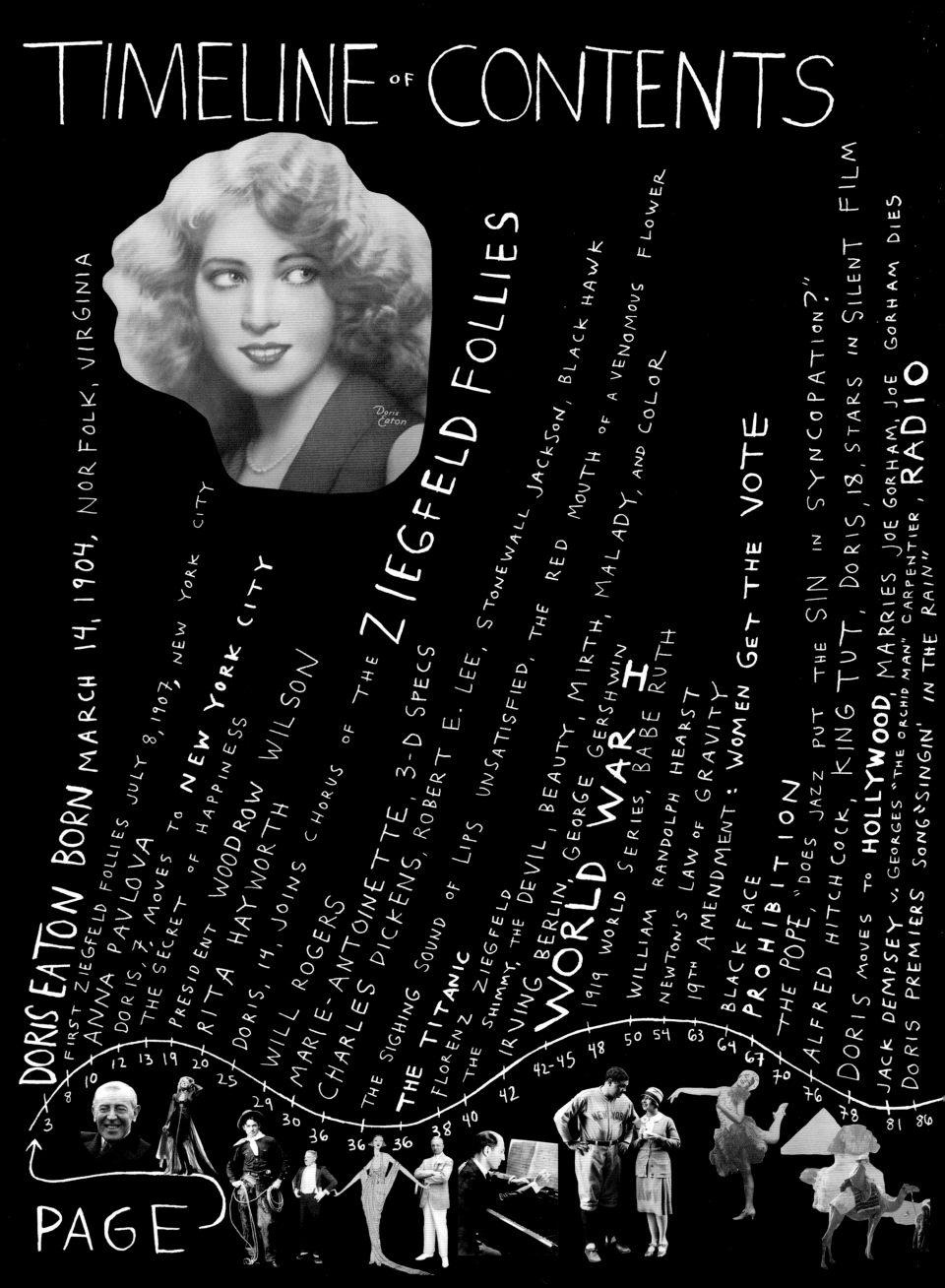

TIMELINE OF CONTENTS

Doris Eaton

PAGE

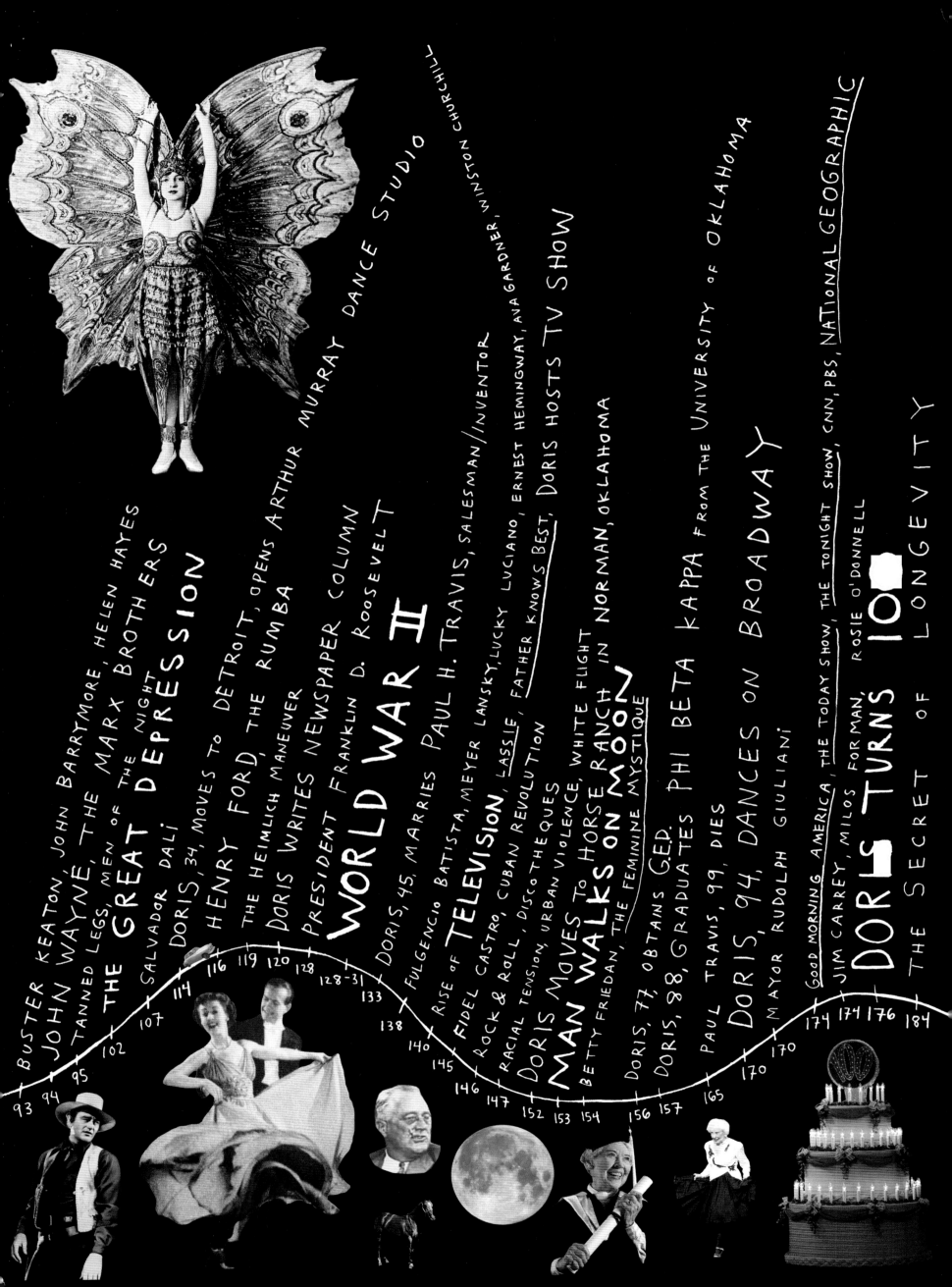

BUSTER KEATON, JOHN BARRYMORE, HELEN HAYES

JOHN WAYNE, THE MARX BROTHERS

TANNED LEGS, MEN OF THE NIGHT

THE GREAT DEPRESSION

SALVADOR DALI

DORIS, 34, MOVES TO DETROIT, OPENS ARTHUR MURRAY DANCE STUDIO

HENRY FORD, THE RUMBA

THE HEIMLICH MANEUVER

DORIS WRITES NEWSPAPER COLUMN

PRESIDENT FRANKLIN D. ROOSEVELT

WORLD WAR II

DORIS, 45, MARRIES PAUL H. TRAVIS, SALESMAN/INVENTOR

FULGENCIO BATISTA, MEYER LANSKY, LUCKY LUCIANO, ERNEST HEMINGWAY, AVA GARDNER, WINSTON CHURCHILL

RISE OF **TELEVISION**

FIDEL CASTRO, CUBAN REVOLUTION

ROCK & ROLL, DISCOTHEQUES

LASSIE, FATHER KNOWS BEST, DORIS HOSTS TV SHOW

RACIAL TENSION, URBAN VIOLENCE, WHITE FLIGHT

DORIS MOVES TO HORSE RANCH IN NORMAN, OKLAHOMA

MAN WALKS ON MOON

BETTY FRIEDAN, THE FEMININE MYSTIQUE

DORIS, 77, OBTAINS G.E.D.

DORIS, 88, GRADUATES PHI BETA KAPPA FROM THE UNIVERSITY OF OKLAHOMA

PAUL TRAVIS, 99, DIES

DORIS, 94, DANCES ON BROADWAY

MAYOR RUDOLPH GIULIANI

GOOD MORNING AMERICA, THE TODAY SHOW, THE TONIGHT SHOW, CNN, PBS, NATIONAL GEOGRAPHIC

JIM CARREY, MILOS FORMAN, ROSIE O'DONNELL

DORIS TURNS 100

THE SECRET OF LONGEVITY

93 94 95 102 107 114 116 119 120 128 128-31 133 138 140 145 146 147 152 153 154 156 157 165 170 170 174 174 176 184

THE EATONS

CHARLES H.S. EATON

MARY SAUNDERS EATON

b. SEPTEMBER 1878

d. 1956: OLD AGE

b. FEBRUARY 1896 d. 1935 : PNEUMONIA, DRUG ABUSE

b. OCTOBER 1869
d. JUNE 1939:
CEREBRAL HEMORRHAGE

ROBERT

b. AUGUST 1894 d. 1980: BROKEN HEART

b. AUGUST 1898 d. 1958: MURDERED

b. JANUARY 1901 d. 1948: SEVERE METAMORPHOSIS OF THE LIVER

b. DECEMBER 1907 d. 1998: HEART FAILURE, DEMENTIA

b. JUNE 1911 d. 2004: DEMENTIA

DORIS

EVELYN

PEARL

MARY

b. MARCH 14, 1904

JOE

CHARLIE

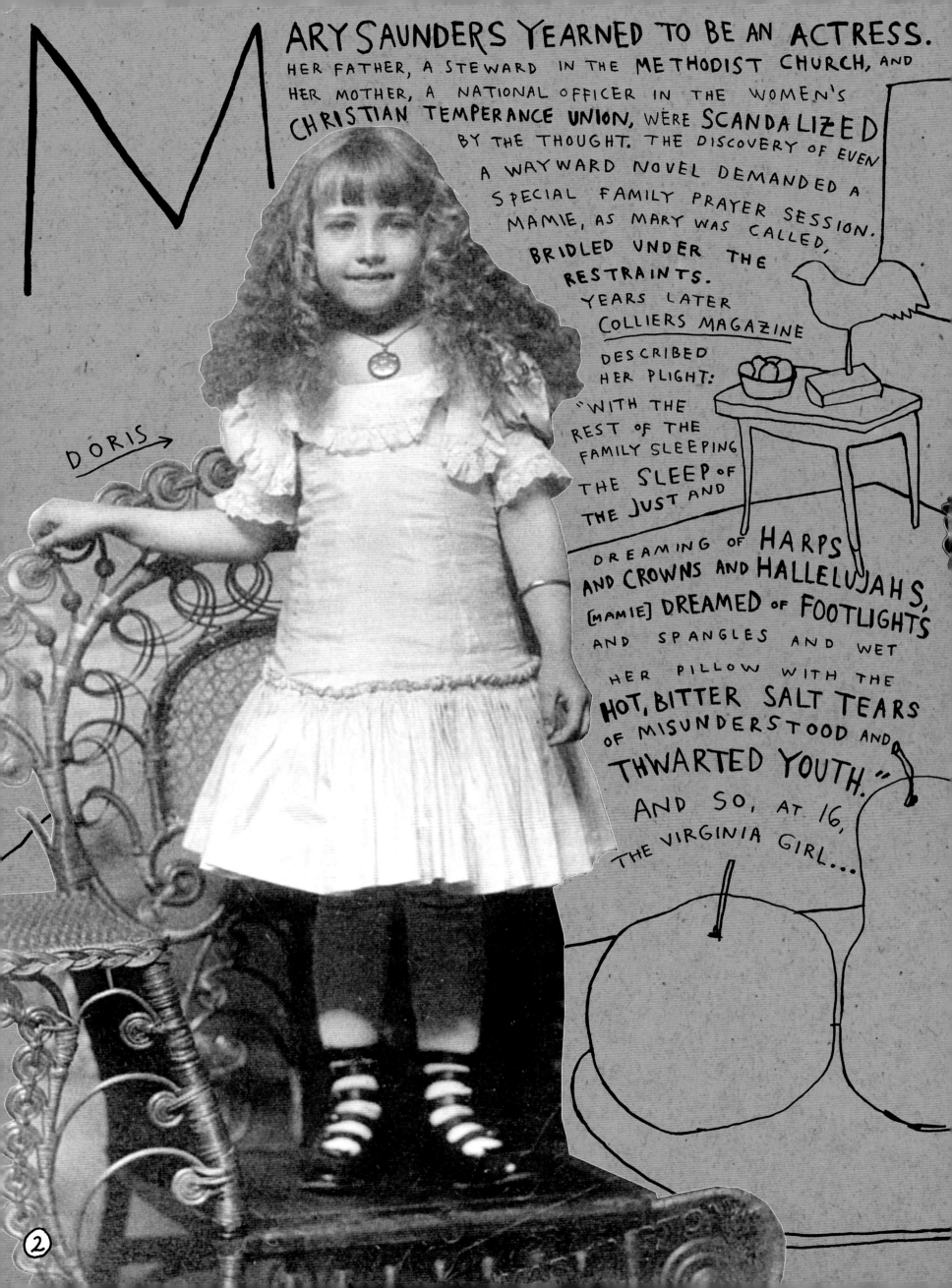

MARY SAUNDERS YEARNED TO BE AN ACTRESS. HER FATHER, A STEWARD IN THE METHODIST CHURCH, AND HER MOTHER, A NATIONAL OFFICER IN THE WOMEN'S CHRISTIAN TEMPERANCE UNION, WERE SCANDALIZED BY THE THOUGHT. THE DISCOVERY OF EVEN A WAYWARD NOVEL DEMANDED A SPECIAL FAMILY PRAYER SESSION. MAMIE, AS MARY WAS CALLED, BRIDLED UNDER THE RESTRAINTS. YEARS LATER COLLIERS MAGAZINE DESCRIBED HER PLIGHT:

"WITH THE REST OF THE FAMILY SLEEPING THE SLEEP OF THE JUST AND DREAMING OF HARPS AND CROWNS AND HALLELUJAHS, [MAMIE] DREAMED OF FOOTLIGHTS AND SPANGLES AND WET HER PILLOW WITH THE HOT, BITTER SALT TEARS OF MISUNDERSTOOD AND THWARTED YOUTH."

AND SO, AT 16, THE VIRGINIA GIRL...

DORIS →

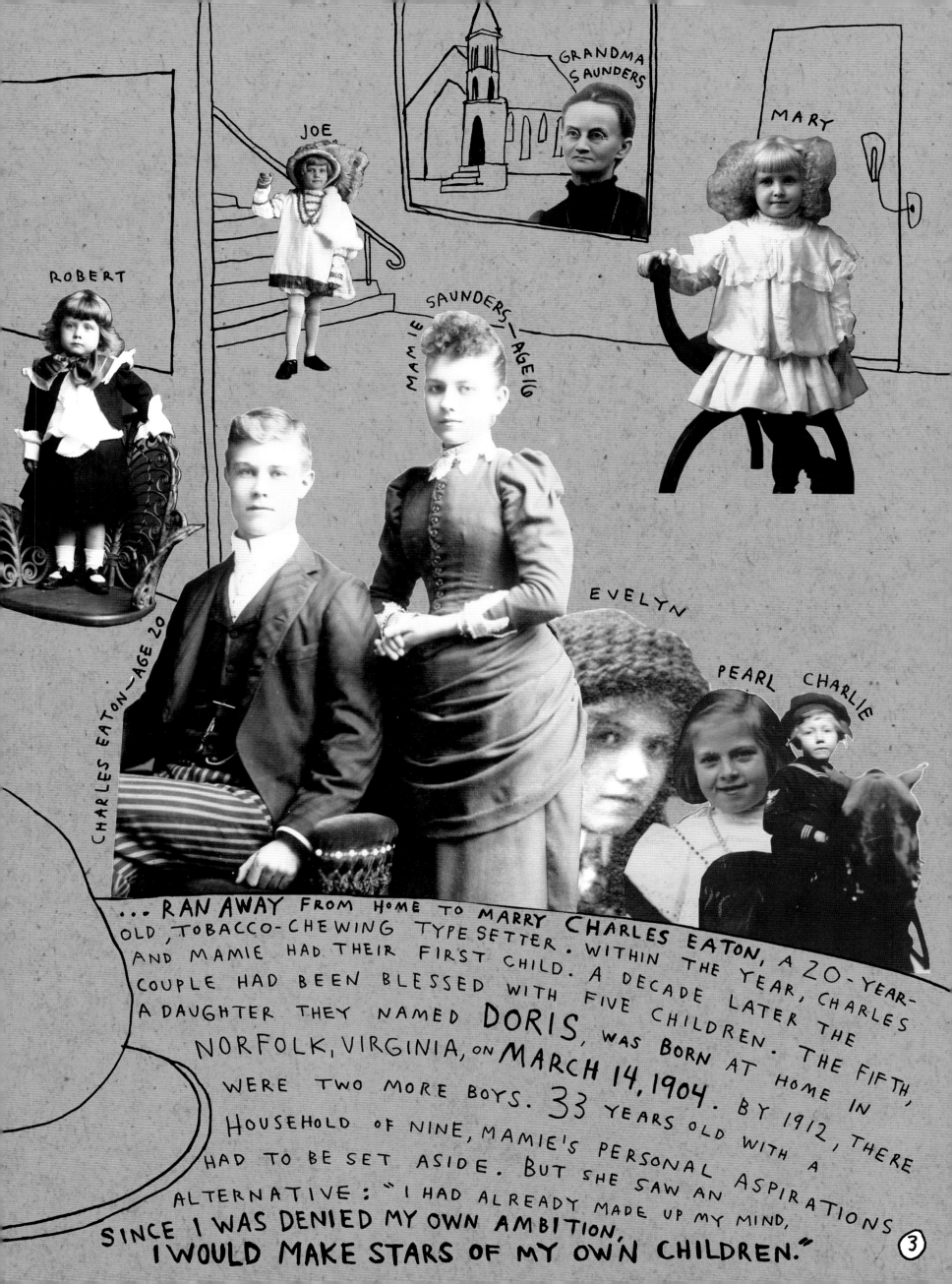

ROBERT

JOE

GRANDMA SAUNDERS

MARY

MAMIE SAUNDERS — AGE 16

CHARLES EATON — AGE 20

EVELYN

PEARL CHARLIE

... RAN AWAY FROM HOME TO MARRY CHARLES EATON, A 20-YEAR-OLD, TOBACCO-CHEWING TYPESETTER. WITHIN THE YEAR, CHARLES AND MAMIE HAD THEIR FIRST CHILD. A DECADE LATER THE COUPLE HAD BEEN BLESSED WITH FIVE CHILDREN. THE FIFTH, A DAUGHTER THEY NAMED DORIS, WAS BORN AT HOME IN NORFOLK, VIRGINIA, ON MARCH 14, 1904. BY 1912, THERE WERE TWO MORE BOYS. 33 YEARS OLD WITH A HOUSEHOLD OF NINE, MAMIE'S PERSONAL ASPIRATIONS HAD TO BE SET ASIDE. BUT SHE SAW AN ALTERNATIVE: "I HAD ALREADY MADE UP MY MIND, SINCE I WAS DENIED MY OWN AMBITION, I WOULD MAKE STARS OF MY OWN CHILDREN."

③

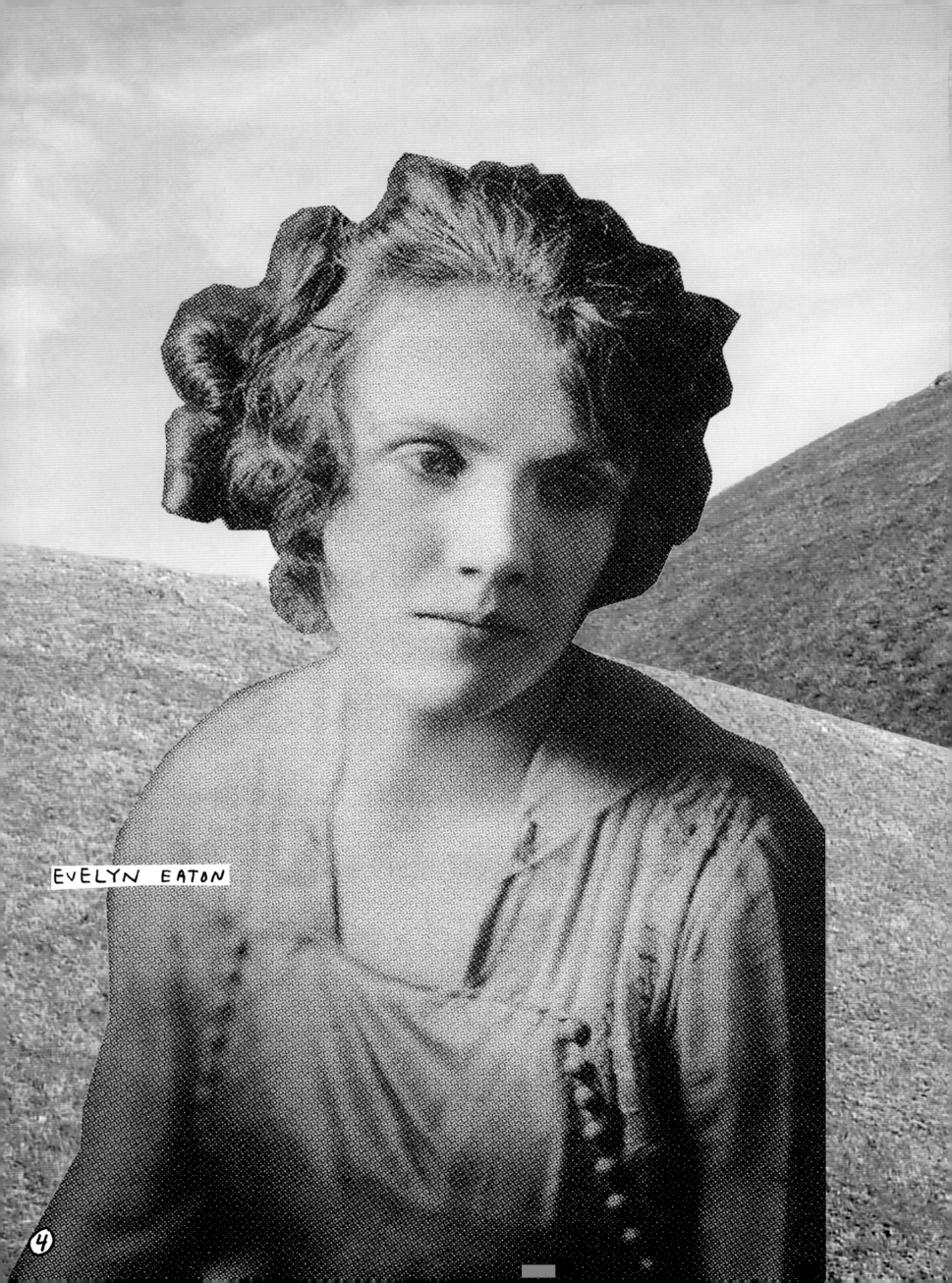

EVELYN EATON

④

Evelyn, slender with dark hair and green eyes, was soon infected with her mother's LOVE of SHOW BUSINESS.

DORIS: "SATURDAYS WHEN SHE COULD, SHE'D SCRAPE TOGETHER ENOUGH MONEY TO TAKE US TO SEE THE VAUDEVILLE SHOWS— SEATS IN THE BALCONY." SHE ORGANIZED HER SIBLINGS INTO HOMESPUN DRAMAS IN THE BACKYARD WHERE A POOR PERFORMANCE WAS REVIEWED WITH A CRITICAL TOSS OF DRY LEAVES.

DORIS: "THE FIRE STATION WAS JUST A FEW BLOCKS FROM US. THE ENGINES WOULD COME CLANGING DOWN THE STREET RIGHT WHERE OUR BACKYARD WAS. HORSES DROVE THEM, AND THE RHYTHM JUST FASCINATED ME—

DA-DUM, DA-DUM, DA-DUM, DA-DUM— COMING DOWN THE STREET AND CLANGING THE BELL, TOO. I USED TO LOVE THE SOUND OF THEIR HOOVES."

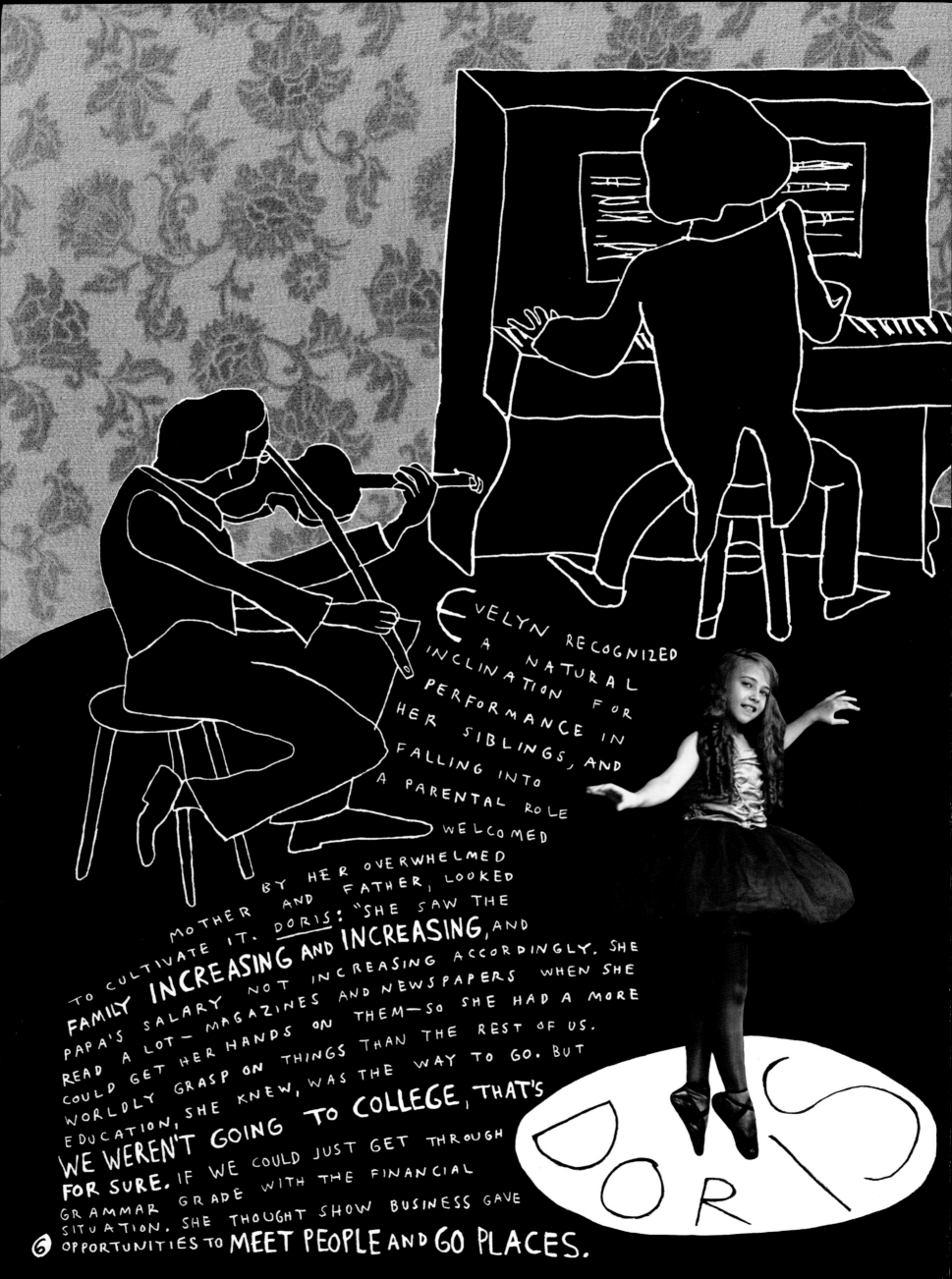

Evelyn recognized a natural inclination for performance in her siblings, and falling into a parental role welcomed by her overwhelmed mother and father, looked to cultivate it. Doris: "She saw the family INCREASING AND INCREASING, and papa's salary not increasing accordingly. She read a lot— magazines and newspapers when she could get her hands on them—so she had a more worldly grasp on things than the rest of us. Education, she knew, was the way to go. But WE WEREN'T GOING TO COLLEGE, THAT'S FOR SURE. If we could just get through grammar grade with the financial situation. She thought show business gave opportunities to MEET PEOPLE AND GO PLACES.

6

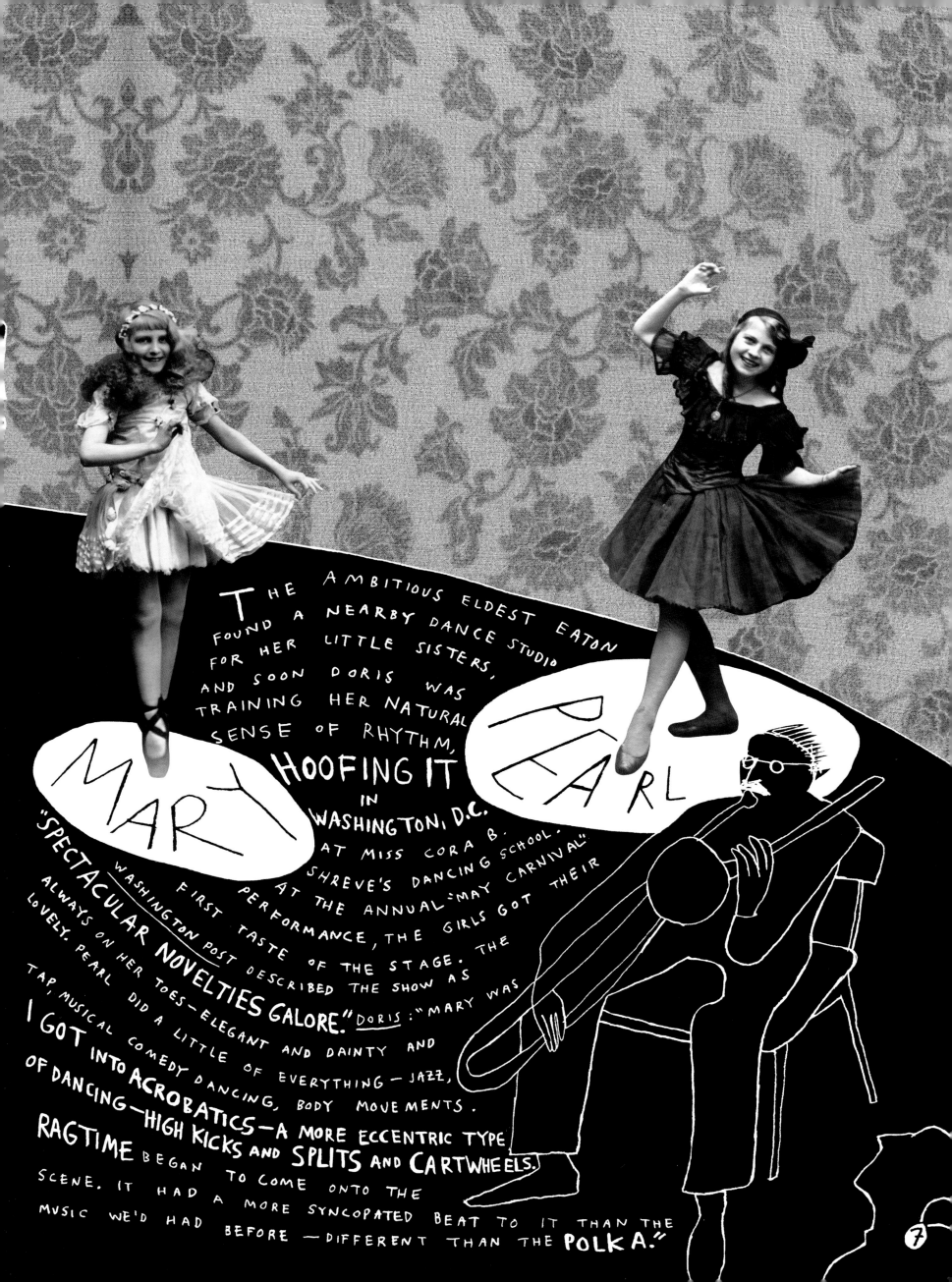

THE AMBITIOUS ELDEST EATON FOUND A NEARBY DANCE STUDIO FOR HER LITTLE SISTERS, AND SOON DORIS WAS TRAINING HER NATURAL SENSE OF RHYTHM, HOOFING IT IN WASHINGTON, D.C. AT MISS CORA B. SHREVE'S DANCING SCHOOL. AT THE ANNUAL "MAY CARNIVAL" PERFORMANCE, THE GIRLS GOT THEIR FIRST TASTE OF THE STAGE. THE WASHINGTON POST DESCRIBED THE SHOW AS "SPECTACULAR NOVELTIES GALORE." DORIS: "MARY WAS ALWAYS ON HER TOES—ELEGANT AND DAINTY AND LOVELY. PEARL DID A LITTLE OF EVERYTHING—JAZZ, TAP, MUSICAL COMEDY DANCING, BODY MOVEMENTS. I GOT INTO ACROBATICS—A MORE ECCENTRIC TYPE OF DANCING—HIGH KICKS AND SPLITS AND CARTWHEELS. RAGTIME BEGAN TO COME ONTO THE SCENE. IT HAD A MORE SYNCOPATED BEAT TO IT THAN THE MUSIC WE'D HAD BEFORE—DIFFERENT THAN THE POLKA."

MARY

PEARL

7

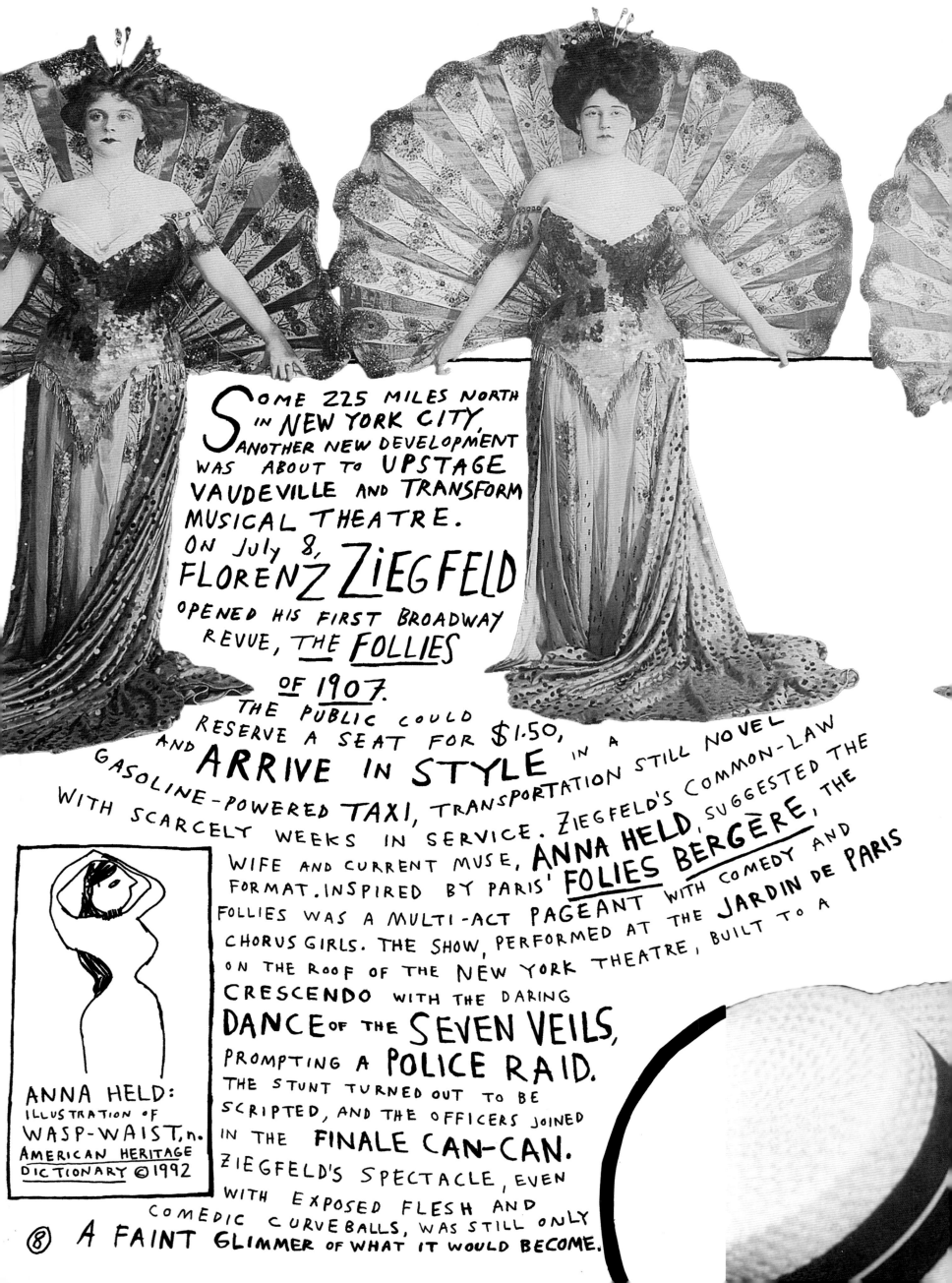

SOME 225 MILES NORTH in NEW YORK CITY, another new development WAS ABOUT TO UPSTAGE VAUDEVILLE AND TRANSFORM MUSICAL THEATRE. ON July 8, FLORENZ ZIEGFELD OPENED HIS FIRST BROADWAY REVUE, THE FOLLIES OF 1907. THE PUBLIC COULD RESERVE A SEAT FOR $1.50, AND ARRIVE IN STYLE IN A GASOLINE-POWERED TAXI, TRANSPORTATION STILL NOVEL WITH SCARCELY WEEKS IN SERVICE. ZIEGFELD'S COMMON-LAW WIFE AND CURRENT MUSE, ANNA HELD, SUGGESTED THE FORMAT. INSPIRED BY PARIS' FOLIES BERGÈRE, THE FOLLIES WAS A MULTI-ACT PAGEANT WITH COMEDY AND CHORUS GIRLS. THE SHOW, PERFORMED AT THE JARDIN DE PARIS ON THE ROOF OF THE NEW YORK THEATRE, BUILT TO A CRESCENDO WITH THE DARING DANCE OF THE SEVEN VEILS, PROMPTING A POLICE RAID. THE STUNT TURNED OUT TO BE SCRIPTED, AND THE OFFICERS JOINED IN THE FINALE CAN-CAN. ZIEGFELD'S SPECTACLE, EVEN WITH EXPOSED FLESH AND COMEDIC CURVEBALLS, WAS STILL ONLY

ⓧ A FAINT GLIMMER OF WHAT IT WOULD BECOME.

ANNA HELD:
ILLUSTRATION OF
WASP-WAIST, n.
AMERICAN HERITAGE
DICTIONARY ©1992

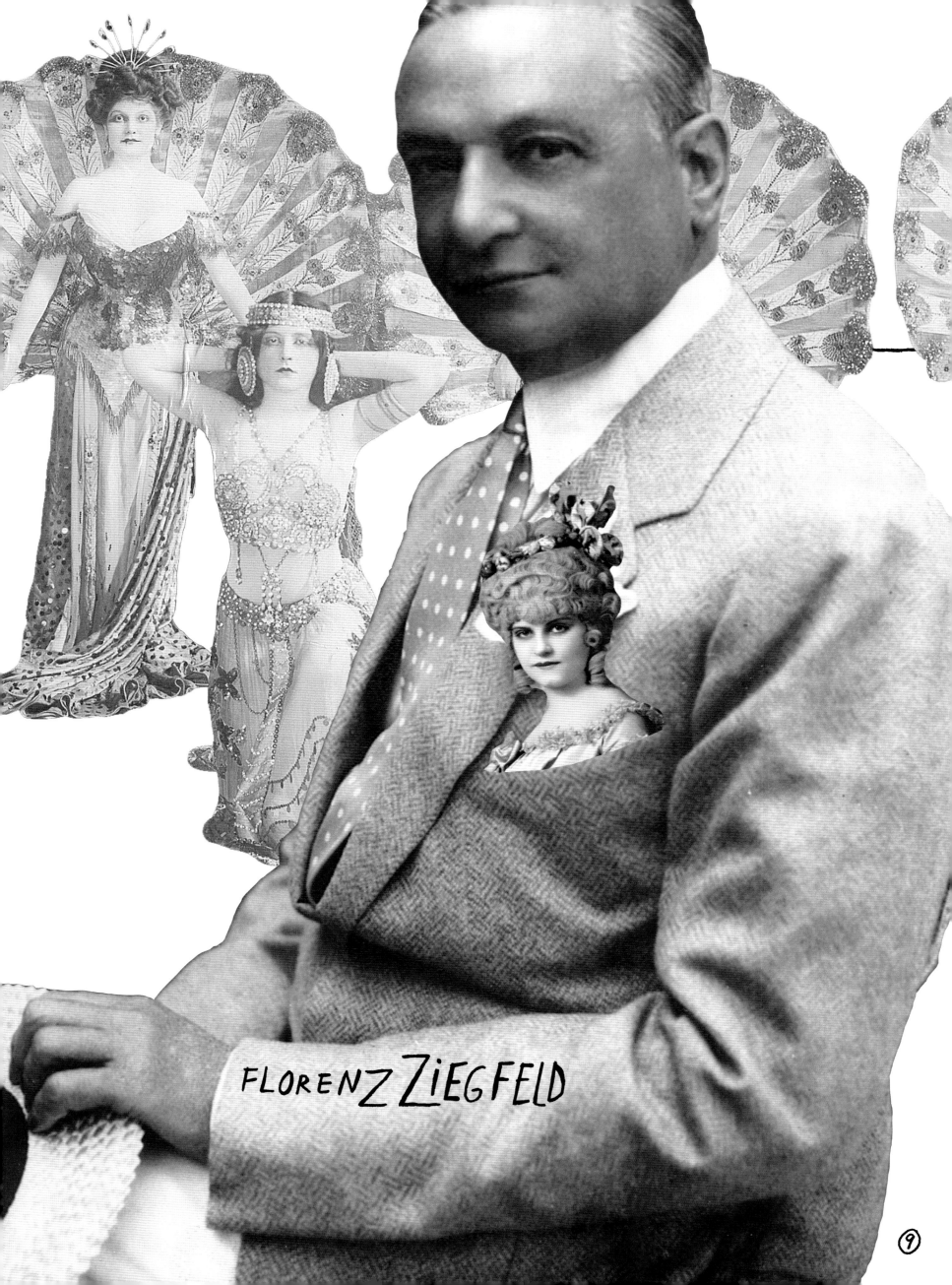

FLORENZ ZIEGFELD

⑨

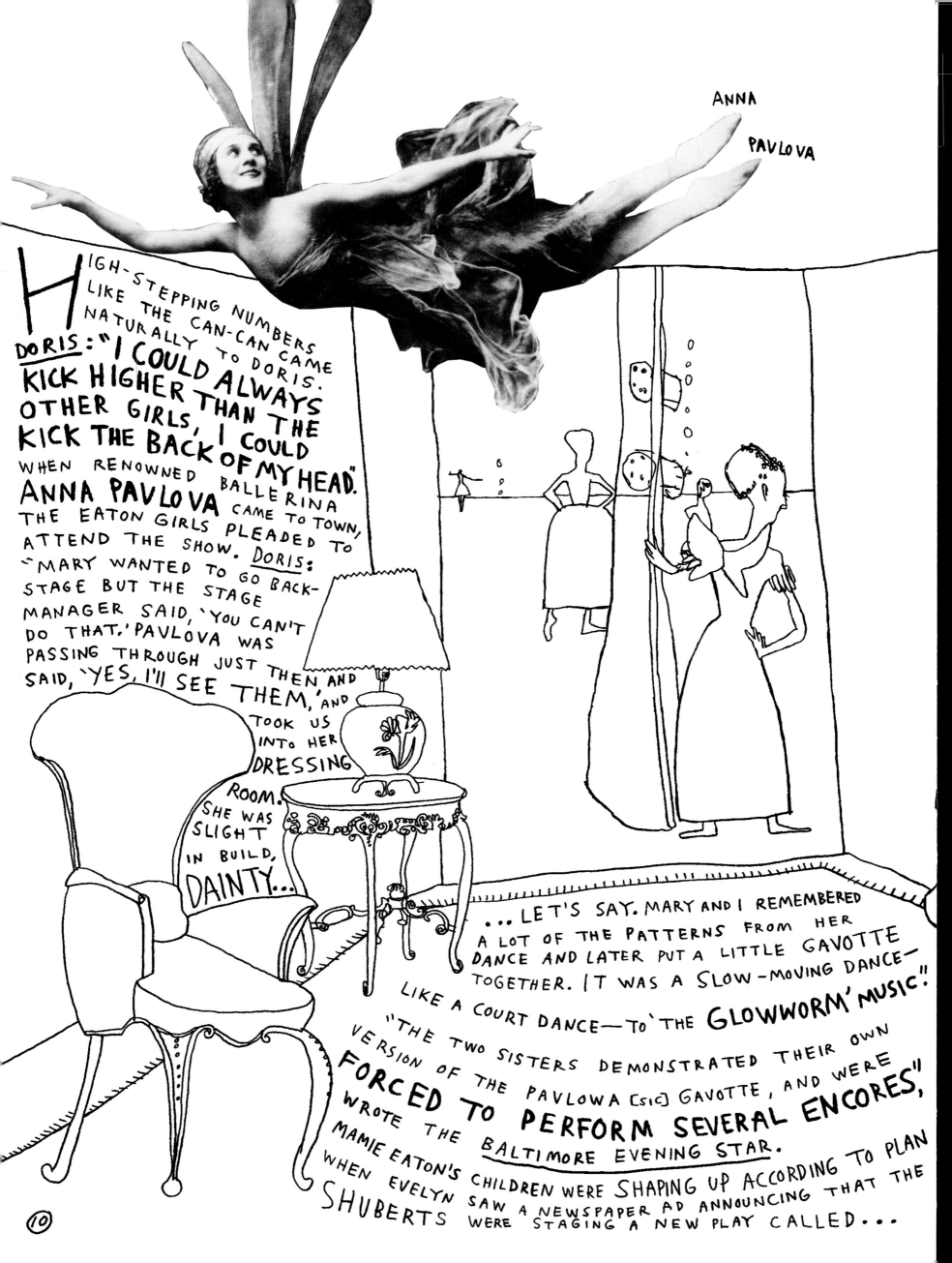

ANNA PAVLOVA

HIGH-STEPPING NUMBERS LIKE THE CAN-CAN CAME NATURALLY TO DORIS.

DORIS: "I COULD ALWAYS KICK HIGHER THAN THE OTHER GIRLS, I COULD KICK THE BACK OF MY HEAD."

WHEN RENOWNED BALLERINA ANNA PAVLOVA CAME TO TOWN, THE EATON GIRLS PLEADED TO ATTEND THE SHOW. DORIS: "MARY WANTED TO GO BACKSTAGE BUT THE STAGE MANAGER SAID, 'YOU CAN'T DO THAT.' PAVLOVA WAS PASSING THROUGH JUST THEN AND SAID, 'YES, I'll SEE THEM,' AND TOOK US INTO HER DRESSING ROOM. SHE WAS SLIGHT IN BUILD, DAINTY...

...LET'S SAY. MARY AND I REMEMBERED A LOT OF THE PATTERNS FROM HER DANCE AND LATER PUT A LITTLE GAVOTTE TOGETHER. IT WAS A SLOW-MOVING DANCE— LIKE A COURT DANCE—TO 'THE GLOWWORM' MUSIC."

"THE TWO SISTERS DEMONSTRATED THEIR OWN VERSION OF THE PAVLOWA [sic] GAVOTTE, AND WERE FORCED TO PERFORM SEVERAL ENCORES," WROTE THE BALTIMORE EVENING STAR.

MAMIE EATON'S CHILDREN WERE SHAPING UP ACCORDING TO PLAN WHEN EVELYN SAW A NEWSPAPER AD ANNOUNCING THAT THE SHUBERTS WERE STAGING A NEW PLAY CALLED...

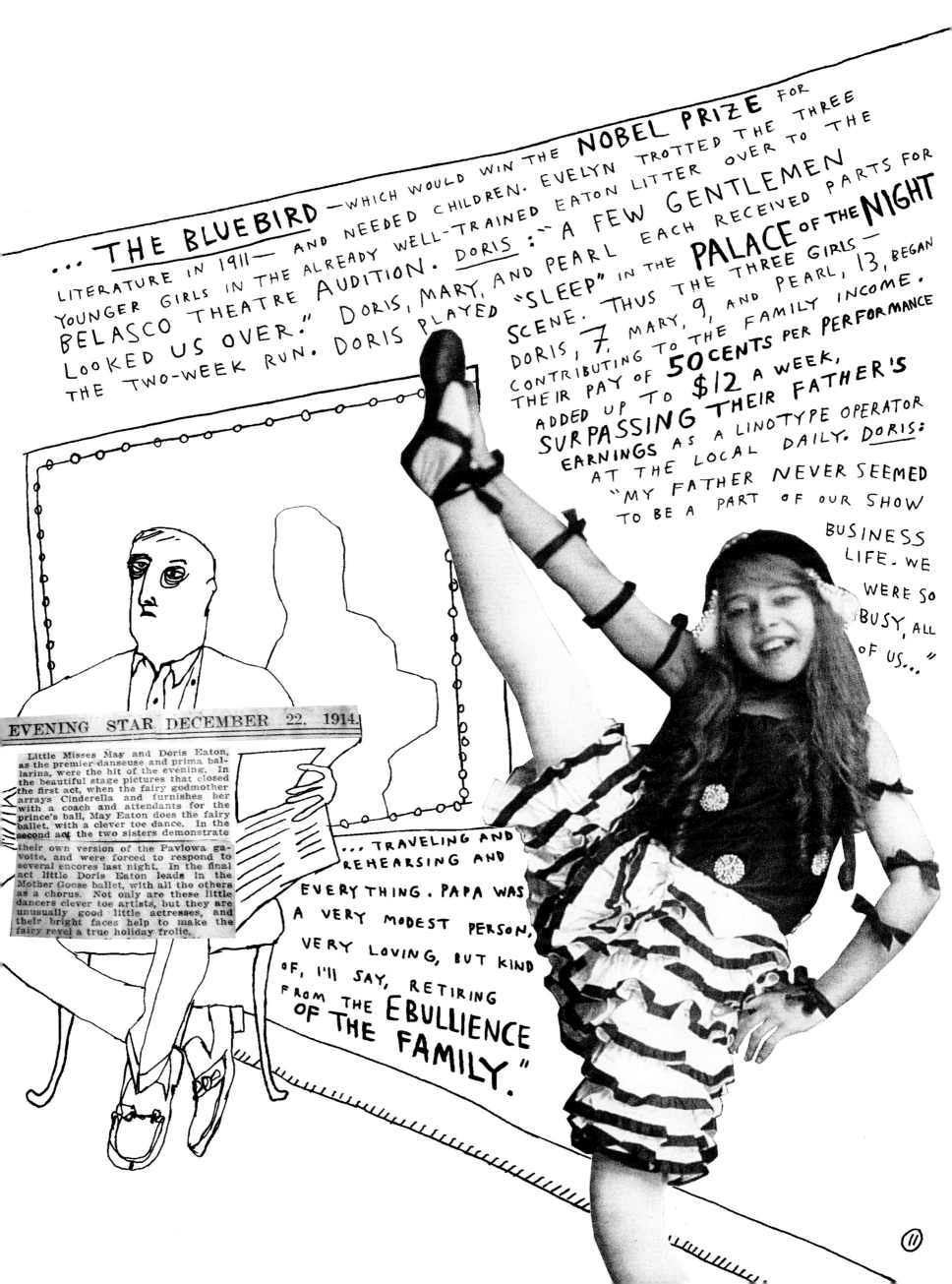

...THE BLUEBIRD—WHICH WOULD WIN THE NOBEL PRIZE FOR LITERATURE IN 1911— AND NEEDED CHILDREN. EVELYN TROTTED THE THREE YOUNGER GIRLS IN THE ALREADY WELL-TRAINED EATON LITTER OVER TO THE BELASCO THEATRE AUDITION. DORIS: "A FEW GENTLEMEN LOOKED US OVER." DORIS, MARY, AND PEARL EACH RECEIVED PARTS FOR THE TWO-WEEK RUN. DORIS PLAYED "SLEEP" IN THE PALACE OF THE NIGHT SCENE. THUS THE THREE GIRLS — DORIS, 7, MARY, 9, AND PEARL, 13, BEGAN CONTRIBUTING TO THE FAMILY INCOME. THEIR PAY OF 50 CENTS PER PERFORMANCE ADDED UP TO $12 A WEEK, SURPASSING THEIR FATHER'S EARNINGS AS A LINOTYPE OPERATOR AT THE LOCAL DAILY. DORIS: "MY FATHER NEVER SEEMED TO BE A PART OF OUR SHOW BUSINESS LIFE. WE WERE SO BUSY, ALL OF US..."

...TRAVELING AND REHEARSING AND EVERYTHING. PAPA WAS A VERY MODEST PERSON, VERY LOVING, BUT KIND OF, I'll SAY, RETIRING FROM THE EBULLIENCE OF THE FAMILY."

⑪

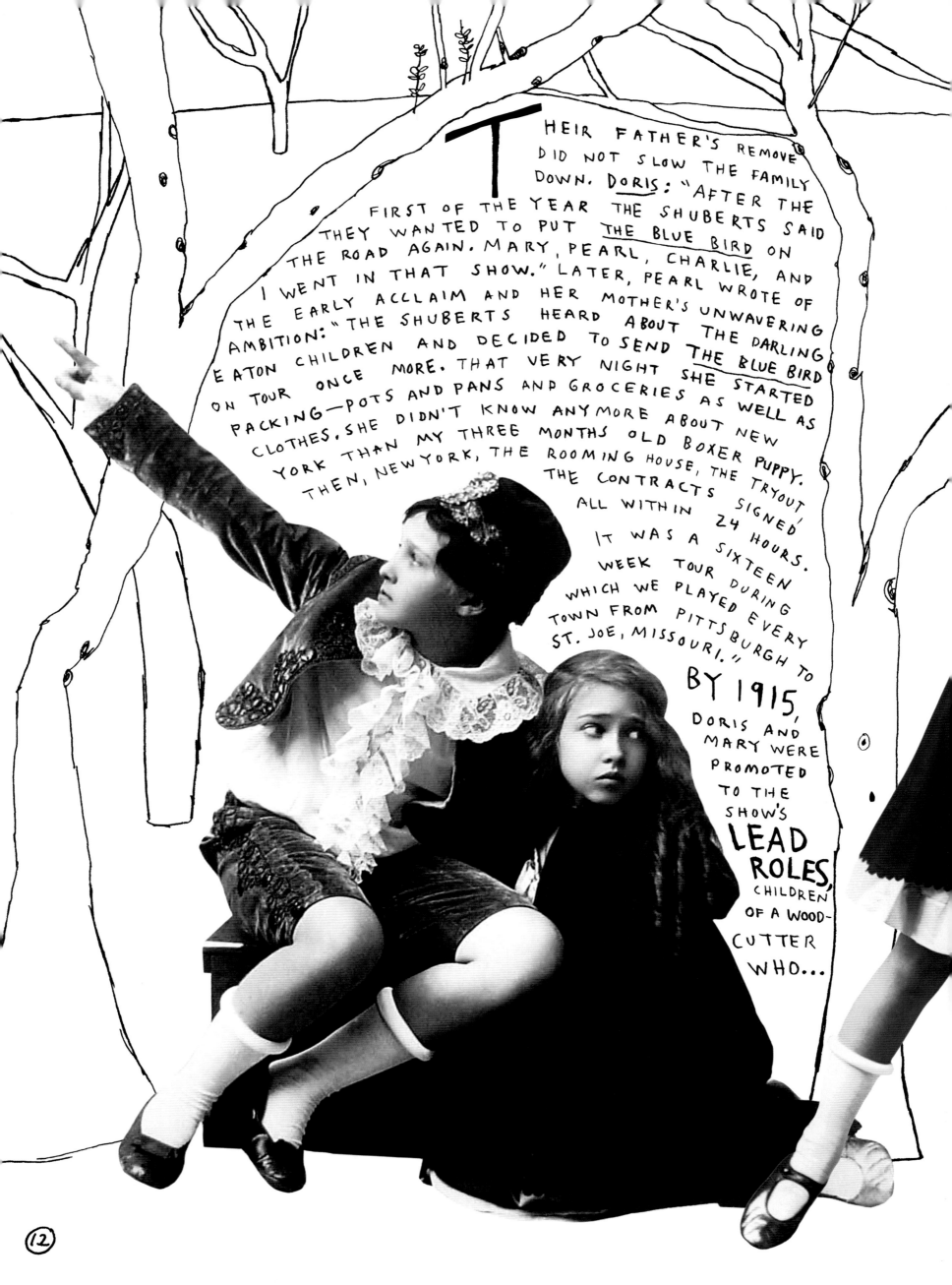

THEIR FATHER'S REMOVE DID NOT SLOW THE FAMILY DOWN. DORIS: "AFTER THE FIRST OF THE YEAR THE SHUBERTS SAID THEY WANTED TO PUT THE BLUE BIRD ON THE ROAD AGAIN. MARY, PEARL, CHARLIE, AND I WENT IN THAT SHOW." LATER, PEARL WROTE OF THE EARLY ACCLAIM AND HER MOTHER'S UNWAVERING AMBITION: "THE SHUBERTS HEARD ABOUT THE DARLING EATON CHILDREN AND DECIDED TO SEND THE BLUE BIRD ON TOUR ONCE MORE. THAT VERY NIGHT SHE STARTED PACKING—POTS AND PANS AND GROCERIES AS WELL AS CLOTHES. SHE DIDN'T KNOW ANYMORE ABOUT NEW YORK THAN MY THREE MONTHS OLD BOXER PUPPY. THEN, NEW YORK, THE ROOMING HOUSE, THE TRYOUT, THE CONTRACTS SIGNED ALL WITHIN 24 HOURS. IT WAS A SIXTEEN WEEK TOUR DURING WHICH WE PLAYED EVERY TOWN FROM PITTSBURGH TO ST. JOE, MISSOURI."

BY 1915, DORIS AND MARY WERE PROMOTED TO THE SHOW'S **LEAD ROLES,** CHILDREN OF A WOOD-CUTTER WHO...

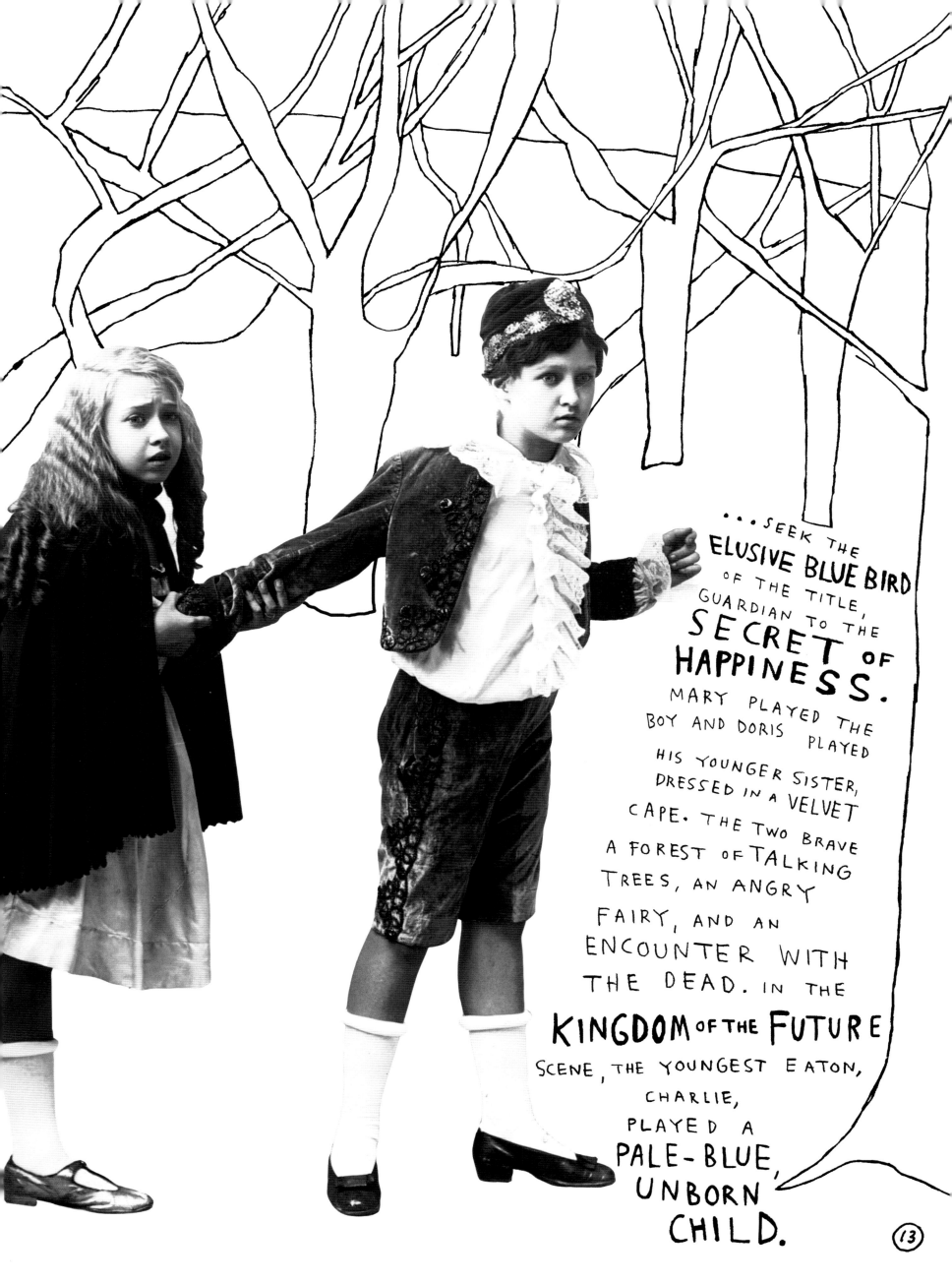

...SEEK THE ELUSIVE BLUE BIRD OF THE TITLE, GUARDIAN TO THE SECRET OF HAPPINESS. MARY PLAYED THE BOY AND DORIS PLAYED HIS YOUNGER SISTER, DRESSED IN A VELVET CAPE. THE TWO BRAVE A FOREST OF TALKING TREES, AN ANGRY FAIRY, AND AN ENCOUNTER WITH THE DEAD. IN THE KINGDOM OF THE FUTURE SCENE, THE YOUNGEST EATON, CHARLIE, PLAYED A PALE-BLUE, UNBORN CHILD.

13

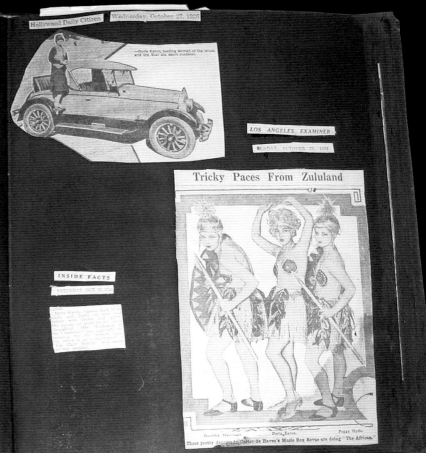

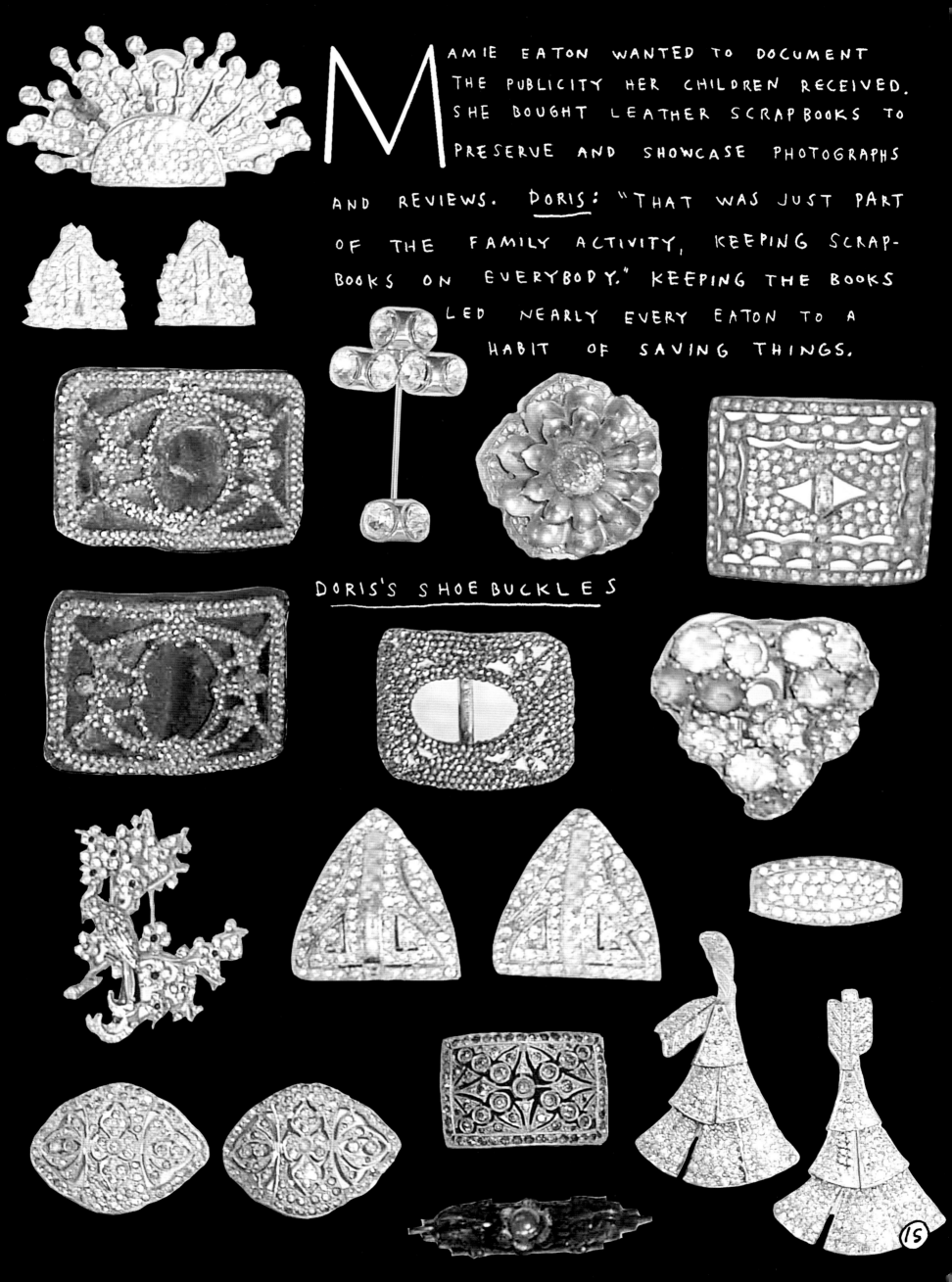

MAMIE EATON WANTED TO DOCUMENT THE PUBLICITY HER CHILDREN RECEIVED. SHE BOUGHT LEATHER SCRAPBOOKS TO PRESERVE AND SHOWCASE PHOTOGRAPHS AND REVIEWS. DORIS: "THAT WAS JUST PART OF THE FAMILY ACTIVITY, KEEPING SCRAPBOOKS ON EVERYBODY." KEEPING THE BOOKS LED NEARLY EVERY EATON TO A HABIT OF SAVING THINGS.

DORIS'S SHOE BUCKLES

GRAY-EYED ROBERT DID NOT ACCOMPANY HIS PARENTS, BROTHERS, AND SISTERS TO NEW YORK. DORIS: "HE JUST KIND OF WANDERED OFF BY HIMSELF. I DON'T KNOW WHERE HE WENT, BUT WE SELDOM SAW HIM. WE HAD A BIG FAMILY. MAYBE HE JUST DIDN'T FIT IN SOME-HOW." RETICENT AND SENSITIVE LIKE HIS FATHER, ROBERT SHUNNED THE SPOTLIGHT. AS IT SHIFTED ITS GLARE TOWARD THE EATONS, HE STEPPED ASIDE, AND HIS FAMILY RUSHED FORWARD.

ROBERT EATON

16

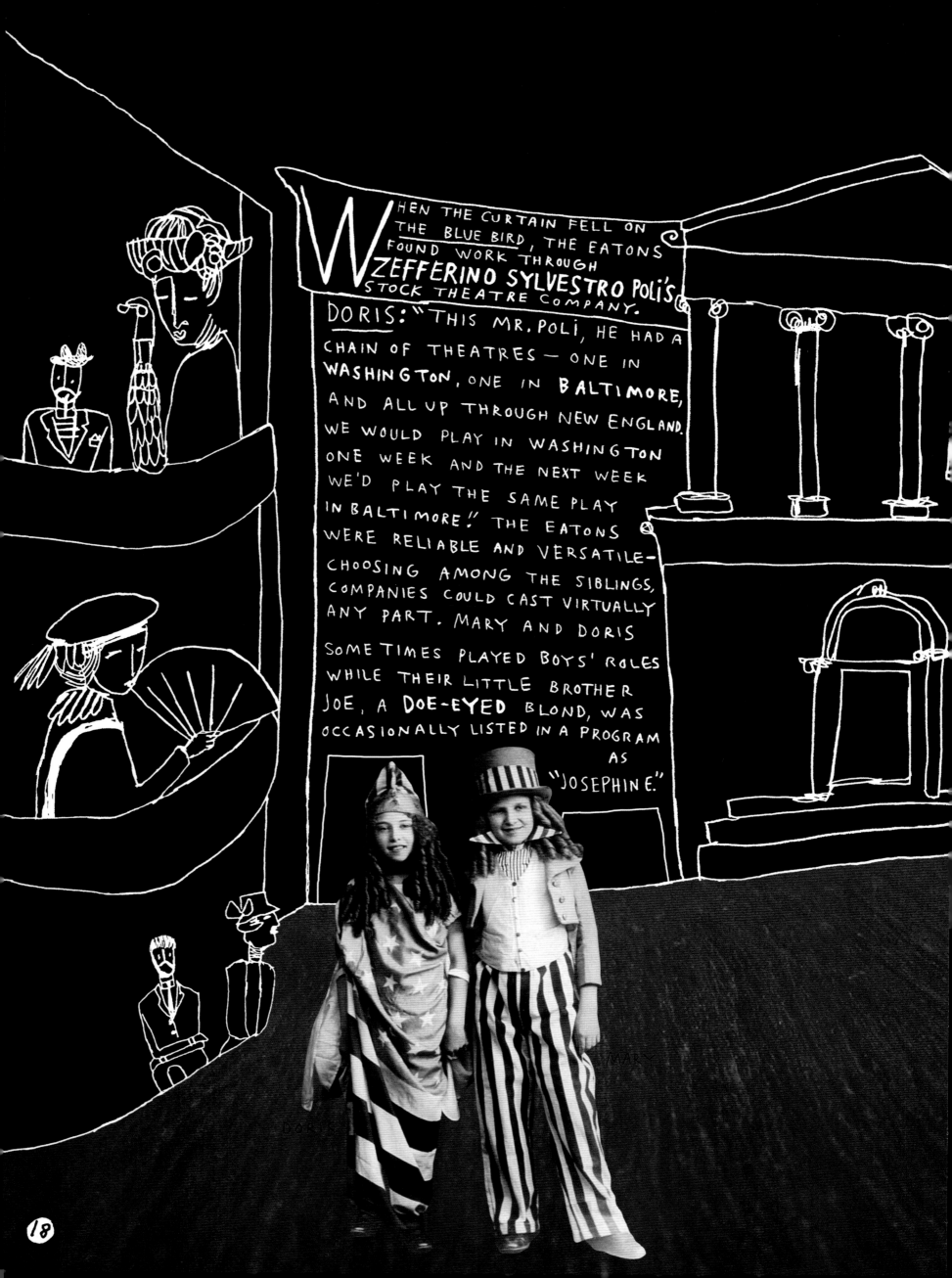

WHEN THE CURTAIN FELL ON THE BLUE BIRD, THE EATONS FOUND WORK THROUGH ZEFFERINO SYLVESTRO POLI'S STOCK THEATRE COMPANY.

DORIS: "THIS MR. POLI, HE HAD A CHAIN OF THEATRES — ONE IN WASHINGTON, ONE IN BALTIMORE, AND ALL UP THROUGH NEW ENGLAND. WE WOULD PLAY IN WASHINGTON ONE WEEK AND THE NEXT WEEK WE'D PLAY THE SAME PLAY IN BALTIMORE." THE EATONS WERE RELIABLE AND VERSATILE— CHOOSING AMONG THE SIBLINGS, COMPANIES COULD CAST VIRTUALLY ANY PART. MARY AND DORIS

SOMETIMES PLAYED BOYS' ROLES WHILE THEIR LITTLE BROTHER JOE, A DOE-EYED BLOND, WAS OCCASIONALLY LISTED IN A PROGRAM AS "JOSEPHINE."

18

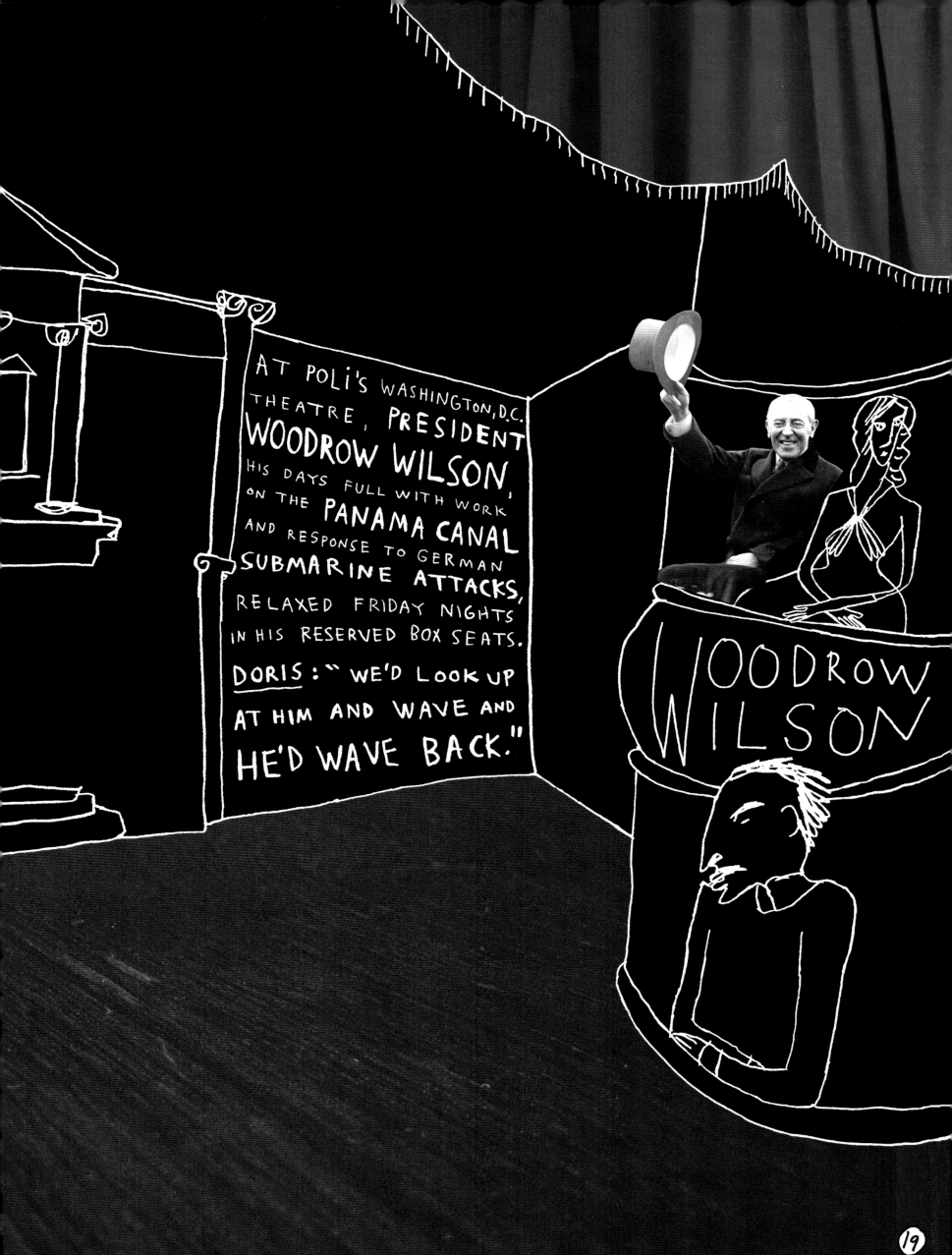

AT POLi'S WASHINGTON, D.C. THEATRE, PRESIDENT WOODROW WILSON, HIS DAYS FULL WITH WORK ON THE PANAMA CANAL AND RESPONSE TO GERMAN SUBMARINE ATTACKS, RELAXED FRIDAY NIGHTS IN HIS RESERVED BOX SEATS.

DORIS: "WE'D LOOK UP AT HIM AND WAVE AND HE'D WAVE BACK."

WOODROW WILSON

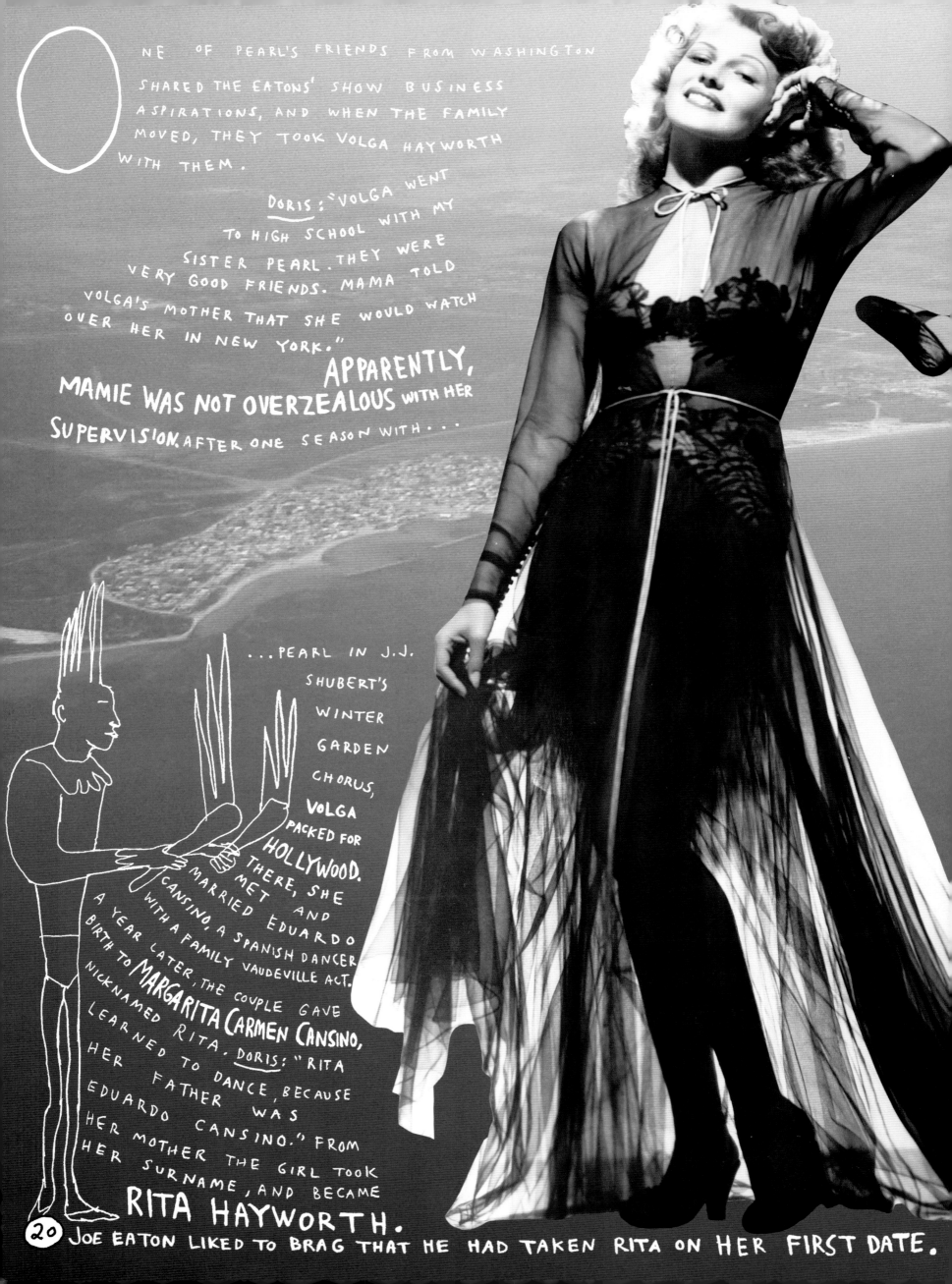

ONE OF PEARL'S FRIENDS FROM WASHINGTON SHARED THE EATONS' SHOW BUSINESS ASPIRATIONS, AND WHEN THE FAMILY MOVED, THEY TOOK VOLGA HAYWORTH WITH THEM.

DORIS: "VOLGA WENT TO HIGH SCHOOL WITH MY SISTER PEARL. THEY WERE VERY GOOD FRIENDS. MAMA TOLD VOLGA'S MOTHER THAT SHE WOULD WATCH OVER HER IN NEW YORK."

APPARENTLY, MAMIE WAS NOT OVERZEALOUS WITH HER SUPERVISION. AFTER ONE SEASON WITH...

...PEARL IN J.J. SHUBERT'S WINTER GARDEN CHORUS, VOLGA PACKED FOR HOLLYWOOD. THERE, SHE MET AND MARRIED EDUARDO CANSINO, A SPANISH DANCER WITH A FAMILY VAUDEVILLE ACT. A YEAR LATER, THE COUPLE GAVE BIRTH TO MARGARITA CARMEN CANSINO, NICKNAMED RITA. DORIS: "RITA LEARNED TO DANCE, BECAUSE HER FATHER WAS EDUARDO CANSINO." FROM HER MOTHER THE GIRL TOOK HER SURNAME, AND BECAME RITA HAYWORTH.

JOE EATON LIKED TO BRAG THAT HE HAD TAKEN RITA ON HER FIRST DATE.

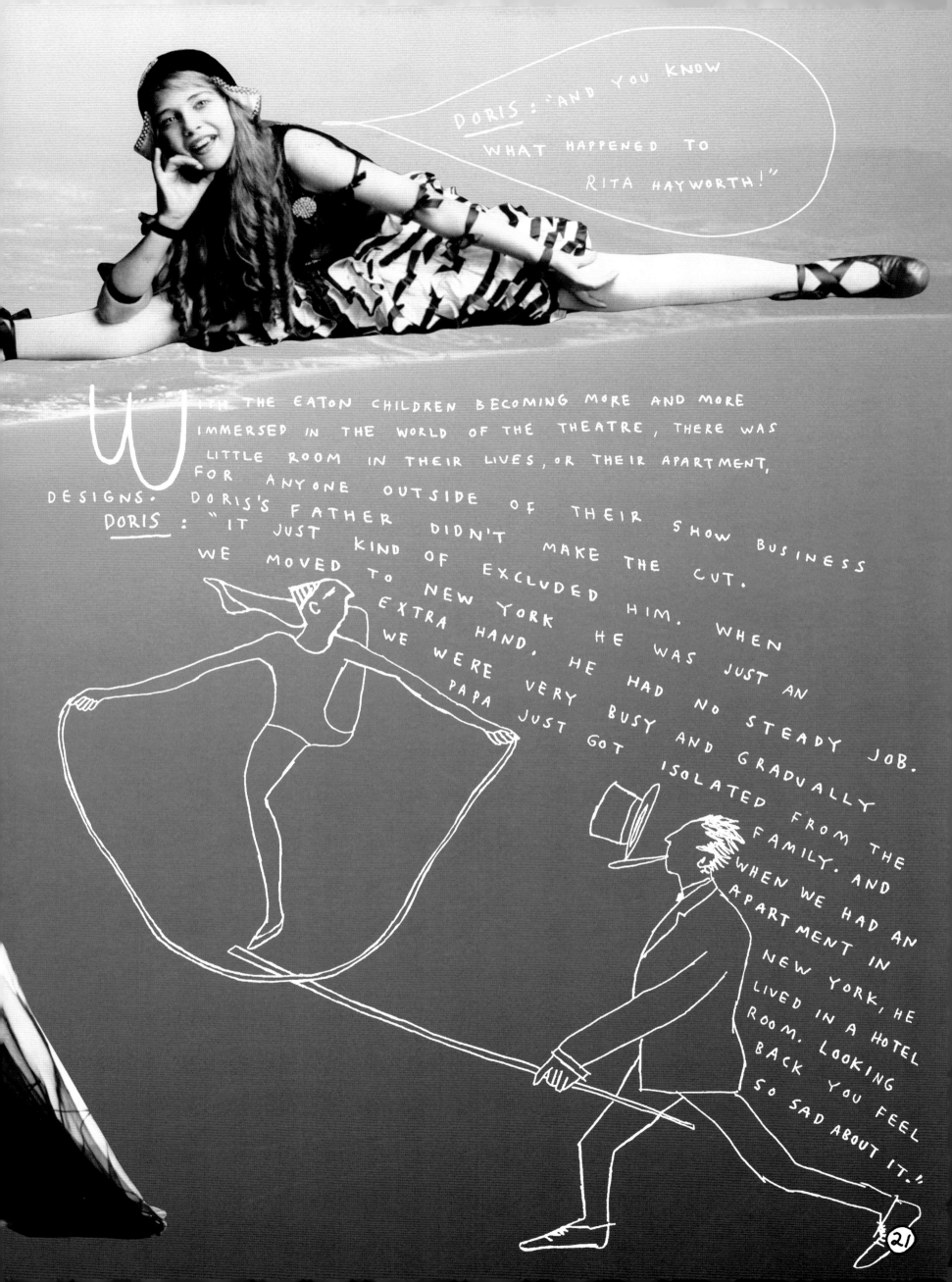

DORIS: "AND YOU KNOW WHAT HAPPENED TO RITA HAYWORTH!"

WITH THE EATON CHILDREN BECOMING MORE AND MORE IMMERSED IN THE WORLD OF THE THEATRE, THERE WAS LITTLE ROOM IN THEIR LIVES, OR THEIR APARTMENT, FOR ANYONE OUTSIDE OF THEIR SHOW BUSINESS DESIGNS. DORIS'S FATHER DIDN'T MAKE THE CUT.

DORIS: "IT JUST KIND OF EXCLUDED HIM. WHEN WE MOVED TO NEW YORK HE WAS JUST AN EXTRA HAND. HE HAD NO STEADY JOB. WE WERE VERY BUSY AND GRADUALLY PAPA JUST GOT ISOLATED FROM THE FAMILY. AND WHEN WE HAD AN APARTMENT IN NEW YORK, HE LIVED IN A HOTEL ROOM. LOOKING BACK YOU FEEL SO SAD ABOUT IT."

JOE EATON, TOO,

WAS LEFT BEHIND.
SIX YEARS OLD, JOE WAS STRUCK BY **POLIO.** HIS
MOTHER TURNED TO EVELYN'S SUNDAY
SCHOOL TEACHER, **CHRISTIAN SCIENCE**
PRACTITIONER JANE LOCKER, FOR GUIDANCE.
LOCKER BECAME A REGULAR
PRESENCE IN THE EATONS' LIVES
AND THE CHILDREN BEGAN CALLING HER
AUNT JANE. WHEN THE FAMILY WENT TO
NEW YORK, AUNT JANE WANTED JOE TO
REMAIN IN HER CARE. <u>DORIS</u>: "SHE FELT
THAT JOE—WHO WAS SEVEN OR EIGHT YEARS
OLD—WOULDN'T GET AN EDUCATION BOUNCING
AROUND THE COUNTRY. WE WERE ALL
TRAVELING IN SHOW BUSINESS, HERE, THERE,
AND EVERYWHERE. SO THERE WAS NO STEADY
PLACE FOR HIM. THE WAY THE FAMILY WORK
CAME, HE WAS NOT PART OF IT."

ONE PHOTO AUNT
JANE KEPT OF JOE WAS LABELED ON THE BACK:
"THE LITTLE BOY WHO LIVED WITH US."
JOE FOUND COMFORT IN LEAD FIGURINES.
JANE LOCKER'S FATHER, A CONFEDERATE
SOLDIER DURING THE CIVIL WAR, GOT THE BOY
HOOKED ON MILITARY LORE. JOE BEGAN
BUILDING AN **ARMY OF TOY SOLDIERS,**
EVENTUALLY AMASSING
100,000 WARRIORS.

The hobby seized Charlie's imagination as well, and he, too, began collecting. When Joe visited his family in New York, together the brothers would stage the battle of Waterloo and other clashes on homemade plaster turf. For both boys, collecting led to more collecting. Joe saw weaponry and combat accessories in the **DETRITUS OF DAILY LIFE.** His son, Joe Eaton Jr., who would inherit the collection, remembered his father. Joe Eaton Jr.: "He had these **ENGLISH MUFFIN** boxes. They made really good separators for trying to organize the soldiers. **HE SAVED ALL THE POP-TOPS** FROM BOTTLES, **CIGAR TUBES, TOOTH PICKS**—THEY MADE GOOD LANCES—**PLASTIC SWORDS** FROM DRINKS—THOUSANDS OF THOSE. WHEN **DOUGLAS FAIRBANKS, JR.** DECIDED NOT TO COLLECT SOLDIERS ANYMORE, HE GAVE HIS COLLECTION TO THEM."

DORIS: "THEY PARTICULARLY LIKED THE NAPOLEONIC ERA."

JOE, AGE 5

23

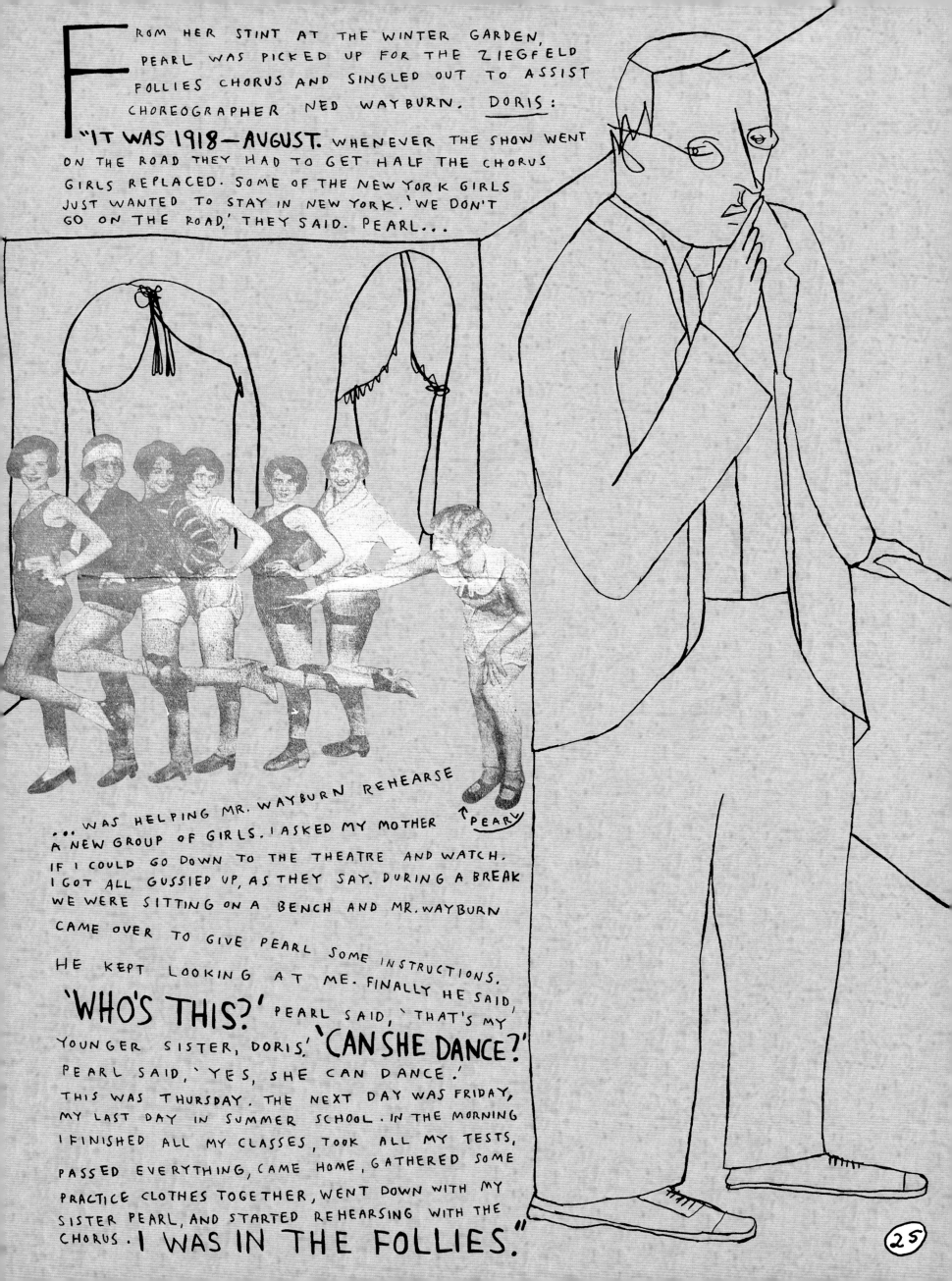

From her stint at the Winter Garden, Pearl was picked up for the Ziegfeld Follies chorus and singled out to assist choreographer Ned Wayburn. DORIS:

"It was 1918—August. Whenever the show went on the road they had to get half the chorus girls replaced. Some of the New York girls just wanted to stay in New York. 'We don't go on the road,' they said. Pearl...

...was helping Mr. Wayburn rehearse a new group of girls. I asked my mother if I could go down to the theatre and watch. I got all gussied up, as they say. During a break we were sitting on a bench and Mr. Wayburn came over to give Pearl some instructions. He kept looking at me. Finally he said, 'WHO'S THIS?' Pearl said, 'That's my younger sister, Doris.' 'CAN SHE DANCE?' Pearl said, 'Yes, she can dance.' This was Thursday. The next day was Friday, my last day in summer school. In the morning I finished all my classes, took all my tests, passed everything, came home, gathered some practice clothes together, went down with my sister Pearl, and started rehearsing with the chorus. I WAS IN THE FOLLIES."

↑ PEARL

25

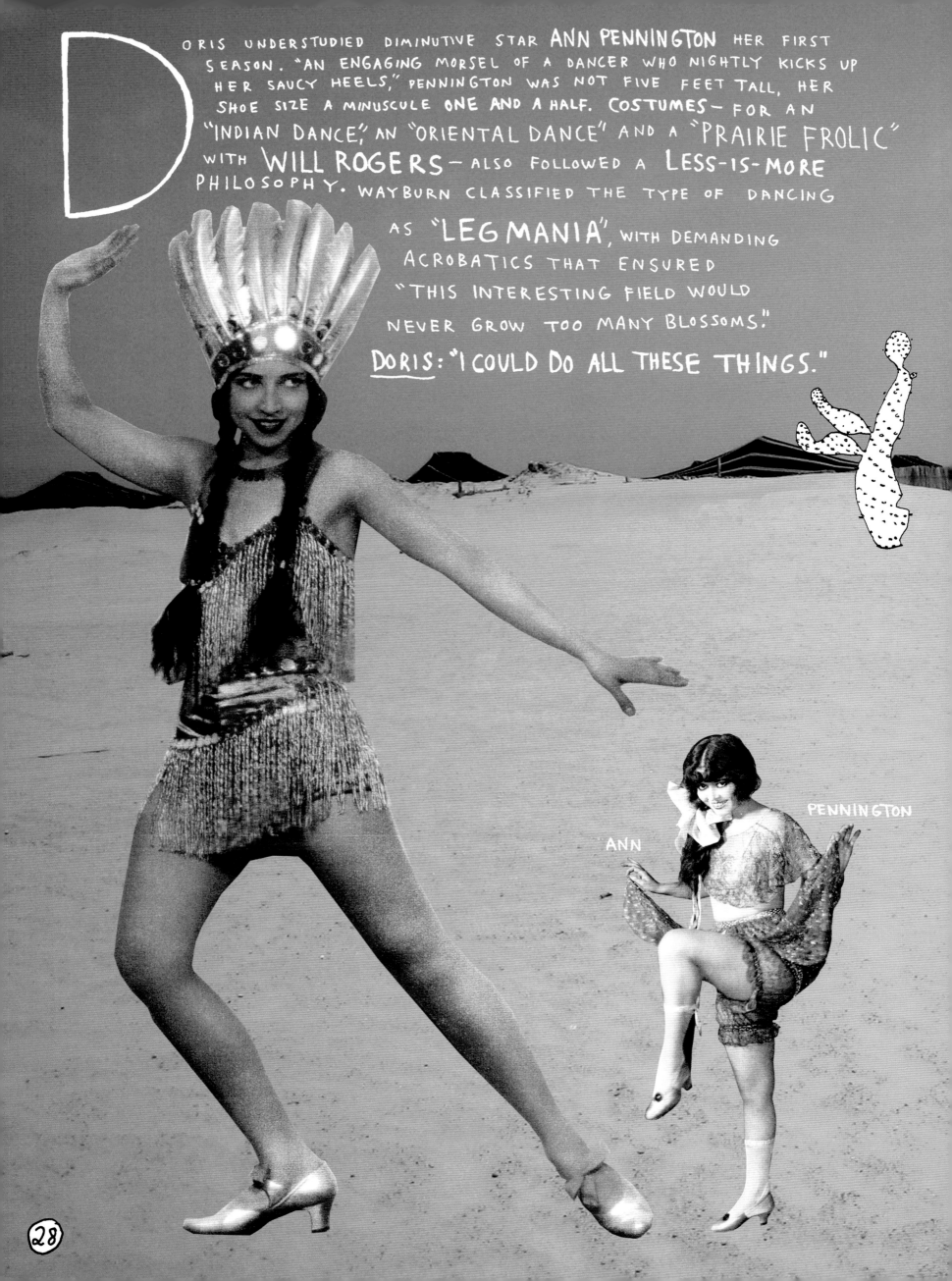

D ORIS UNDERSTUDIED DIMINUTIVE STAR ANN PENNINGTON HER FIRST SEASON. "AN ENGAGING MORSEL OF A DANCER WHO NIGHTLY KICKS UP HER SAUCY HEELS," PENNINGTON WAS NOT FIVE FEET TALL, HER SHOE SIZE A MINUSCULE ONE AND A HALF. COSTUMES— FOR AN "INDIAN DANCE," AN "ORIENTAL DANCE" AND A "PRAIRIE FROLIC" WITH WILL ROGERS — ALSO FOLLOWED A LESS-IS-MORE PHILOSOPHY. WAYBURN CLASSIFIED THE TYPE OF DANCING

AS "LEGMANIA", WITH DEMANDING ACROBATICS THAT ENSURED "THIS INTERESTING FIELD WOULD NEVER GROW TOO MANY BLOSSOMS."

DORIS: "I COULD DO ALL THESE THINGS."

ANN PENNINGTON

28

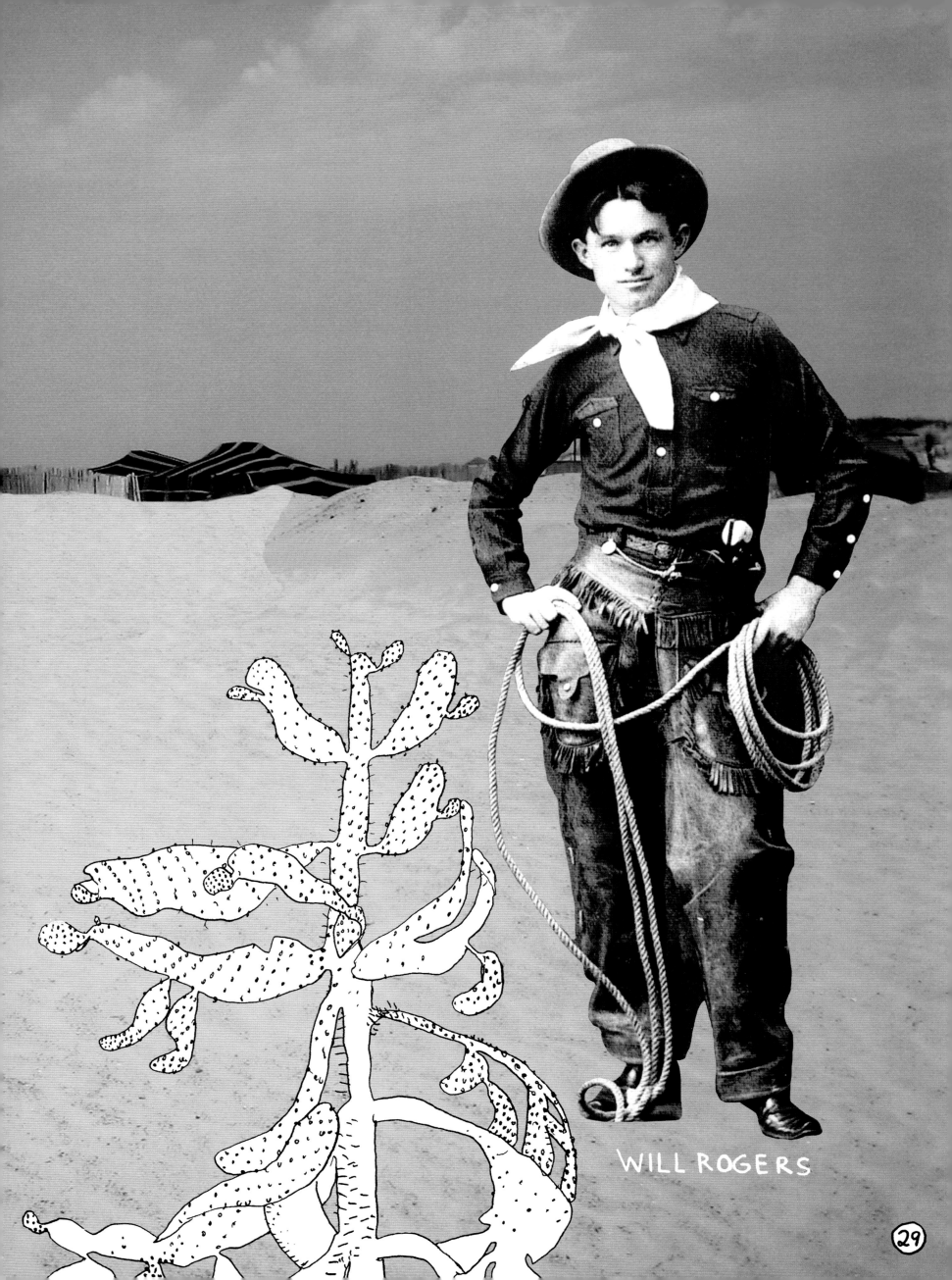

WILL ROGERS

29

THE ZIEGFELD FOLLIES, UNPRECEDENTED IN SPLENDOR AND SPECTACLE, WERE REDEFINING WHAT IT MEANT TO MOUNT A BROADWAY SHOW. TICKET-SEEKERS LINED UP AROUND THE BLOCK FOR SEATS AT THE NEW AMSTERDAM THEATRE (PROCLAIMED BY THE NEW YORK TIMES TO BE "A VISION OF GORGEOUSNESS" AND THE VERY EMBODIMENT OF THE CURRENT STYLISTIC AVANT-GARDE KNOWN AS ART NOUVEAU). EACH YEAR FLORENZ ZIEGFELD OUTDID HIS PREVIOUS PRODUCTION. HE LURED PERFORMERS WITH UNHEARD-OF SALARIES. HE SOUGHT OUT (AND OFTEN SEDUCED) THE MOST BEAUTIFUL GIRLS. VIENNESE SET DESIGNER JOSEPH URBAN CRAFTED TRAP DOORS, SPOUTING FOUNTAINS, STEEP STAIR CASES READY TO BE STACKED WITH GIRLS, ELECTRIFIED FLOORS THAT SPARKED WHEN DANCERS SET DOWN A FOOT. HIS PAINTED BACKDROPS DEPICTED VERTIGINOUS VISTAS, WHITE SWANS RISING INTO A TWILIT SKY, A PERSIAN HIDEAWAY GUARDED BY PEACOCKS.

ZIEGFELD Look Through Other Side ZIEGFELD
FOLLIES FOLLIES
Robert Greathouse Rep.-N.Y.C.

30

GELATINE SPECTACLES WERE DISTRIBUTED SO AUDIENCES COULD ENJOY 3-D SEQUENCES. "SPREAD THEM ON YOUR NOSE AND WONDERS HAPPEN," SAID THE NEW YORK TIMES.

ARTIST JAMES BEN ALI-HAGGIN ARRANGED MOTIONLESS, OFTEN SEMI-NUDE MODELS INTO LIVING PAINTINGS. DORIS: "HE DID ONE OF THAT QUEEN OF FRANCE—MARIE-ANTOINETTE. THE FIRST PART OF THE TABLEAU SHOWED THE GROUP THERE WITH HER BEING JUDGED. THEN THEY CLOSED THE CURTAINS. WHEN THEY REOPENED IT, THEY'D PUT A PIECE OF BLACK VELVET OVER HER SHOULDERS! AND A MAN WAS HOLDING HER HEAD. IT JUST LOOKED LIKE HE WAS THERE HOLDING HER HEAD."

ZIEGFELD'S LOVE OF WILD LIFE TRANSLATED INTO A LIVE ON-STAGE MENAGERIE. AN OSTRICH, HORSES, ELEPHANTS, A CHIMPANZEE, A DYED FLOCK OF MULTI-COLORED PIGEONS ALL JOINED THE COMPANY AT ONE TIME OR ANOTHER. AMONG THOSE SETTING THIS GARDEN OF EARTHLY DELIGHTS ...

... TO MUSIC WERE COMPOSERS IRVING BERLIN AND JEROME KERN.

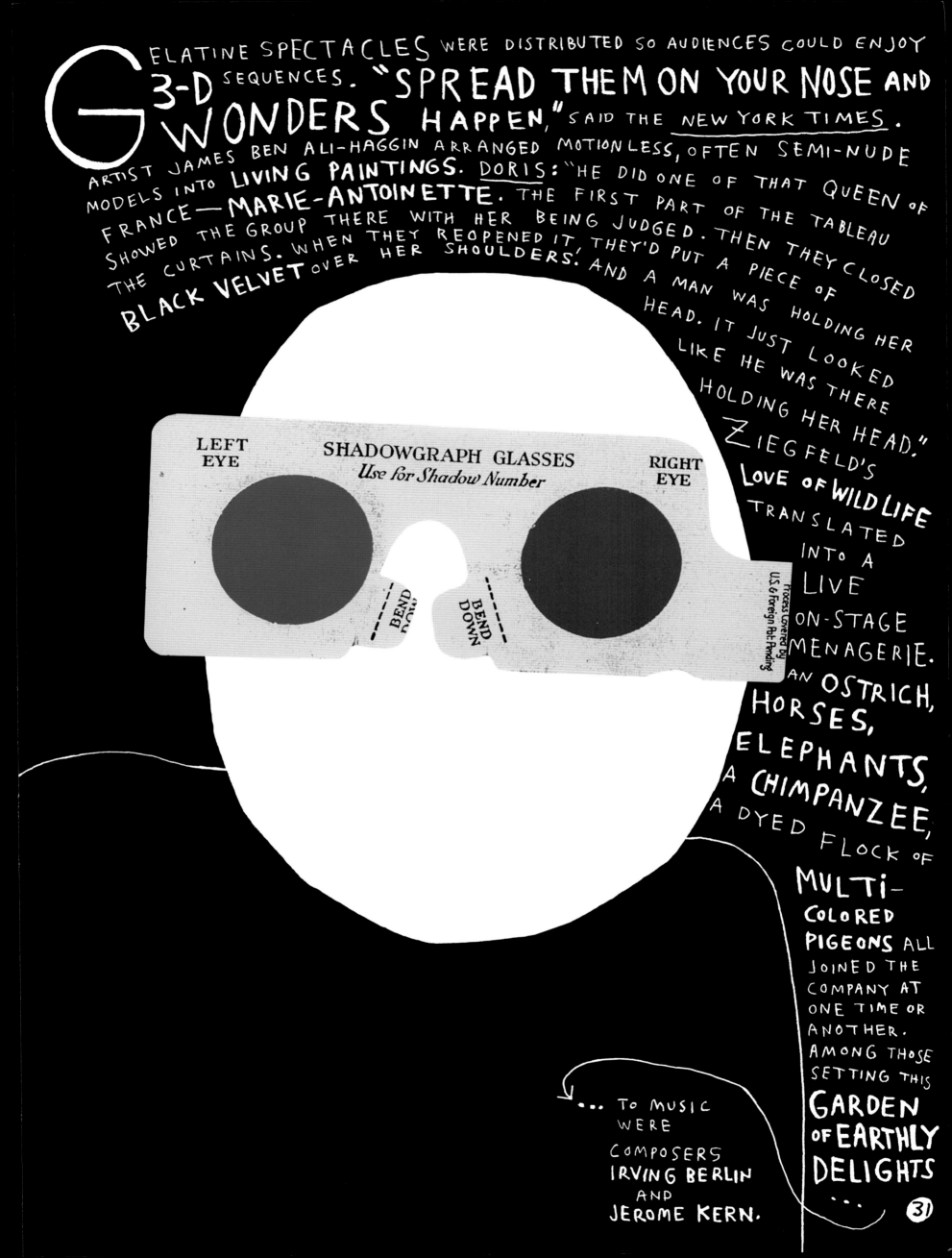

LEFT EYE

SHADOWGRAPH GLASSES
Use for Shadow Number

RIGHT EYE

BEND DOWN

BEND DOWN

Process Covered by U.S & Foreign Pat. Pending

31

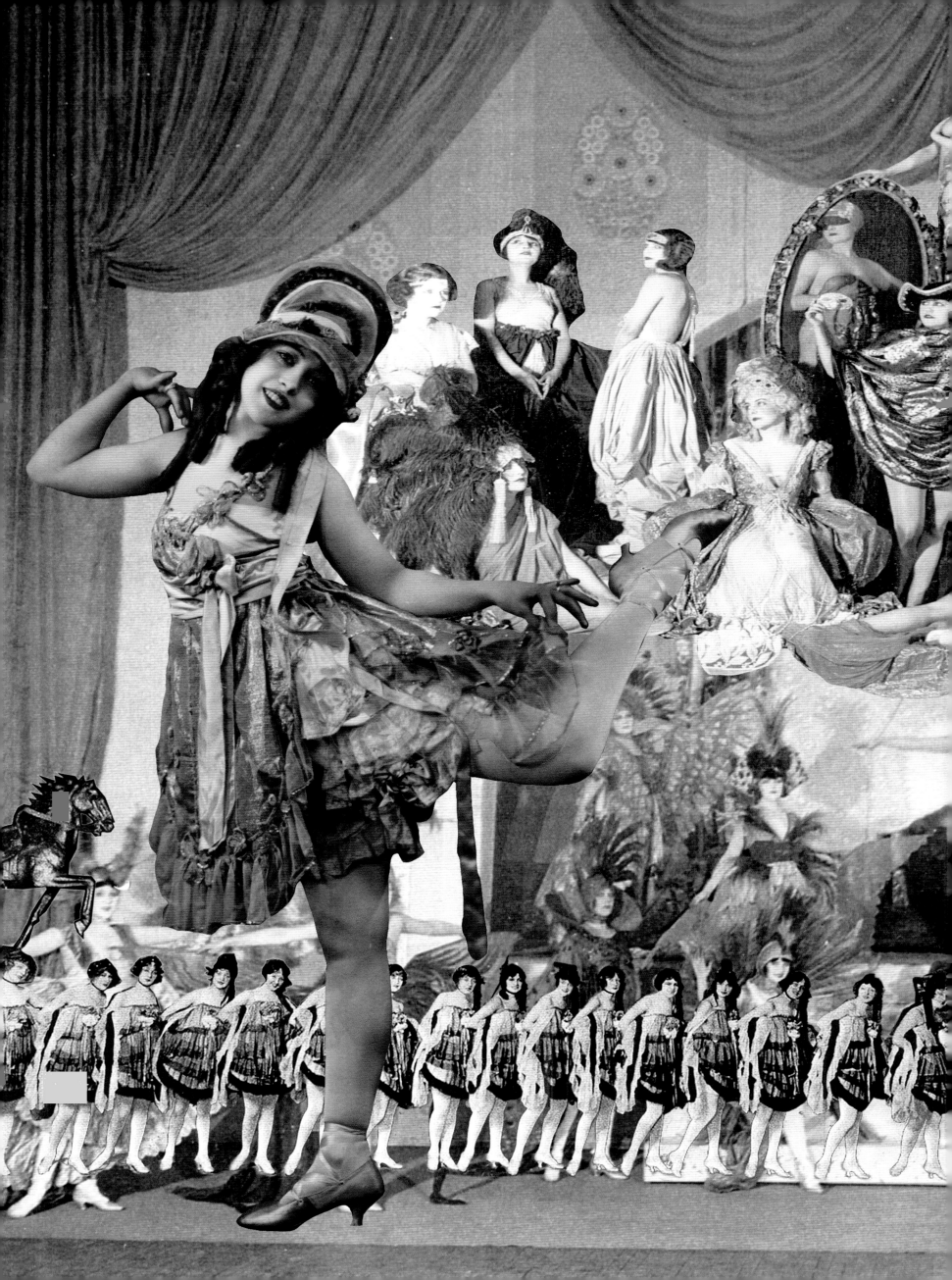

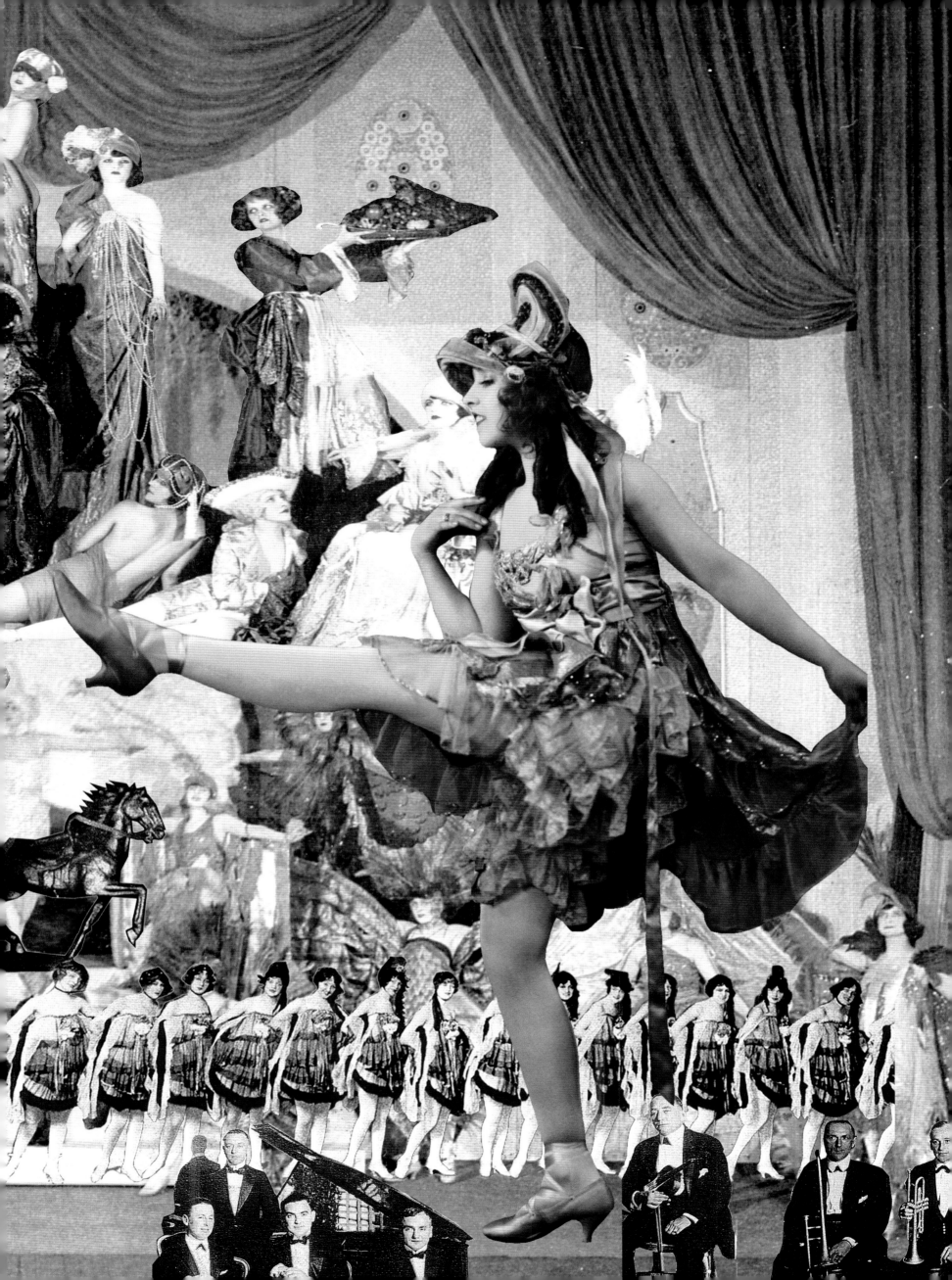

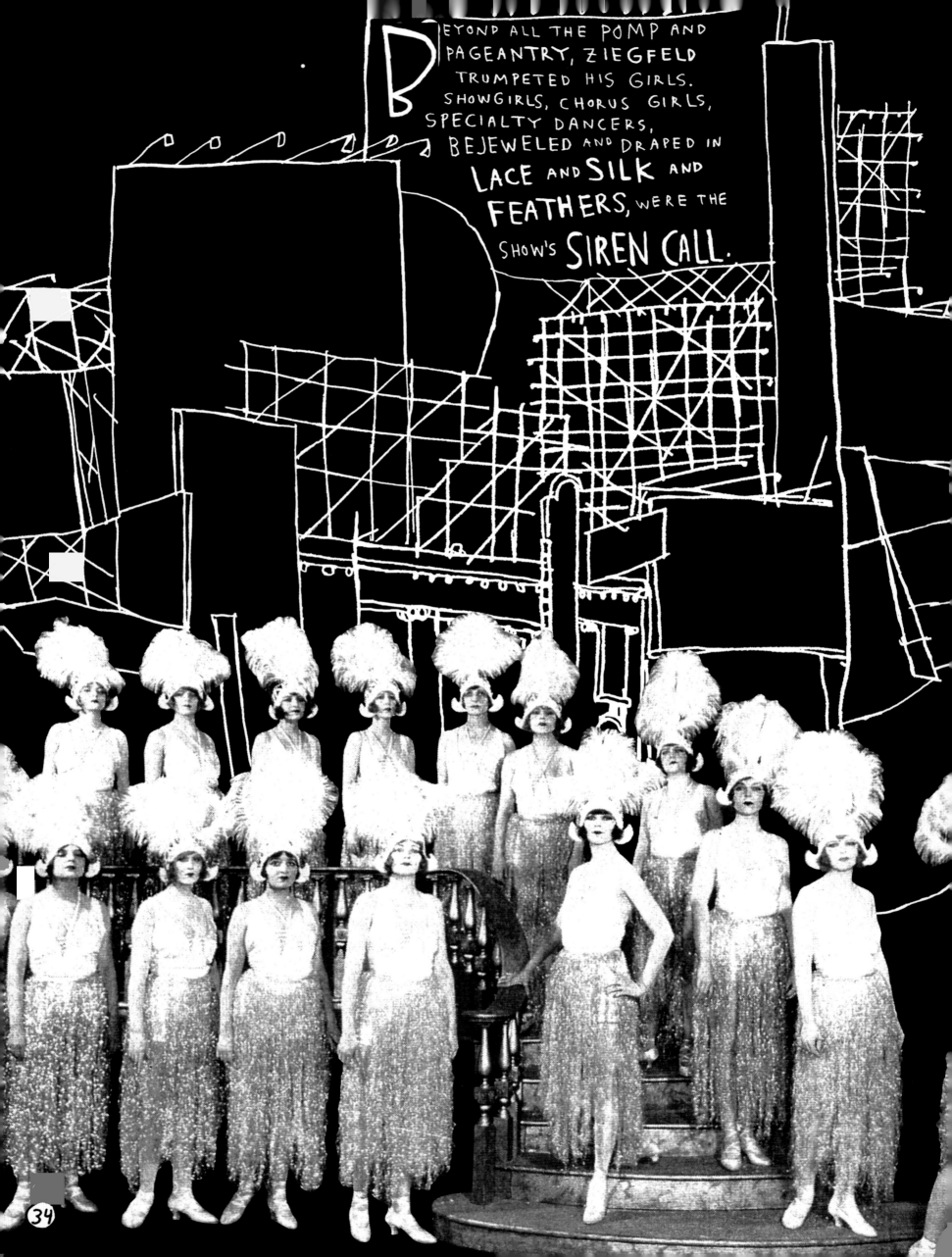

BEYOND ALL THE POMP AND PAGEANTRY, ZIEGFELD TRUMPETED HIS GIRLS. SHOWGIRLS, CHORUS GIRLS, SPECIALTY DANCERS, BEJEWELED AND DRAPED IN LACE AND SILK AND FEATHERS, WERE THE SHOW'S SIREN CALL.

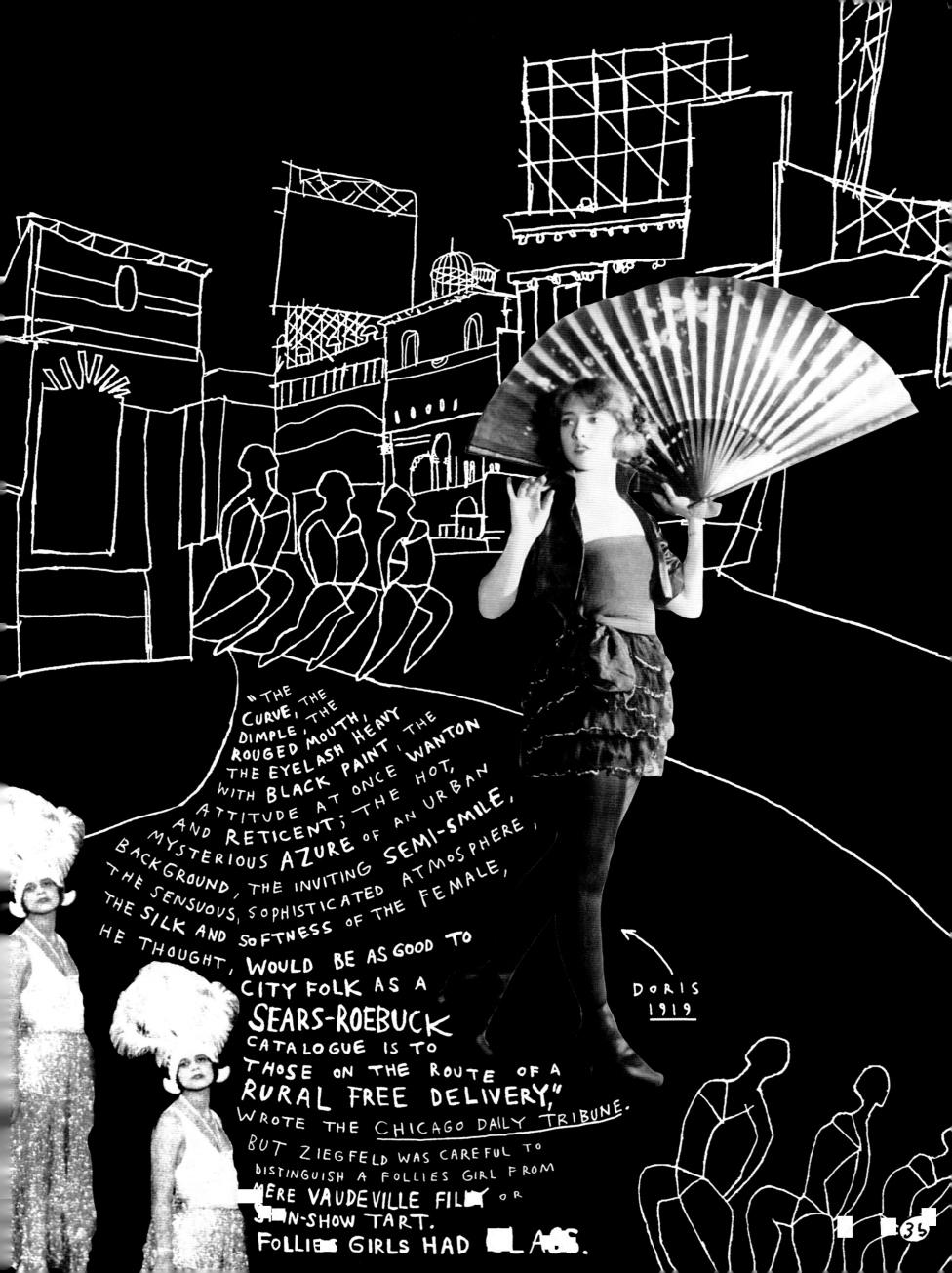

"THE CURVE, THE DIMPLE, THE ROUGED MOUTH, THE EYELASH HEAVY WITH BLACK PAINT, THE ATTITUDE AT ONCE WANTON AND RETICENT; THE HOT, MYSTERIOUS AZURE OF AN URBAN BACKGROUND, THE INVITING SEMI-SMILE, THE SENSUOUS, SOPHISTICATED ATMOSPHERE, THE SILK AND SOFTNESS OF THE FEMALE, HE THOUGHT, WOULD BE AS GOOD TO CITY FOLK AS A SEARS-ROEBUCK CATALOGUE IS TO THOSE ON THE ROUTE OF A RURAL FREE DELIVERY," WROTE THE CHICAGO DAILY TRIBUNE. BUT ZIEGFELD WAS CAREFUL TO DISTINGUISH A FOLLIES GIRL FROM MERE VAUDEVILLE FILM OR SKIN-SHOW TART. FOLLIES GIRLS HAD CLASS.

DORIS 1919

35

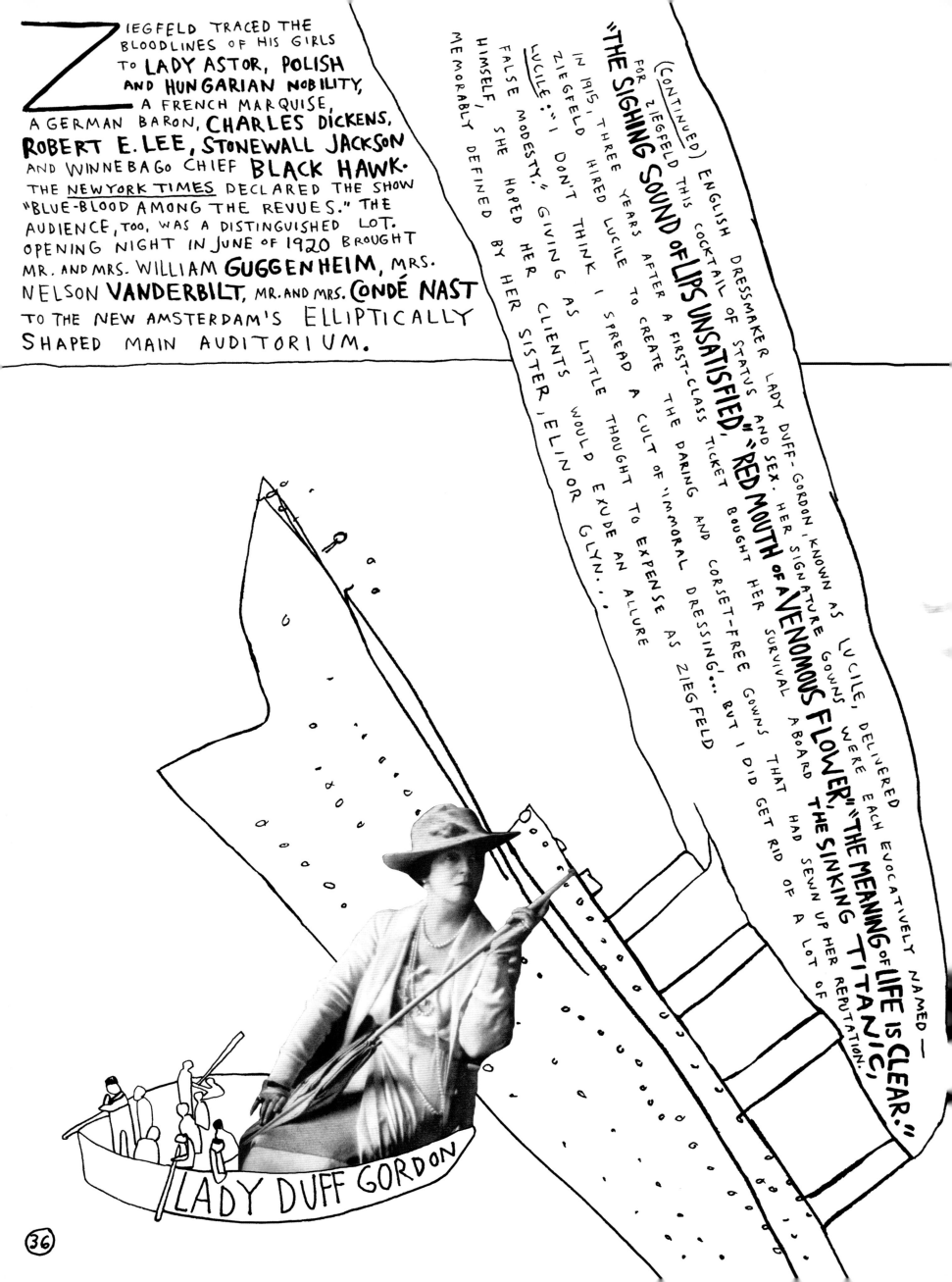

ZIEGFELD TRACED THE BLOODLINES OF HIS GIRLS TO **LADY ASTOR,** POLISH AND **HUNGARIAN NOBILITY,** A FRENCH MARQUISE, A GERMAN BARON, **CHARLES DICKENS, ROBERT E. LEE, STONEWALL JACKSON** AND WINNEBAGO CHIEF **BLACK HAWK.** THE <u>NEW YORK TIMES</u> DECLARED THE SHOW "BLUE-BLOOD AMONG THE REVUES." THE AUDIENCE, TOO, WAS A DISTINGUISHED LOT. OPENING NIGHT IN JUNE OF 1920 BROUGHT MR. AND MRS. WILLIAM **GUGGENHEIM,** MRS. NELSON **VANDERBILT,** MR. AND MRS. **CONDÉ NAST** TO THE NEW AMSTERDAM'S **ELLIPTICALLY** SHAPED MAIN AUDITORIUM.

(CONTINUED) ENGLISH DRESSMAKER LADY DUFF-GORDON, KNOWN AS LUCILE, DELIVERED EVOCATIVELY NAMED FOR ZIEGFELD THIS COCKTAIL OF STATUS AND SEX. HER SIGNATURE GOWNS WERE EACH EVOCATIVELY NAMED—"THE SIGHING SOUND OF LIPS UNSATISFIED", "RED MOUTH OF A VENOMOUS FLOWER", "THE MEANING OF LIFE IS CLEAR." IN 1915, THREE YEARS AFTER A FIRST-CLASS TICKET BOUGHT HER SURVIVAL ABOARD THE SINKING TITANIC, ZIEGFELD HIRED LUCILE TO CREATE THE DARING AND CORSET-FREE GOWNS THAT HAD SEWN UP HER REPUTATION. LUCILE: "I DON'T THINK I SPREAD A CULT OF 'IMMORAL DRESSING'... BUT I DID GET RID OF A LOT OF FALSE MODESTY." GIVING AS LITTLE THOUGHT TO EXPENSE AS ZIEGFELD HIMSELF, SHE HOPED HER CLIENTS WOULD EXUDE AN ALLURE MEMORABLY DEFINED BY HER SISTER, ELINOR GLYN...

LADY DUFF GORDON

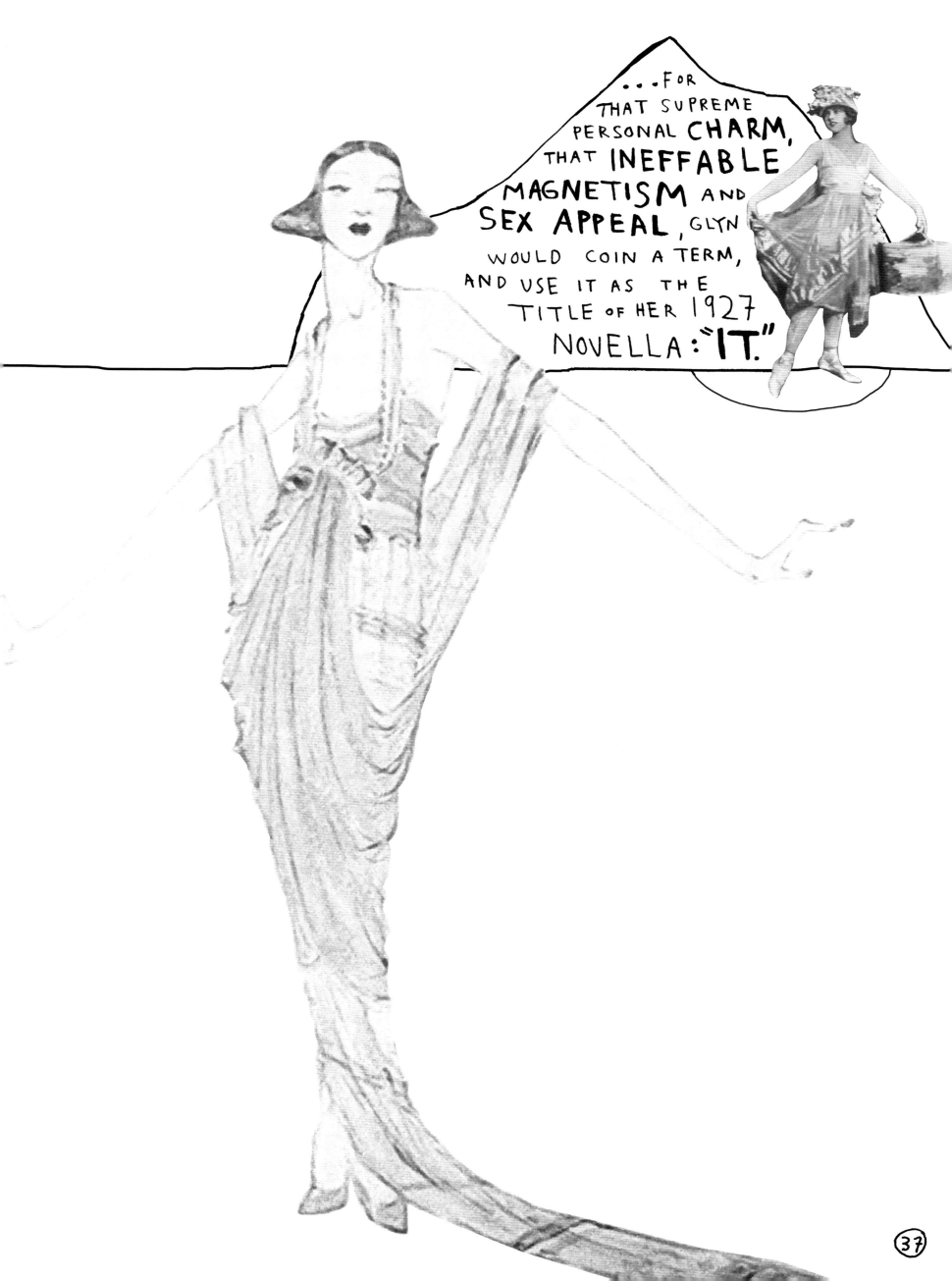

...FOR THAT SUPREME PERSONAL **CHARM**, THAT **INEFFABLE MAGNETISM** AND **SEX APPEAL**, GLYN WOULD COIN A TERM, AND USE IT AS THE TITLE OF HER 1927 NOVELLA: "**IT.**"

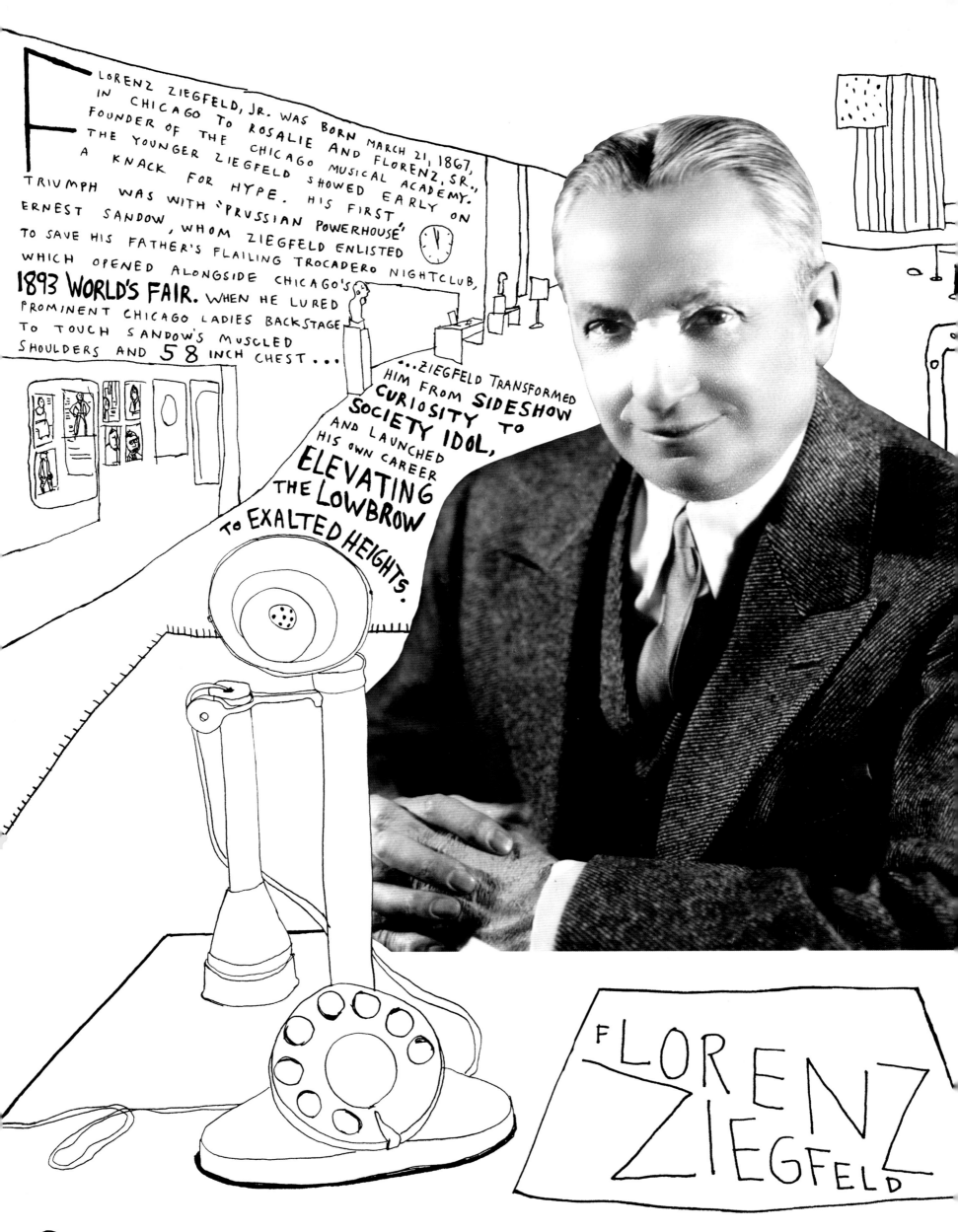

Florenz Ziegfeld, Jr. was born March 21, 1867, in Chicago to Rosalie and Florenz, Sr., founder of the Chicago Musical Academy. The younger Ziegfeld showed early on a knack for hype. His first triumph was with "Prussian Powerhouse" Ernest Sandow, whom Ziegfeld enlisted to save his father's flailing Trocadero Nightclub, which opened alongside Chicago's 1893 World's Fair. When he lured prominent Chicago ladies backstage to touch Sandow's muscled shoulders and 58 inch chest...

...Ziegfeld transformed him from sideshow curiosity to society idol, and launched his own career **elevating the lowbrow to exalted heights.**

FLORENZ ZIEGFELD

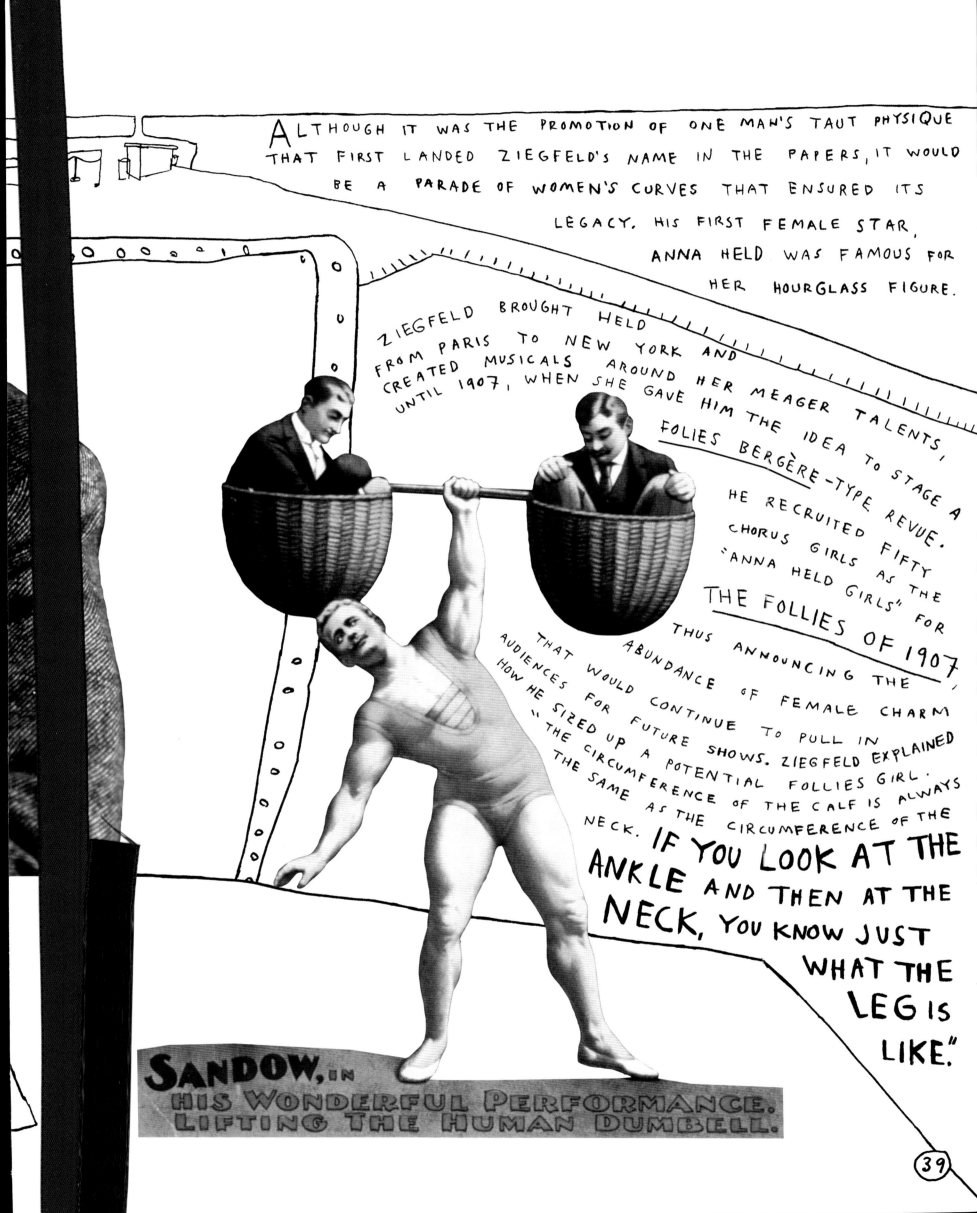

ALTHOUGH IT WAS THE PROMOTION OF ONE MAN'S TAUT PHYSIQUE THAT FIRST LANDED ZIEGFELD'S NAME IN THE PAPERS, IT WOULD BE A PARADE OF WOMEN'S CURVES THAT ENSURED ITS LEGACY. HIS FIRST FEMALE STAR, ANNA HELD WAS FAMOUS FOR HER HOURGLASS FIGURE.

ZIEGFELD BROUGHT HELD FROM PARIS TO NEW YORK AND CREATED MUSICALS AROUND HER MEAGER TALENTS, UNTIL 1907, WHEN SHE GAVE HIM THE IDEA TO STAGE A FOLIES BERGÈRE-TYPE REVUE. HE RECRUITED FIFTY CHORUS GIRLS AS THE "ANNA HELD GIRLS" FOR THE FOLLIES OF 1907, THUS ANNOUNCING THE ABUNDANCE OF FEMALE CHARM THAT WOULD CONTINUE TO PULL IN AUDIENCES FOR FUTURE SHOWS. ZIEGFELD EXPLAINED HOW HE SIZED UP A POTENTIAL FOLLIES GIRL. "THE CIRCUMFERENCE OF THE CALF IS ALWAYS THE SAME AS THE CIRCUMFERENCE OF THE NECK. IF YOU LOOK AT THE ANKLE AND THEN AT THE NECK, YOU KNOW JUST WHAT THE LEG IS LIKE."

SANDOW, IN HIS WONDERFUL PERFORMANCE. LIFTING THE HUMAN DUMBELL.

DORIS JOINED THE ZIEGFELD FOLLIES CHORUS AT A SALARY OF $10 A WEEK.

DORIS: "I LOOKED LIKE A ROSE UNFURLING." AT 14, DORIS WAS THE YOUNGEST GIRL IN THE FOLLIES.

DORIS: "THERE WAS A LAW YOU COULDN'T APPEAR IN A MUSICAL COMEDY UNLESS YOU WERE 16. SO I TOOK THE NAME DORIS LEVANT. THEN THE SECOND YEAR, I DIDN'T WANT THEM TO TRACK ME, SO I DECIDED TO BECOME FRENCH. I CHANGED MY NAME TO LUCILLE LEVANT."

WITH THE STAGE NAME, DORIS JOINED THE SHOW'S ALLITERATIVE ATTRACTIONS— MARILYN MILLER, BILLIE BLANCHARD, LILLIAN LORRAINE, GILDA GRAY (THE ORIGINATOR OF THE SHIMMY). REVIEWS APPLAUDED THE FOLLIES OF 1918, A REVUE IN TWO ACTS AND 26 SCENES. NEW YORK WORLD DECLARED THAT ZIEGFELD HAD ACHIEVED A "NEW HIGH LEVEL OF GORGEOUSNESS." THE CHICAGO DAILY TRIBUNE REPORTED: "THE FOLLIES ARE UPON US LIKE A WELCOME PLAGUE, THREATENING OUR PLACID VISCERA WITH PROSCRIBED EMOTIONS, INCULCATING US WITH THE DANGEROUS DOCTRINE THAT LIFE IS NEITHER REAL NOR EARNEST, AND TURNING US, IF BUT FOR AN EVENING, FROM OUR HONEST, BLUE-NOSE SUBURBAN WAYS INTO APPROVING ALLIES OF THE WORLD, THE FLESH, AND THE DEVIL

(40)

CHICAGO EVENING AMERICAN

SEEK BEAUTY? TRY THIS

Miss Doris Eaton, "Follies" dancer, illustrating the central idea of "Upside Down," the new beauty system being taught by Mr. and Mrs. R. W. Corbin.

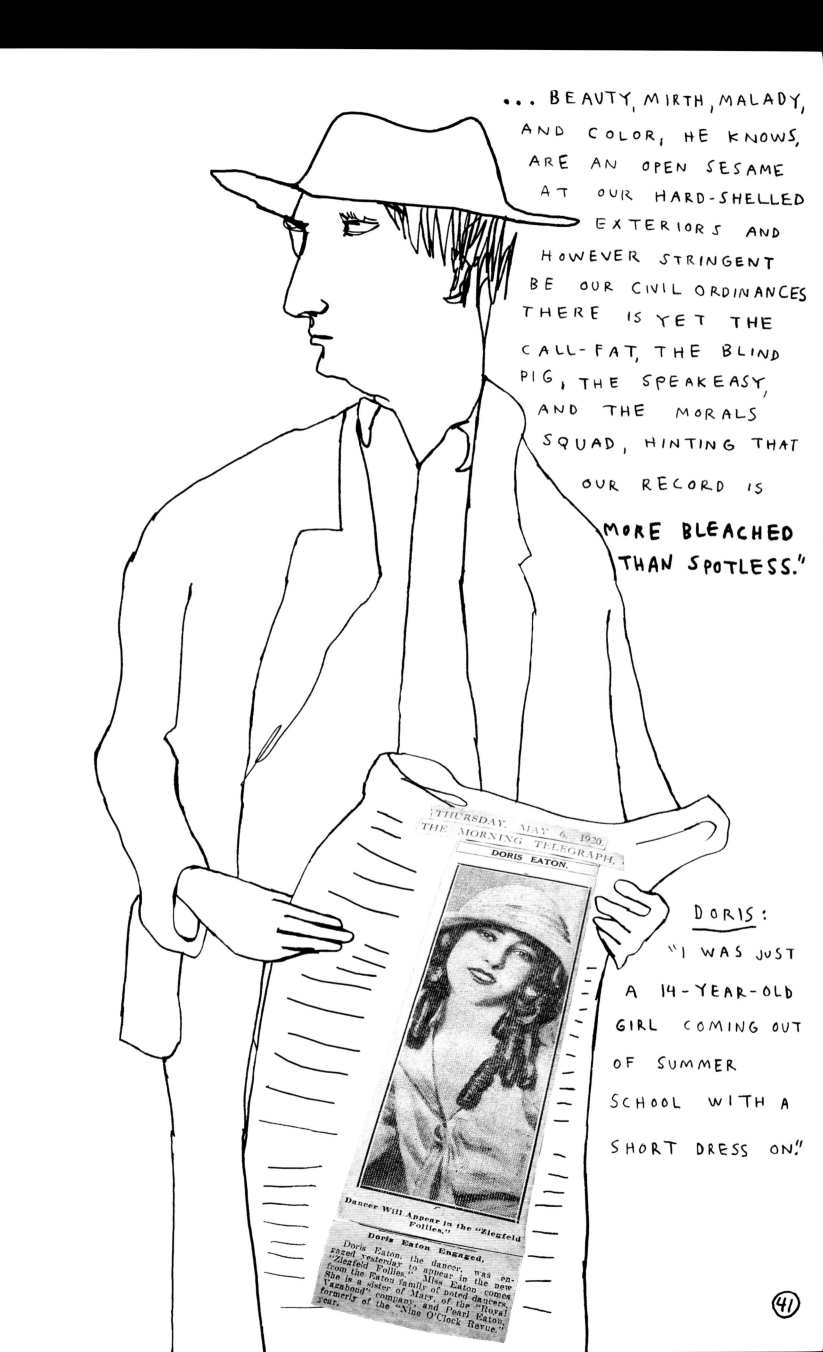

... BEAUTY, MIRTH, MALADY, AND COLOR, HE KNOWS, ARE AN OPEN SESAME AT OUR HARD-SHELLED EXTERIORS AND HOWEVER STRINGENT BE OUR CIVIL ORDINANCES THERE IS YET THE CALL-FAT, THE BLIND PIG, THE SPEAKEASY, AND THE MORALS SQUAD, HINTING THAT OUR RECORD IS **MORE BLEACHED THAN SPOTLESS."**

DORIS: "I WAS JUST A 14-YEAR-OLD GIRL COMING OUT OF SUMMER SCHOOL WITH A SHORT DRESS ON."

THURSDAY, MAY 6, 1920,
THE MORNING TELEGRAPH,
DORIS EATON.

Dancer Will Appear in the "Ziegfeld Follies."

Doris Eaton Engaged.
Doris Eaton, the dancer, was engaged yesterday to appear in the new "Ziegfeld Follies." Miss Eaton comes from the Eaton family of noted dancers. She is a sister of Mary, of the "Royal Vagabond" company, and Pearl Eaton, formerly of the "Nine O'Clock Revue."

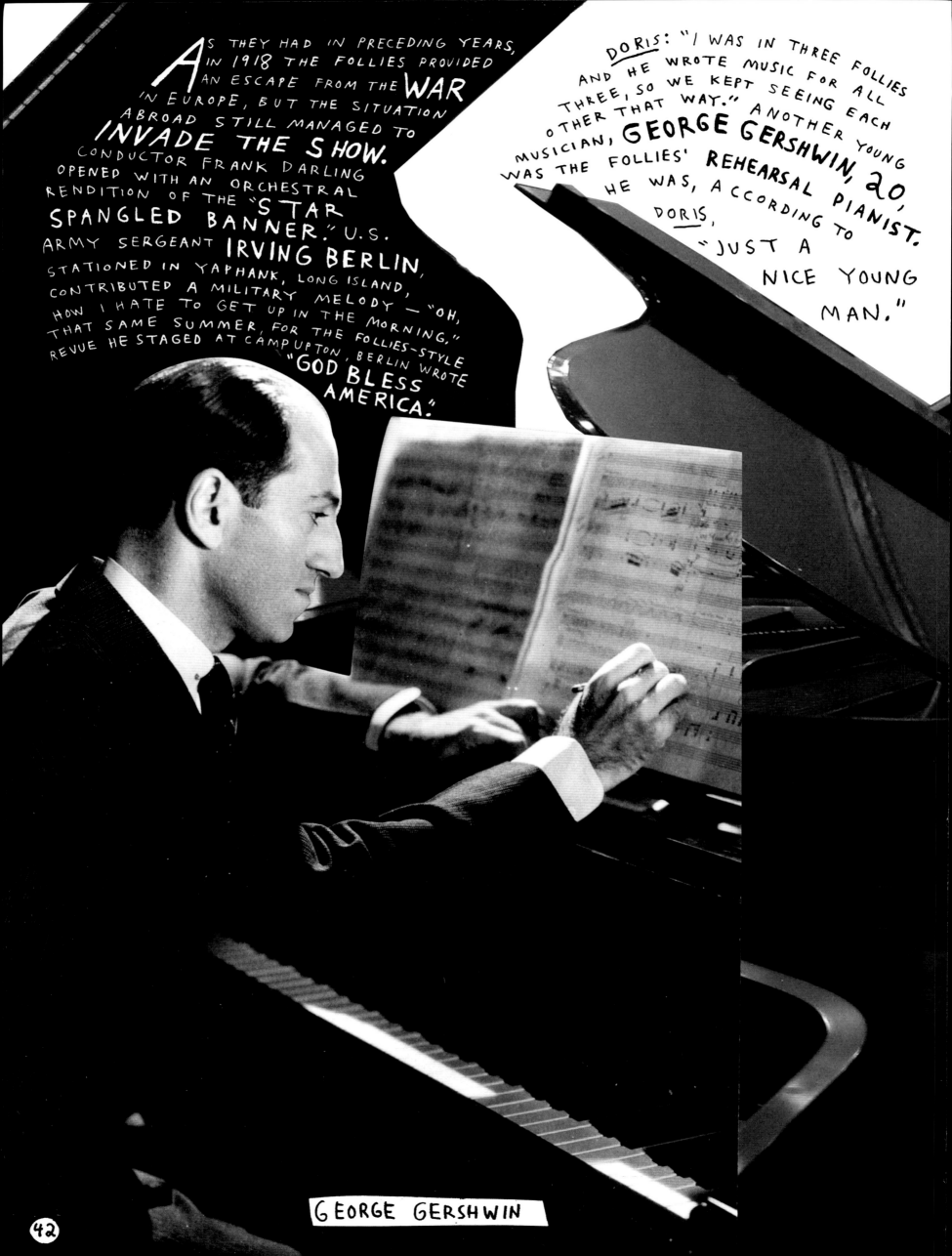

As they had in preceding years, in 1918 the Follies provided an escape from the WAR in Europe, but the situation abroad still managed to INVADE THE SHOW. Conductor Frank Darling opened with an orchestral rendition of the "STAR SPANGLED BANNER." U.S. Army Sergeant IRVING BERLIN, stationed in Yaphank, Long Island, contributed a military melody — "Oh, How I Hate to Get Up in the Morning." That same summer, for the Follies-style revue he staged at Camp Upton, Berlin wrote "GOD BLESS AMERICA."

DORIS: "I was in three Follies and he wrote music for all three, so we kept seeing each other that way." Another young musician, GEORGE GERSHWIN, 20, was the Follies' REHEARSAL PIANIST. He was, according to DORIS, "JUST A NICE YOUNG MAN."

GEORGE GERSHWIN

IRVING BERLIN

THE ELDEST EATON SON, ROBERT, ALREADY ISOLATED FROM THE FAMILY, FOUND HIMSELF NOT ON BROADWAY SINGING PATRIOTIC NUMBERS, BUT INSTEAD SENT TO THE EUROPEAN THEATER, STATIONED IN BELGIUM. DORIS: "ROBERT WAS GIVEN A DREADFUL ASSIGNMENT. HE HAD TO GO OUT INTO THE BATTLEFIELDS TO IDENTIFY THE DEAD. AT NIGHT THE BOYS WOULD DRINK TO WASH THAT FROM YOUR MINDS. IF YOU ARE A SENSITIVE PERSON IT COULD REALLY DIG INTO YOU. AND ROBERT WAS, NOTHING SHARP OR AGGRESSIVE ABOUT HIM." HE NEVER RECOVERED FROM THE SHELLSHOCK.

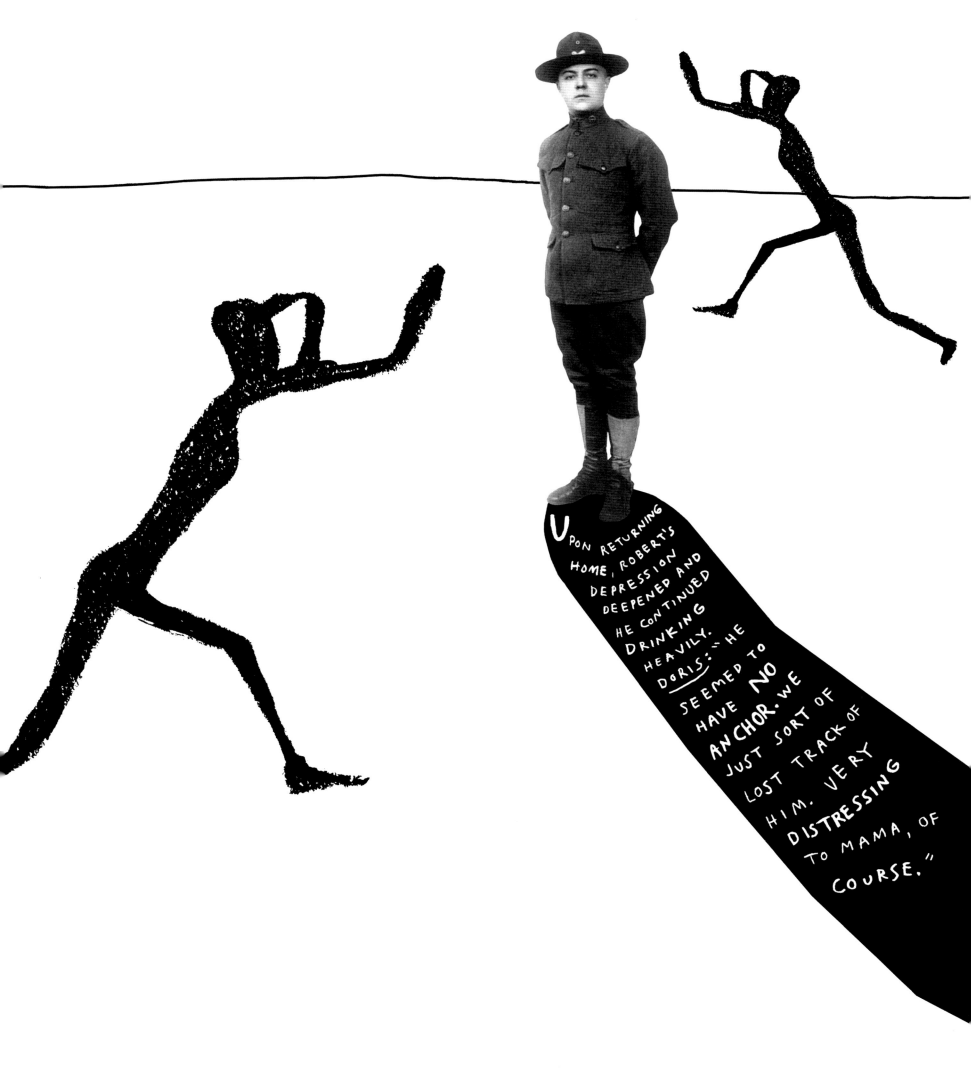

Upon returning home, Robert's depression deepened and he continued drinking heavily. Doris:—he seemed to have **NO** **ANCHOR**. We just sort of lost track of him. Very **DISTRESSING** to mama, of course."

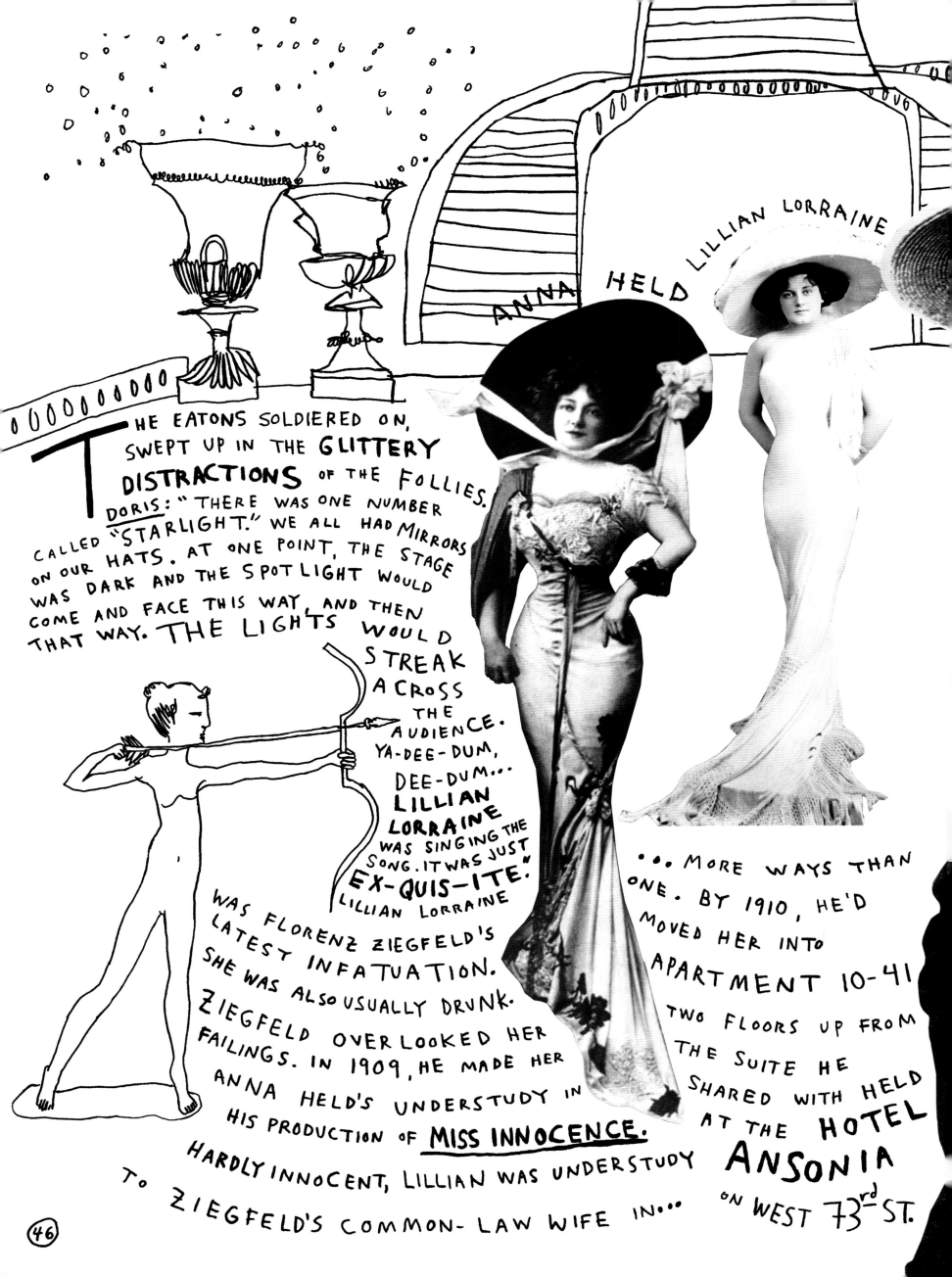

THE EATONS SOLDIERED ON, SWEPT UP IN THE **GLITTERY DISTRACTIONS** OF THE FOLLIES. DORIS: "THERE WAS ONE NUMBER CALLED "STARLIGHT." WE ALL HAD MIRRORS ON OUR HATS. AT ONE POINT, THE STAGE WAS DARK AND THE SPOTLIGHT WOULD COME AND FACE THIS WAY, AND THEN THAT WAY. THE LIGHTS WOULD STREAK ACROSS THE AUDIENCE. YA-DEE-DUM, DEE-DUM... LILLIAN LORRAINE WAS SINGING THE SONG. IT WAS JUST **EX-QUIS-ITE**."

LILLIAN LORRAINE WAS FLORENZ ZIEGFELD'S LATEST INFATUATION. SHE WAS ALSO USUALLY DRUNK. ZIEGFELD OVERLOOKED HER FAILINGS. IN 1909, HE MADE HER ANNA HELD'S UNDERSTUDY IN HIS PRODUCTION OF <u>MISS INNOCENCE</u>. HARDLY INNOCENT, LILLIAN WAS UNDERSTUDY TO ZIEGFELD'S COMMON-LAW WIFE IN...

ANNA HELD LILLIAN LORRAINE

... MORE WAYS THAN ONE. BY 1910, HE'D MOVED HER INTO APARTMENT 10-41 TWO FLOORS UP FROM THE SUITE HE SHARED WITH HELD AT THE **HOTEL ANSONIA** ON WEST 73RD ST.

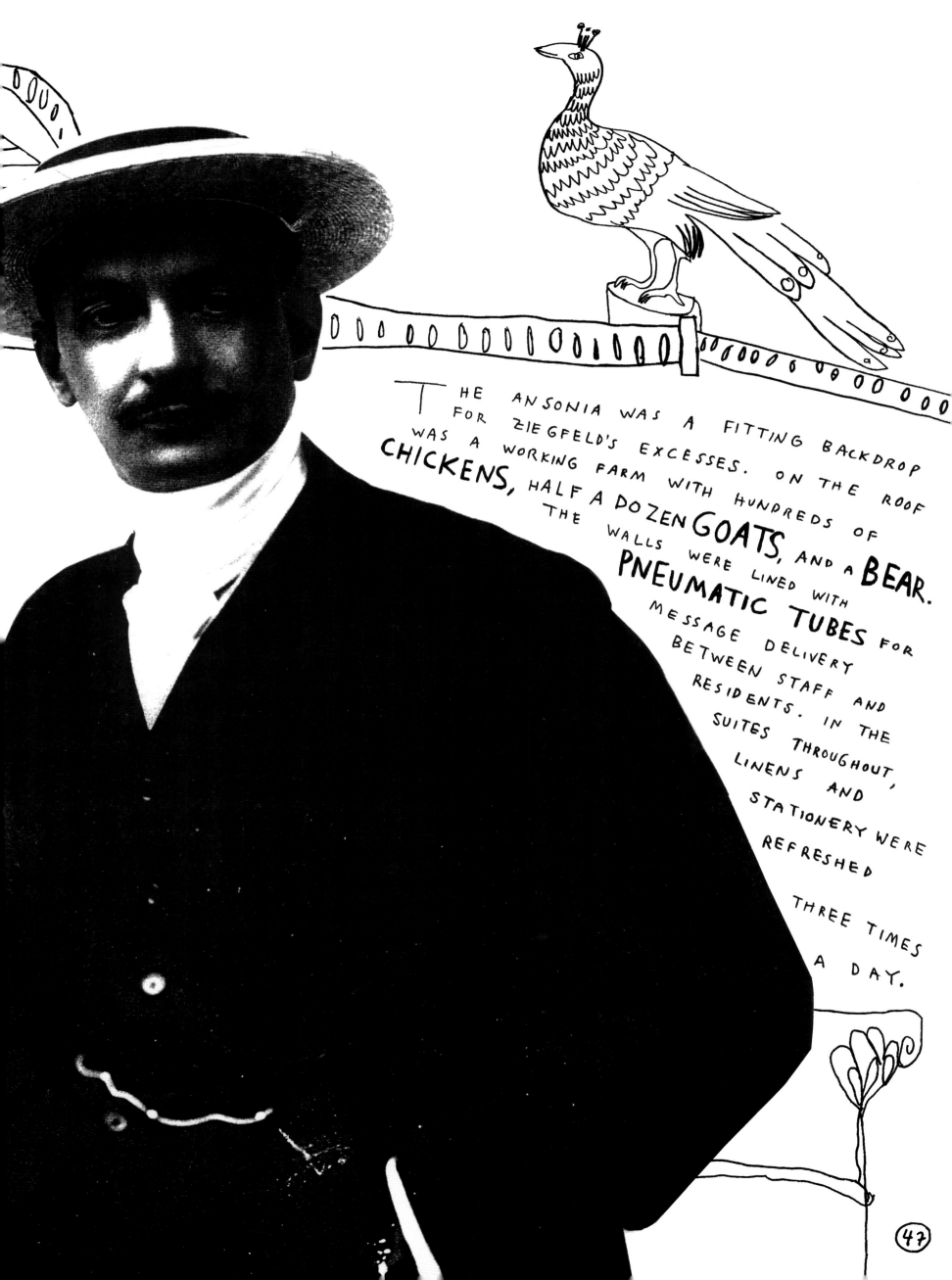

THE ANSONIA WAS A FITTING BACKDROP FOR ZIEGFELD'S EXCESSES. ON THE ROOF WAS A WORKING FARM WITH HUNDREDS OF CHICKENS, HALF A DOZEN GOATS, AND A BEAR. THE WALLS WERE LINED WITH PNEUMATIC TUBES FOR MESSAGE DELIVERY BETWEEN STAFF AND RESIDENTS. IN THE SUITES THROUGHOUT, LINENS AND STATIONERY WERE REFRESHED THREE TIMES A DAY.

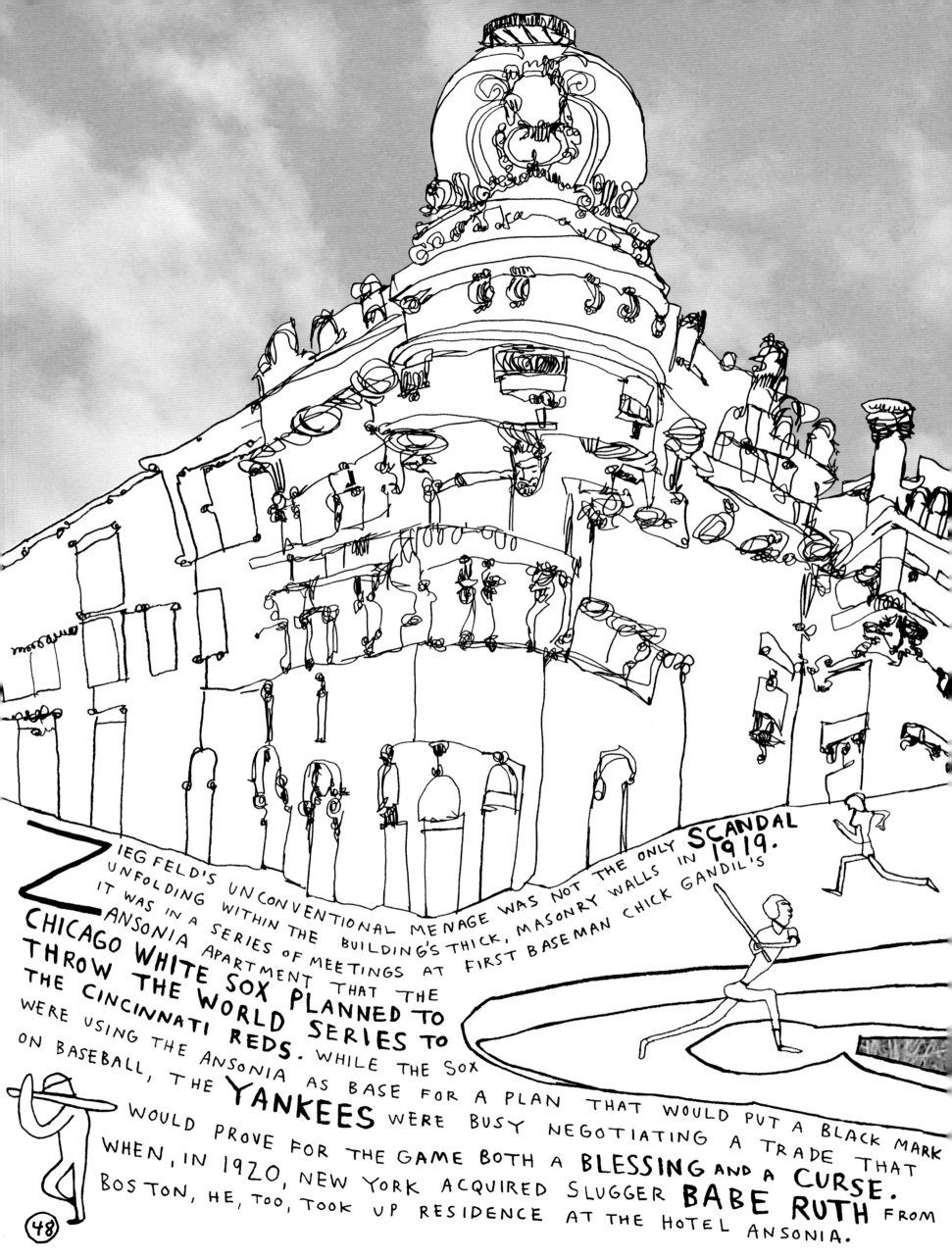

ZIEGFELD'S UNCONVENTIONAL MENAGE WAS NOT THE ONLY SCANDAL UNFOLDING WITHIN THE BUILDING'S THICK, MASONRY WALLS IN 1919. IT WAS IN A SERIES OF MEETINGS AT FIRST BASEMAN CHICK GANDIL'S ANSONIA APARTMENT THAT THE CHICAGO WHITE SOX PLANNED TO THROW THE WORLD SERIES TO THE CINCINNATI REDS. WHILE THE SOX WERE USING THE ANSONIA AS BASE FOR A PLAN THAT WOULD PUT A BLACK MARK ON BASEBALL, THE YANKEES WERE BUSY NEGOTIATING A TRADE THAT WOULD PROVE FOR THE GAME BOTH A BLESSING AND A CURSE. WHEN, IN 1920, NEW YORK ACQUIRED SLUGGER BABE RUTH FROM BOSTON, HE, TOO, TOOK UP RESIDENCE AT THE HOTEL ANSONIA.

48

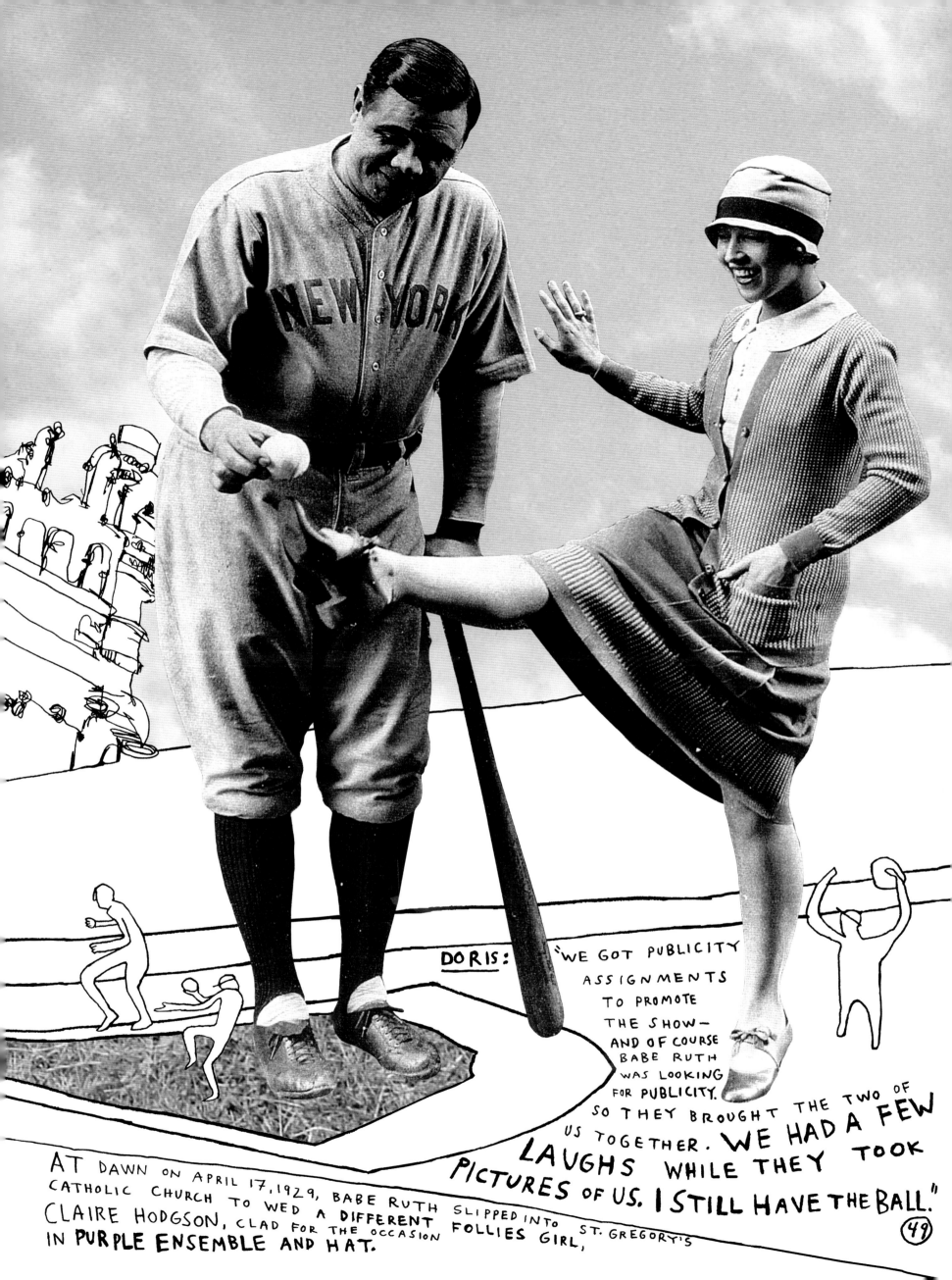

DORIS: "WE GOT PUBLICITY ASSIGNMENTS TO PROMOTE THE SHOW— AND OF COURSE BABE RUTH WAS LOOKING FOR PUBLICITY. SO THEY BROUGHT THE TWO OF US TOGETHER. WE HAD A FEW LAUGHS WHILE THEY TOOK PICTURES OF US. I STILL HAVE THE BALL."

AT DAWN ON APRIL 17, 1929, BABE RUTH SLIPPED INTO ST. GREGORY'S CATHOLIC CHURCH TO WED A DIFFERENT FOLLIES GIRL, CLAIRE HODGSON, CLAD FOR THE OCCASION IN PURPLE ENSEMBLE AND HAT.

49

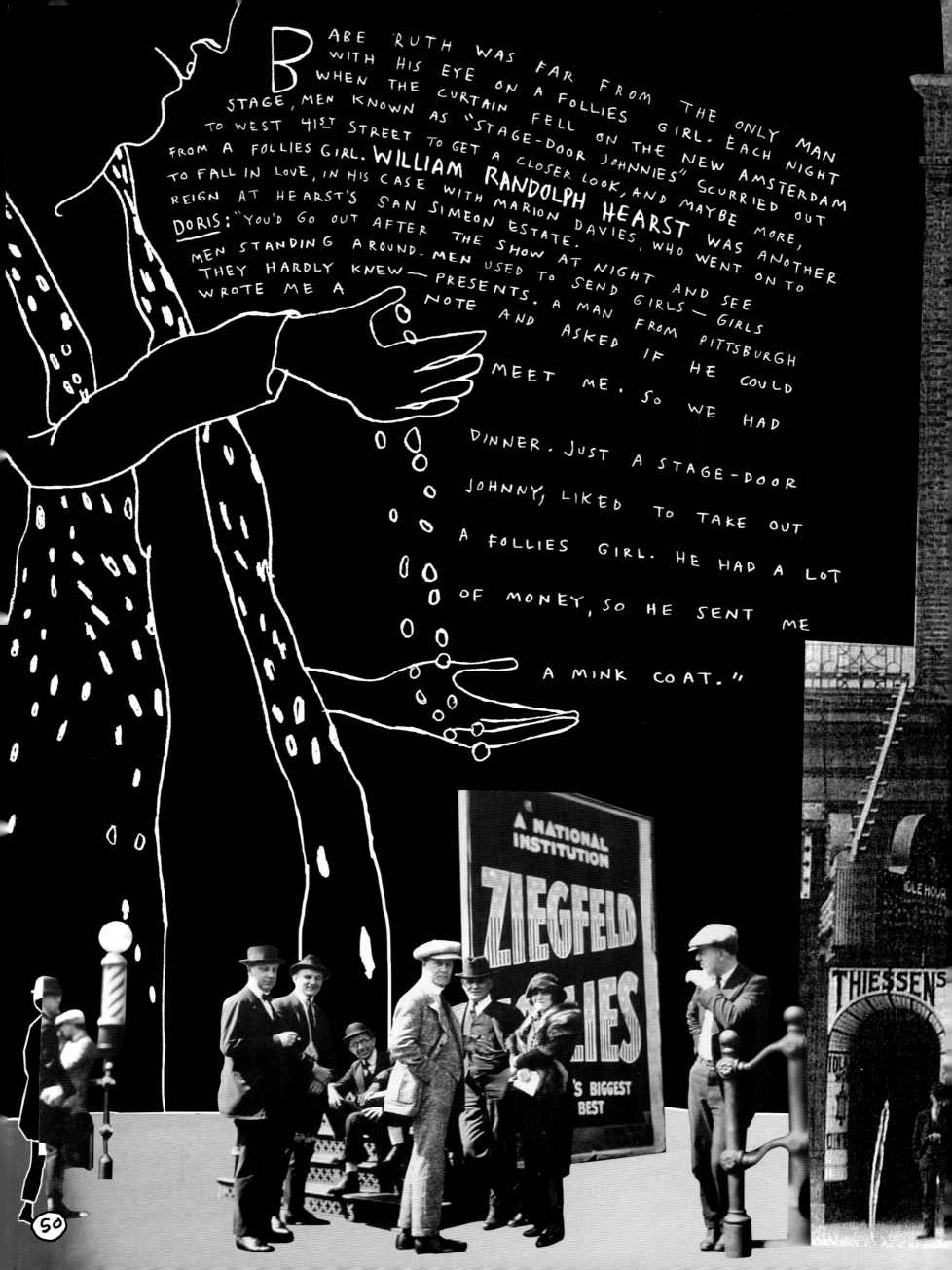

BABE RUTH WAS FAR FROM THE ONLY MAN WITH HIS EYE ON A FOLLIES GIRL. EACH NIGHT WHEN THE CURTAIN FELL ON THE NEW AMSTERDAM STAGE, MEN KNOWN AS "STAGE-DOOR JOHNNIES" SCURRIED OUT TO WEST 41ˢᵗ STREET TO GET A CLOSER LOOK, AND MAYBE MORE, FROM A FOLLIES GIRL. **WILLIAM RANDOLPH HEARST** WAS ANOTHER TO FALL IN LOVE, IN HIS CASE WITH MARION DAVIES, WHO WENT ON TO REIGN AT HEARST'S SAN SIMEON ESTATE.

<u>DORIS</u>: "YOU'D GO OUT AFTER THE SHOW AT NIGHT AND SEE MEN STANDING AROUND. MEN USED TO SEND GIRLS — GIRLS THEY HARDLY KNEW — PRESENTS. A MAN FROM PITTSBURGH WROTE ME A NOTE AND ASKED IF HE COULD MEET ME. SO WE HAD DINNER. JUST A STAGE-DOOR JOHNNY, LIKED TO TAKE OUT A FOLLIES GIRL. HE HAD A LOT OF MONEY, SO HE SENT ME A MINK COAT."

A NATIONAL INSTITUTION
ZIEGFELD
FOLLIES
'S BIGGEST
BEST

THIESSEN'S

52

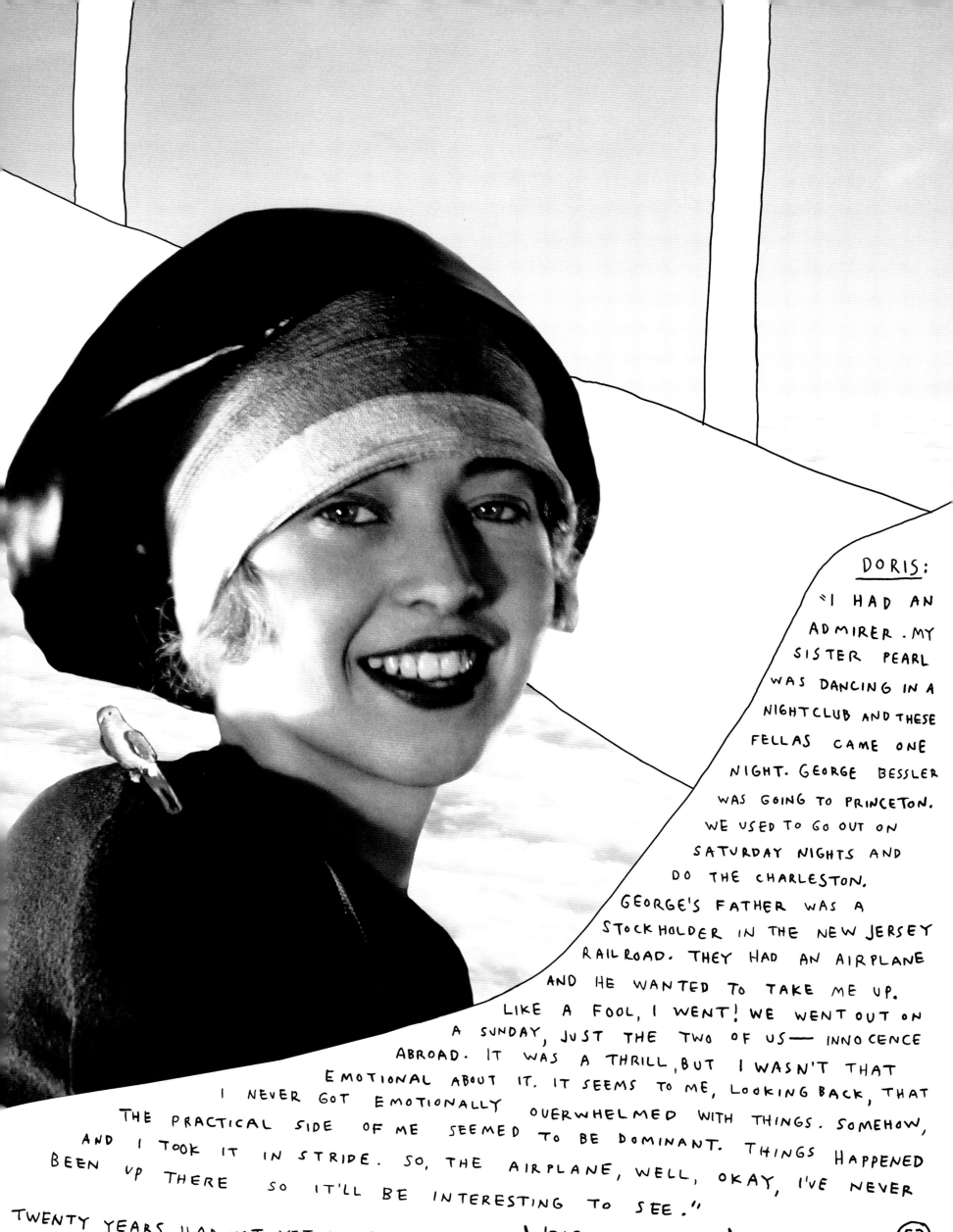

DORIS:
"I HAD AN ADMIRER. MY SISTER PEARL WAS DANCING IN A NIGHTCLUB AND THESE FELLAS CAME ONE NIGHT. GEORGE BESSLER WAS GOING TO PRINCETON. WE USED TO GO OUT ON SATURDAY NIGHTS AND DO THE CHARLESTON. GEORGE'S FATHER WAS A STOCKHOLDER IN THE NEW JERSEY RAILROAD. THEY HAD AN AIRPLANE AND HE WANTED TO TAKE ME UP. LIKE A FOOL, I WENT! WE WENT OUT ON A SUNDAY, JUST THE TWO OF US— INNOCENCE ABROAD. IT WAS A THRILL, BUT I WASN'T THAT EMOTIONAL ABOUT IT. IT SEEMS TO ME, LOOKING BACK, THAT I NEVER GOT EMOTIONALLY OVERWHELMED WITH THINGS. SOMEHOW, THE PRACTICAL SIDE OF ME SEEMED TO BE DOMINANT. THINGS HAPPENED AND I TOOK IT IN STRIDE. SO, THE AIRPLANE, WELL, OKAY, I'VE NEVER BEEN UP THERE SO IT'LL BE INTERESTING TO SEE."

TWENTY YEARS HAD NOT YET PASSED SINCE THE **WRIGHT BROTHERS'** OWN FIRST FLIGHT. 53

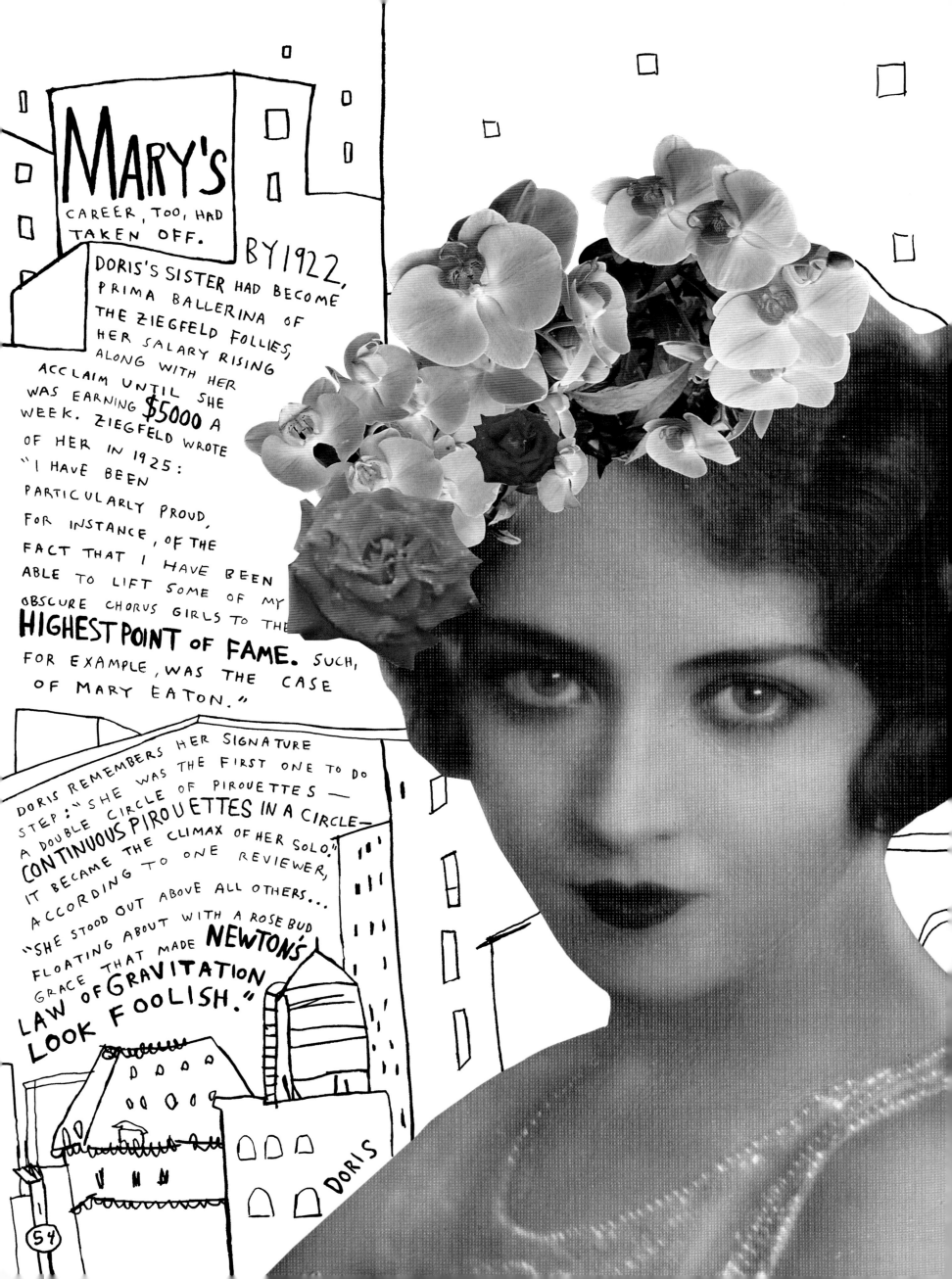

MARY'S

CAREER, TOO, HAD TAKEN OFF.

BY 1922, DORIS'S SISTER HAD BECOME PRIMA BALLERINA OF THE ZIEGFELD FOLLIES, HER SALARY RISING ALONG WITH HER ACCLAIM UNTIL SHE WAS EARNING **$5000** A WEEK. ZIEGFELD WROTE OF HER IN 1925: "I HAVE BEEN PARTICULARLY PROUD, FOR INSTANCE, OF THE FACT THAT I HAVE BEEN ABLE TO LIFT SOME OF MY OBSCURE CHORUS GIRLS TO THE **HIGHEST POINT OF FAME.** SUCH, FOR EXAMPLE, WAS THE CASE OF MARY EATON."

DORIS REMEMBERS HER SIGNATURE STEP: "SHE WAS THE FIRST ONE TO DO A DOUBLE CIRCLE OF PIROUETTES — **CONTINUOUS PIROUETTES IN A CIRCLE**— IT BECAME THE CLIMAX OF HER SOLO." ACCORDING TO ONE REVIEWER, "SHE STOOD OUT ABOVE ALL OTHERS... FLOATING ABOUT WITH A ROSEBUD GRACE THAT MADE **NEWTON'S LAW OF GRAVITATION LOOK FOOLISH.**"

DORIS

54

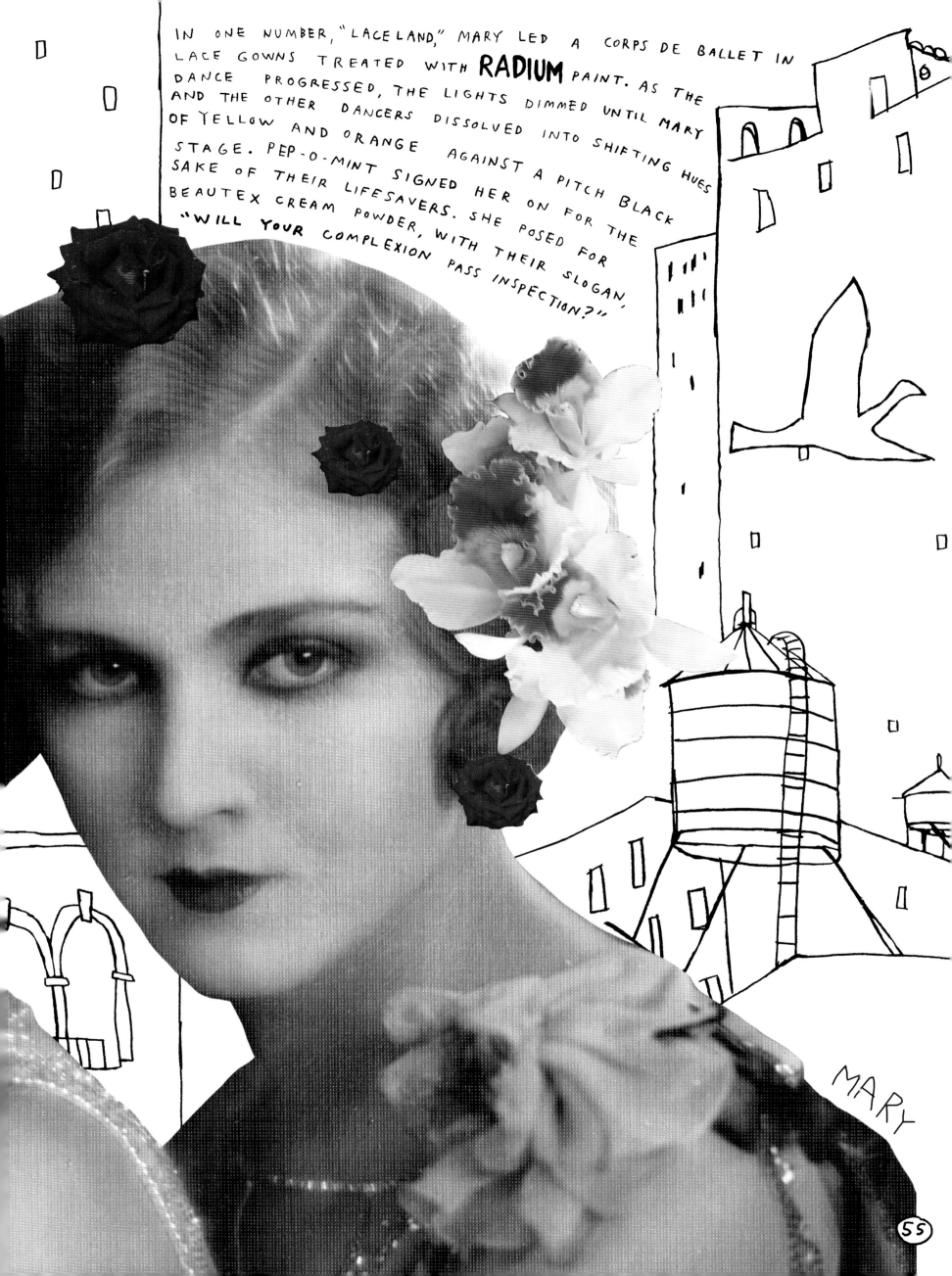

IN ONE NUMBER, "LACELAND," MARY LED A CORPS DE BALLET IN LACE GOWNS TREATED WITH **RADIUM** PAINT. AS THE DANCE PROGRESSED, THE LIGHTS DIMMED UNTIL MARY AND THE OTHER DANCERS DISSOLVED INTO SHIFTING HUES OF YELLOW AND ORANGE AGAINST A PITCH BLACK STAGE. PEP-O-MINT SIGNED HER ON FOR THE SAKE OF THEIR LIFESAVERS. SHE POSED FOR BEAUTEX CREAM POWDER, WITH THEIR SLOGAN, "WILL YOUR COMPLEXION PASS INSPECTION?"

MARY

55

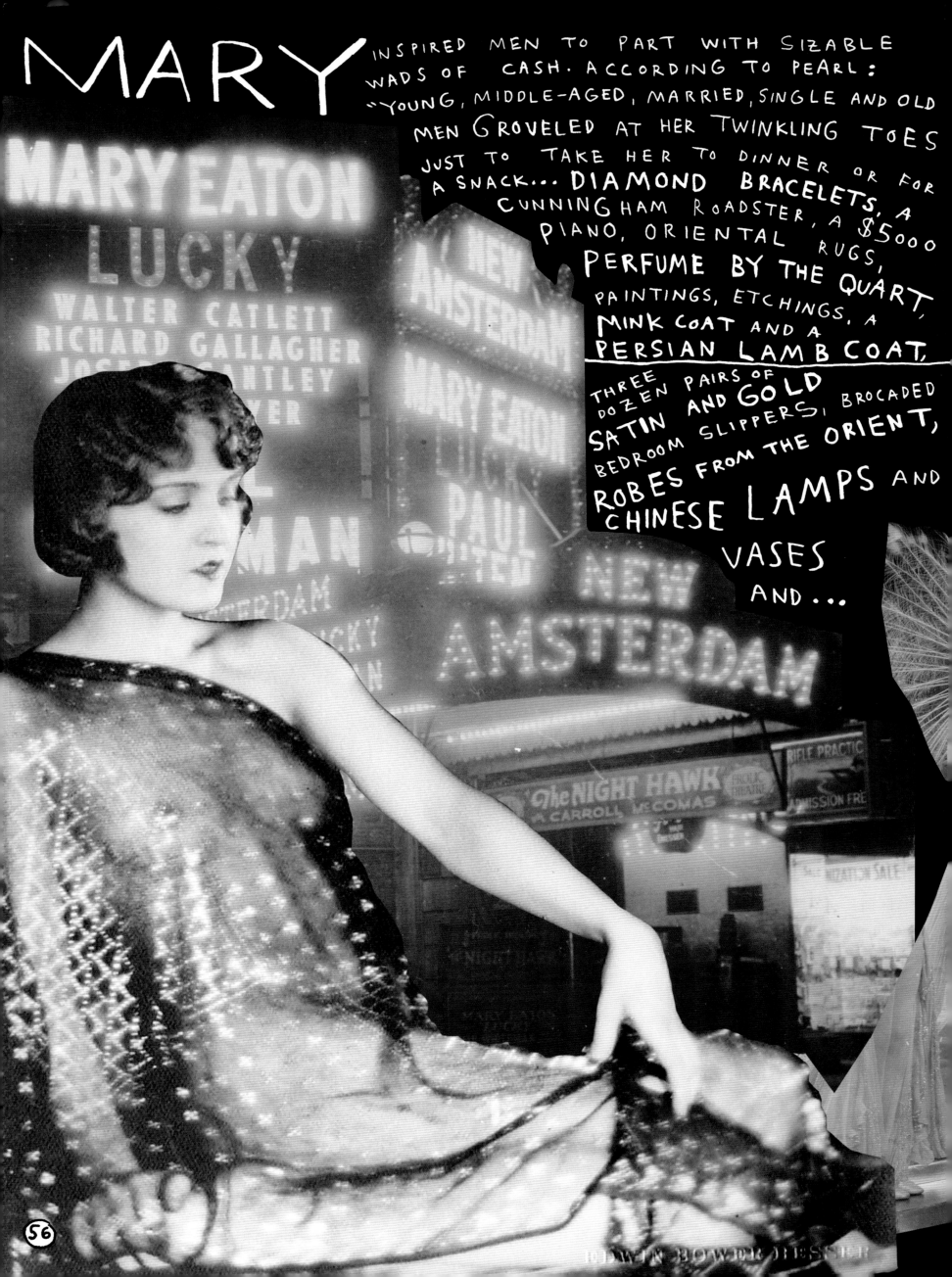

MARY

INSPIRED MEN TO PART WITH SIZABLE WADS OF CASH. ACCORDING TO PEARL: "YOUNG, MIDDLE-AGED, MARRIED, SINGLE AND OLD MEN GROVELED AT HER TWINKLING TOES JUST TO TAKE HER TO DINNER OR FOR A SNACK... DIAMOND BRACELETS, A CUNNINGHAM ROADSTER, A $5000 PIANO, ORIENTAL RUGS, PERFUME BY THE QUART, PAINTINGS, ETCHINGS, A MINK COAT AND A PERSIAN LAMB COAT,

THREE DOZEN PAIRS OF SATIN AND GOLD BEDROOM SLIPPERS, BROCADED ROBES FROM THE ORIENT, CHINESE LAMPS AND VASES AND...

... LITTLE TRINKETS LIKE A **SOLID GOLD VANITY CASE** AND A MESH BAG, A LITTLE FINGER RING WITH **SAPPHIRES** AND **DIAMONDS**, OR FIVE DOZEN PAIRS OF **SILK HOSE** (NO NYLONS THEN). THESE THINGS HAD LITTLE OR NO EFFECT ON MARY'S EMOTIONS... MARY COULDN'T SEEM TO FIND ANYONE TO SIGH OVER....

THEN IT HAPPENED. A HANDSOME-LOOKING MAN IN ONE OF HER PLAYS STOLE HER **HEART.** HE TOLD HER HE WAS GETTING A DIVORCE. WELL— HE WAS, BUT HIS WIFE WASN'T... THERE WAS **NOTHING THEY COULD DO WITHOUT RUINING THEIR CAREERS."**

OSCAR SHAW DIDN'T LEAVE HIS WIFE, AND MARY, WITH A PROPOSAL FROM PARAMOUNT, WENT TO **HOLLYWOOD.**

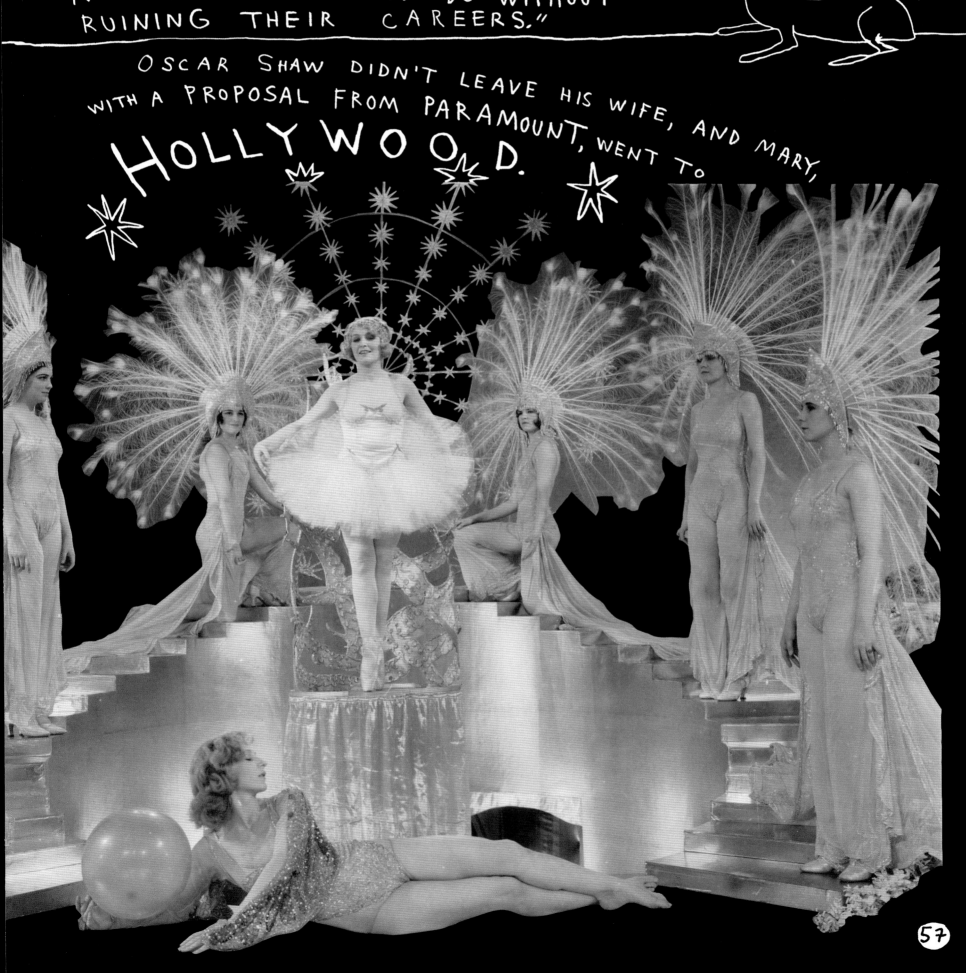

57

Two D. C. Girls, Selected as Handsomest in Seven States, Overwhelmed by Spiteful Letters From Jealous Rivals

(C.) Harris & Ewing.

MISS DORIS EATON,
Who gives beauty secrets to Herald readers.

(C.) Harris & Ewing.

MISS MARY EATON,
Selected as handsomest girl among 250 in New York contest.

Washington's Daughters Surpass Beauties of Europe, Says Expert.

Having won first beauty honors in seven States, Doris and Mary Eaton, of Washington, D. C., will take part in no more contests because they fear nationwide feminine jealousy.

Spiteful letters from girls who had carried away all awards in their native States before the advent of these blond Washington sisters have hurt the feelings of Doris and Mary, and they will rest on these honors rather than stir further animosity in the ranks of their own sex.

Doris' and Mary's latest contest was won last week when they were selected from among 250 beauties in a New York contest.

Aesthetic America kowtows at the feet of these girls. From Cape Cod to the Golden Gate their progress has been like a Roman triumph. Dr. Zephire Duhamel, who has officiated at the Luxem-

Here's D. C. Beauty's Advice

By DORIS EATON,
Washington Girl Beauty Winner in Seven States.

Beauty doesn't come from any set of rules.

Easy shoes, easy corsets and an easy conscience are the best beauty aids I know.

A girl's head-dress and the way she wears it vastly affects the impression she makes on others.

God made women beautiful. Why try to spoil his handiwork?

Don't hire a taxicab when you can afford to walk.

burg national beauty contest for many years, recently declared in New York that the Eaton sisters surpassed in many respects any women who had been called to his attention in Europe.

Of Virginia stock, they combine the most perfect features of womanhood for which the Old Dominion has been noted since the days of the first settlers. They were born and reared in Washington, and the family lived for many years at 1408 Rhode Island avenue.

Doris and Mary started their triumphs early. While school girls in Washington they attracted wide attention when they were declared winners of a large number of church and society beauty contests, but triumphs meant little to them in those days.

Cosmetics and weird costumes never have been part of the stock in trade of these Washington girls, except on the stage. Both sisters declare natural beauty is destroyed by using artificial devices to enhance it. They also believe rouge is usually the last resort of homely women.

Mother Paved Way to Fame And Happiness She Had Lost.

To their mother, Doris and Mary give much credit for the unusual success that has attended them in life. Mrs. Eaton came of a deeply religious family. Homeliness was considered a virtue. Drab dresses and undecorated bonnets were the limit in feminine apparel. She determined when young, she declared, that her own daughters never would be limited as she had been. When they were small girls she made the path easy for them to enter amateur theatricals in Washington, and their beauty and talents made their path to the legitimate stage easy.

Seven members of the Eaton family, all reared in Washington, are now on the stage. Mary is starring in "The Royal Vagabond." Doris played Washington with the "Follies." The girls now live in New York.

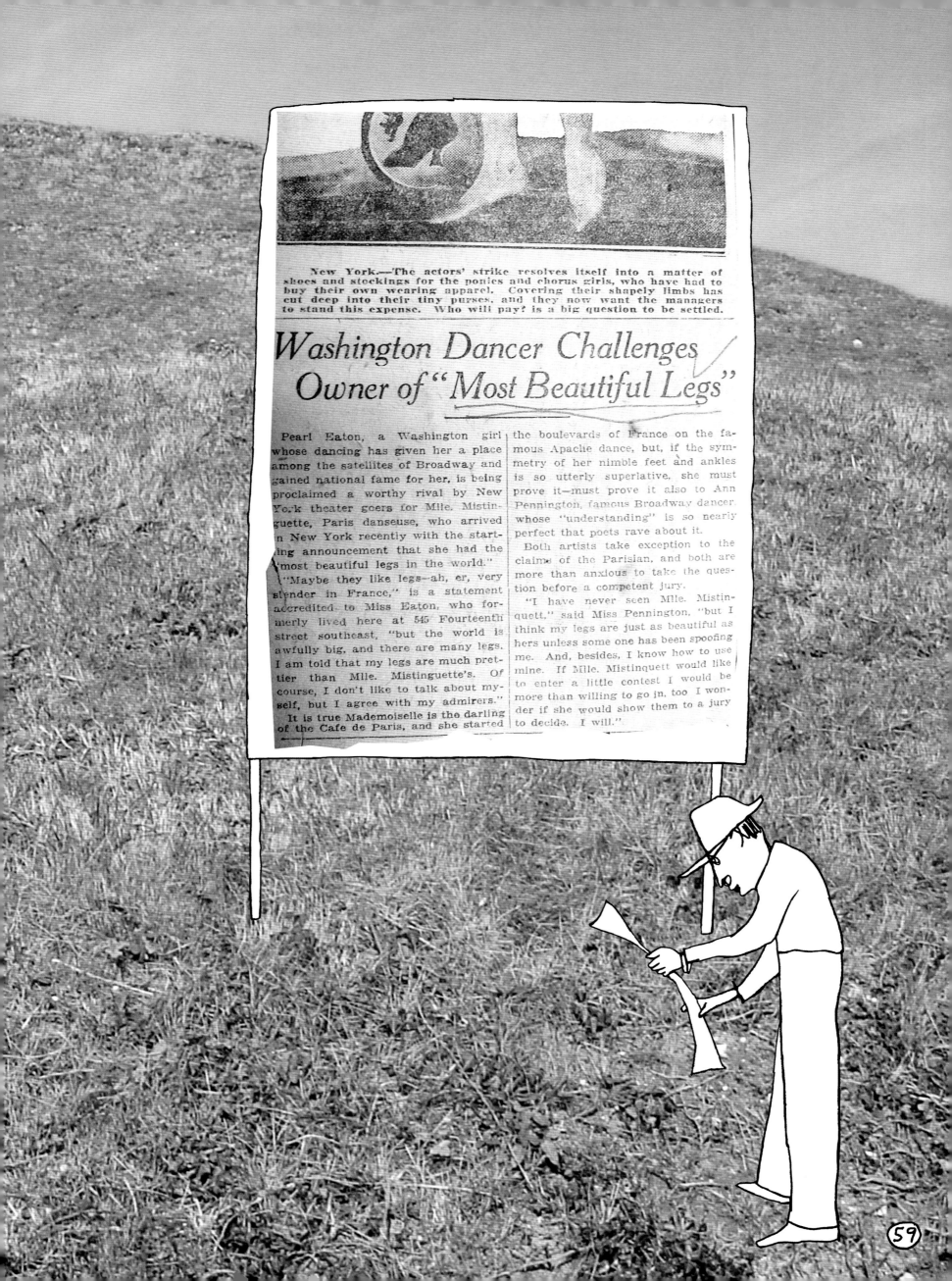

New York.—The actors' strike resolves itself into a matter of shoes and stockings for the ponies and chorus girls, who have had to buy their own wearing apparel. Covering their shapely limbs has cut deep into their tiny purses, and they now want the managers to stand this expense. Who will pay? is a big question to be settled.

Washington Dancer Challenges Owner of "Most Beautiful Legs"

Pearl Eaton, a Washington girl whose dancing has given her a place among the satellites of Broadway and gained national fame for her, is being proclaimed a worthy rival by New York theater goers for Mlle. Mistinguette, Paris danseuse, who arrived in New York recently with the startling announcement that she had the "most beautiful legs in the world."

"Maybe they like legs—ah, er, very slender in France," is a statement accredited to Miss Eaton, who formerly lived here at 545 Fourteenth street southeast, "but the world is awfully big, and there are many legs. I am told that my legs are much prettier than Mlle. Mistinguette's. Of course, I don't like to talk about myself, but I agree with my admirers."

It is true Mademoiselle is the darling of the Cafe de Paris, and she started the boulevards of France on the famous Apache dance, but, if the symmetry of her nimble feet and ankles is so utterly superlative, she must prove it—must prove it also to Ann Pennington, famous Broadway dancer, whose "understanding" is so nearly perfect that poets rave about it.

Both artists take exception to the claims of the Parisian, and both are more than anxious to take the question before a competent jury.

"I have never seen Mlle. Mistinquett," said Miss Pennington, "but I think my legs are just as beautiful as hers unless some one has been spoofing me. And, besides, I know how to use mine. If Mlle. Mistinquett would like to enter a little contest I would be more than willing to go in, too I wonder if she would show them to a jury to decide. I will."

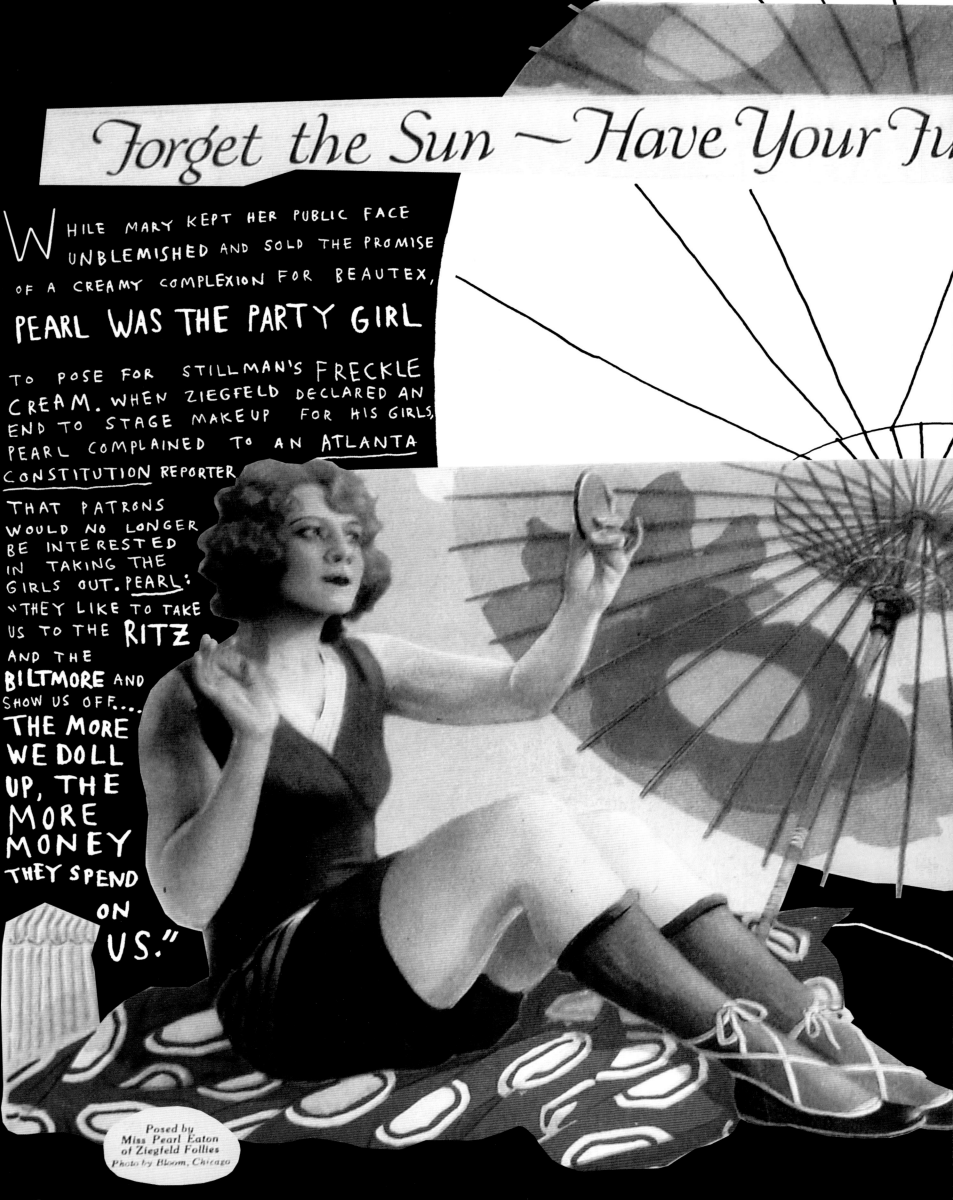

Forget the Sun ~ Have Your Fu

WHILE MARY KEPT HER PUBLIC FACE UNBLEMISHED AND SOLD THE PROMISE OF A CREAMY COMPLEXION FOR BEAUTEX, **PEARL WAS THE PARTY GIRL** TO POSE FOR STILLMAN'S FRECKLE CREAM. WHEN ZIEGFELD DECLARED AN END TO STAGE MAKEUP FOR HIS GIRLS, PEARL COMPLAINED TO AN ATLANTA CONSTITUTION REPORTER THAT PATRONS WOULD NO LONGER BE INTERESTED IN TAKING THE GIRLS OUT. <u>PEARL</u>: "THEY LIKE TO TAKE US TO THE **RITZ** AND THE **BILTMORE** AND SHOW US OFF.... **THE MORE WE DOLL UP, THE MORE MONEY THEY SPEND ON US.**"

Posed by Miss Pearl Eaton of Ziegfeld Follies Photo by Bloom, Chicago

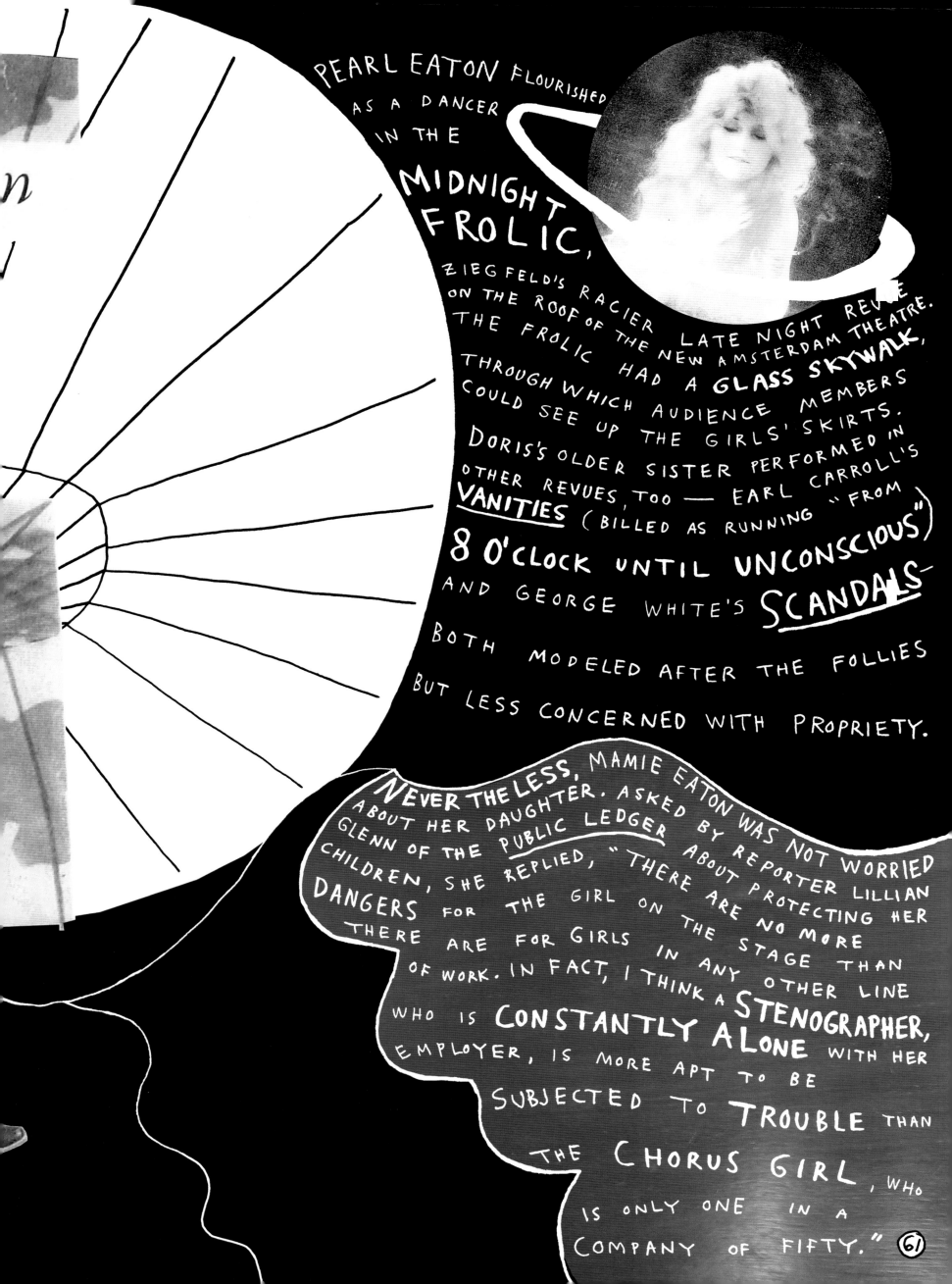

PEARL EATON FLOURISHED AS A DANCER IN THE **MIDNIGHT FROLIC,** ZIEGFELD'S RACIER LATE NIGHT REVUE ON THE ROOF OF THE NEW AMSTERDAM THEATRE. THE FROLIC HAD A **GLASS SKYWALK,** THROUGH WHICH AUDIENCE MEMBERS COULD SEE UP THE GIRLS' SKIRTS. DORIS'S OLDER SISTER PERFORMED IN OTHER REVUES, TOO — EARL CARROLL'S VANITIES (BILLED AS RUNNING "FROM **8 O'CLOCK UNTIL UNCONSCIOUS**") AND GEORGE WHITE'S **SCANDALS**— BOTH MODELED AFTER THE FOLLIES BUT LESS CONCERNED WITH PROPRIETY.

NEVERTHELESS, MAMIE EATON WAS NOT WORRIED ABOUT HER DAUGHTER. ASKED BY REPORTER LILLIAN GLENN OF THE PUBLIC LEDGER ABOUT PROTECTING HER CHILDREN, SHE REPLIED, "THERE ARE NO MORE DANGERS FOR THE GIRL ON THE STAGE THAN THERE ARE FOR GIRLS IN ANY OTHER LINE OF WORK. IN FACT, I THINK A **STENOGRAPHER,** WHO IS **CONSTANTLY ALONE** WITH HER EMPLOYER, IS MORE APT TO BE SUBJECTED TO **TROUBLE** THAN THE **CHORUS GIRL,** WHO IS ONLY ONE IN A COMPANY OF FIFTY."

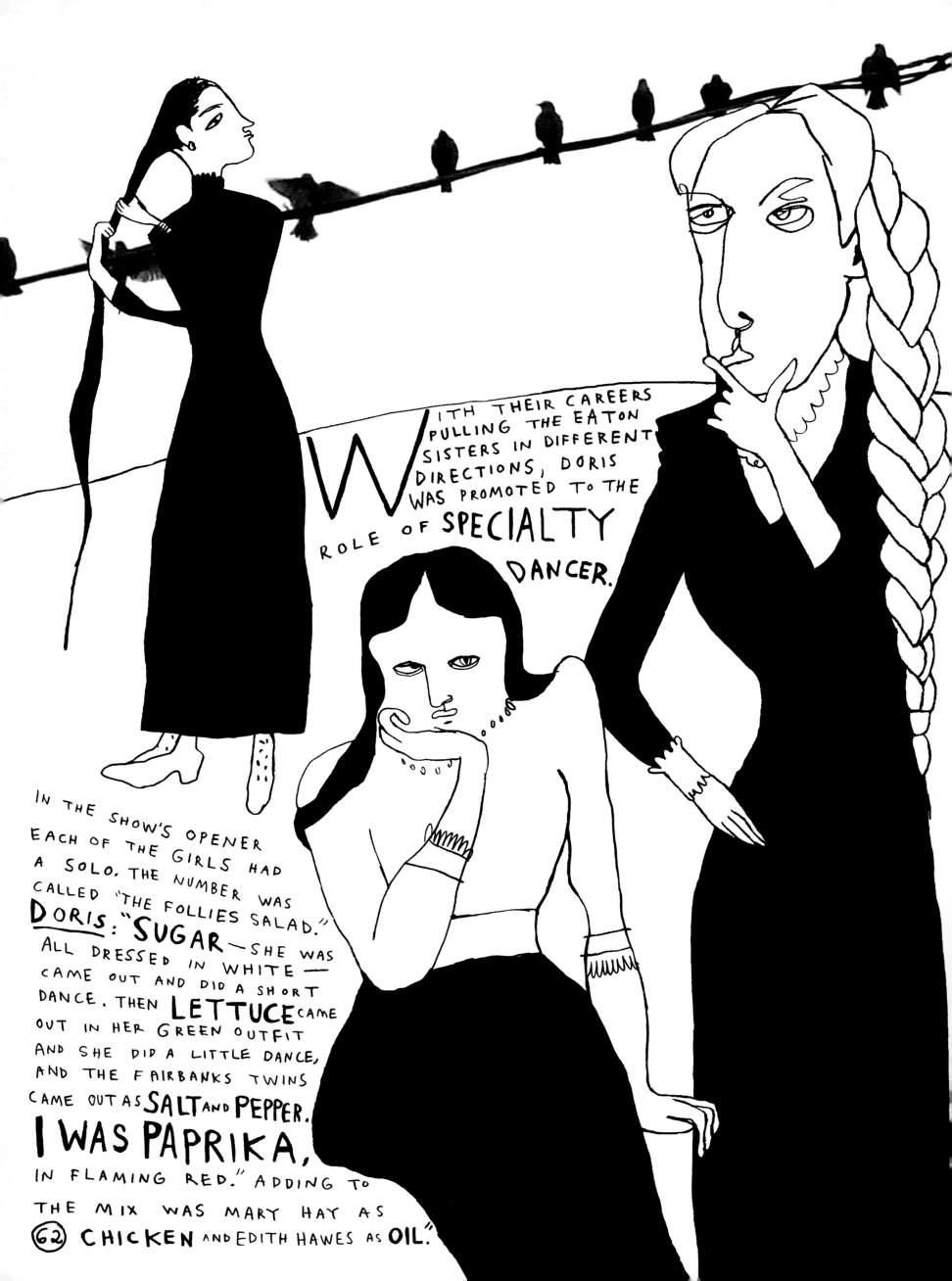

WITH THEIR CAREERS PULLING THE EATON SISTERS IN DIFFERENT DIRECTIONS, DORIS WAS PROMOTED TO THE ROLE OF **SPECIALTY** DANCER.

IN THE SHOW'S OPENER EACH OF THE GIRLS HAD A SOLO. THE NUMBER WAS CALLED "THE FOLLIES SALAD." DORIS: "**SUGAR** — SHE WAS ALL DRESSED IN WHITE — CAME OUT AND DID A SHORT DANCE. THEN **LETTUCE** CAME OUT IN HER GREEN OUTFIT AND SHE DID A LITTLE DANCE, AND THE FAIRBANKS TWINS CAME OUT AS **SALT** AND **PEPPER**. **I WAS PAPRIKA,** IN FLAMING RED." ADDING TO THE MIX WAS MARY HAY AS ⑥② **CHICKEN** AND EDITH HAWES AS **OIL**."

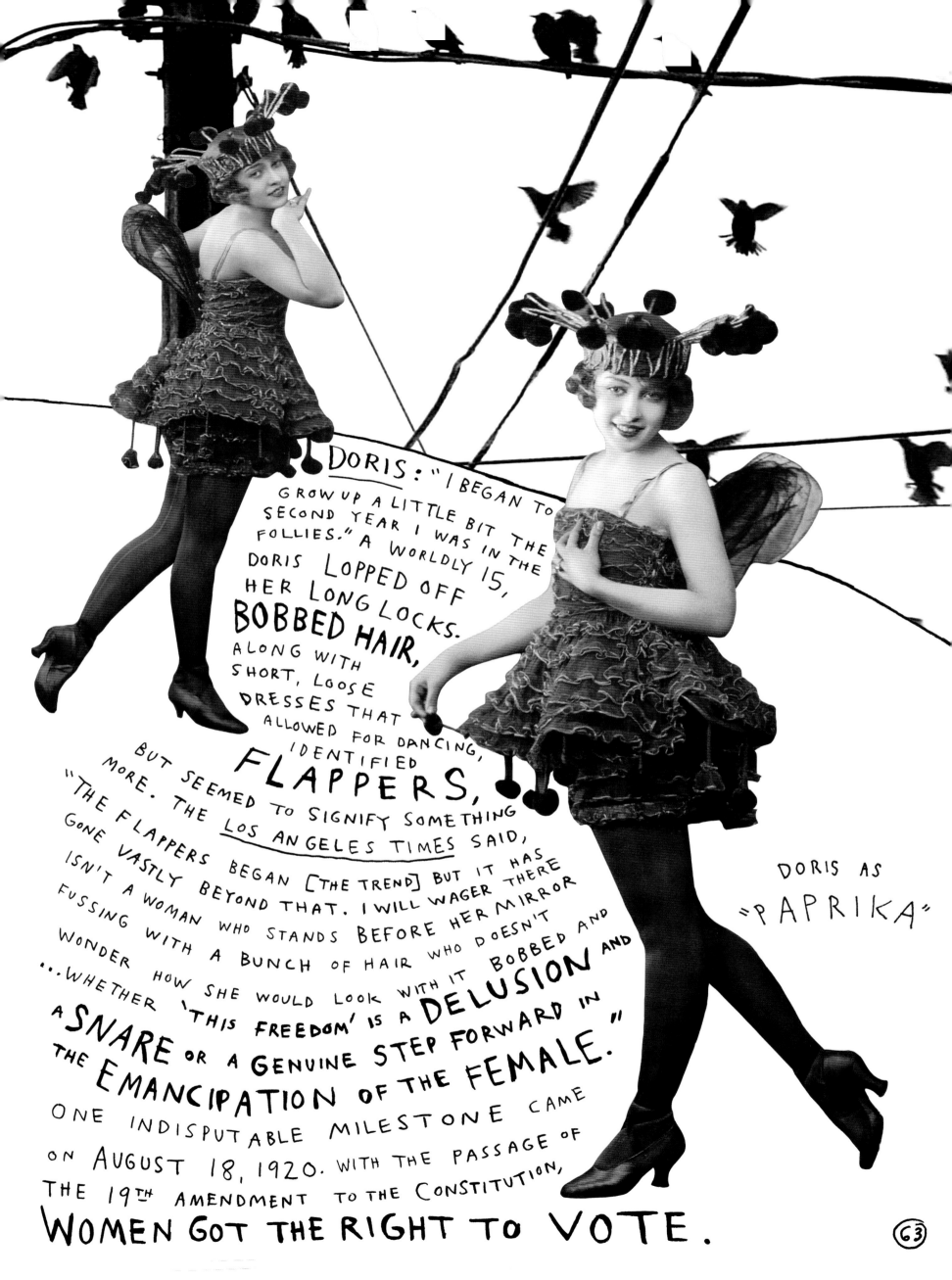

DORIS: "I BEGAN TO GROW UP A LITTLE BIT THE SECOND YEAR I WAS IN THE FOLLIES." A WORLDLY 15, DORIS LOPPED OFF HER LONG LOCKS. **BOBBED HAIR**, ALONG WITH SHORT, LOOSE DRESSES THAT ALLOWED FOR DANCING, IDENTIFIED FLAPPERS, BUT SEEMED TO SIGNIFY SOMETHING MORE. THE LOS ANGELES TIMES SAID, "THE FLAPPERS BEGAN [THE TREND] BUT IT HAS GONE VASTLY BEYOND THAT. I WILL WAGER THERE ISN'T A WOMAN WHO STANDS BEFORE HER MIRROR FUSSING WITH A BUNCH OF HAIR WHO DOESN'T WONDER HOW SHE WOULD LOOK WITH IT BOBBED AND ...WHETHER 'THIS FREEDOM' IS A DELUSION AND A SNARE OR A GENUINE STEP FORWARD IN THE EMANCIPATION OF THE FEMALE." ONE INDISPUTABLE MILESTONE CAME ON AUGUST 18, 1920. WITH THE PASSAGE OF THE 19TH AMENDMENT TO THE CONSTITUTION, WOMEN GOT THE RIGHT TO VOTE.

DORIS AS "PAPRIKA"

63

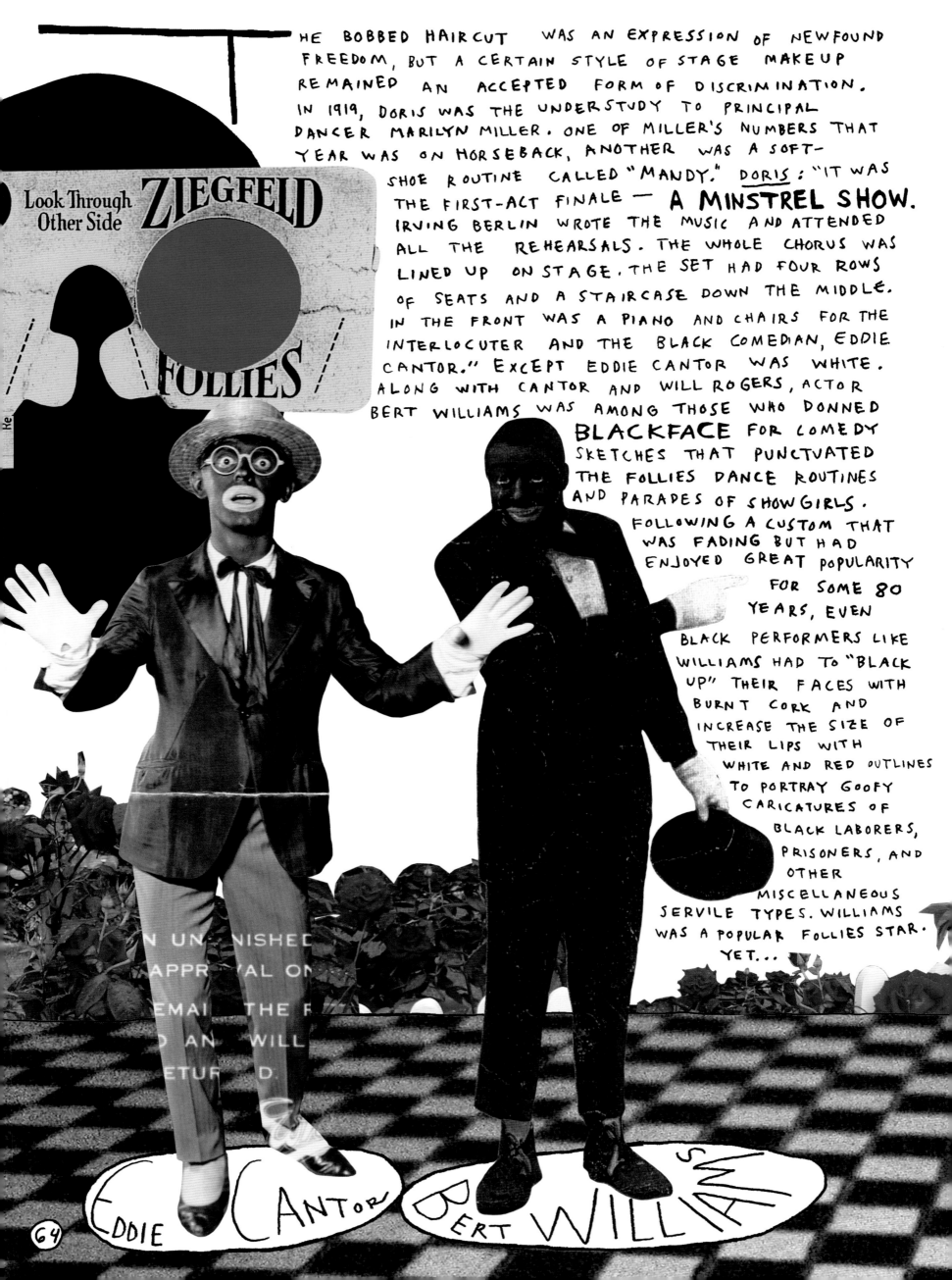

THE BOBBED HAIRCUT WAS AN EXPRESSION OF NEWFOUND FREEDOM, BUT A CERTAIN STYLE OF STAGE MAKEUP REMAINED AN ACCEPTED FORM OF DISCRIMINATION. IN 1919, DORIS WAS THE UNDERSTUDY TO PRINCIPAL DANCER MARILYN MILLER. ONE OF MILLER'S NUMBERS THAT YEAR WAS ON HORSEBACK, ANOTHER WAS A SOFT-SHOE ROUTINE CALLED "MANDY." DORIS: "IT WAS THE FIRST-ACT FINALE — A MINSTREL SHOW. IRVING BERLIN WROTE THE MUSIC AND ATTENDED ALL THE REHEARSALS. THE WHOLE CHORUS WAS LINED UP ON STAGE. THE SET HAD FOUR ROWS OF SEATS AND A STAIRCASE DOWN THE MIDDLE. IN THE FRONT WAS A PIANO AND CHAIRS FOR THE INTERLOCUTER AND THE BLACK COMEDIAN, EDDIE CANTOR." EXCEPT EDDIE CANTOR WAS WHITE. ALONG WITH CANTOR AND WILL ROGERS, ACTOR BERT WILLIAMS WAS AMONG THOSE WHO DONNED BLACKFACE FOR COMEDY SKETCHES THAT PUNCTUATED THE FOLLIES DANCE ROUTINES AND PARADES OF SHOWGIRLS. FOLLOWING A CUSTOM THAT WAS FADING BUT HAD ENJOYED GREAT POPULARITY FOR SOME 80 YEARS, EVEN BLACK PERFORMERS LIKE WILLIAMS HAD TO "BLACK UP" THEIR FACES WITH BURNT CORK AND INCREASE THE SIZE OF THEIR LIPS WITH WHITE AND RED OUTLINES TO PORTRAY GOOFY CARICATURES OF BLACK LABORERS, PRISONERS, AND OTHER MISCELLANEOUS SERVILE TYPES. WILLIAMS WAS A POPULAR FOLLIES STAR. YET...

Look Through Other Side ZIEGFELD FOLLIES

EDDIE CANTOR

BERT WILLIAMS

64

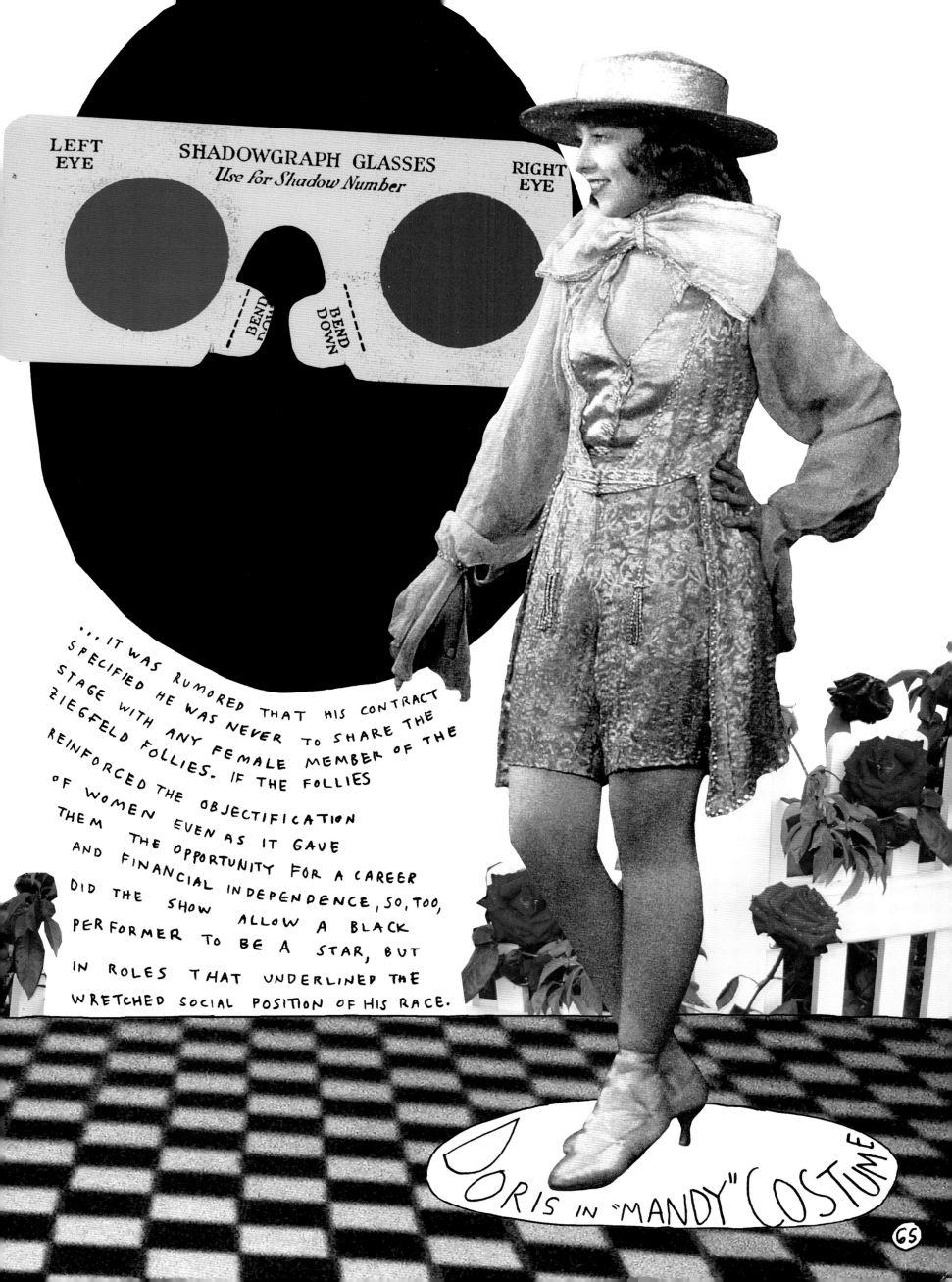

SHADOWGRAPH GLASSES
Use for Shadow Number

LEFT EYE

RIGHT EYE

BEND DOWN

BEND DOWN

... IT WAS RUMORED THAT HIS CONTRACT SPECIFIED HE WAS NEVER TO SHARE THE STAGE WITH ANY FEMALE MEMBER OF THE ZIEGFELD FOLLIES. IF THE FOLLIES REINFORCED THE OBJECTIFICATION OF WOMEN EVEN AS IT GAVE THEM THE OPPORTUNITY FOR A CAREER AND FINANCIAL INDEPENDENCE, SO, TOO, DID THE SHOW ALLOW A BLACK PERFORMER TO BE A STAR, BUT IN ROLES THAT UNDERLINED THE WRETCHED SOCIAL POSITION OF HIS RACE.

DORIS IN "MANDY" COSTUME

65

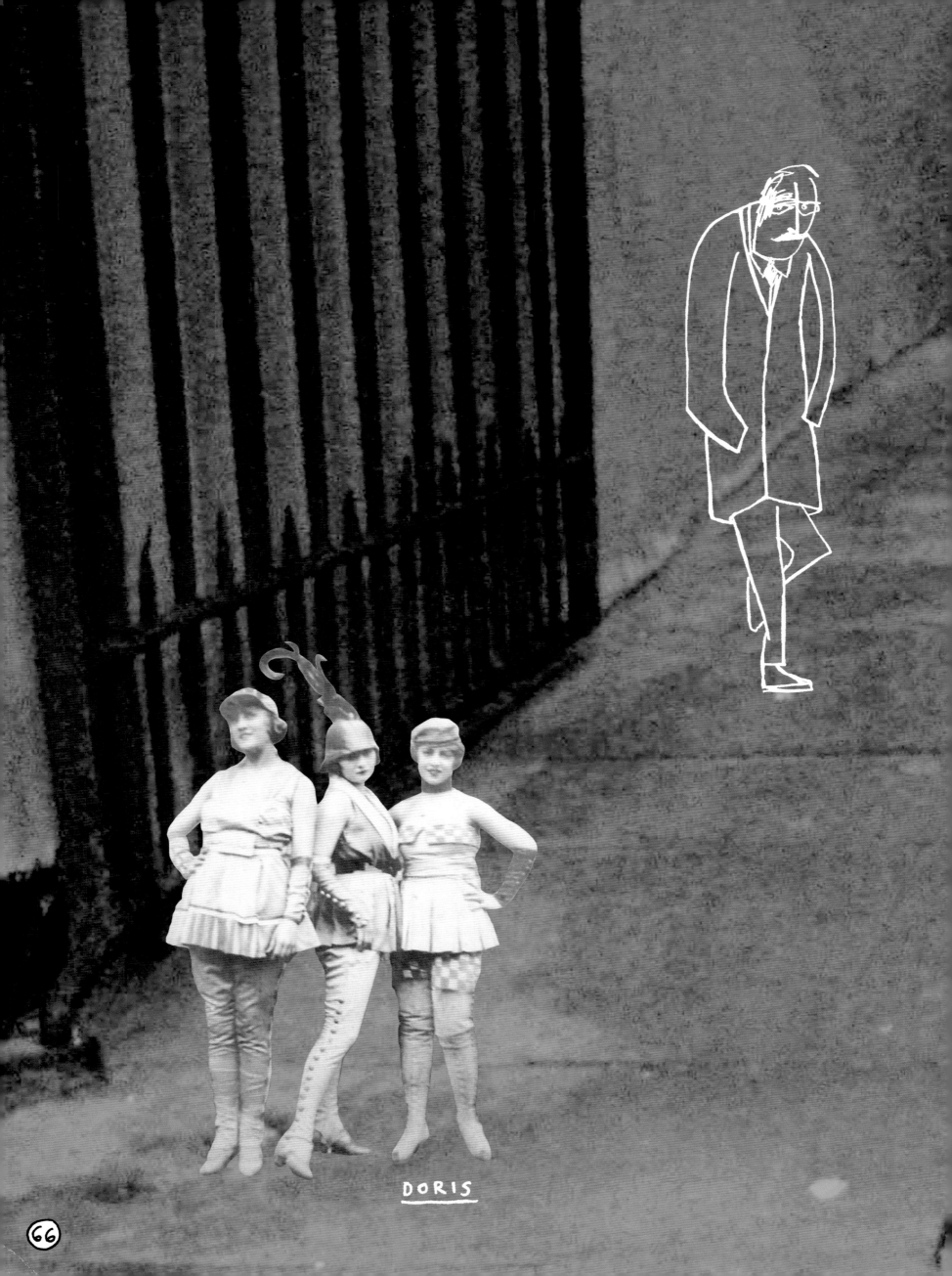

DORIS

On January 16, 1920, America officially swore off BOOZE. The Volstead Act banned the sale, transportation, and manufacture of alcohol. But PROHIBITION BACKFIRED. Instead of establishing a sober utopia, alcohol-related deaths jumped and crime soared, with even the most respectable citizens flouting the law. BOOTLEGGERS, MOONSHINERS, and MOBSTERS needed entertainment, and showgirls proved very entertaining. Even dry nightclubs compensated for absence of spirits with INTOXICATINGLY dressed, or UNDRESSED, girls. Arrests were so common that speakeasy hostess TEXAS GUINAN reported that her favorite saying was "GOOD MORNING, JUDGE." Guinan, a former TRICK RIDER at the Cheyenne rodeo, served up Hungarian goulash along with LIQUOR AND LEGS. "Guinan's in New York was wetter than the Atlantic," said crime reporter and regular James Doherty. Pearl Eaton was among the handful of FOLLIES FILLIES Guinan hired to dance on the BLUE VELVET carpet of the El Fey nightclub on West 45th street, where she played hostess. DORIS: "Texas was a rough customer. She didn't take any guff from anyone, but she was very good to her girls."

68

69

Liquor wasn't the only temptation threatening polite society in the 1920's. In August of 1921, LADIES HOME JOURNAL asked "DOES JAZZ PUT THE SIN IN SYNCOPATION?" The magazine declared, "THE EFFECT OF JAZZ ON THE NORMAL BRAIN PRODUCES AN ATROPHIED CONDITION ON THE BRAIN CELLS OF CONCEPTION, UNTIL VERY FREQUENTLY THOSE UNDER THE DEMORALIZING INFLUENCE OF THE PERSISTENT USE OF INHARMONIC PARTIAL TONES, ARE ACTUALLY INCAPABLE OF DISTINGUISHING BETWEEN GOOD AND EVIL, RIGHT AND WRONG." From Rome THE POPE condemned the new american dances. Chicago courts debated the legality of the Shimmy. Hoboken police banned the Charleston, fearing the collapse of buildings. British doctor Edwin Craw warned that the "continual smacking of thin shoes on the dance floor" would result in a NEW FOOT DISEASE with corns and warts, reported the WASHINGTON POST.

DORIS DIDN'T CONCERN HERSELF WITH SUCH JUDGMENTS OR RISKS.

DORIS: "IF YOU DIDN'T GET KICKED DOING THE CHARLESTON, YOU WEREN'T REALLY DANCING." CALLED "AN EDUCATED EXPONENT OF SYNCOPATION" BY ONE CRITIC, DORIS SHOWCASED HER TALENTS IN A DANCING ROLE OPPOSITE AL JOLSON IN BIG BOY AT THE WINTER GARDEN.

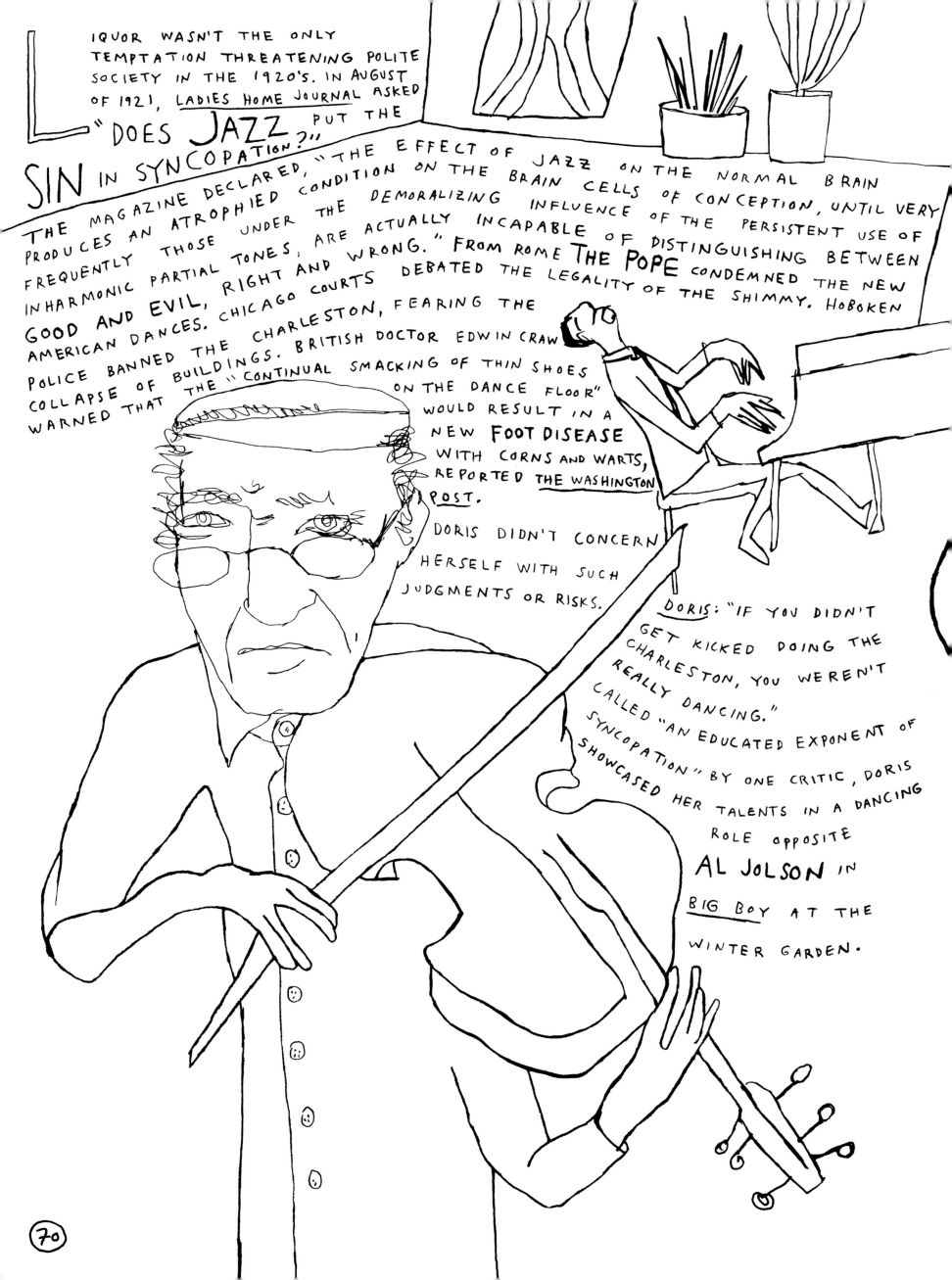

70

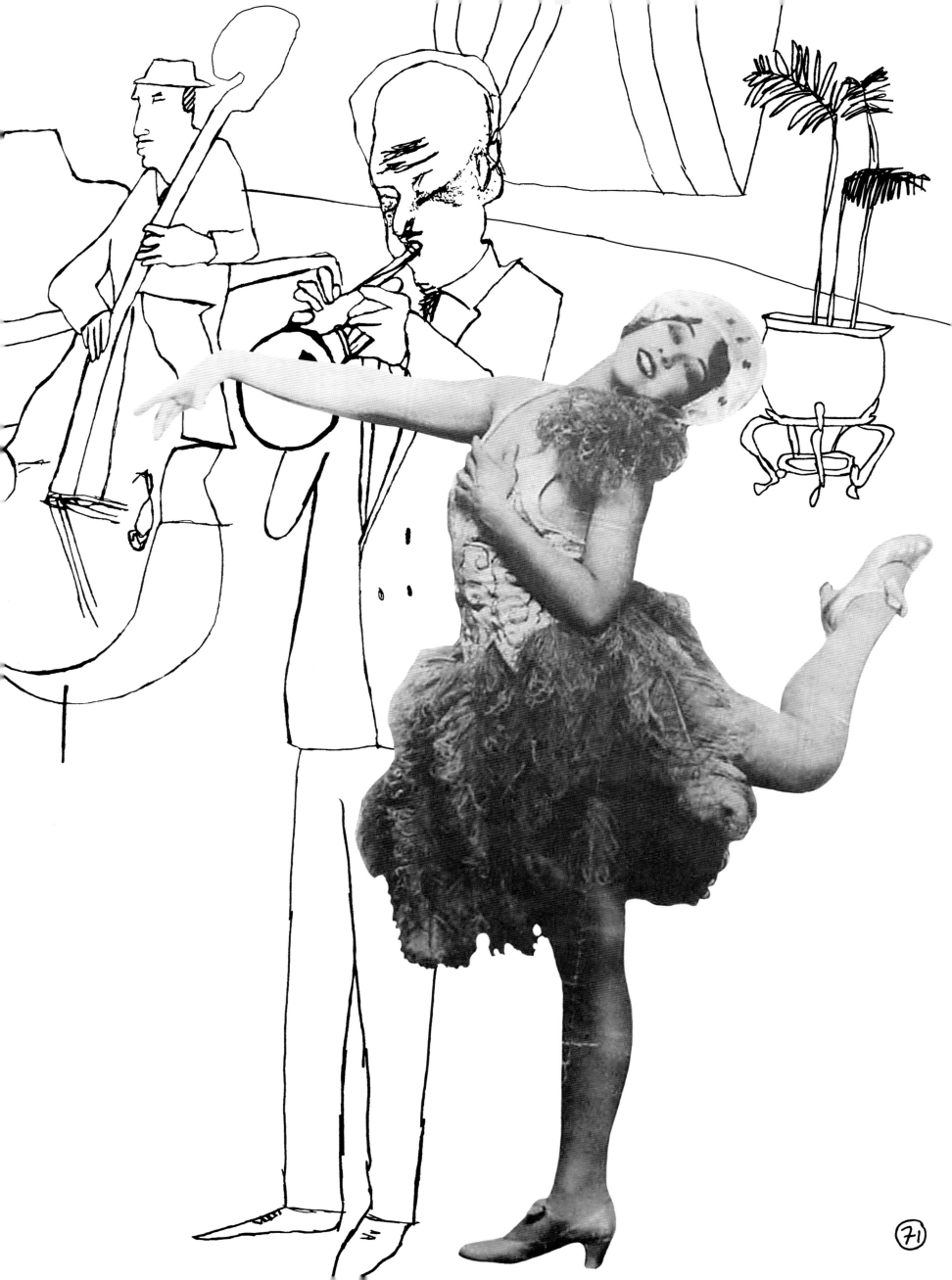

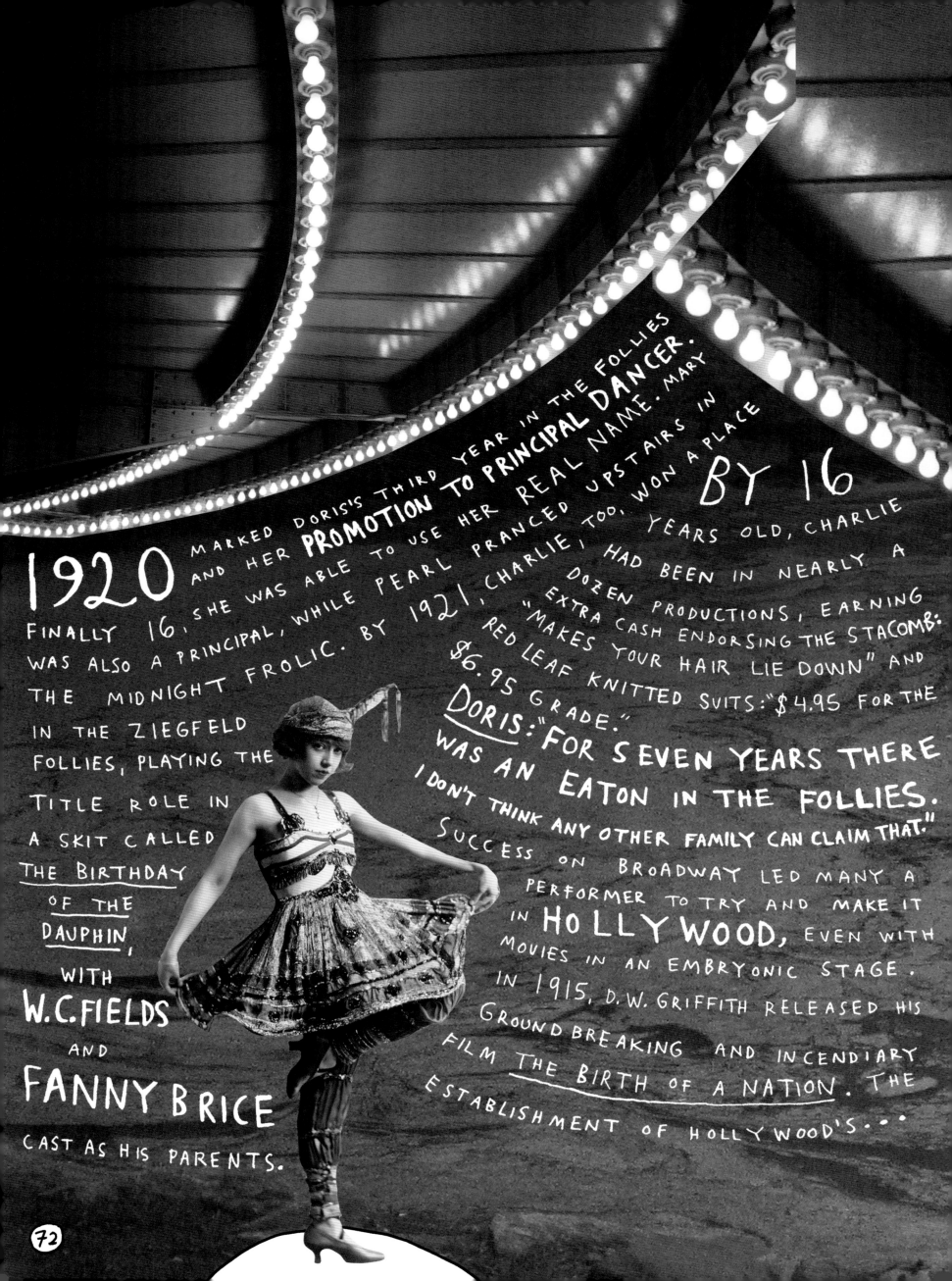

1920 MARKED DORIS'S THIRD YEAR IN THE FOLLIES AND HER **PROMOTION TO PRINCIPAL DANCER.** FINALLY 16, SHE WAS ABLE TO USE HER REAL NAME. MARY WAS ALSO A PRINCIPAL, WHILE PEARL PRANCED UPSTAIRS IN THE MIDNIGHT FROLIC. BY 1921, CHARLIE, TOO, WON A PLACE IN THE ZIEGFELD FOLLIES, PLAYING THE TITLE ROLE IN A SKIT CALLED THE BIRTHDAY OF THE DAUPHIN, WITH **W.C.FIELDS** AND **FANNY BRICE** CAST AS HIS PARENTS.

BY 16 YEARS OLD, CHARLIE HAD BEEN IN NEARLY A DOZEN PRODUCTIONS, EARNING EXTRA CASH ENDORSING THE STACOMB "MAKES YOUR HAIR LIE DOWN" AND RED LEAF KNITTED SUITS:"$4.95 FOR THE $6.95 GRADE."

DORIS:"FOR SEVEN YEARS THERE WAS AN EATON IN THE FOLLIES. I DON'T THINK ANY OTHER FAMILY CAN CLAIM THAT." SUCCESS ON BROADWAY LED MANY A PERFORMER TO TRY AND MAKE IT IN **HOLLYWOOD,** EVEN WITH MOVIES IN AN EMBRYONIC STAGE. IN 1915, D.W. GRIFFITH RELEASED HIS GROUNDBREAKING AND INCENDIARY FILM THE BIRTH OF A NATION. THE ESTABLISHMENT OF HOLLYWOOD'S....

FANNY BRICE

W.C. FIELDS

CHARLIE EATON

...MAJOR STUDIOS,
INCLUDING RKO,
WARNER BROTHERS,
MGM, FOX, UNIVERSAL,
UNITED ARTISTS,
COLUMBIA,

AND
DISNEY, SOON
FOLLOWED. WHEN,
IN 1921, DORIS
RECEIVED AN OFFER
TO STAR IN A
SILENT FILM BEING
SHOT ON LOCATION
IN ENGLAND AND
AFRICA, IT SEEMED
ZIEGFELD'S ANNUAL
EXTRAVAGANZA HAD
PAVED A PROMISING
NEW AVENUE FOR
HER CAREER.

73

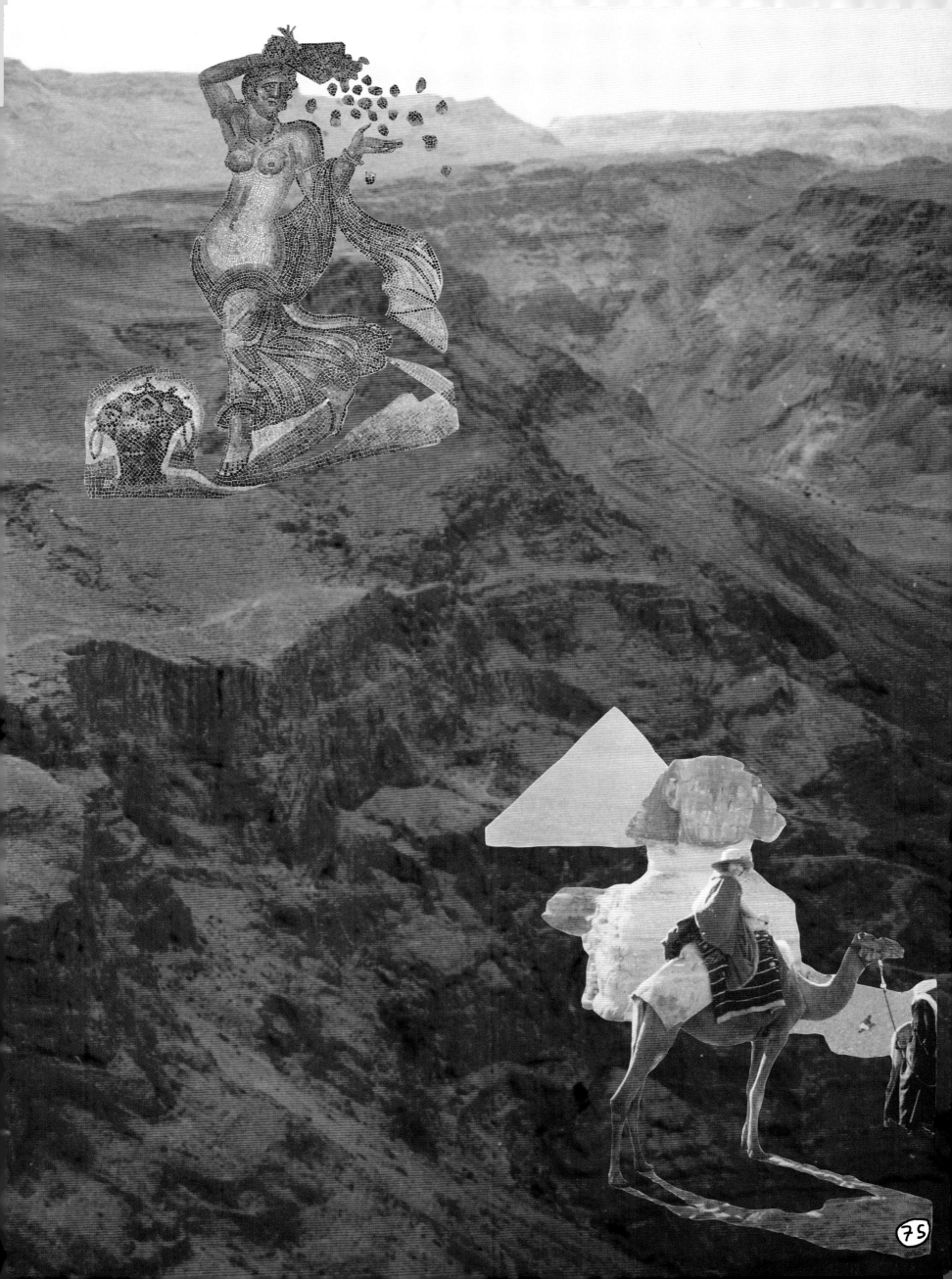

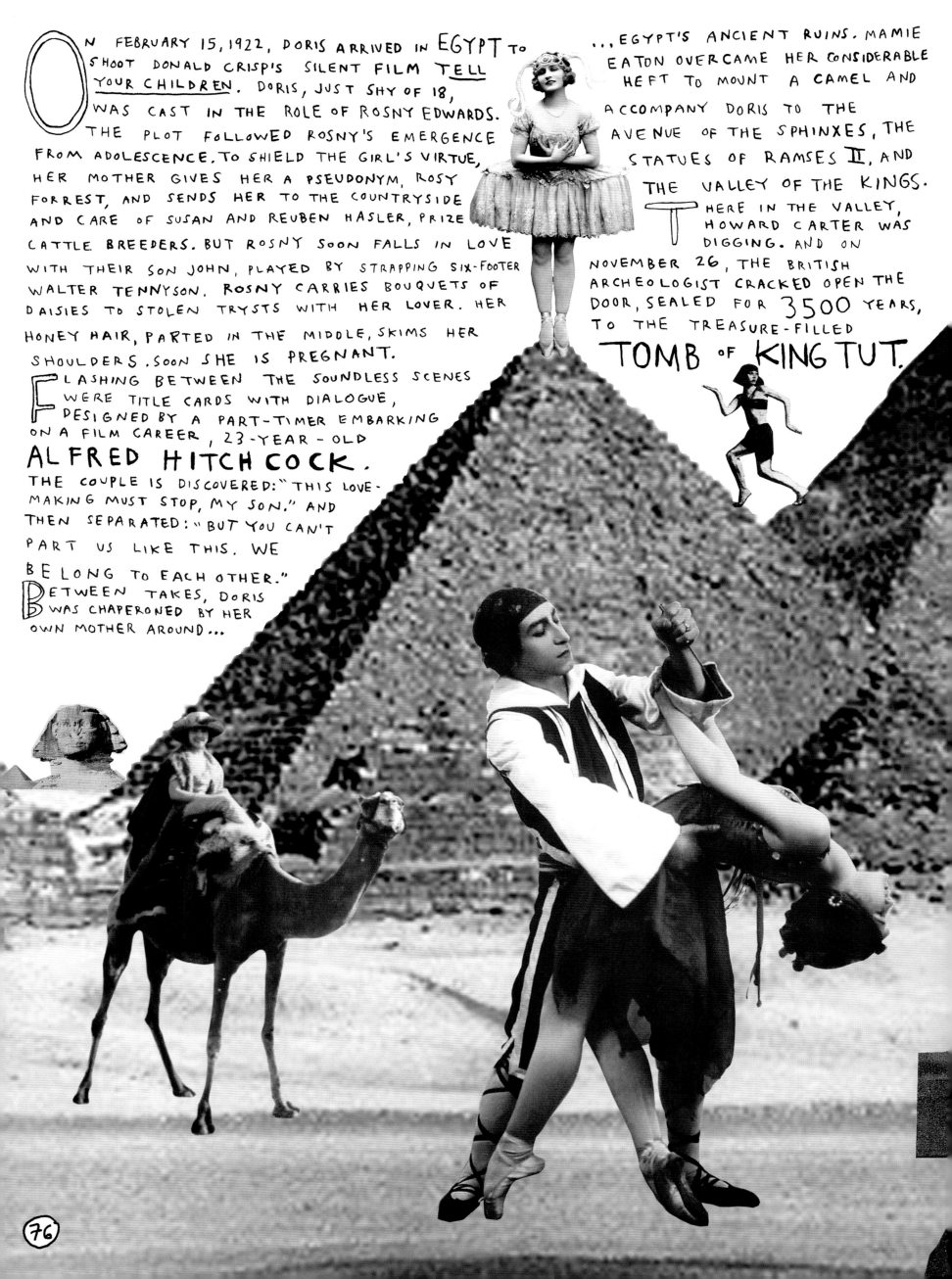

ON FEBRUARY 15, 1922, DORIS ARRIVED IN EGYPT TO SHOOT DONALD CRISP'S SILENT FILM TELL YOUR CHILDREN. DORIS, JUST SHY OF 18, WAS CAST IN THE ROLE OF ROSNY EDWARDS. THE PLOT FOLLOWED ROSNY'S EMERGENCE FROM ADOLESCENCE. TO SHIELD THE GIRL'S VIRTUE, HER MOTHER GIVES HER A PSEUDONYM, ROSY FORREST, AND SENDS HER TO THE COUNTRYSIDE AND CARE OF SUSAN AND REUBEN HASLER, PRIZE CATTLE BREEDERS. BUT ROSNY SOON FALLS IN LOVE WITH THEIR SON JOHN, PLAYED BY STRAPPING SIX-FOOTER WALTER TENNYSON. ROSNY CARRIES BOUQUETS OF DAISIES TO STOLEN TRYSTS WITH HER LOVER. HER HONEY HAIR, PARTED IN THE MIDDLE, SKIMS HER SHOULDERS. SOON SHE IS PREGNANT.

FLASHING BETWEEN THE SOUNDLESS SCENES WERE TITLE CARDS WITH DIALOGUE, DESIGNED BY A PART-TIMER EMBARKING ON A FILM CAREER, 23-YEAR-OLD ALFRED HITCHCOCK. THE COUPLE IS DISCOVERED: "THIS LOVE-MAKING MUST STOP, MY SON." AND THEN SEPARATED: "BUT YOU CAN'T PART US LIKE THIS. WE BELONG TO EACH OTHER."

BETWEEN TAKES, DORIS WAS CHAPERONED BY HER OWN MOTHER AROUND...

...EGYPT'S ANCIENT RUINS. MAMIE EATON OVERCAME HER CONSIDERABLE HEFT TO MOUNT A CAMEL AND ACCOMPANY DORIS TO THE AVENUE OF THE SPHINXES, THE STATUES OF RAMSES II, AND THE VALLEY OF THE KINGS.

THERE IN THE VALLEY, HOWARD CARTER WAS DIGGING. AND ON NOVEMBER 26, THE BRITISH ARCHEOLOGIST CRACKED OPEN THE DOOR, SEALED FOR 3500 YEARS, TO THE TREASURE-FILLED TOMB OF KING TUT.

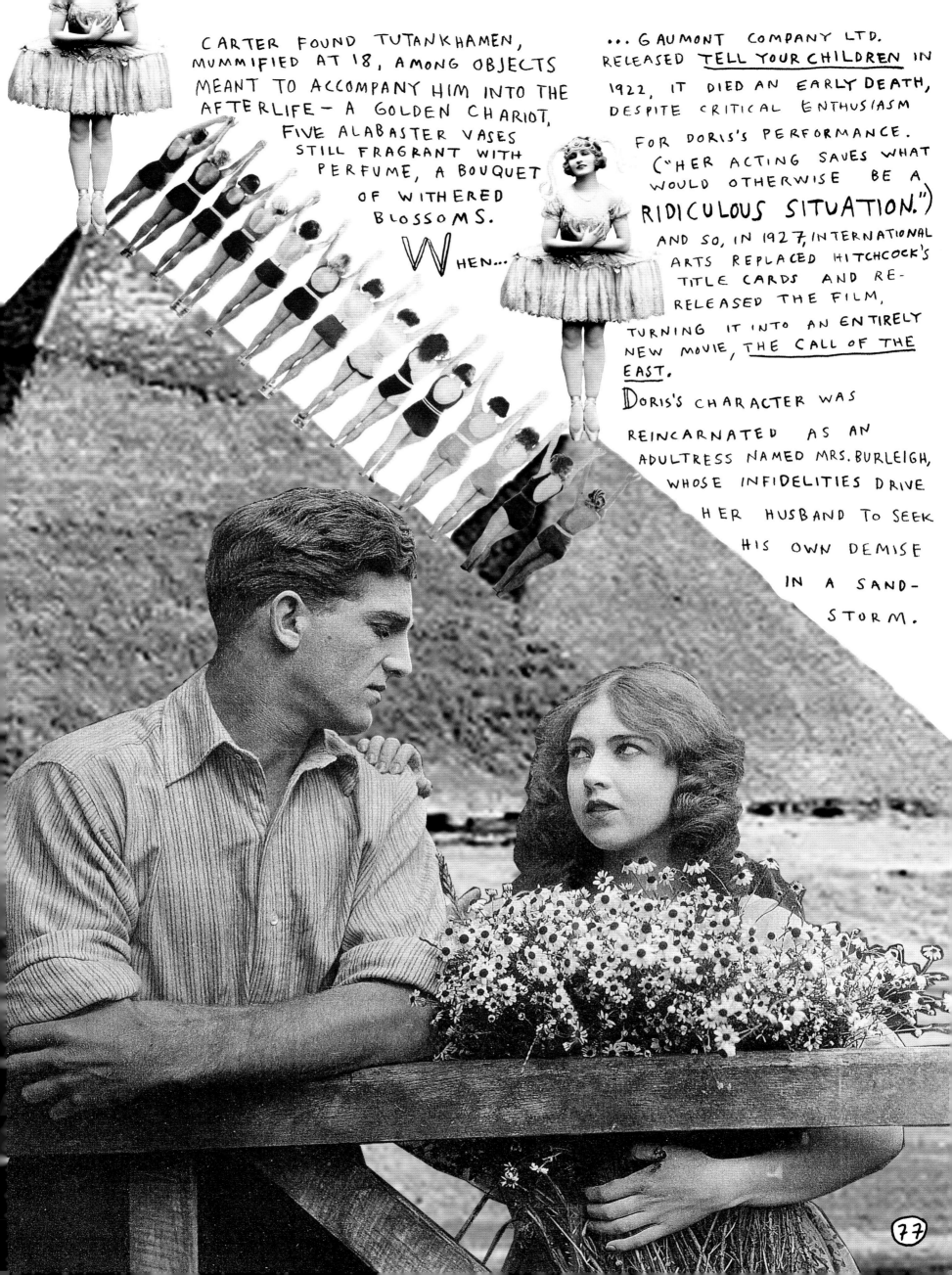

CARTER FOUND TUTANKHAMEN, MUMMIFIED AT 18, AMONG OBJECTS MEANT TO ACCOMPANY HIM INTO THE AFTERLIFE — A GOLDEN CHARIOT, FIVE ALABASTER VASES STILL FRAGRANT WITH PERFUME, A BOUQUET OF WITHERED BLOSSOMS. WHEN...

... GAUMONT COMPANY LTD. RELEASED TELL YOUR CHILDREN IN 1922, IT DIED AN EARLY DEATH, DESPITE CRITICAL ENTHUSIASM FOR DORIS'S PERFORMANCE. ("HER ACTING SAVES WHAT WOULD OTHERWISE BE A RIDICULOUS SITUATION.") AND SO, IN 1927, INTERNATIONAL ARTS REPLACED HITCHCOCK'S TITLE CARDS AND RE-RELEASED THE FILM, TURNING IT INTO AN ENTIRELY NEW MOVIE, THE CALL OF THE EAST. DORIS'S CHARACTER WAS REINCARNATED AS AN ADULTRESS NAMED MRS. BURLEIGH, WHOSE INFIDELITIES DRIVE HER HUSBAND TO SEEK HIS OWN DEMISE IN A SAND-STORM.

IN 1922, DORIS RETURNED STATESIDE AND FOUND AN ILLUSORY PARADISE IN THE PAPIER-MACHE PALM TREES OF HOLLYWOOD'S COCOANUT GROVE. THE TREES, ABANDONED SET PIECES FROM... ... RUDOLPH VALENTINO'S 1921 FILM _THE SHEIK_, FORMED A CANOPY OF FAUX VERDURE INSIDE THE HOTEL AMBASSADOR NIGHTCLUB. (THE HOTEL WOULD BECOME THE SET OF THE 1967 FILM _THE GRADUATE_, AND, A YEAR LATER, THE SITE OF ROBERT KENNEDY'S ASSASSINATION.) THERE, DORIS HEADLINED IN JOE GORHAM'S FOLLIES, A MIXED BILL OF...

True Experiences

SEPTEMBER

TRUE STORIES OF LIFE AND LOVE

A MACFADDEN PUBLICATION

PRICE UNITED STATES 25¢ CANADA 30¢

Doris Eaton

HER ONE MISSTEP

BONDS OF PASSION

RACING LUCK

(78)

"... ACROBATS — TUMBLERS AND JUGGLERS— DANCERS, AND COMEDIANS. FOR HER INTRODUCTION, COMPOSER ARTHUR FREED WROTE A SONG, "DORIS, COME OUT OF THE CHORUS." PRODUCER JOE GORHAM, TWICE DORIS'S EIGHTEEN YEARS AND HIDING A FEROCIOUS TEMPER, WOOED HIS STAR, AND..."

"...ON JANUARY 8, 1923, MUSE WED MAKER. IN A CEREMONY AT TRINITY METHODIST CHURCH, THE BRIDE WORE WHITE CHIFFON "SPLASHED WITH ORANGE BLOSSOMS." SCARCELY THREE HOURS INTO THE MARRIAGE, DEPUTY SHERIFFS TRACKED THE NEWLYWEDS DOWN AT MARCELL'S CAFE, PLACED GORHAM UNDER ARREST AND TOSSED HIM INTO THE COUNTY JAIL, ONE EUGENIE LA PLACE, AKA JENNIE BLOSSOM, WAS CHARGING MISUSE OF $10,000. WHEN RELEASED HOURS LATER ON $5000 BAIL, GORHAM SCURRIED OFF WITH DORIS TO THEIR HONEY MOON IN FLORIDA. DORIS: "IT WASN'T A VERY HAPPY MARRIAGE. MY HUSBAND DIED OF A HEART ATTACK IN ABOUT NINE MONTHS."

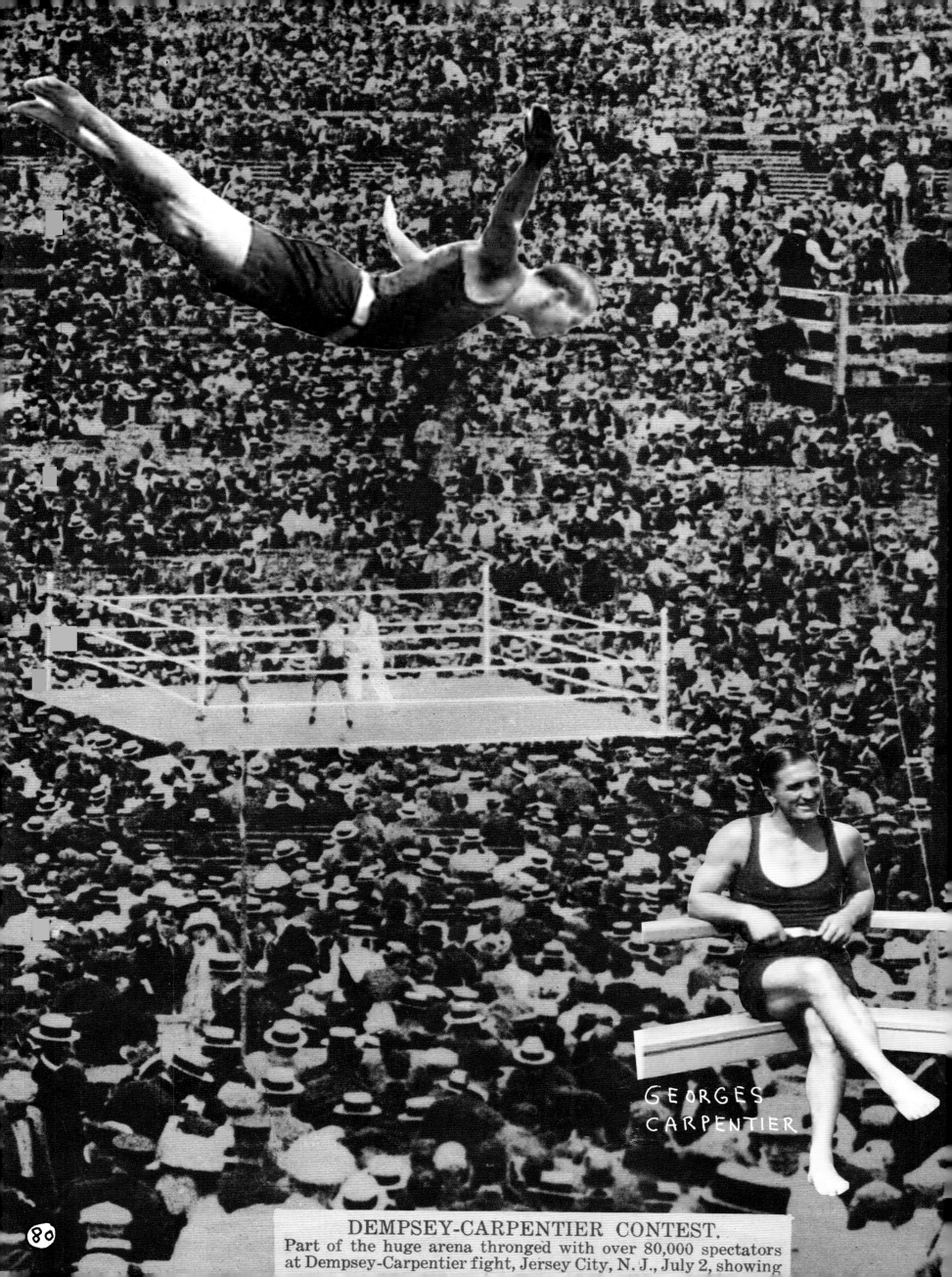

GEORGES
CARPENTIER

DEMPSEY-CARPENTIER CONTEST.
Part of the huge arena thronged with over 80,000 spectators
at Dempsey-Carpentier fight, Jersey City, N. J., July 2, showing

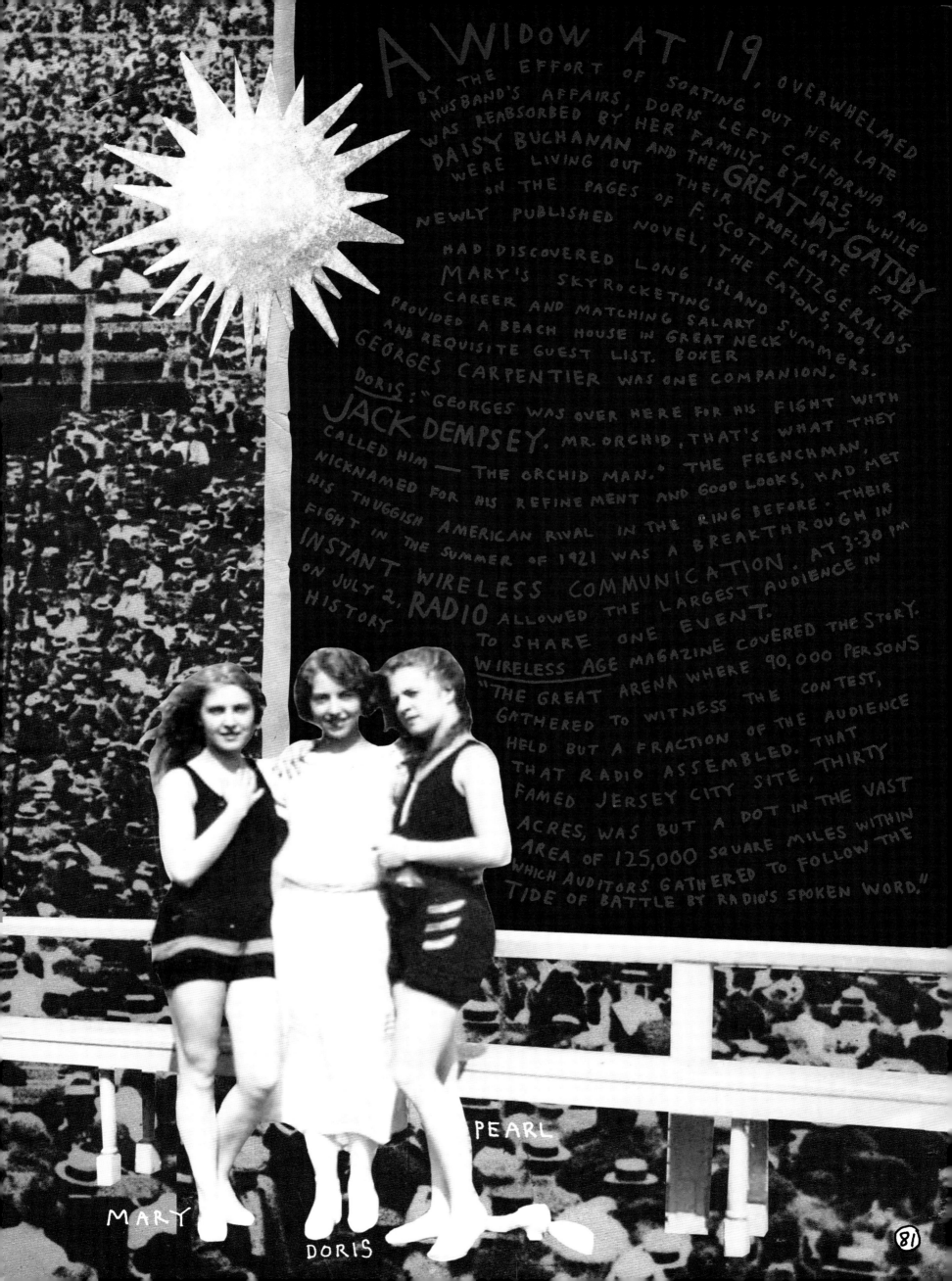

A WIDOW AT 19

OVERWHELMED BY THE EFFORT OF SORTING OUT HER LATE HUSBAND'S AFFAIRS, DORIS LEFT CALIFORNIA AND WAS REABSORBED BY HER FAMILY. BY 1925 WHILE DAISY BUCHANAN AND THE GREAT JAY GATSBY WERE LIVING OUT THEIR PROFLIGATE FATE ON THE PAGES OF F. SCOTT FITZGERALD'S NEWLY PUBLISHED NOVEL, THE EATONS, TOO, HAD DISCOVERED LONG ISLAND SUMMERS. MARY'S SKYROCKETING CAREER AND MATCHING SALARY PROVIDED A BEACH HOUSE IN GREAT NECK AND REQUISITE GUEST LIST. BOXER GEORGES CARPENTIER WAS ONE COMPANION. DORIS: "GEORGES WAS OVER HERE FOR HIS FIGHT WITH JACK DEMPSEY. MR. ORCHID, THAT'S WHAT THEY CALLED HIM — THE ORCHID MAN." THE FRENCHMAN, NICKNAMED FOR HIS REFINEMENT AND GOOD LOOKS, HAD MET HIS THUGGISH AMERICAN RIVAL IN THE RING BEFORE. THEIR FIGHT IN THE SUMMER OF 1921 WAS A BREAKTHROUGH IN INSTANT WIRELESS COMMUNICATION. AT 3:30 PM ON JULY 2, RADIO ALLOWED THE LARGEST AUDIENCE IN HISTORY TO SHARE ONE EVENT. WIRELESS AGE MAGAZINE COVERED THE STORY. "THE GREAT ARENA WHERE 90,000 PERSONS GATHERED TO WITNESS THE CONTEST, HELD BUT A FRACTION OF THE AUDIENCE THAT RADIO ASSEMBLED. THAT FAMED JERSEY CITY SITE, THIRTY ACRES, WAS BUT A DOT IN THE VAST AREA OF 125,000 SQUARE MILES WITHIN WHICH AUDITORS GATHERED TO FOLLOW THE TIDE OF BATTLE BY RADIO'S SPOKEN WORD."

MARY

DORIS

PEARL

81

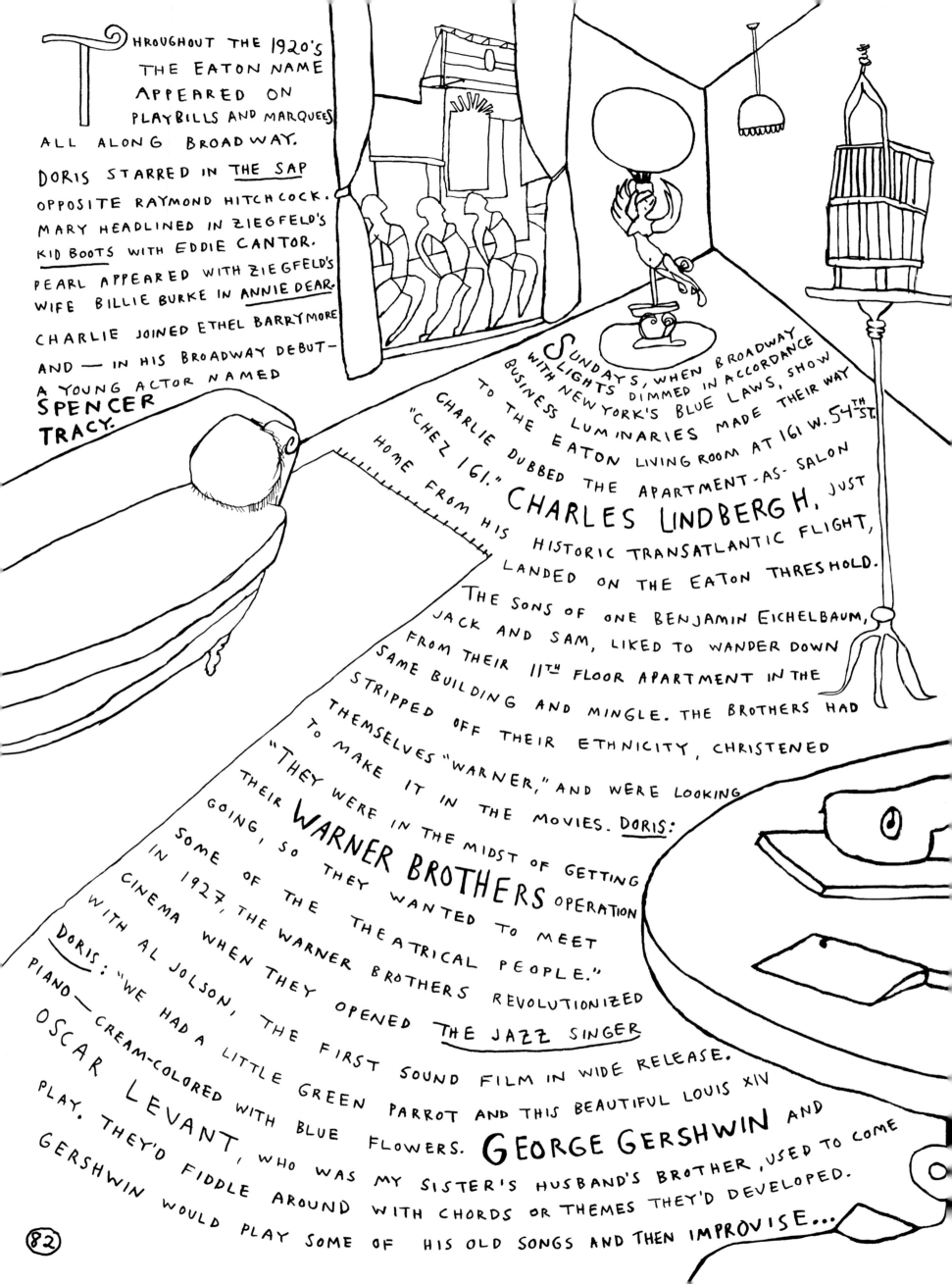

Throughout the 1920's the Eaton name appeared on playbills and marquees all along Broadway. Doris starred in THE SAP opposite Raymond Hitchcock. Mary headlined in Ziegfeld's KID BOOTS with Eddie Cantor. Pearl appeared with Ziegfeld's wife Billie Burke in ANNIE DEAR. Charlie joined Ethel Barrymore and — in his Broadway debut — a young actor named SPENCER TRACY.

Sundays, when Broadway lights dimmed in accordance with New York's blue laws, show business luminaries made their way to the Eaton living room at 161 W. 54th St. Charlie dubbed the apartment-as-salon "Chez 161." CHARLES LINDBERGH, just home from his historic transatlantic flight, landed on the Eaton threshold.

The sons of one Benjamin Eichelbaum, Jack and Sam, liked to wander down from their 11th floor apartment in the same building and mingle. The brothers had stripped off their ethnicity, christened themselves "Warner," and were looking to make it in the movies. Doris: "They were in the midst of getting their WARNER BROTHERS operation going, so they wanted to meet some of the theatrical people."

In 1927, the Warner brothers revolutionized cinema when they opened the first sound film in wide release, THE JAZZ SINGER with Al Jolson.

Doris: "We had a little green parrot and this beautiful Louis XIV piano — cream-colored with blue flowers. GEORGE GERSHWIN and OSCAR LEVANT, who was my sister's husband's brother, used to come play. They'd fiddle around with chords or themes they'd developed. Gershwin would play some of his old songs and then improvise..."

82

...MAMA, WHO WAS A SOUTHERN COOK, WOULD ALWAYS HAVE A BUFFET. EVERYONE LOVED HER BISCUITS. ONE AFTERNOON CHARLIE WAS DOING SOME SCATTING — THAT FUNNY SOUND PEOPLE WERE MAKING — AND FRED ASTAIRE SAID, "TEACH ME SOME OF THAT!"

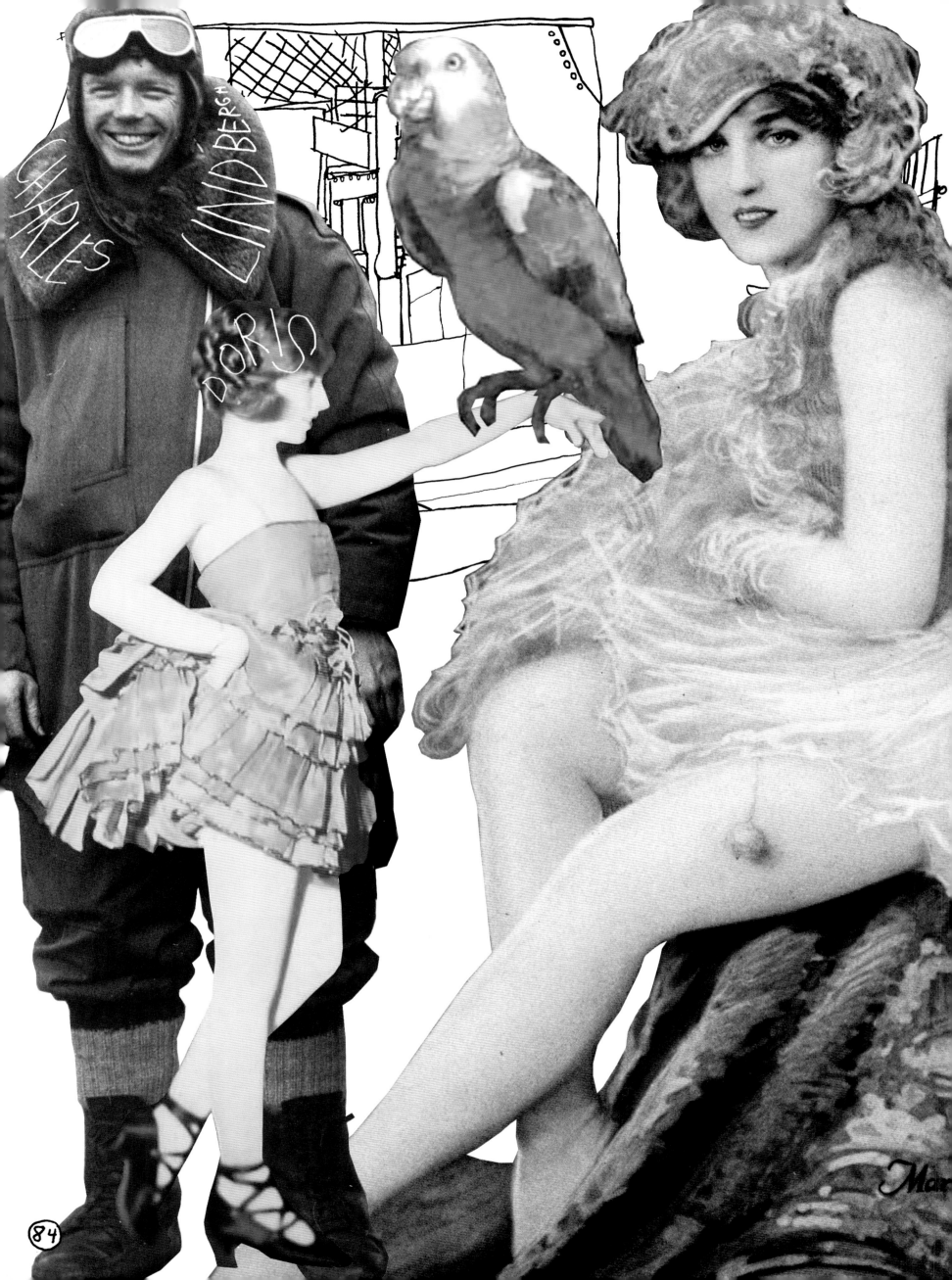

CHARLES LINDBERGH

DORIS

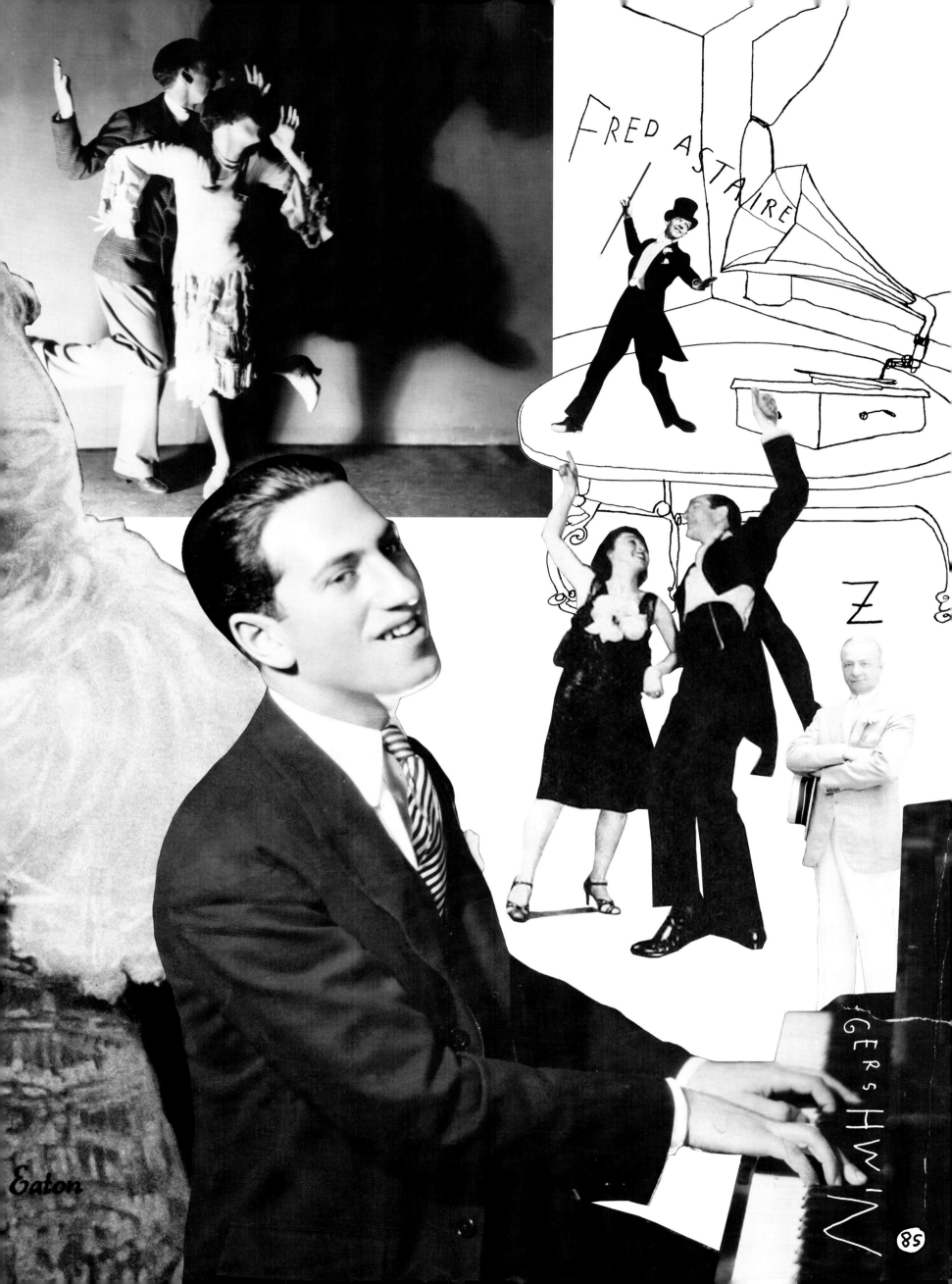

FRED ASTAIRE

Eaton

GERSHWIN

85

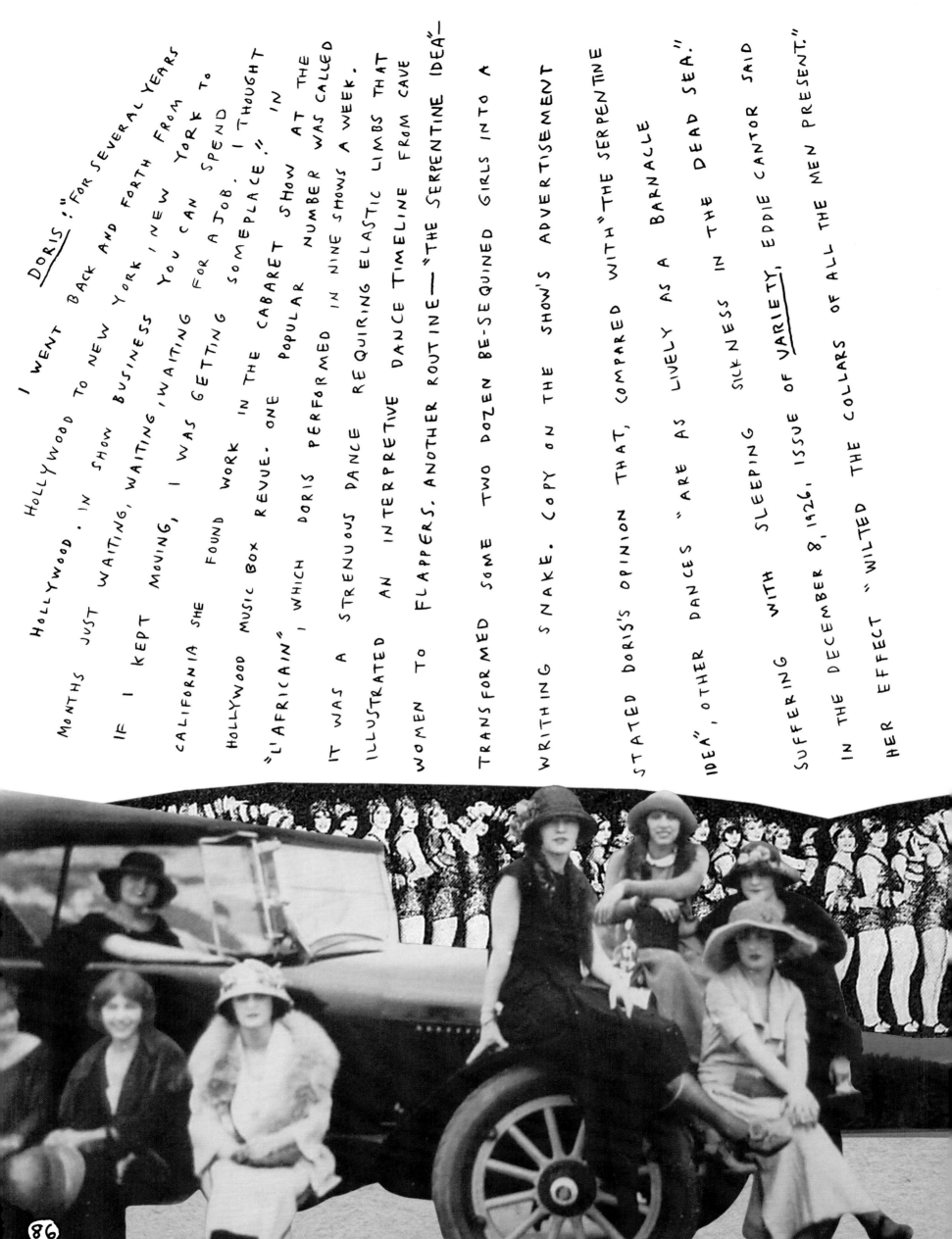

DORIS: "FOR SEVERAL YEARS I WENT BACK AND FORTH FROM HOLLYWOOD TO NEW YORK, NEW YORK TO HOLLYWOOD. IN SHOW BUSINESS YOU CAN SPEND MONTHS JUST WAITING, WAITING, WAITING FOR A JOB. I THOUGHT IF I KEPT MOVING, I WAS GETTING SOMEPLACE." IN CALIFORNIA SHE FOUND WORK IN THE CABARET SHOW AT THE HOLLYWOOD MUSIC BOX REVUE. ONE POPULAR NUMBER WAS CALLED "L'AFRICAIN", WHICH DORIS PERFORMED IN NINE SHOWS A WEEK. IT WAS A STRENUOUS DANCE REQUIRING ELASTIC LIMBS THAT ILLUSTRATED AN INTERPRETIVE DANCE TIMELINE FROM CAVE WOMEN TO FLAPPERS. ANOTHER ROUTINE—"THE SERPENTINE IDEA"— TRANSFORMED SOME TWO DOZEN BE-SEQUINED GIRLS INTO A WRITHING SNAKE. COPY ON THE SHOW'S ADVERTISEMENT STATED DORIS'S OPINION THAT, COMPARED WITH "THE SERPENTINE IDEA", OTHER DANCES "ARE AS LIVELY AS A BARNACLE SUFFERING WITH SLEEPING SICKNESS IN THE DEAD DEAD SEA." IN THE DECEMBER 8, 1926, ISSUE OF VARIETY, EDDIE CANTOR SAID HER EFFECT "WILTED THE COLLARS OF ALL THE MEN PRESENT."

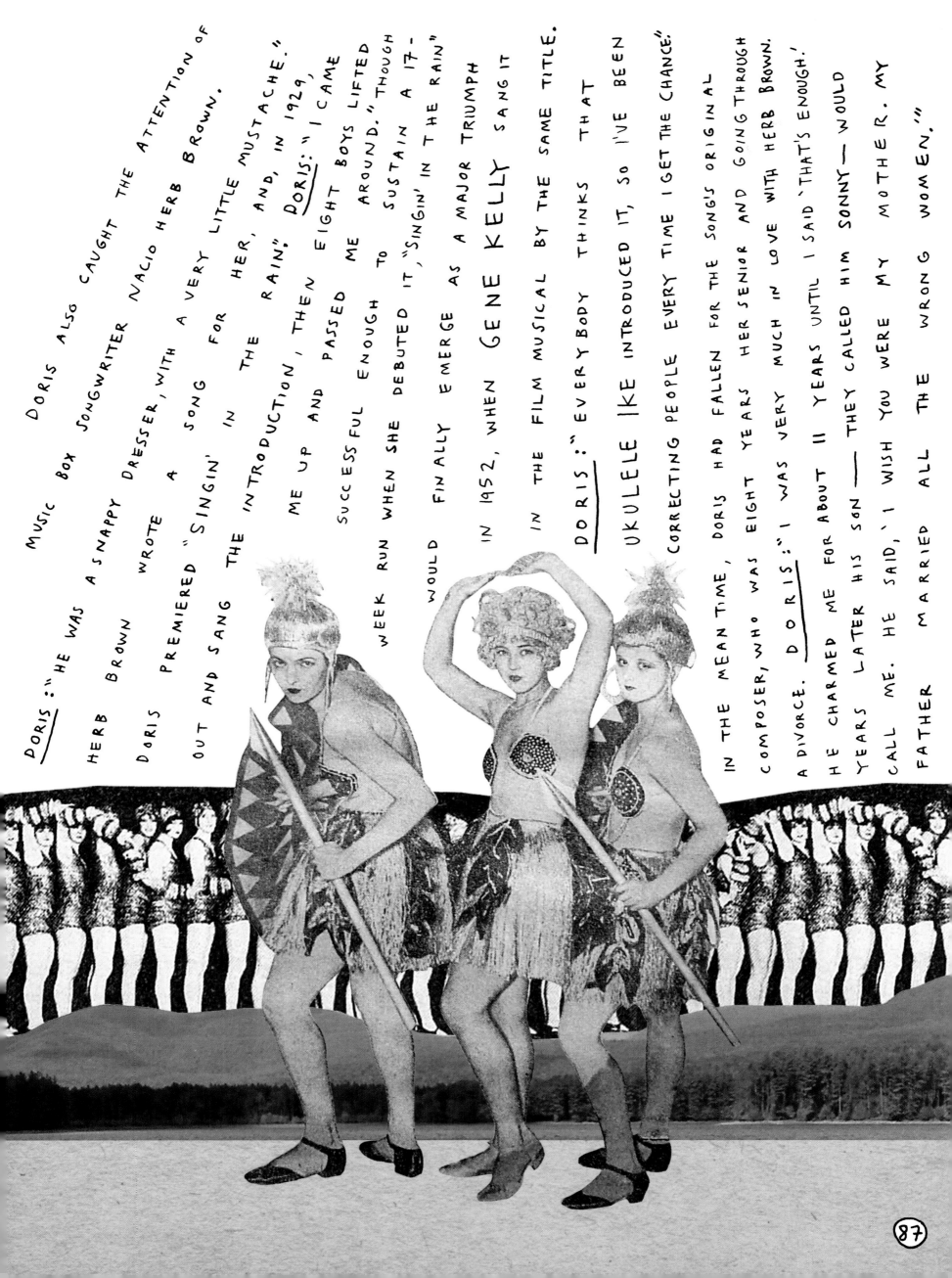

DORIS ALSO CAUGHT THE ATTENTION OF MUSIC BOX SONGWRITER NACIO HERB BROWN.

DORIS: "HE WAS A SNAPPY DRESSER, WITH A VERY LITTLE MUSTACHE." HERB BROWN WROTE A SONG FOR HER, AND, IN 1929, DORIS PREMIERED "SINGIN' IN THE RAIN." DORIS: "I CAME OUT AND SANG THE INTRODUCTION, THEN EIGHT BOYS LIFTED ME UP AND PASSED ME AROUND." THOUGH SUCCESSFUL ENOUGH TO SUSTAIN A 17-WEEK RUN WHEN SHE DEBUTED IT, "SINGIN' IN THE RAIN" WOULD FINALLY EMERGE AS A MAJOR TRIUMPH IN 1952, WHEN GENE KELLY SANG IT IN THE FILM MUSICAL BY THE SAME TITLE.

DORIS: "EVERYBODY THINKS THAT UKULELE IKE INTRODUCED IT, SO I'VE BEEN CORRECTING PEOPLE EVERY TIME I GET THE CHANCE."

IN THE MEANTIME, DORIS HAD FALLEN FOR THE SONG'S ORIGINAL COMPOSER, WHO WAS EIGHT YEARS HER SENIOR AND GOING THROUGH A DIVORCE. DORIS: "I WAS VERY MUCH IN LOVE WITH HERB BROWN. HE CHARMED ME FOR ABOUT 11 YEARS UNTIL I SAID 'THAT'S ENOUGH! YEARS LATER HIS SON — THEY CALLED HIM SONNY — WOULD CALL ME. HE SAID, 'I WISH YOU WERE MY MOTHER. MY FATHER MARRIED ALL THE WRONG WOMEN.'"

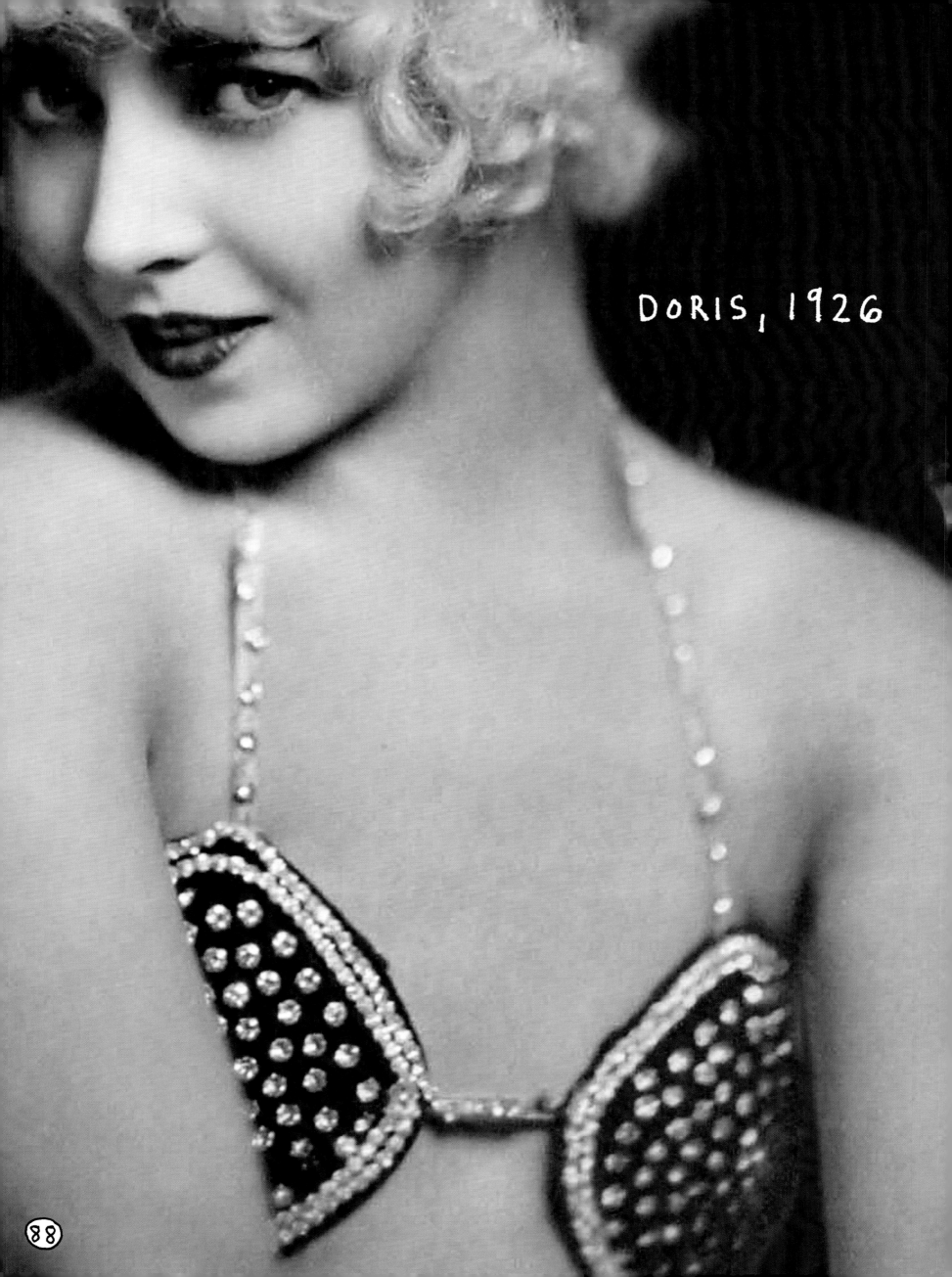

DORIS, 1926

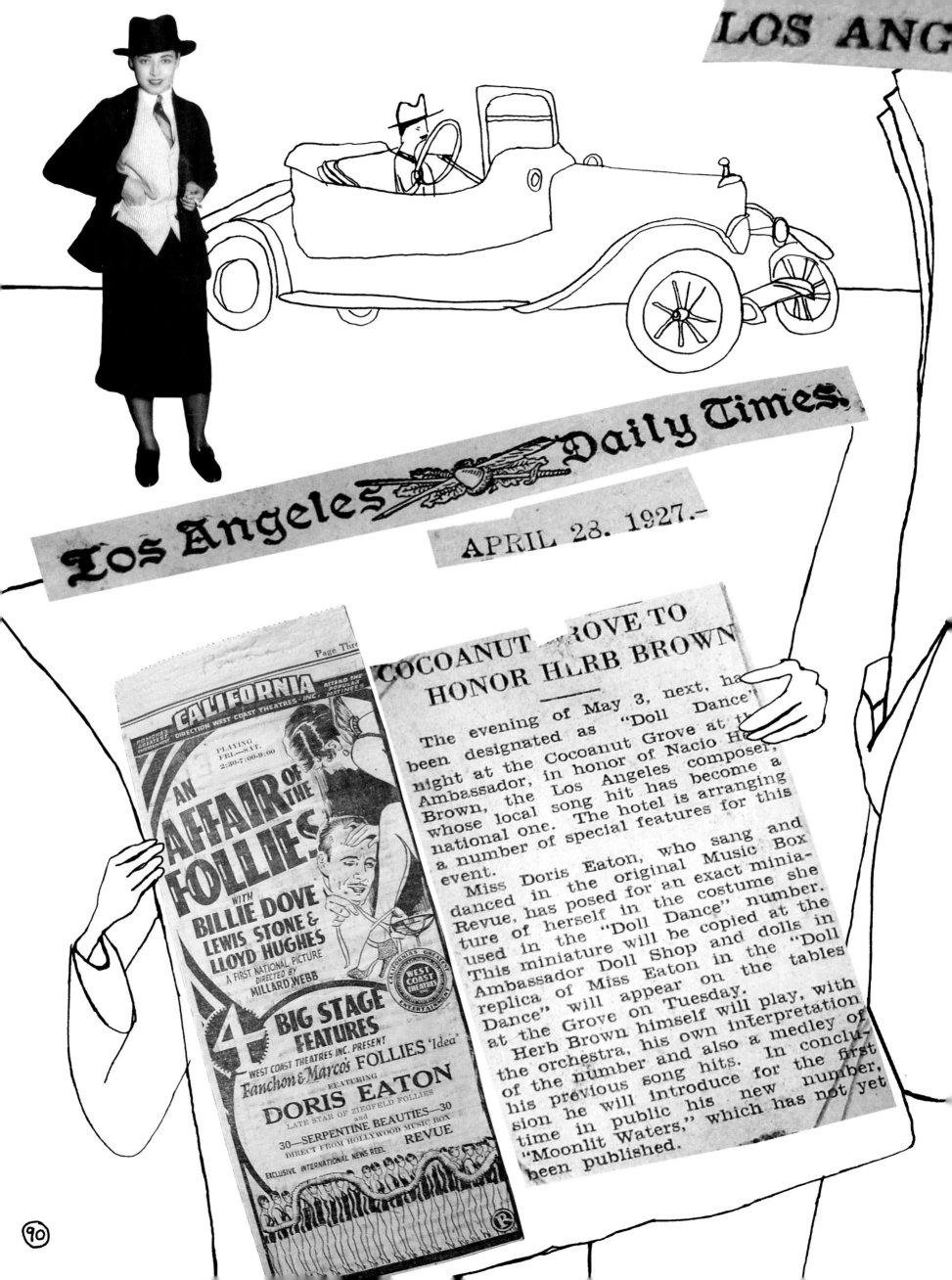

Los Angeles Daily Times.

APRIL 28, 1927.—

Page Three

CALIFORNIA
DIRECTION WEST COAST THEATRES INC.

RAMONA'S GREATEST ENTERTAINMENT
ATTEND THE POPULAR MATINEES

PLAYING
FRI.—SAT.
2:30-7:00-9:00

AN
AFFAIR OF THE
FOLLIES

WITH
BILLIE DOVE
LEWIS STONE &
LLOYD HUGHES
A FIRST NATIONAL PICTURE
DIRECTED BY
MILLARD WEBB

CALIFORNIA'S GREATEST MUSICAL ENTERTAINMENT
WEST COAST THEATRES INC.

4 BIG STAGE FEATURES

WEST COAST THEATRES INC. PRESENT
Fanchon & Marco's FOLLIES 'Idea'
FEATURING
DORIS EATON
LATE STAR OF ZIEGFELD FOLLIES
and
30—SERPENTINE BEAUTIES—30
DIRECT FROM HOLLYWOOD MUSIC BOX
REVUE
EXCLUSIVE INTERNATIONAL NEWS REEL

COCOANUT GROVE TO HONOR HERB BROWN

The evening of May 3, next, has been designated as "Doll Dance" night at the Cocoanut Grove at the Ambassador, in honor of Nacio Herb Brown, the Los Angeles composer, whose local song hit has become a national one. The hotel is arranging a number of special features for this event.

Miss Doris Eaton, who sang and danced in the original Music Box Revue, has posed for an exact miniature of herself in the costume she used in the "Doll Dance" number. This miniature will be copied at the Ambassador Doll Shop and dolls in replica of Miss Eaton in the "Doll Dance" will appear on the tables at the Grove on Tuesday.

Herb Brown himself will play, with the orchestra, his own interpretation of the number and also a medley of his previous song hits. In conclusion he will introduce for the first time in public his new number, "Moonlit Waters," which has not yet been published.

DORIS EATON HAS HER TOES INSURED FOR $10,000

Doris Eaton, late of the Music Box revue and, at present touring the West Coast circuit at the head of her 24 girls in the Fanchon and Marco "___ntine Idea," has taken out a ___m of insurance for dancers.

___ Eaton has followed the ex-___ of her sister, Mary Eaton, of ___eigfeld follies and "Sunny" has ___ch of her 10 toes insured for ___ a total of $10,000. Miss ___ues her tootsie wootsies at ___t since she makes a liv-___, and she is taking ___ces ___ accident of ___rt ___ mig__ ___revent he__ __om toe___ng.

91

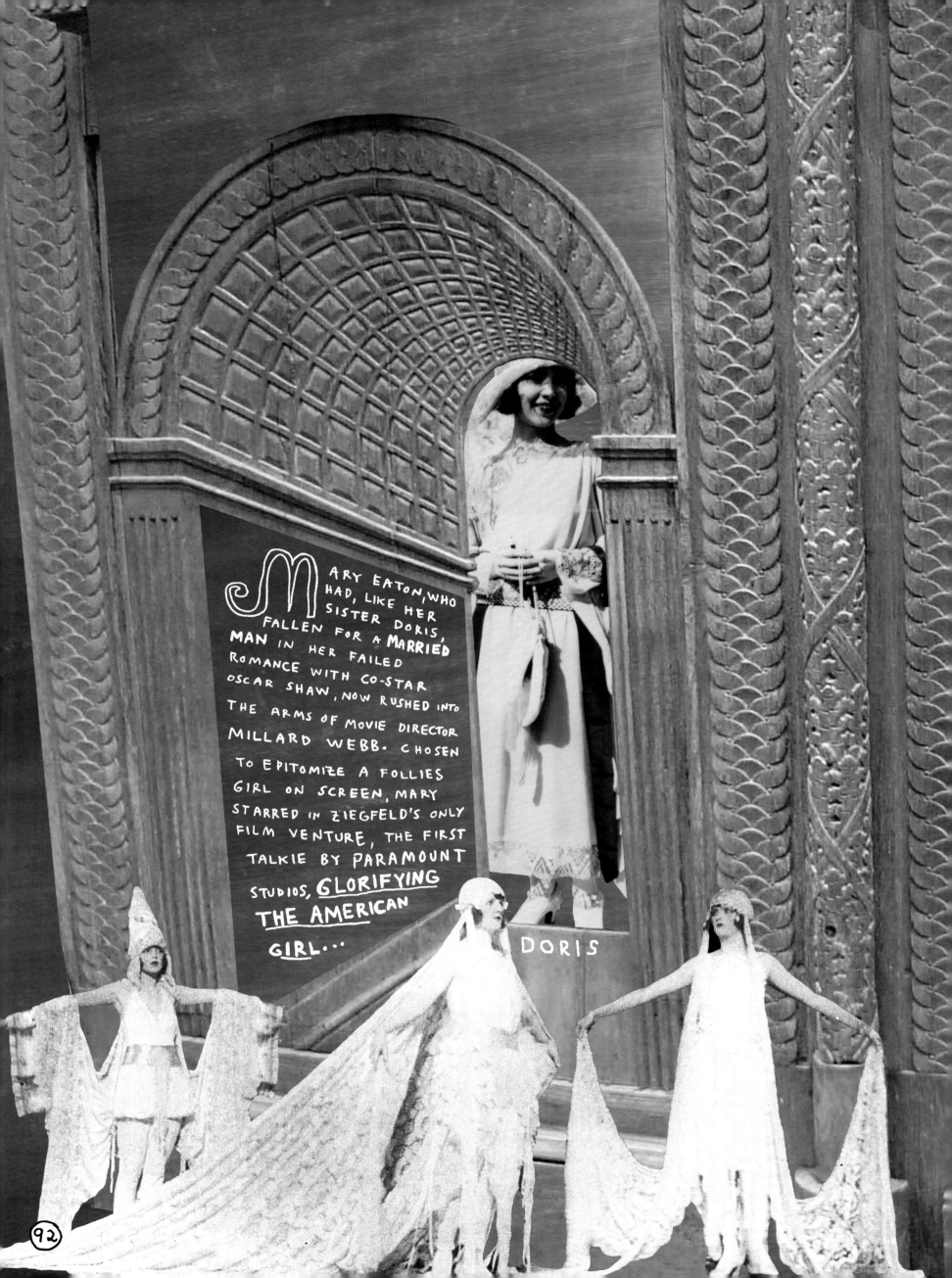

MARY EATON, WHO HAD, LIKE HER SISTER DORIS, FALLEN FOR A MARRIED MAN IN HER FAILED ROMANCE WITH CO-STAR OSCAR SHAW, NOW RUSHED INTO THE ARMS OF MOVIE DIRECTOR MILLARD WEBB. CHOSEN TO EPITOMIZE A FOLLIES GIRL ON SCREEN, MARY STARRED IN ZIEGFELD'S ONLY FILM VENTURE, THE FIRST TALKIE BY PARAMOUNT STUDIOS, _GLORIFYING THE AMERICAN GIRL_...

DORIS

MARY

... WEBB DIRECTED. AFTER A BRIEF COURTSHIP, THE TWO MARRIED IN GRAND FASHION IN HOLLYWOOD. NEWSPAPERS COAST TO COAST CARRIED THE STORY.

THE DETROIT NEWS BLARED:

"THEY MOB THE CHURCH TO SEE BEAUTIFUL MARY EATON WED" AND RELAYED ACCOUNTS OF SPECTATORS FAINTING FROM THE HEAT AND THE EXCITEMENT. DORIS WAS A BRIDESMAID. BUSTER KEATON, JOHN BARRYMORE AND HELEN HAYES WERE AMONG THE GUESTS.

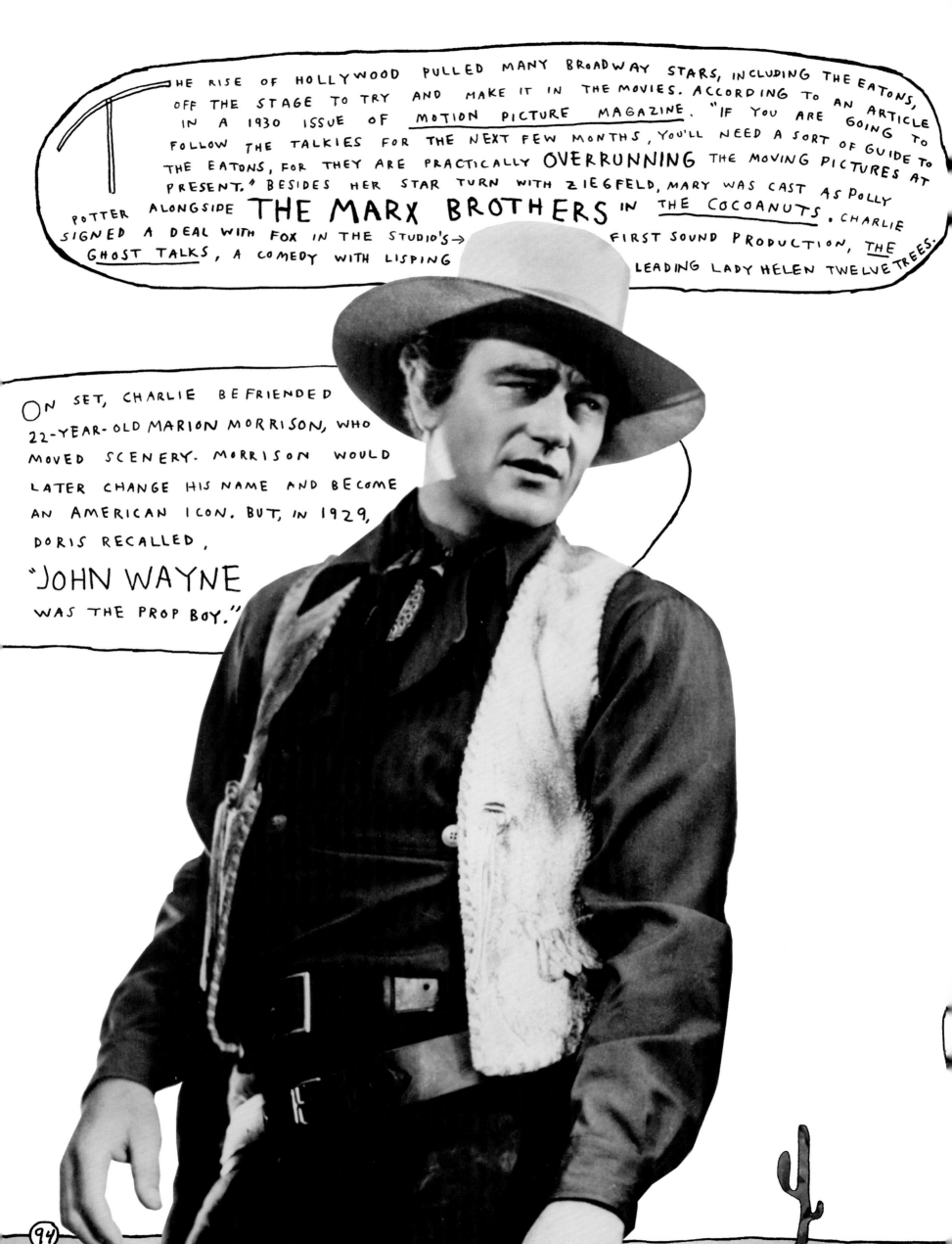

THE RISE OF HOLLYWOOD PULLED MANY BROADWAY STARS, INCLUDING THE EATONS, OFF THE STAGE TO TRY AND MAKE IT IN THE MOVIES. ACCORDING TO AN ARTICLE IN A 1930 ISSUE OF <u>MOTION PICTURE MAGAZINE</u>, "IF YOU ARE GOING TO FOLLOW THE TALKIES FOR THE NEXT FEW MONTHS, YOU'LL NEED A SORT OF GUIDE TO THE EATONS, FOR THEY ARE PRACTICALLY **OVERRUNNING** THE MOVING PICTURES AT PRESENT." BESIDES HER STAR TURN WITH ZIEGFELD, MARY WAS CAST AS POLLY POTTER ALONGSIDE **THE MARX BROTHERS** IN <u>THE COCOANUTS</u>. CHARLIE SIGNED A DEAL WITH FOX IN THE STUDIO'S→ FIRST SOUND PRODUCTION, <u>THE GHOST TALKS</u>, A COMEDY WITH LISPING LEADING LADY HELEN TWELVETREES.

ON SET, CHARLIE BEFRIENDED 22-YEAR-OLD MARION MORRISON, WHO MOVED SCENERY. MORRISON WOULD LATER CHANGE HIS NAME AND BECOME AN AMERICAN ICON. BUT, IN 1929, DORIS RECALLED,

"JOHN WAYNE WAS THE PROP BOY."

DORIS'S SISTER PEARL PARLAYED HER CREDENTIALS AS THE FIRST WOMAN STAGE MANAGER ON BROADWAY INTO A POSITION AS DANCE DIRECTOR AT RKO, STAGING THE STUDIO'S EARLIEST SOUND FILMS, INCLUDING TANNED LEGS, MEN OF THE NIGHT, AND LEATHERNECKING. RKO AWARDED DORIS PARTS IN STREET GIRL AND THE VERY IDEA.

Can Tell a Girl's Nationalit

M. Dekobra, of Paris, Distinguishel Writer and Explorer, Classifies the Characteristic Caress of CivilizedWomen After Patient Experiments With Thousands o Lovely Living Lips

"THE VERY IDEA INTRODUCES TO THE SCREEN EUGENIC IDEAS, BASED ON THE ANGLE OF HUMAN THOROUGHBREDS, FOR THE FIRST TIME, IN A CLEVER AND HILARIOUS MANNER. A WEALTHY YOUNG COUPLE IS PERSUADED BY AN ARDENT EXPONENT OF EUGENICS TO PAY $1,500 FOR A CHILD, WHICH IS TO BE THE OFFSPRING OF TWO PERFECT SPECIMENS BY HIM," WROTE THE ATLANTA CONSTITUTION. DORIS PLAYED THE WIFE, EDITH GOODHUE. THE FILM, IF NOT OSCAR-CALIBER, SEEMED AT LEAST AN INNOCUOUS ROMP. AS A LOOK AT GENETIC ENGINEERING, THE MOVIE MAY HAVE BEEN AHEAD OF ITS TIME, BUT THE THEME OF SELECTIVE BREEDING COINCIDED WITH A MORE OMINOUS MOVEMENT TOWARDS RACIAL PURITY RISING IN EUROPE.

Miss Doris Eaton, of the Talented Theatrical Family, Whose Lips Have Been Identified by Artists as the Perfect Cupid's Bow, and, Therefore, the Characteristic American Type.

SPANISH. Extreme Mobility of Anterior Surface. The Kiss Is Violent, Mad, Tyrannical, With a Mordant Tendency.

ITALIAN. The Design of the Lips Conforms to the Canons of Classical Beauty. The Kiss Has the Rare Peculiarity of Being by Turns Quivering, Vibratory and Impetuous.

AMERICAN. The Lips Form an Alluring Crushed Ellipse. The Kiss, Jerky in Style, Is Characterized by Alternative Applications of the Lips, Which Advance and Recede.

IN THIS AMERICAN WEEKLY SPREAD ON KISSING AND ETHNICITY, DORIS HERSELF WAS SINGLED OUT AS AN IDEAL AMERICAN SPECIMEN.

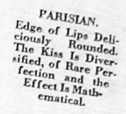

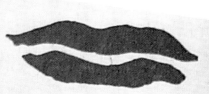

GERMAN.

Lips Agreeable, Velvety and Mobile. The Characteristic of the Kiss Is Warmth, With a Motion in Perfect Rhythm to a Metronome Set at 80.

VIENNESE.

Upper Lip Almost Similar to Lower. The Kiss Is Gentle, With a Tendency to Touch Lightly Without Excessive Pressure.

ENGLISH.

Mouth Has the Shape of Three Plump Cotyledons. The Kiss Is Nonchalant in Appearance, But Subtle in Its Abandon.

PARISIAN.

Edge of Lips Deliciously Rounded. The Kiss Is Diversified, of Rare Perfection and the Effect Is Mathematical.

SLAV.

The Orbicular Muscle Gives an Air of Melancholy. The Kiss Is Elusive, With Cleverly Calculated Languor, and May Lead to Crime or Repetition.

HUNGARIAN.

The Nasolabial Line Gives Lightly Ironical Expression. The Kiss Is Spontaneous and Masterful.

—And Under Each Imprint His Condensed Description of the Lips and the Quality of the Kiss.

Such kisses as belong to early days,
 Where heart, and soul, and sense, in concert move,
And the blood's lava, and the pulse ablaze,
Each kiss a heart-quake—for a kiss's strength,
I think, it must be reckon'd by its length."

An excellent prose definition of a kiss is given by the scholarly English writer and traveler, Haliburton:

"Kissing is as old as the creation, and yet young and fresh as ever. Depend upon it, Eve learned it in Paradise and was taught its beauties, virtues, and varieties by an angel, there is something so transcendent in it."

However, the early American writer, Bovee, has left a definition which is hard to surpass:

"Four sweet lips, two pure souls, and one undying affection—these are love's pretty ingredients for a kiss."

It will be noted, of course, that Mr. Dekobra's conception of the kiss is more advanced, complicated and sophisticated than the simple early American's.

The artistic value of such studies of the kiss as that undertaken by the self-sacrificing Mr. Dekobra is widely recognized.

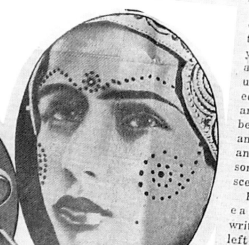

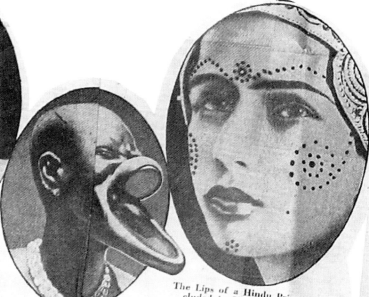

...fect Chinese Lips—the Essential ...teristics of These M. Dekobra ...Still to Study and Describe.

The Lips of a Hindu Princess, Not Included in M. Dekobra's Category.

BRAZILIAN.

The Mentolabial Furrow ...s Very Marked. The Kiss ... Progressive, With ...ressure at 45 Degrees ...e Nasal Axis of the Fac... of the Partner.

M. Maurice Dekobra and, Above Him, One of ...e Duck-Billed Women of Ubars, Whose Kiss Anybody Would Ctainly Be Likely to Recognize inhe Dark Without Previous Exrimentation.

SCANDINAVIAN.

Upper Lip Thin, Lower Lip Extremely Soft. The Kiss Is Not Masterful, But Insinuating, Longitudinal and, in Certain Instances, Helical.

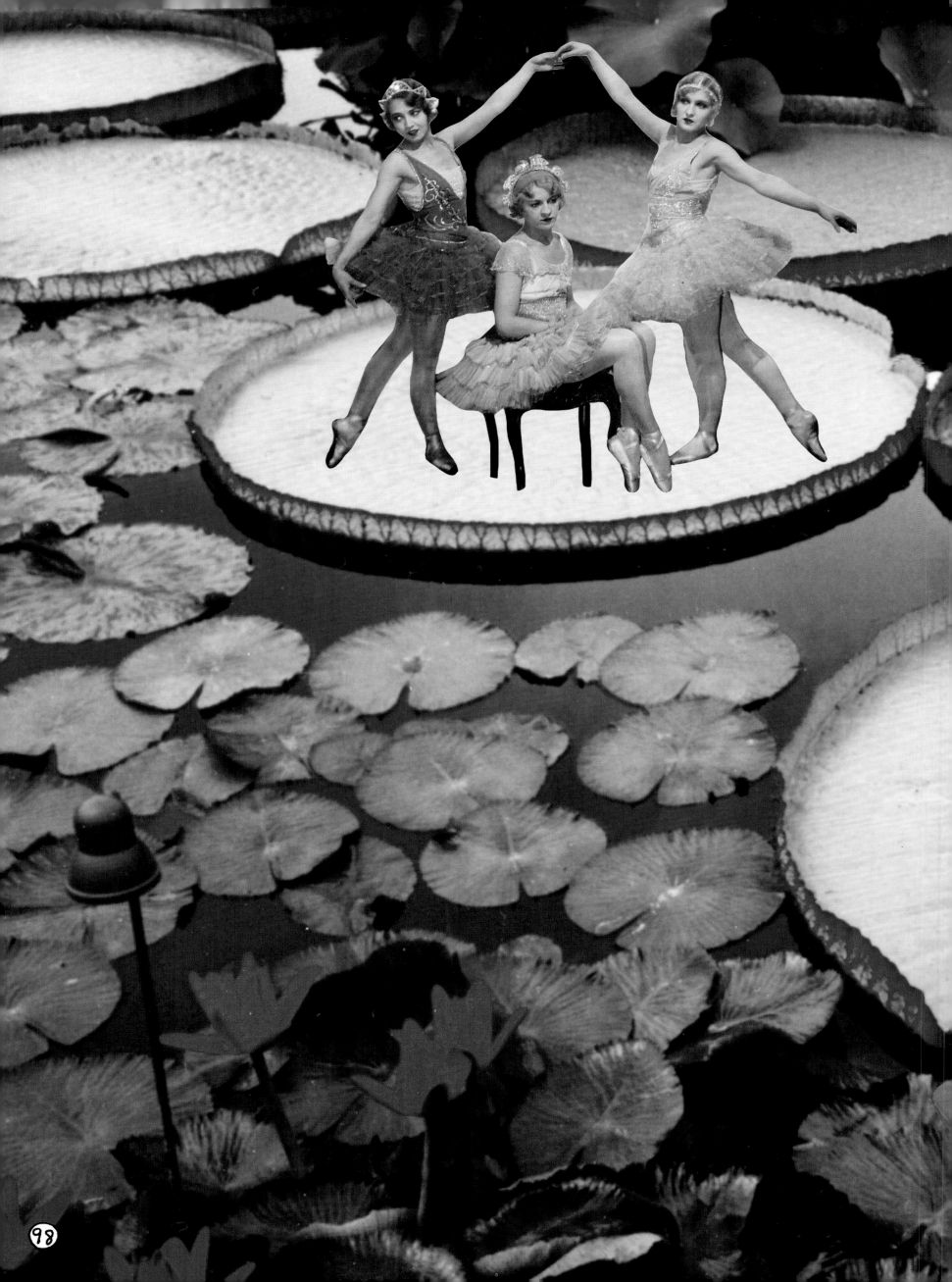

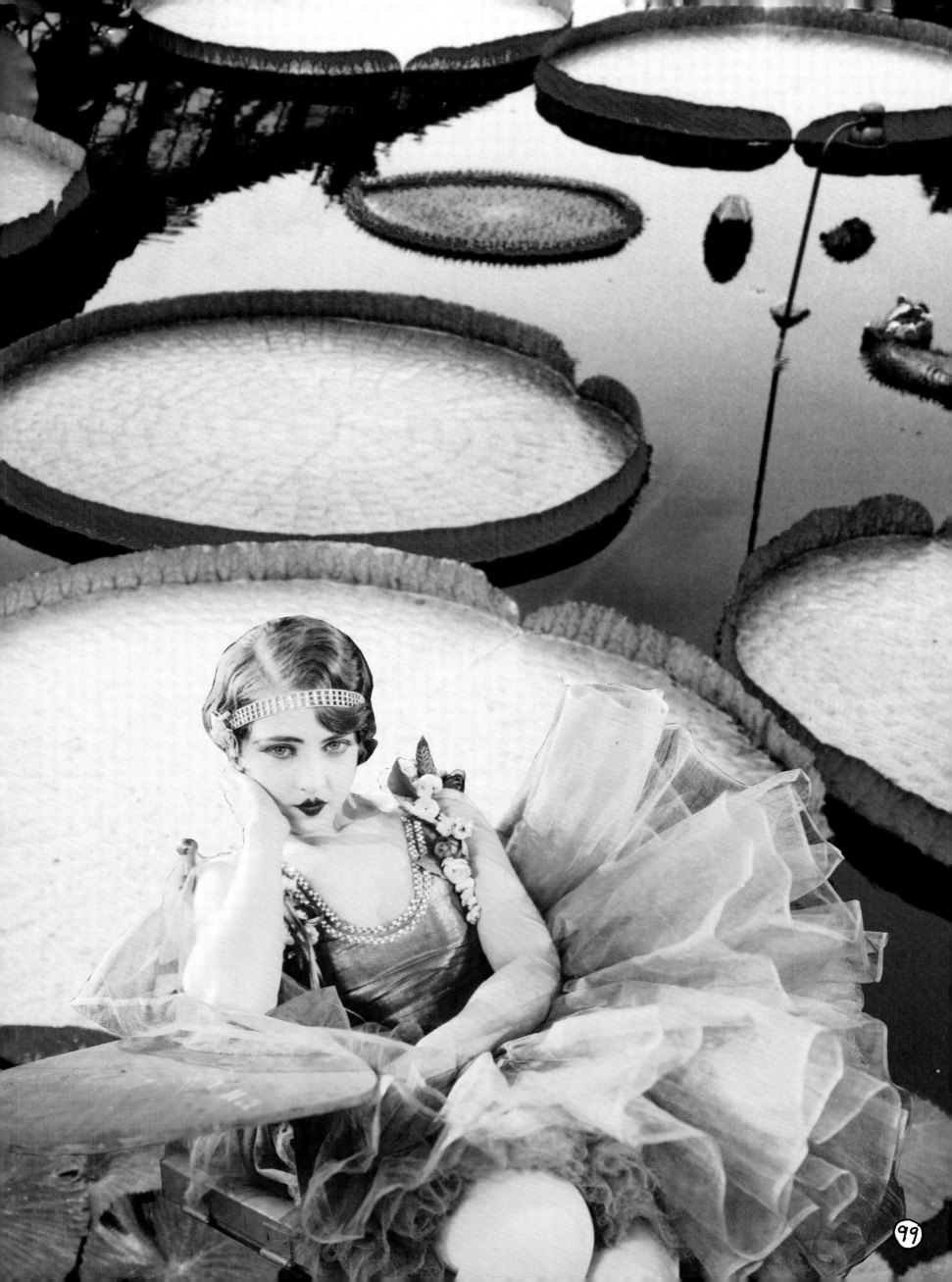

With strength in numbers and a solid pedigree, the Eatons seemed unstoppable.

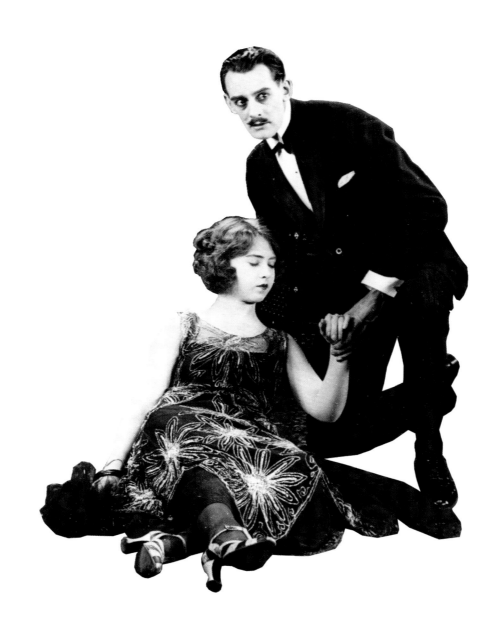

BUT TIMES CHANGED.

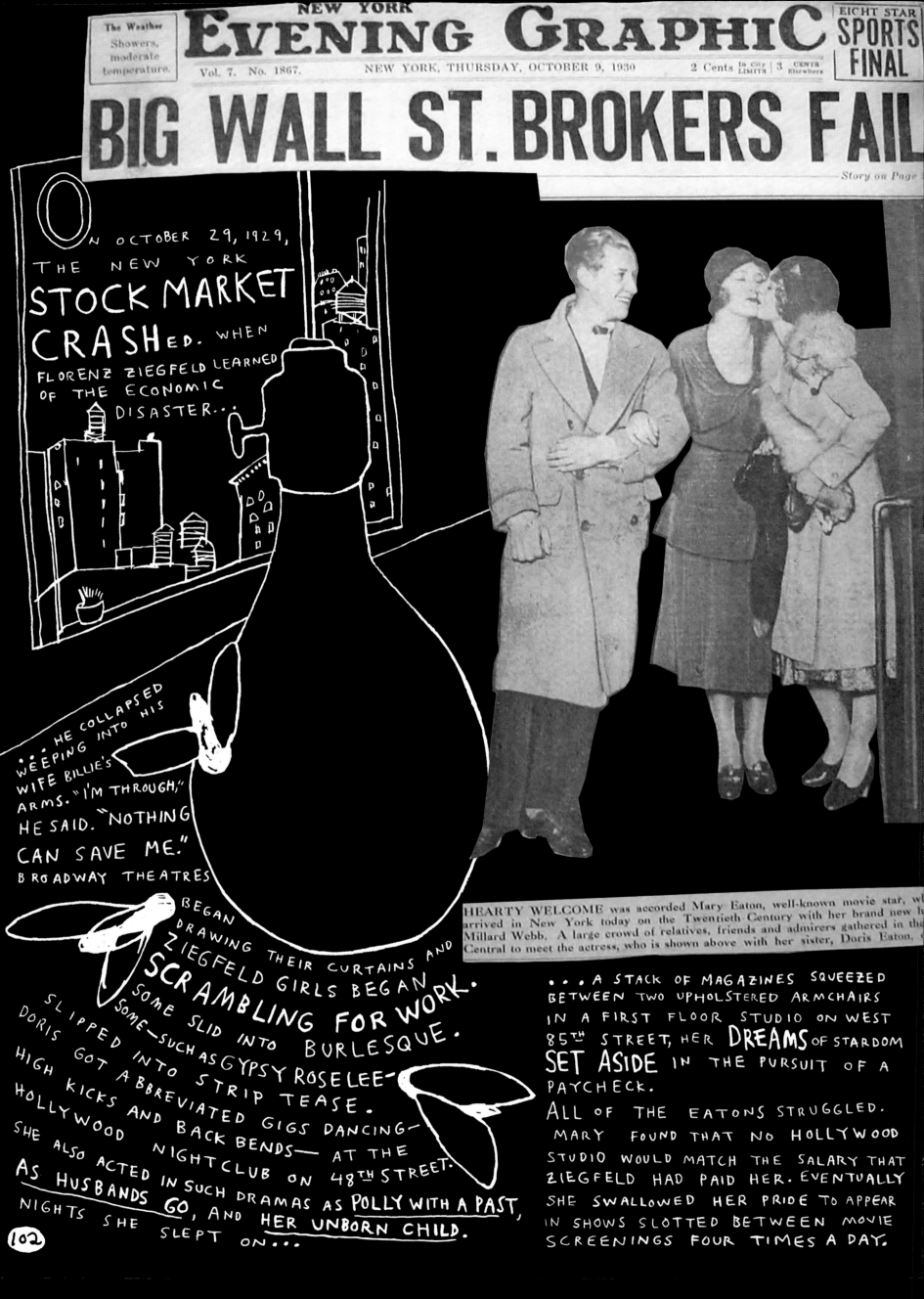

NEW YORK
EVENING GRAPHIC
EIGHT STAR
SPORTS
FINAL
The Weather
Showers,
moderate
temperature.
Vol. 7. No. 1867. NEW YORK, THURSDAY, OCTOBER 9, 1930 2 Cents In City Limits | 3 Cents Elsewhere

BIG WALL ST. BROKERS FAIL

Story on Page

ON OCTOBER 29, 1929, THE NEW YORK STOCK MARKET CRASHed. WHEN FLORENZ ZIEGFELD LEARNED OF THE ECONOMIC DISASTER...

...HE COLLAPSED WEEPING INTO HIS WIFE BILLIE'S ARMS. "I'M THROUGH," HE SAID. "NOTHING CAN SAVE ME." BROADWAY THEATRES BEGAN DRAWING THEIR CURTAINS AND ZIEGFELD GIRLS BEGAN SCRAMBLING FOR WORK. SOME SLID INTO BURLESQUE. SOME—SUCH AS GYPSY ROSE LEE—SLIPPED INTO STRIP TEASE.

DORIS GOT ABBREVIATED GIGS DANCING—HIGH KICKS AND BACK BENDS— AT THE HOLLYWOOD NIGHTCLUB ON 48TH STREET. SHE ALSO ACTED IN SUCH DRAMAS AS POLLY WITH A PAST, AS HUSBANDS GO, AND HER UNBORN CHILD. NIGHTS SHE SLEPT ON...

HEARTY WELCOME was accorded Mary Eaton, well-known movie star, wh arrived in New York today on the Twentieth Century with her brand new h Millard Webb. A large crowd of relatives, friends and admirers gathered in th Central to meet the actress, who is shown above with her sister, Doris Eaton,

...A STACK OF MAGAZINES SQUEEZED BETWEEN TWO UPHOLSTERED ARMCHAIRS IN A FIRST FLOOR STUDIO ON WEST 85TH STREET, HER DREAMS OF STARDOM SET ASIDE IN THE PURSUIT OF A PAYCHECK. ALL OF THE EATONS STRUGGLED. MARY FOUND THAT NO HOLLYWOOD STUDIO WOULD MATCH THE SALARY THAT ZIEGFELD HAD PAID HER. EVENTUALLY SHE SWALLOWED HER PRIDE TO APPEAR IN SHOWS SLOTTED BETWEEN MOVIE SCREENINGS FOUR TIMES A DAY.

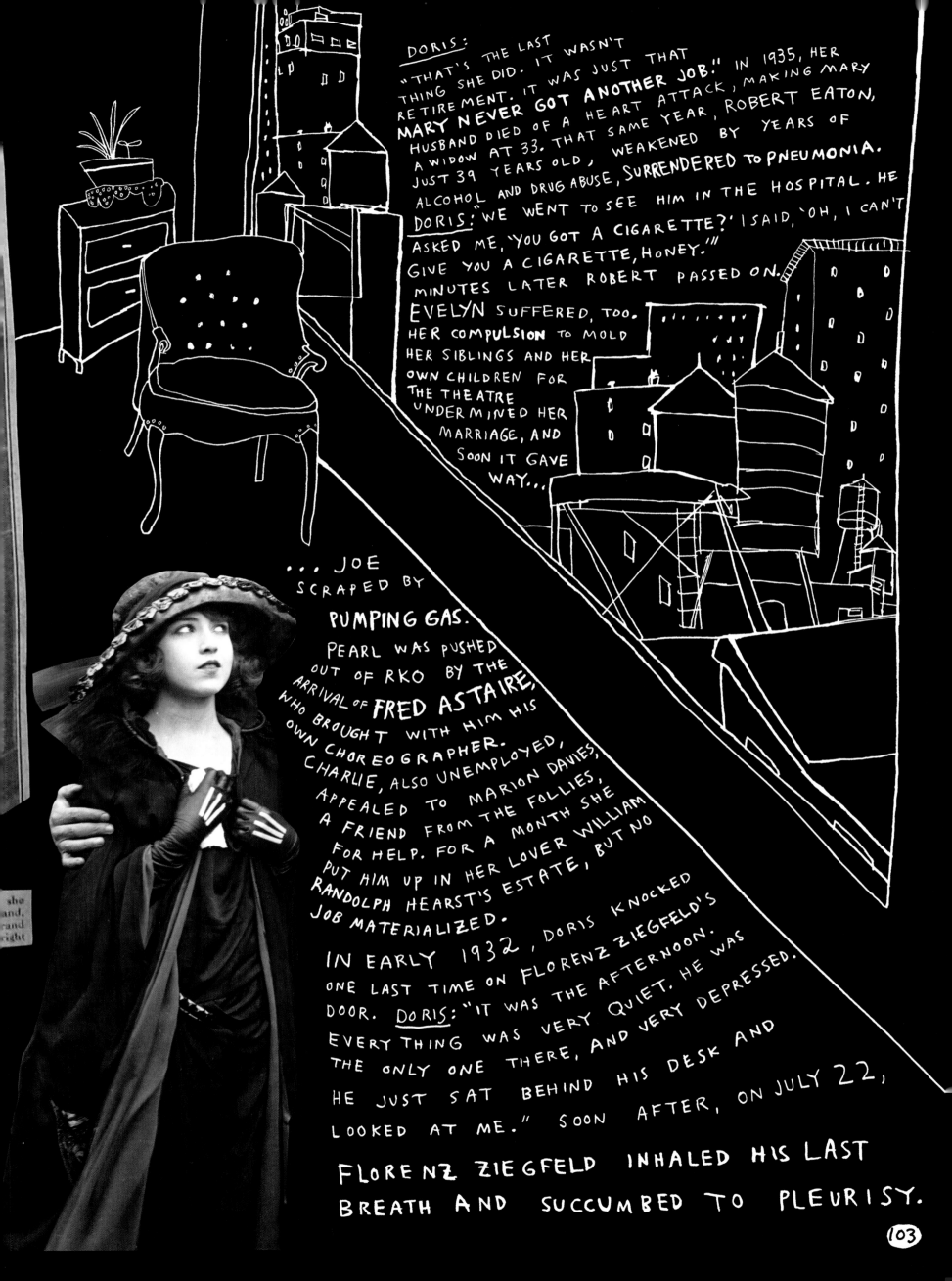

DORIS:
"THAT'S THE LAST THING SHE DID. IT WASN'T RETIREMENT. IT WAS JUST THAT **MARY NEVER GOT ANOTHER JOB."** IN 1935, HER HUSBAND DIED OF A HEART ATTACK, MAKING MARY A WIDOW AT 33. THAT SAME YEAR, ROBERT EATON, JUST 39 YEARS OLD, WEAKENED BY YEARS OF ALCOHOL AND DRUG ABUSE, SURRENDERED TO PNEUMONIA.

DORIS: "WE WENT TO SEE HIM IN THE HOSPITAL. HE ASKED ME, 'YOU GOT A CIGARETTE?' I SAID, 'OH, I CAN'T GIVE YOU A CIGARETTE, HONEY.'" MINUTES LATER ROBERT PASSED ON.

EVELYN SUFFERED, TOO. HER COMPULSION TO MOLD HER SIBLINGS AND HER OWN CHILDREN FOR THE THEATRE UNDERMINED HER MARRIAGE, AND SOON IT GAVE WAY...

... JOE SCRAPED BY PUMPING GAS.

PEARL WAS PUSHED OUT OF RKO BY THE ARRIVAL OF **FRED ASTAIRE,** WHO BROUGHT WITH HIM HIS OWN CHOREOGRAPHER. CHARLIE, ALSO UNEMPLOYED, APPEALED TO MARION DAVIES, A FRIEND FROM THE FOLLIES, FOR HELP. FOR A MONTH SHE PUT HIM UP IN HER LOVER WILLIAM RANDOLPH HEARST'S ESTATE, BUT NO JOB MATERIALIZED.

IN EARLY 1932, DORIS KNOCKED ONE LAST TIME ON FLORENZ ZIEGFELD'S DOOR. DORIS: "IT WAS THE AFTERNOON. EVERYTHING WAS VERY QUIET. HE WAS THE ONLY ONE THERE, AND VERY DEPRESSED. HE JUST SAT BEHIND HIS DESK AND LOOKED AT ME." SOON AFTER, ON JULY 22, FLORENZ ZIEGFELD INHALED HIS LAST BREATH AND SUCCUMBED TO PLEURISY.

THE SHUBERTS BOUGHT THE NAME AND, WITH BILLIE BURKE PAYING OFF HER LATE HUSBAND'S VOLUMINOUS DEBTS, CONTINUED PRODUCING A SHOW CALLED THE ZIEGFELD FOLLIES. ZIEGFELDIAN IN NAME ONLY, COSTS WERE SLASHED, AND THE SHOWS WERE A MERE SHADOW OF THE ORIGINAL. NEVERTHELESS, THE NAME STILL HAD CLOUT AND WORK WAS HARD TO COME BY.

"IN 25 YEARS OF HANDLING SUCH CALLS [THE JUDGES OF THE 1936 FOLLIES AUDITION] HAD NEVER SEEN SO GREAT OR SO VARIED A MASS OF FEMININITY IN SEARCH OF EMPLOYMENT," REPORTED THE WASHINGTON POST. "GIRLS WERE ELIMINATED AT A RATE OF 150 PER HOUR."

DORIS: "YOU COULDN'T GET A JOB. INSTEAD OF HAVING 50 SHOWS ON BROADWAY, THERE WERE FIVE OR SIX. THERE WAS JUST NO PLACE TO GO. IT FINALLY DAWNED ON ME—I DIDN'T WANT SOMEONE TELLING ME YOU CAN WORK THREE DAYS HERE AND THEN STAY OFF FOR SIX MONTHS. I WAS GOING TO GO TO A DANCE HALL AND GET A JOB THAT GAVE ME SOME INCOME. I DIDN'T CARE WHAT IT WAS."

BY THE WINTER OF 1936, HUNGRY AND BEHIND ON RENT, A DESPAIRING DORIS WAS ABOUT TO PICK UP THE TELEPHONE TO ANSWER A NEWSPAPER AD SEEKING

TAXI DANCERS.

TAXI DANCING "IS THE HARDEST KIND OF LABOR IMAGINABLE," WROTE THE <u>LOS ANGELES TIMES</u>

"TEN CENTS A DANCE. GET YOUR TICKET AT THE CASHIER. SELECT YOUR LADY, AND ENJOY 60 SECONDS OF SALTATORY EXERCISE... THE HALL IS HOT AND SMELLY, AND SO ARE MANY OF THE PARTNERS THEY MUST DANCE WITH: THEY MUST STAY MOVING ON THEIR FEET FOR FIVE HOURS, DURING WHICH TIME THEY ARE MAULED, SHOVED AROUND, TRAMPLED ON BY AN INFINITE VARIETY OF INEXPERT FOX-TROTTERS."

FAULTY FOOT WORK WAS THE LEAST OF TAXI DANCING'S HAZARDS. THE PROFESSION WITNESSED MURDER, SUICIDE, AND, IN THE CASE OF AN 18-YEAR-OLD DANCER NAMED MARIE LAMBERT, THE ABETTING OF A PRISON BREAK. ACCORDING TO POLICE, "THE GIRL 'KNEW TOO MUCH.'"

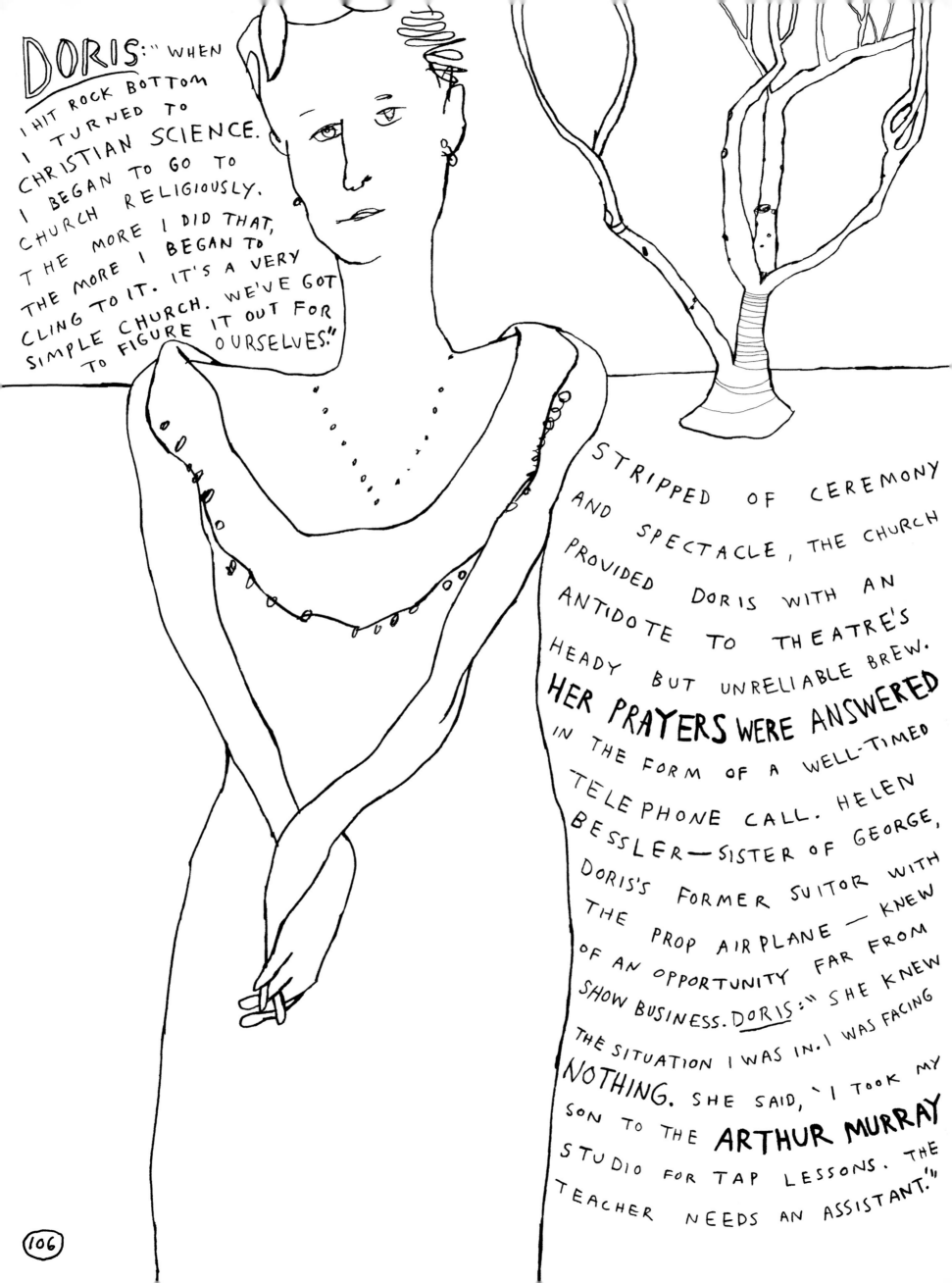

DORIS: "WHEN I HIT ROCK BOTTOM I TURNED TO CHRISTIAN SCIENCE. I BEGAN TO GO TO CHURCH RELIGIOUSLY. THE MORE I DID THAT, THE MORE I BEGAN TO CLING TO IT. IT'S A VERY SIMPLE CHURCH. WE'VE GOT TO FIGURE IT OUT FOR OURSELVES."

STRIPPED OF CEREMONY AND SPECTACLE, THE CHURCH PROVIDED DORIS WITH AN ANTIDOTE TO THEATRE'S HEADY BUT UNRELIABLE BREW. HER PRAYERS WERE ANSWERED IN THE FORM OF A WELL-TIMED TELEPHONE CALL. HELEN BESSLER—SISTER OF GEORGE, DORIS'S FORMER SUITOR WITH THE PROP AIRPLANE — KNEW OF AN OPPORTUNITY FAR FROM SHOW BUSINESS. DORIS: "SHE KNEW THE SITUATION I WAS IN. I WAS FACING NOTHING. SHE SAID, `I TOOK MY SON TO THE ARTHUR MURRAY STUDIO FOR TAP LESSONS. THE TEACHER NEEDS AN ASSISTANT.'"

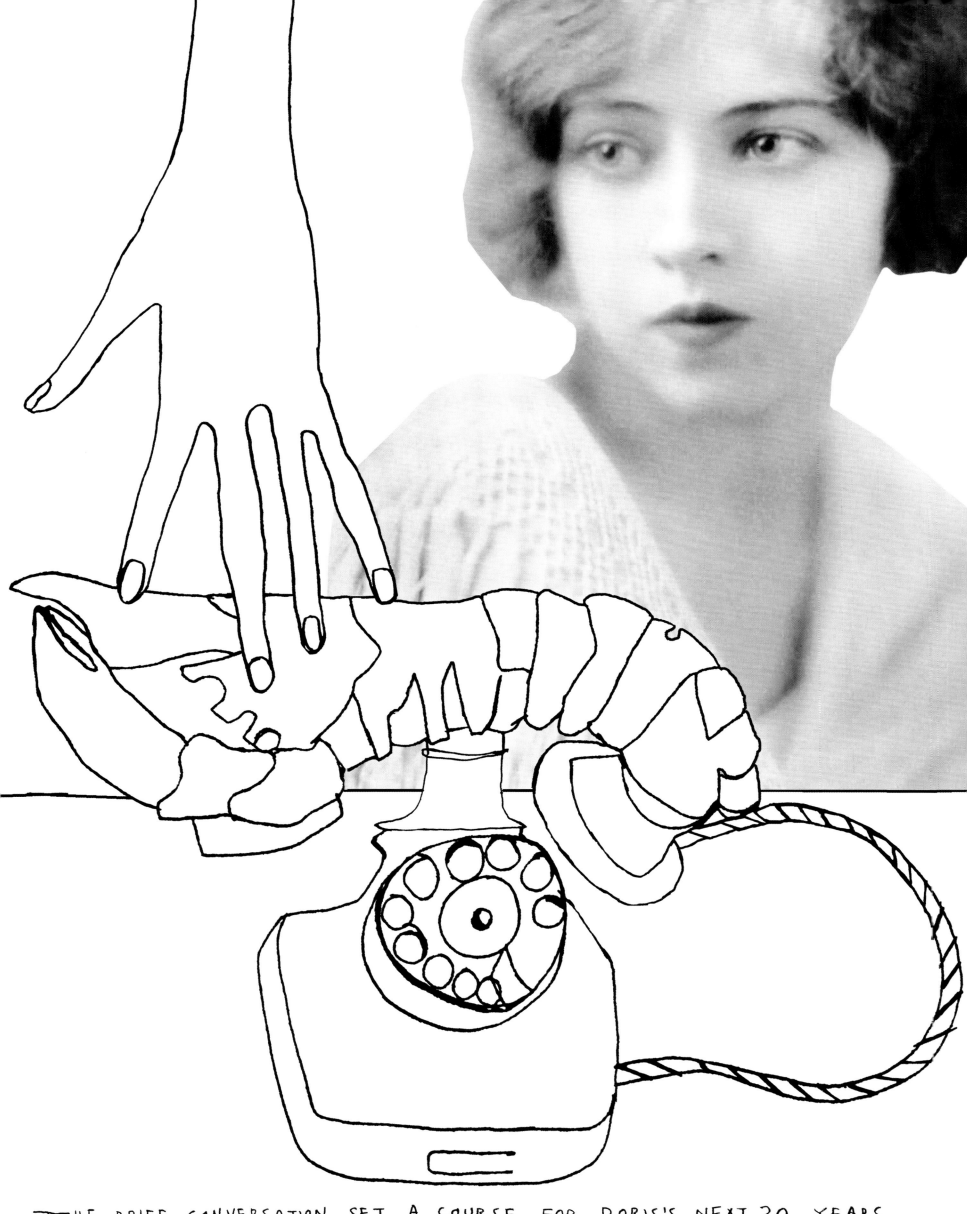

THE BRIEF CONVERSATION SET A COURSE FOR DORIS'S NEXT 30 YEARS.

ALSO IN 1936, SALVADOR DALI DESIGNED HIS "LOBSTER TELEPHONE."

(107)

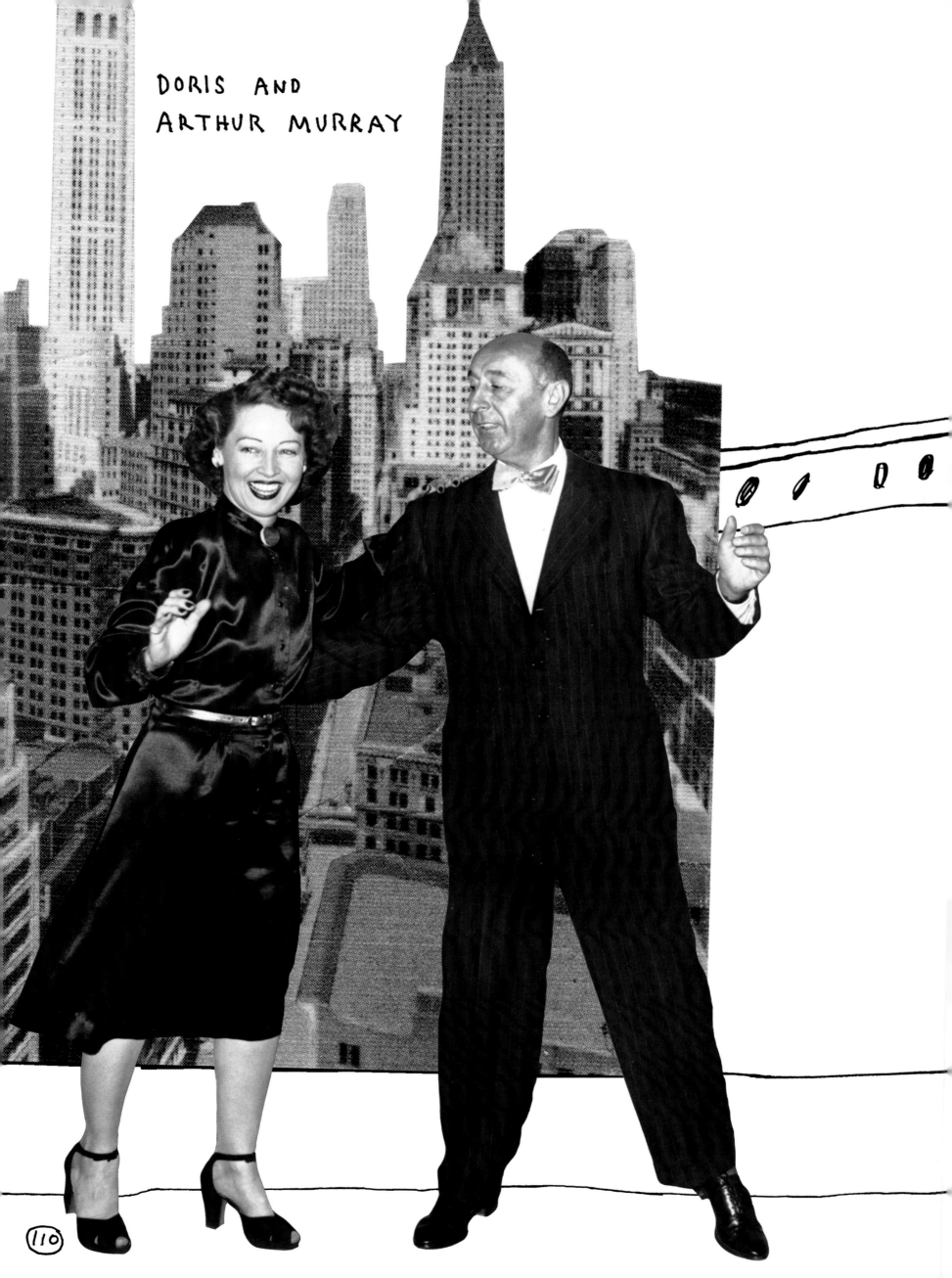

DORIS AND
ARTHUR MURRAY

(110)

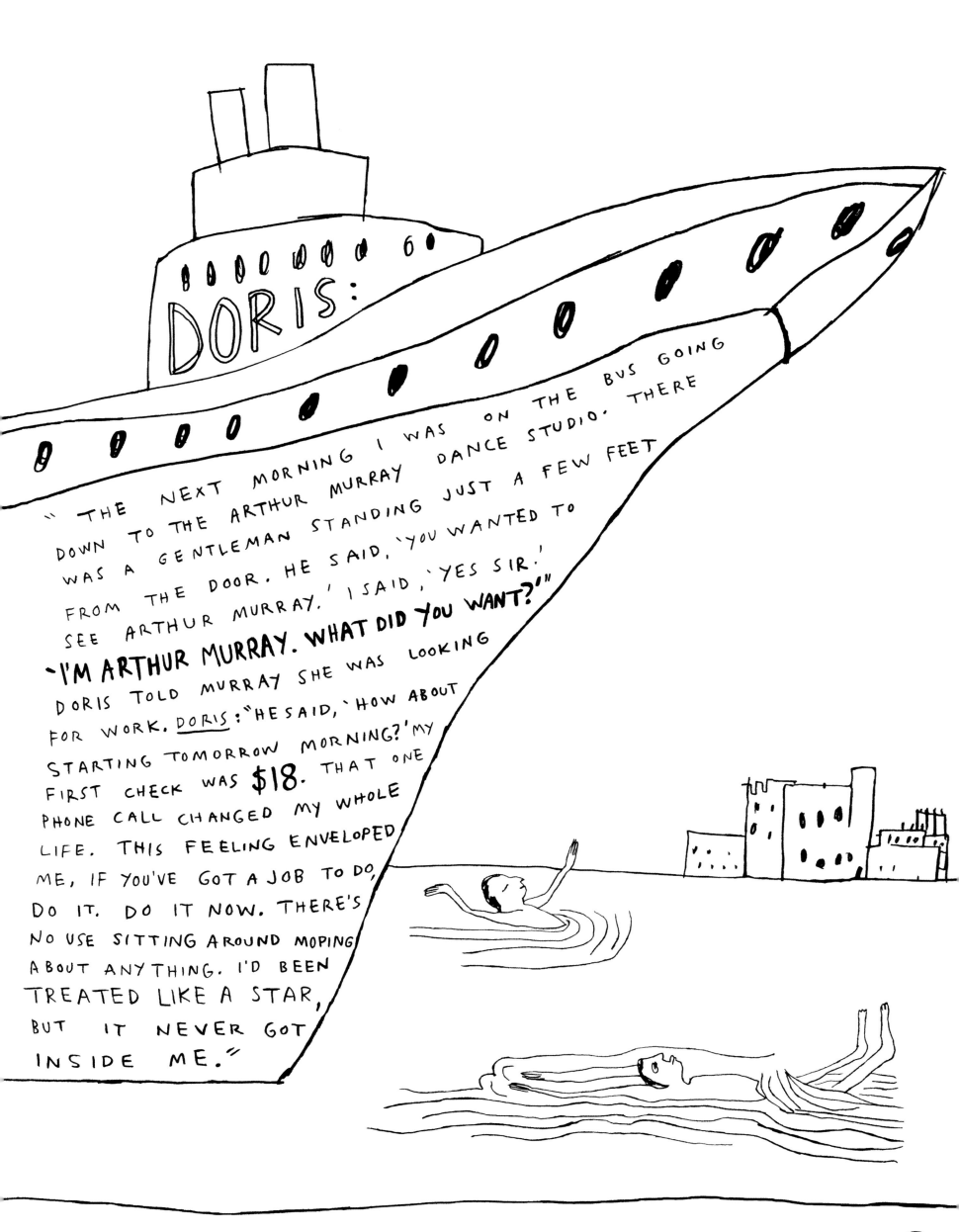

DORIS:

" THE NEXT MORNING I WAS ON THE BUS GOING DOWN TO THE ARTHUR MURRAY DANCE STUDIO. THERE WAS A GENTLEMAN STANDING JUST A FEW FEET FROM THE DOOR. HE SAID, 'YOU WANTED TO SEE ARTHUR MURRAY.' I SAID, 'YES SIR.'

~ I'M ARTHUR MURRAY. WHAT DID YOU WANT?'"

DORIS TOLD MURRAY SHE WAS LOOKING FOR WORK. DORIS: "HE SAID, 'HOW ABOUT STARTING TOMORROW MORNING?' MY FIRST CHECK WAS $18. THAT ONE PHONE CALL CHANGED MY WHOLE LIFE. THIS FEELING ENVELOPED ME, IF YOU'VE GOT A JOB TO DO, DO IT. DO IT NOW. THERE'S NO USE SITTING AROUND MOPING ABOUT ANYTHING. I'D BEEN TREATED LIKE A STAR, BUT IT NEVER GOT INSIDE ME."

111

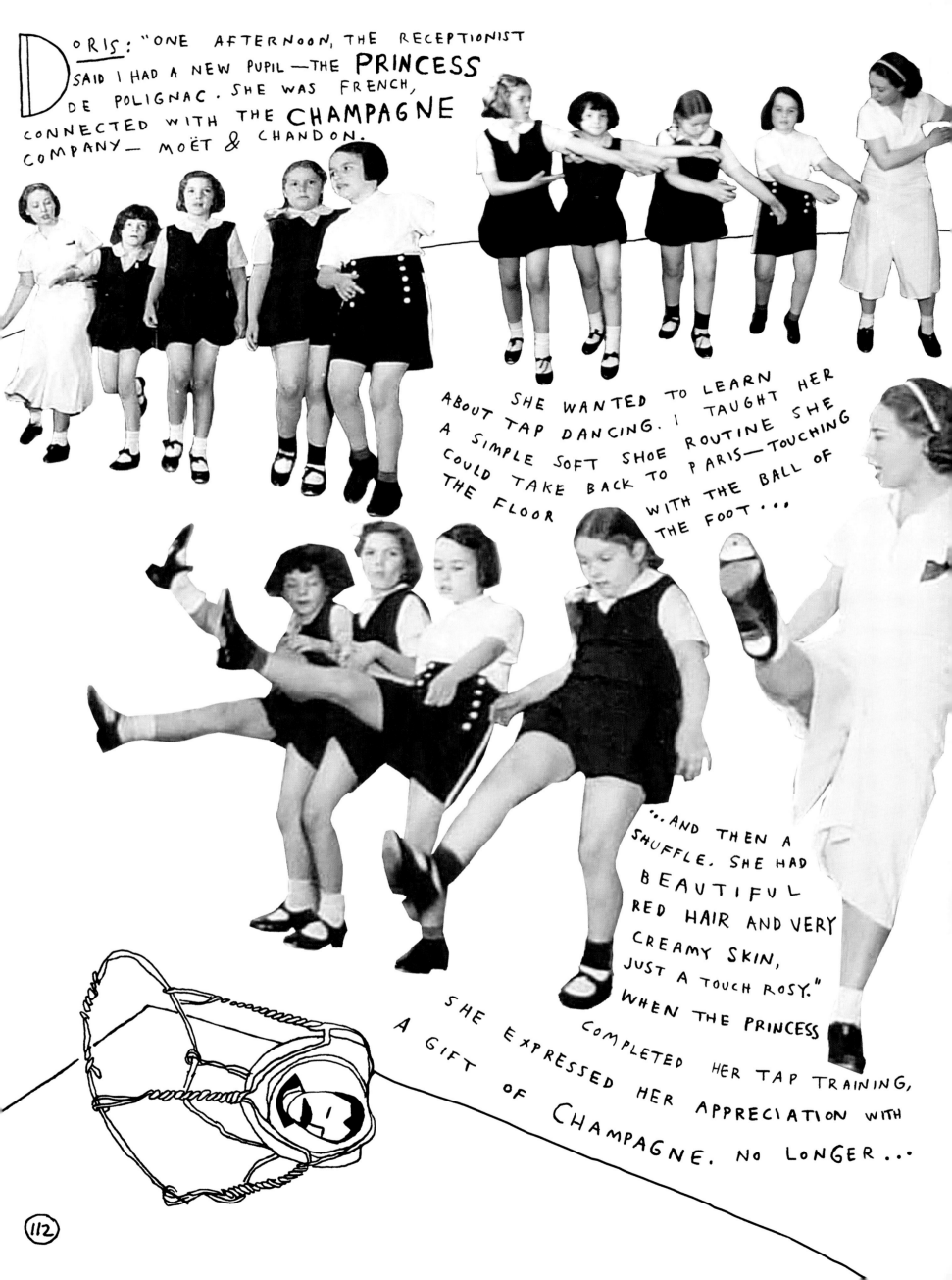

DORIS: "ONE AFTERNOON, THE RECEPTIONIST SAID I HAD A NEW PUPIL—THE PRINCESS DE POLIGNAC. SHE WAS FRENCH, CONNECTED WITH THE CHAMPAGNE COMPANY— MOËT & CHANDON.

SHE WANTED TO LEARN ABOUT TAP DANCING. I TAUGHT HER A SIMPLE SOFT SHOE ROUTINE SHE COULD TAKE BACK TO PARIS—TOUCHING THE FLOOR WITH THE BALL OF THE FOOT . . .

. . . AND THEN A SHUFFLE. SHE HAD BEAUTIFUL RED HAIR AND VERY CREAMY SKIN, JUST A TOUCH ROSY." WHEN THE PRINCESS COMPLETED HER TAP TRAINING, SHE EXPRESSED HER APPRECIATION WITH A GIFT OF CHAMPAGNE. NO LONGER . . .

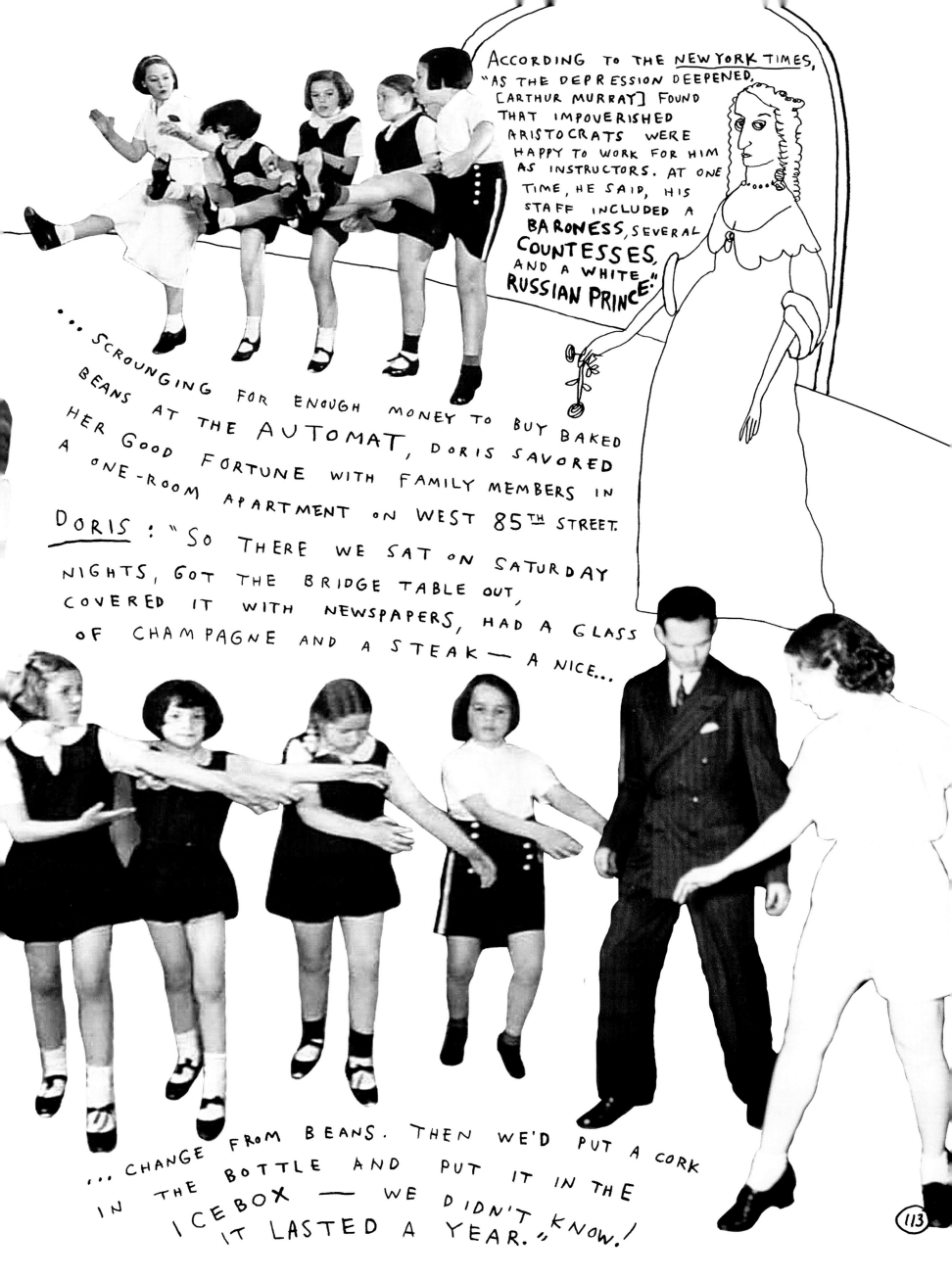

ACCORDING TO THE NEW YORK TIMES, "AS THE DEPRESSION DEEPENED, [ARTHUR MURRAY] FOUND THAT IMPOVERISHED ARISTOCRATS WERE HAPPY TO WORK FOR HIM AS INSTRUCTORS. AT ONE TIME, HE SAID, HIS STAFF INCLUDED A BARONESS, SEVERAL COUNTESSES, AND A WHITE RUSSIAN PRINCE."

... SCROUNGING FOR ENOUGH MONEY TO BUY BAKED BEANS AT THE AUTOMAT, DORIS SAVORED HER GOOD FORTUNE WITH FAMILY MEMBERS IN A ONE-ROOM APARTMENT ON WEST 85TH STREET.

DORIS: "SO THERE WE SAT ON SATURDAY NIGHTS, GOT THE BRIDGE TABLE OUT, COVERED IT WITH NEWSPAPERS, HAD A GLASS OF CHAMPAGNE AND A STEAK — A NICE...

... CHANGE FROM BEANS. THEN WE'D PUT A CORK IN THE BOTTLE AND PUT IT IN THE ICEBOX — WE DIDN'T KNOW! IT LASTED A YEAR."

From tap, Doris graduated to teaching ballroom. She found a partner in fellow instructor Cy Andrews. Arthur Murray liked their moves and began sending the two out to promote the studio at dance exhibitions. One stint took Doris and Cy to Miami's Flamingo Hotel.

to Dance

There, vacationing auto executives gave Cy an idea. DORIS: "Cy wanted to open an Arthur Murray branch studio. Mr. Murray made arrangements for us to go to DETROIT."

Arthur Murray's operation would eventually expand to some 300 studios and earn over $25 MILLION a year in revenue, but in the spring of 1938, Doris Eaton and Cy Andrews held the very FIRST FRANCHISE LICENSE.

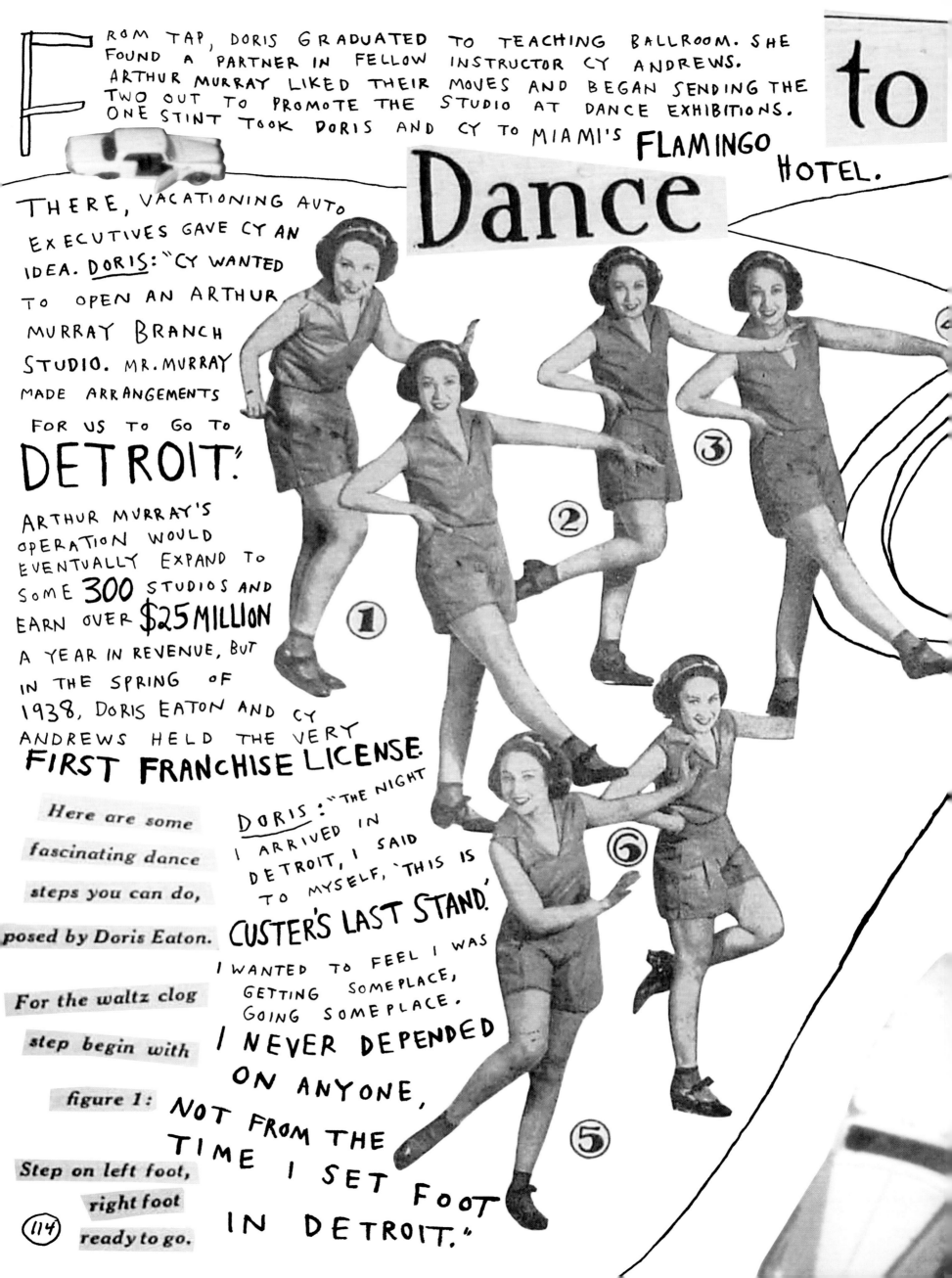

Here are some fascinating dance steps you can do, posed by Doris Eaton.

For the waltz clog step begin with

figure 1:

Step on left foot, right foot ready to go.

DORIS: "The night I arrived in Detroit, I said to myself, 'This is CUSTER'S LAST STAND.' I wanted to feel I was getting someplace, going someplace. I NEVER DEPENDED ON ANYONE, NOT FROM THE TIME I SET FOOT IN DETROIT."

Slenderness

IN 1938, MOTOR CITY WELCOMED DORIS'S DANCING SCHOOL ALONG WITH ITS FIRST DRIVE-IN MOVIE THEATRE.

THAT YEAR'S PASSAGE OF THE FAIR LABOR STANDARDS ACT ESTABLISHED FOR THE NATION A MINIMUM WAGE AND 44-HOUR WORK WEEK. GREATER...

... DISPOSABLE INCOME AND MORE LEISURE TIME, AS WELL AS A THRIVING MUSIC SCENE, MADE DETROIT A NATURAL HAVEN FOR SOCIAL DANCING. ADS FOR CLASSES ENCOURAGED ENROLLMENT WITH THE PROMISE OF HEALTHY, CONVIVIAL EXERCISE:

"SCORES OF DOCTORS PRESCRIBE THESE LESSONS."

PEOPLE PICKED UP THEIR PHONES AND DIALED "CADILLAC 3377" TO SIGN UP, AND BUSINESS BOOMED. DORIS: "WE'D HAVE LIGHTS ON AND LEAVE THE WINDOWS OPEN. IF YOU WERE WALKING DOWN WASHINGTON BOULEVARD YOU COULD SEE THE DANCERS' SILHOUETTES IN THE WINDOWS."

(115)

TOP BRASS AT DETROIT'S AUTOMAKERS REGISTERED FOR DORIS'S DANCE CLASSES. DORIS: "FRED ZEDER, THE CEO of CHRYSLER — A GREAT GUY WITH WHITE HAIR AND A RED COMPLEXION, TOOK LESSONS. ALBERT BRADLEY, CHAIRMAN OF THE BOARD of GENERAL MOTORS, USED TO GET OUT OF HIS CEO MEETINGS TO COME TAKE HIS LESSONS ON TIME." BUT THE BIGGEST OF DETROIT'S BIG THREE, THE MAN WHO REVOLUTIONIZED CAR MANUFACTURING... MAKING AUTOMOBILES AFFORDABLE WITH ASSEMBLY LINE PRODUCTION, WAS NOTABLY ABSENT. AND IT WASN'T BECAUSE HENRY FORD WAS TOO BUSY.

AN ARDENT DANCE ENTHUSIAST, FORD HIRED AN IN-HOUSE BALLROOM INSTRUCTOR, BENJAMIN LOVETT, TO TEACH HIS EMPLOYEES MINUETS, JIGS, AND POLKAS. FORD BUILT AN ELEGANT, CHANDELIERED BALLROOM ON THE GROUNDS OF HIS AUTOMOTIVE PLANT AND NAMED IT LOVETT HALL, IN HONOR OF HIS DANCE MASTER. FORD PUBLISHED A GUIDE TO SOME 70 "OLD-TIME" DANCES WITH ACCOMPANYING SHEET MUSIC AND DIAGRAMS.

YET EVEN AS HE DROVE MODERNITY INTO THE LIVES OF MILLIONS OF AMERICANS, HENRY FORD WAS VIGOROUSLY OPPOSED TO ANY INNOVATION ON THE DANCE FLOOR.

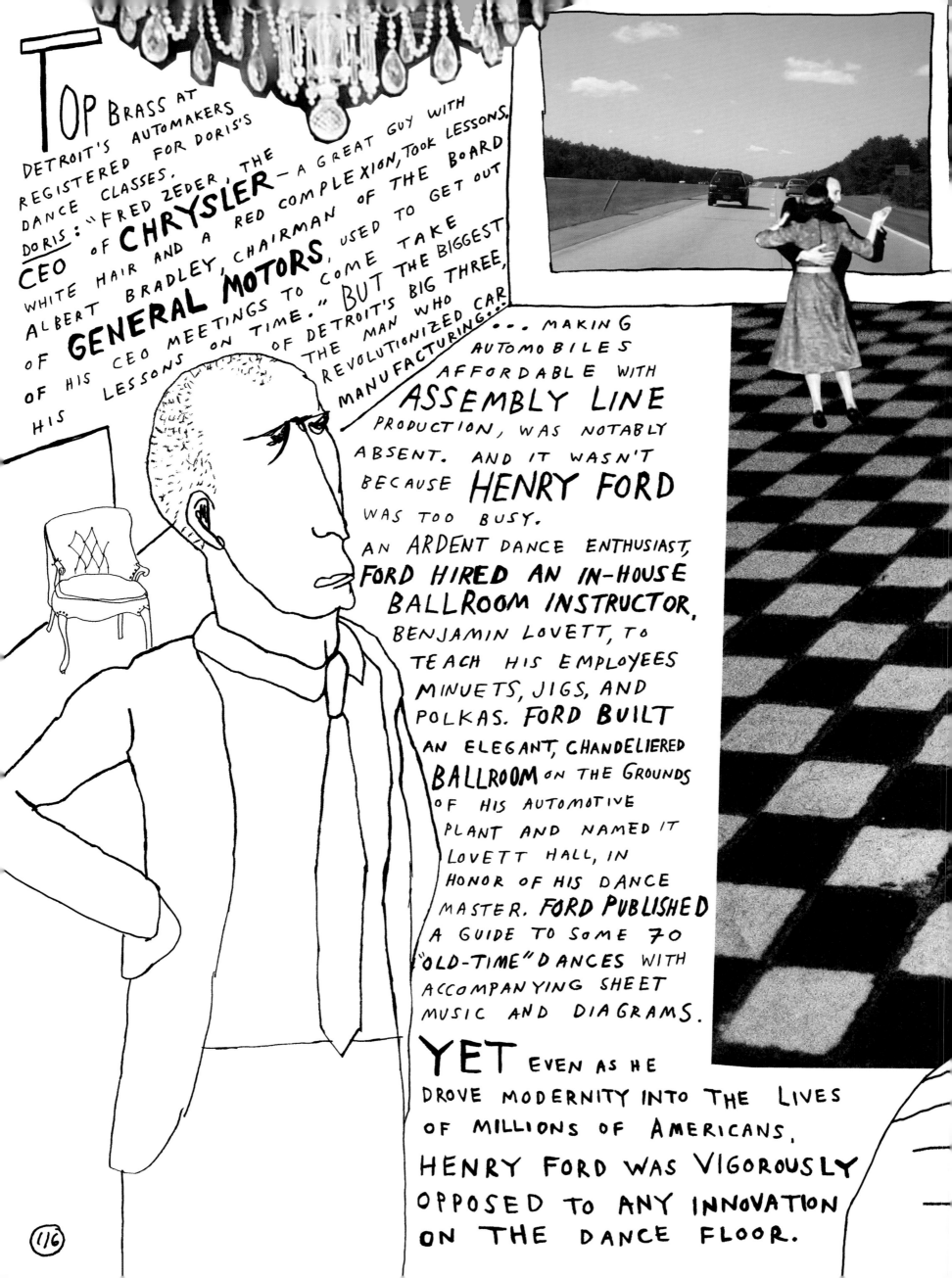

DORIS: "BENJAMIN LOVETT WANTED TO HAVE A PRIVATE AUDIENCE WITH ME. HE CAME TO THE OFFICE AND SAID, 'MR. FORD WILL HAVE NOTHING TO DO WITH THE MODERN DANCES, BUT I SEE THESE LATIN DANCES AND I WOULD LIKE TO TASTE WHAT IT IS ALL ABOUT. DON'T TELL HIM I'M HERE OR HE'LL FIRE ME!'" THUS DORIS EATON AND BENJAMIN LOVETT BEGAN A **SECRET SWAP OF FANCY FOOTWORK.**

CLARA AND HENRY FORD

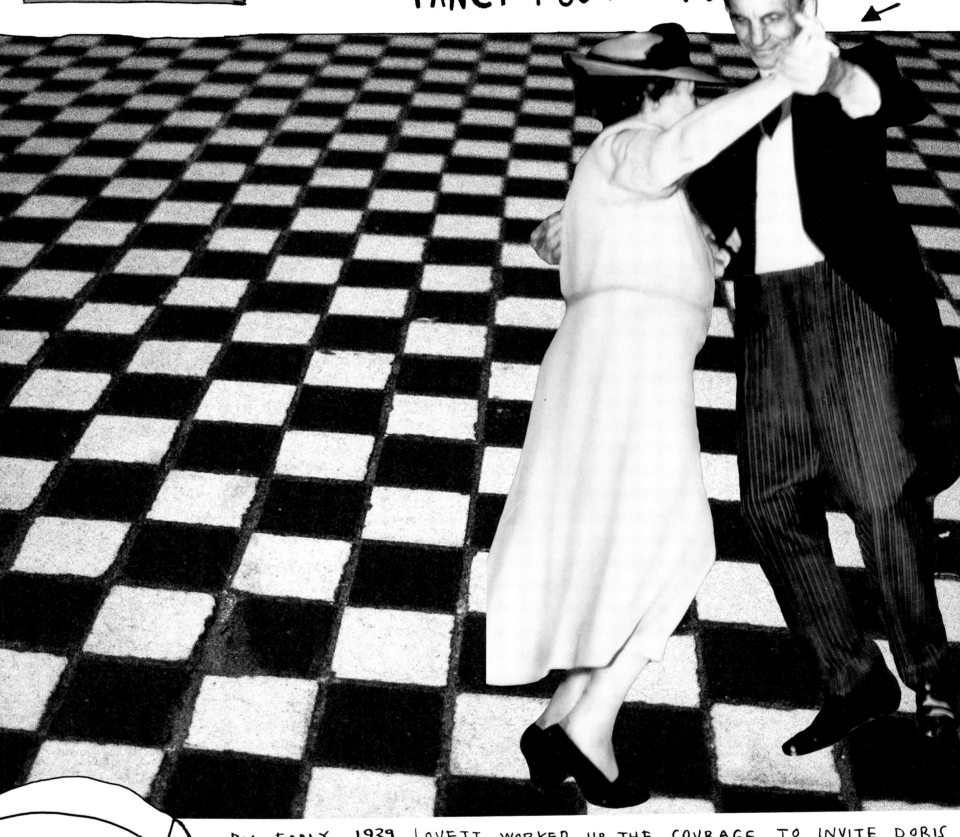

BY EARLY 1939 LOVETT WORKED UP THE COURAGE TO INVITE DORIS AND HER STUDIO TO TAKE PART IN ONE OF THE DANCE DEMONSTRATIONS HELD IN LOVETT HALL. HENRY FORD WAS IN ATTENDANCE. AFTER DUTIFULLY OBSERVING THE FORD COMPANY PRESENTATION, THE MURRAY DANCERS ROSE TO PUT THEIR ARMS AROUND EACH OTHER AND RUMBA. DORIS:" MR. FORD JUST GOT UP AND WALKED OUT. HE WAS JUST AN OLD-FASHIONED INDIVIDUAL. HE DIDN'T LIKE ALL THE BODYWORK." (117)

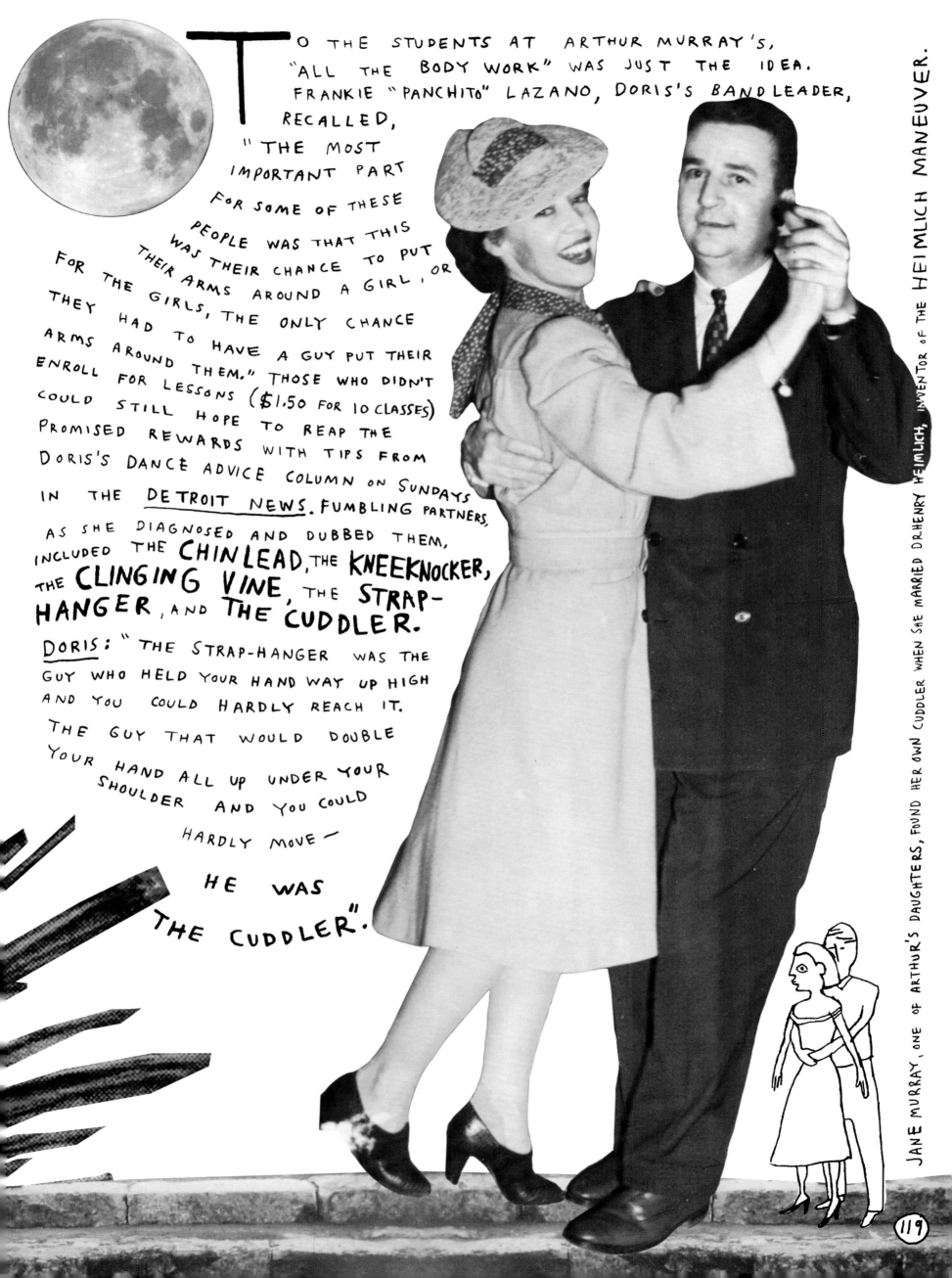

T o the students at Arthur Murray's, "all the body work" was just the idea. Frankie "Panchito" Lazano, Doris's bandleader, recalled, "the most important part for some of these people was that this was their chance to put their arms around a girl, or for the girls, the only chance they had to have a guy put their arms around them." Those who didn't enroll for lessons ($1.50 for 10 classes) could still hope to reap the promised rewards with tips from Doris's dance advice column on Sundays in the DETROIT NEWS. Fumbling partners, as she diagnosed and dubbed them, included THE CHINLEAD, THE KNEEKNOCKER, THE CLINGING VINE, THE STRAP-HANGER, AND THE CUDDLER.

DORIS: "The strap-hanger was the guy who held your hand way up high and you could hardly reach it. The guy that would double your hand all up under your shoulder and you could hardly move—

HE WAS THE CUDDLER".

JANE MURRAY, ONE OF ARTHUR'S DAUGHTERS, FOUND HER OWN CUDDLER WHEN SHE MARRIED DR. HENRY HEIMLICH, INVENTOR OF THE HEIMLICH MANEUVER.

119

'on your toes'---

By Doris Eaton
of the Arthur Murray Dance Studios

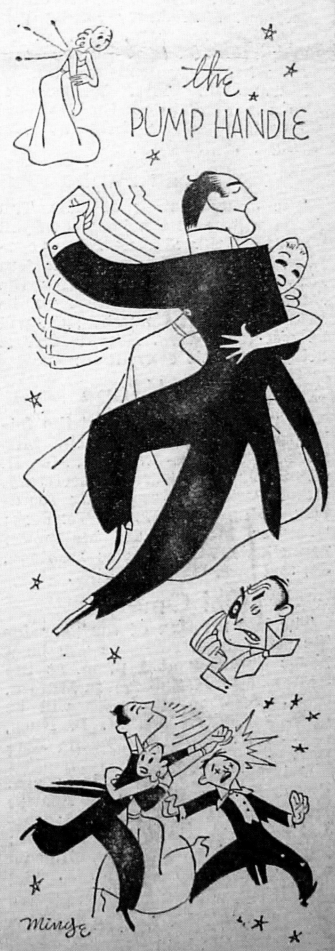

the PUMP HANDLE

THE Pestiferous Pump-Handle Performer was active over at the Statler the other night.

Did you ever see him? He's a common sight and not hard to recognize. He steps on the floor with his partner, withers her with a "You-Lucky-Girl-You" look, clamps a death-grip around her slim waist. Then he grabs her right hand, almost pulls her fragile arm out of its socket, by extending his own brawny left, full length to the side. This is the Pump-Handle Position.

Now, he's off! As he begins to dance, the left arm begins to pump. Up and down, up and down! Sometimes in rhythm; more often not. His steps are wide and far apart. Over the floor he goes in leaps and bounds. And the Pump-Handle never stops.

His partner is by no means the sole sufferer. Everybody in his orbit is in danger. He cuts a wide path. Everybody gives him the road. But even so it's lucky if there are no casualties before the dance is over.

* * *

HERE is how he should improve his own dancing — and finally his own pleasure in the art — and save his neighbors from black eyes and broken bones:

1. Relax the left arm and bend it at the elbow, holding it at a comfortable height for your partner and supporting your own weight.

2. Loosen your hold on your partner's waist, placing your right hand across her shoulder-blades so that she may follow more gracefully.

3. Don't try to cover the whole floor in three leaps.

'on your toes'

by doris eaton

OF THE ARTHUR MURRAY DANCE SCHOOL

"TRIPPING THE LIGHT FANTASTIC" is one thing but to trip fantastically is another.

There is a limit to all things and our Strap-Hanger Stepper just about reaches it. Many a dance floor is paved with his good intentions. He is strictly the uplifting type — albeit the process is a somewhat painful one.

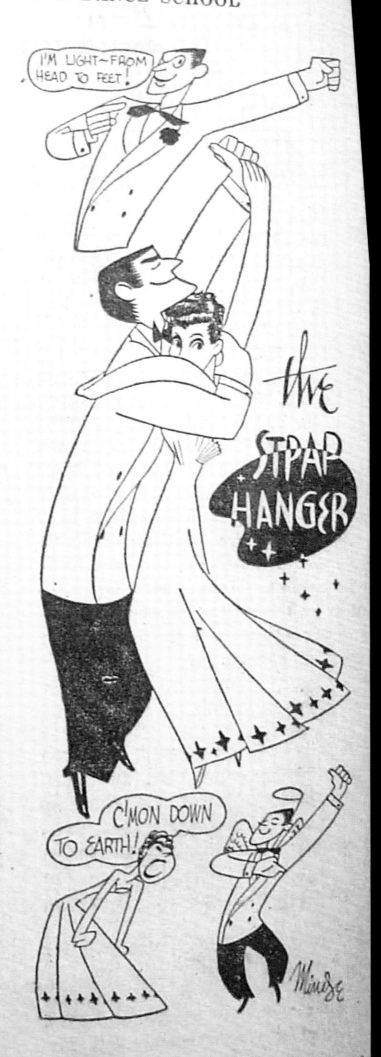

As you step in front of him, he nonchalantly takes your right hand and shoots it straight up in the air. If your arm is not as long as his, don't let it worry you. It is a mere detail that his particular technique will soon alter. Besides, numbness will quickly obliterate your consciousness of it.

The next move is his right arm. This goes under your left and completes the uplift movement by dislocating your shoulder, allowing his hand to brace itself against the right side of your neck.

To cap the climax, he rises up on his toes as far as possible. By this time your posture seems slightly strung up. You're amazed when your feet actually touch the floor now and then and you wonder when and how it will all end.

* * *

I CAN TELL you "how." With you feeling like you have been let off a rack and him suggesting with a withering look that you have been very light on his feet. At this point you are too weak to take offense.

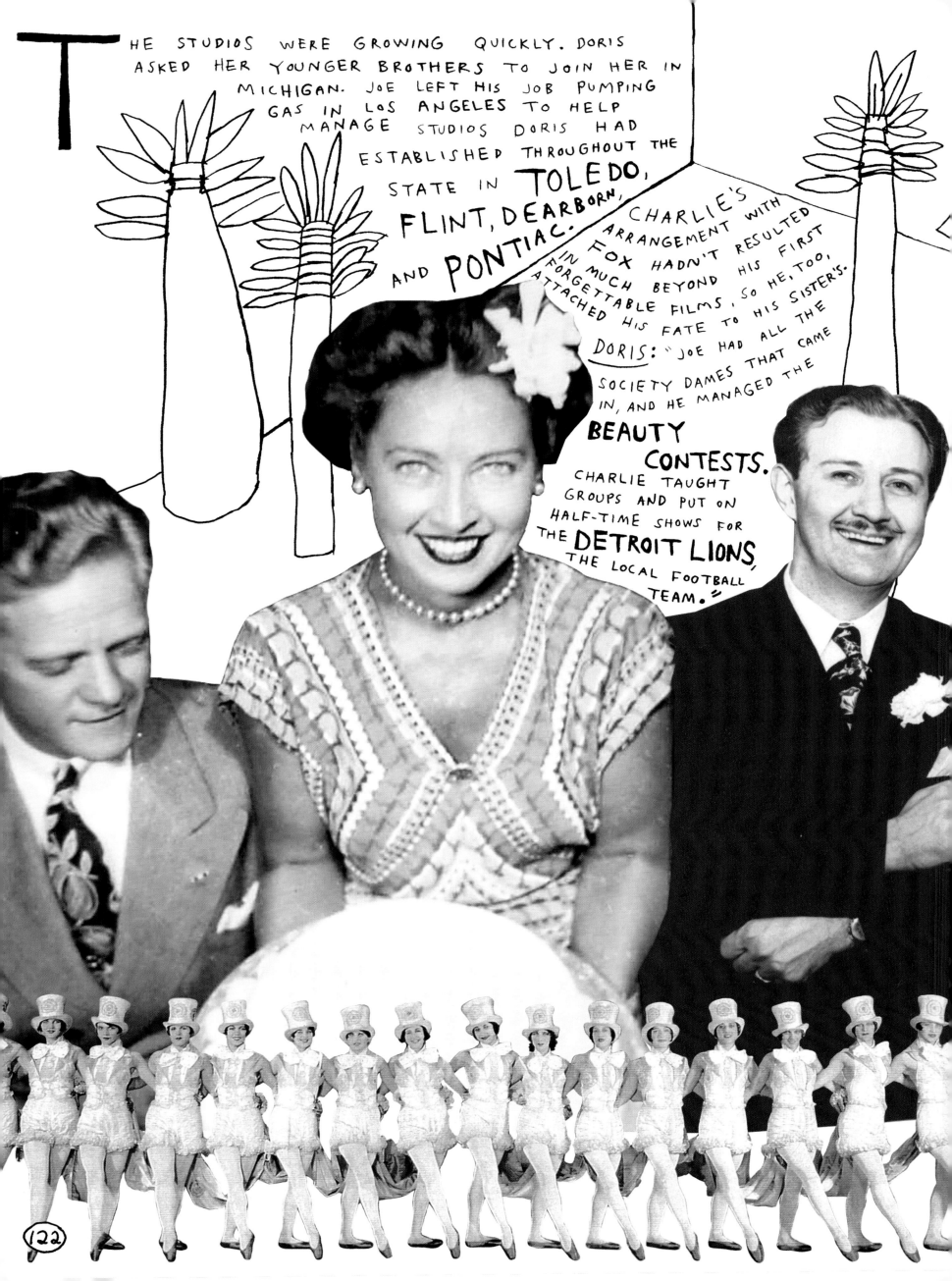

T HE STUDIOS WERE GROWING QUICKLY. DORIS
ASKED HER YOUNGER BROTHERS TO JOIN HER IN
MICHIGAN. JOE LEFT HIS JOB PUMPING
GAS IN LOS ANGELES TO HELP
MANAGE STUDIOS DORIS HAD
ESTABLISHED THROUGHOUT THE
STATE IN TOLEDO,
FLINT, DEARBORN,
AND PONTIAC.

CHARLIE'S
ARRANGEMENT WITH
FOX HADN'T RESULTED
IN MUCH BEYOND HIS FIRST
FORGETTABLE FILMS, SO HE, TOO,
ATTACHED HIS FATE TO HIS SISTER'S.

DORIS: "JOE HAD ALL THE
SOCIETY DAMES THAT CAME
IN, AND HE MANAGED THE
BEAUTY
CONTESTS.
CHARLIE TAUGHT
GROUPS AND PUT ON
HALF-TIME SHOWS FOR
THE DETROIT LIONS,
THE LOCAL FOOTBALL
TEAM."

(122)

WHILE DORIS, ALONG WITH HER BROTHERS, EMBARKED ON A PROMISING NEW CAREER, THE OTHER EATONS FALTERED.

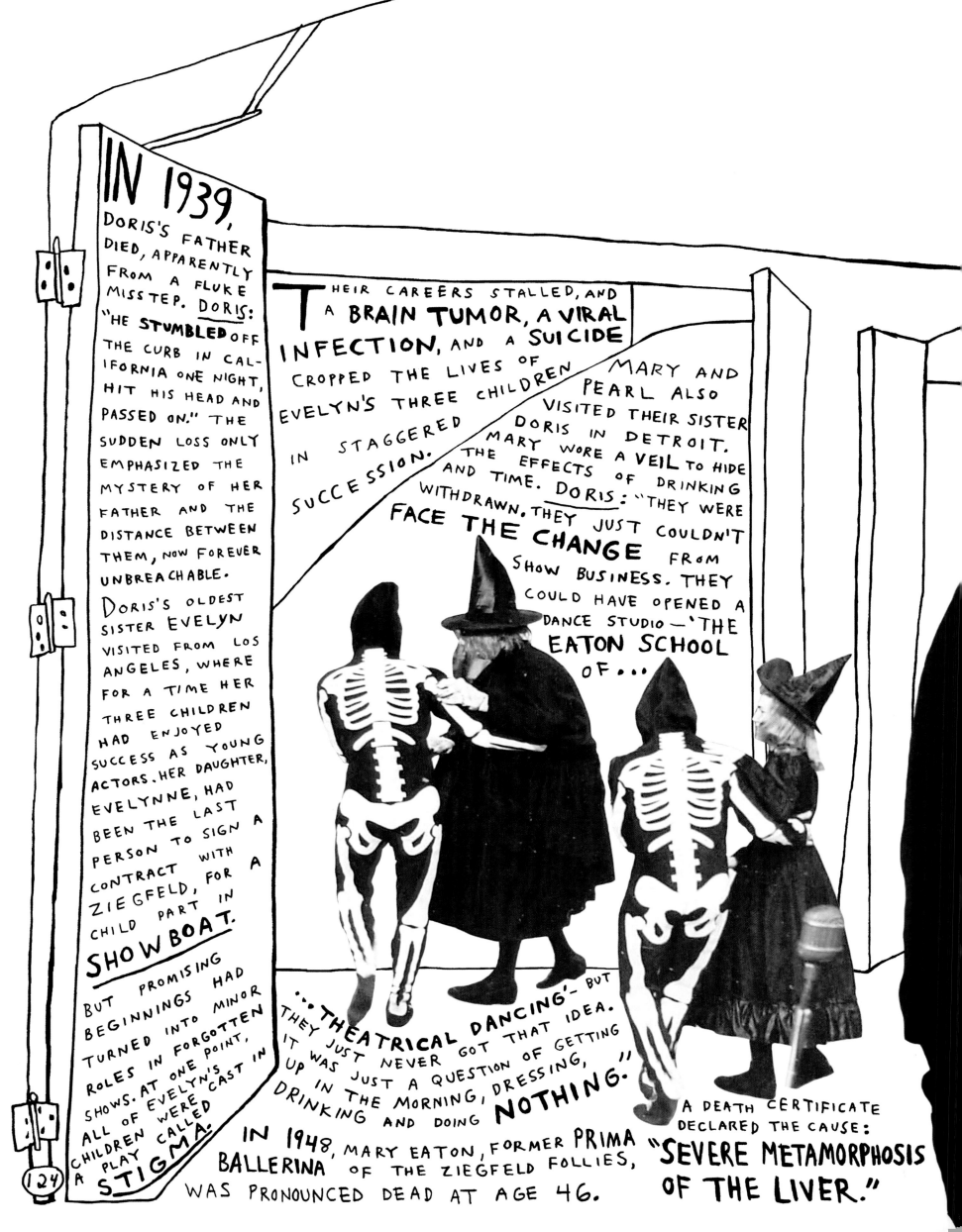

IN 1939,

DORIS'S FATHER DIED, APPARENTLY FROM A FLUKE MISSTEP. DORIS: "HE **STUMBLED** OFF THE CURB IN CALIFORNIA ONE NIGHT, HIT HIS HEAD AND PASSED ON." THE SUDDEN LOSS ONLY EMPHASIZED THE MYSTERY OF HER FATHER AND THE DISTANCE BETWEEN THEM, NOW FOREVER UNBREACHABLE.

DORIS'S OLDEST SISTER EVELYN VISITED FROM LOS ANGELES, WHERE FOR A TIME HER THREE CHILDREN HAD ENJOYED SUCCESS AS YOUNG ACTORS. HER DAUGHTER, EVELYNNE, HAD BEEN THE LAST PERSON TO SIGN A CONTRACT WITH ZIEGFELD, FOR A CHILD PART IN **SHOW BOAT.** BUT PROMISING BEGINNINGS HAD TURNED INTO MINOR ROLES IN FORGOTTEN SHOWS. AT ONE POINT, ALL OF EVELYN'S CHILDREN WERE CAST IN A PLAY CALLED **STIGMA.**

124

THEIR CAREERS STALLED, AND A **BRAIN TUMOR, A VIRAL INFECTION,** AND A **SUICIDE** CROPPED THE LIVES OF EVELYN'S THREE CHILDREN IN STAGGERED SUCCESSION.

MARY AND PEARL ALSO VISITED THEIR SISTER DORIS IN DETROIT. MARY WORE A VEIL TO HIDE THE EFFECTS OF DRINKING AND TIME. DORIS: "THEY WERE WITHDRAWN, THEY JUST COULDN'T **FACE THE CHANGE** FROM SHOW BUSINESS. THEY COULD HAVE OPENED A DANCE STUDIO—'THE **EATON SCHOOL** OF...

...**THEATRICAL DANCING'**— BUT THEY JUST NEVER GOT THAT IDEA. IT WAS JUST A QUESTION OF GETTING UP IN THE MORNING, DRESSING, DRINKING AND DOING **NOTHING.**"

IN 1948, MARY EATON, FORMER **PRIMA BALLERINA** OF THE ZIEGFELD FOLLIES, WAS PRONOUNCED DEAD AT AGE 46.

A DEATH CERTIFICATE DECLARED THE CAUSE: **"SEVERE METAMORPHOSIS OF THE LIVER."**

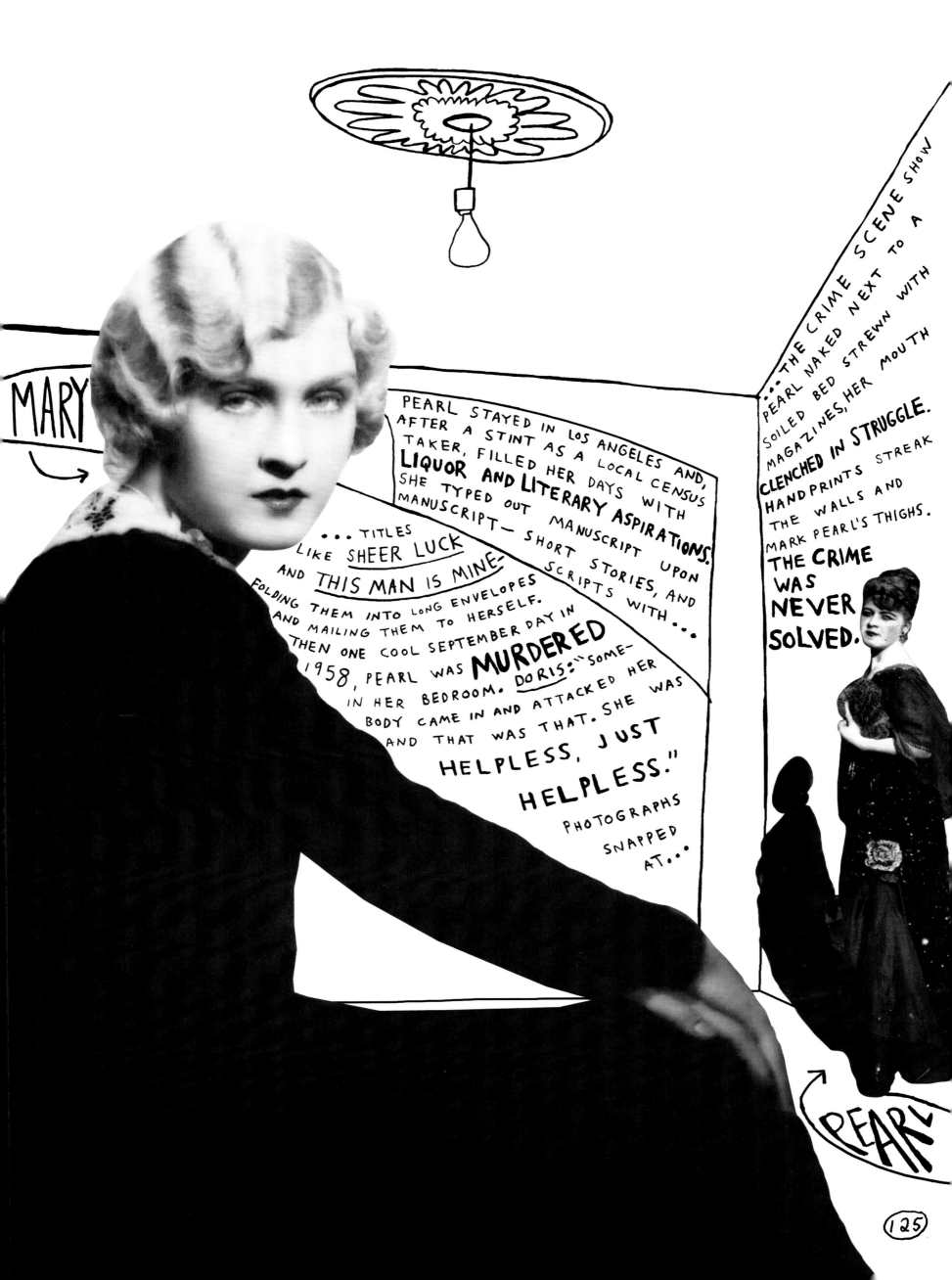

MARY →

PEARL STAYED IN LOS ANGELES AND, AFTER A STINT AS A LOCAL CENSUS TAKER, FILLED HER DAYS WITH **LIQUOR AND LITERARY ASPIRATIONS.** SHE TYPED OUT MANUSCRIPT UPON MANUSCRIPT— SHORT STORIES, AND SCRIPTS WITH ...

... TITLES LIKE SHEER LUCK AND THIS MAN IS MINE— FOLDING THEM INTO LONG ENVELOPES AND MAILING THEM TO HERSELF. THEN ONE COOL SEPTEMBER DAY IN 1958, PEARL WAS **MURDERED** IN HER BEDROOM. DORIS: "SOME- BODY CAME IN AND ATTACKED HER AND THAT WAS THAT. SHE WAS **HELPLESS, JUST HELPLESS."** PHOTOGRAPHS SNAPPED AT ...

... THE CRIME SCENE SHOW PEARL NAKED NEXT TO A SOILED BED STREWN WITH MAGAZINES, HER MOUTH **CLENCHED IN STRUGGLE.** HANDPRINTS STREAK THE WALLS AND MARK PEARL'S THIGHS. **THE CRIME WAS NEVER SOLVED.**

PEARL →

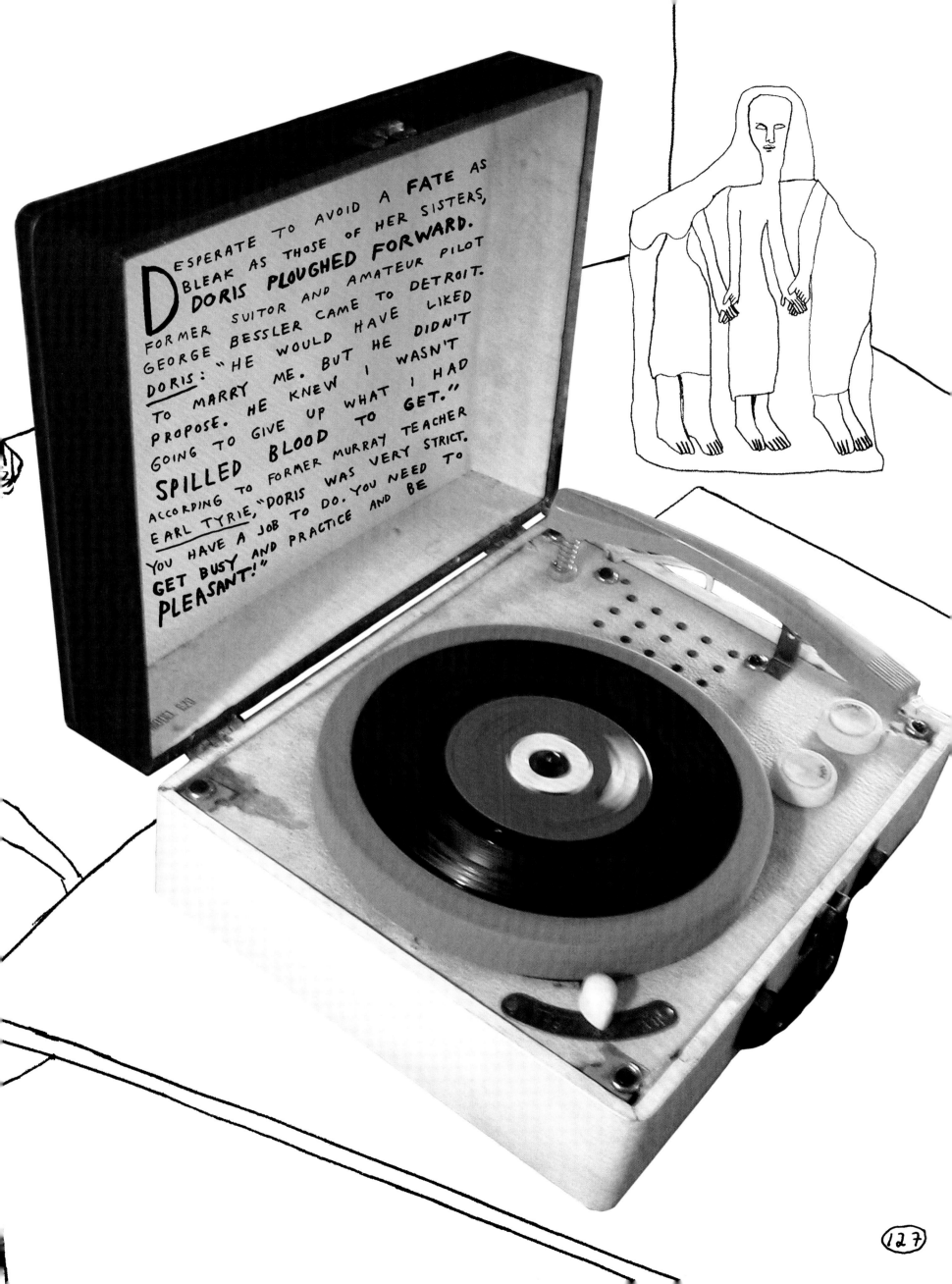

Desperate to avoid a fate as bleak as those of her sisters, Doris ploughed forward. Former suitor and amateur pilot George Bessler came to Detroit. Doris: "He would have liked to marry me. But he didn't propose. He knew I wasn't going to give up what I had SPILLED BLOOD to GET." According to former Murray teacher Earl Tyrie, "Doris was very strict. You have a job to do. You need to GET BUSY and practice and be PLEASANT!"

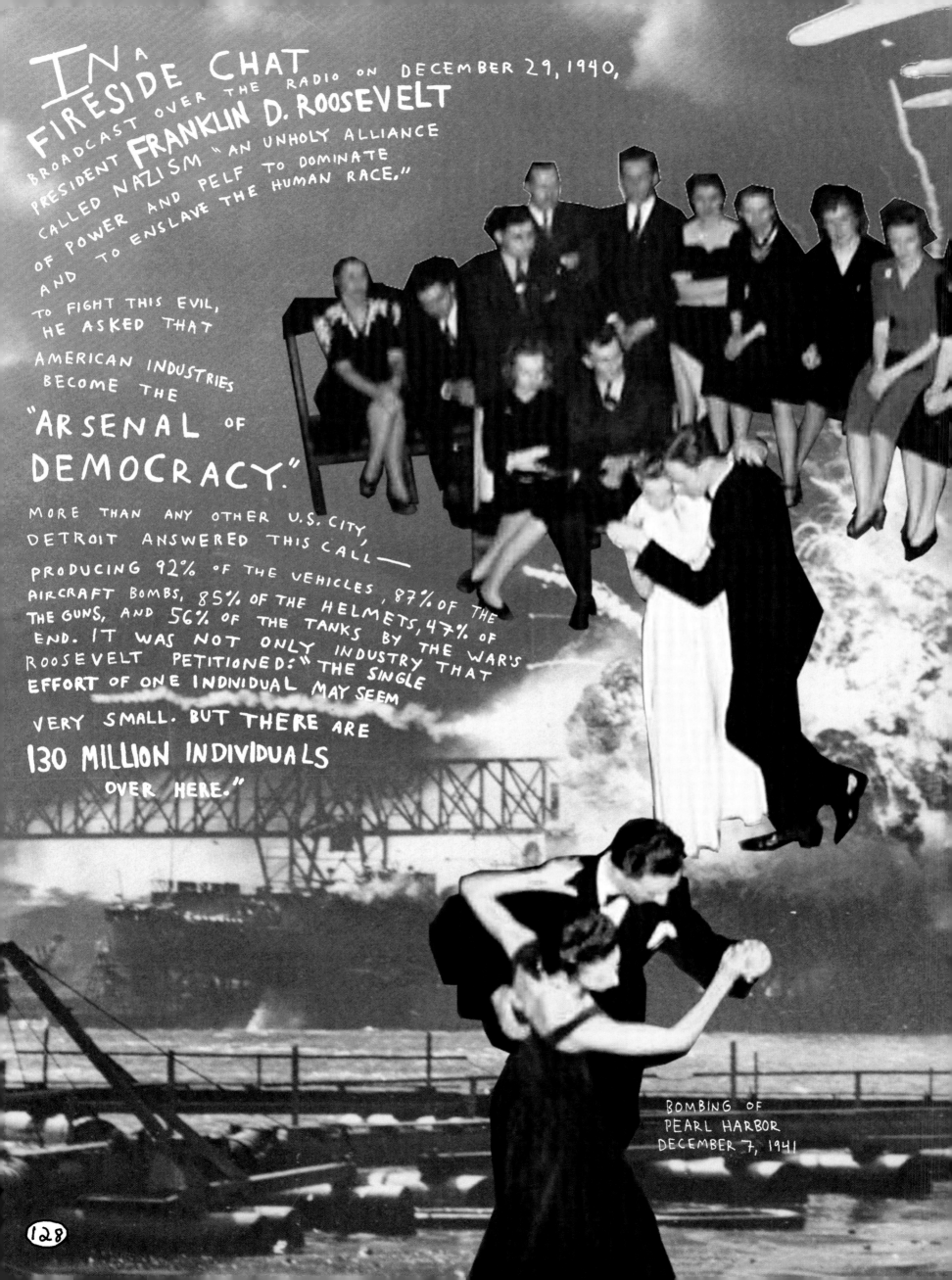

IN A FIRESIDE CHAT BROADCAST OVER THE RADIO ON DECEMBER 29, 1940, PRESIDENT FRANKLIN D. ROOSEVELT CALLED NAZISM "AN UNHOLY ALLIANCE OF POWER AND PELF TO DOMINATE AND TO ENSLAVE THE HUMAN RACE."

TO FIGHT THIS EVIL, HE ASKED THAT AMERICAN INDUSTRIES BECOME THE "ARSENAL OF DEMOCRACY."

MORE THAN ANY OTHER U.S. CITY, DETROIT ANSWERED THIS CALL— PRODUCING 92% OF THE VEHICLES, 87% OF THE AIRCRAFT BOMBS, 85% OF THE HELMETS, 47% OF THE GUNS, AND 56% OF THE TANKS BY THE WAR'S END. IT WAS NOT ONLY INDUSTRY THAT ROOSEVELT PETITIONED: "THE SINGLE EFFORT OF ONE INDIVIDUAL MAY SEEM VERY SMALL. BUT THERE ARE 130 MILLION INDIVIDUALS OVER HERE."

BOMBING OF PEARL HARBOR DECEMBER 7, 1941

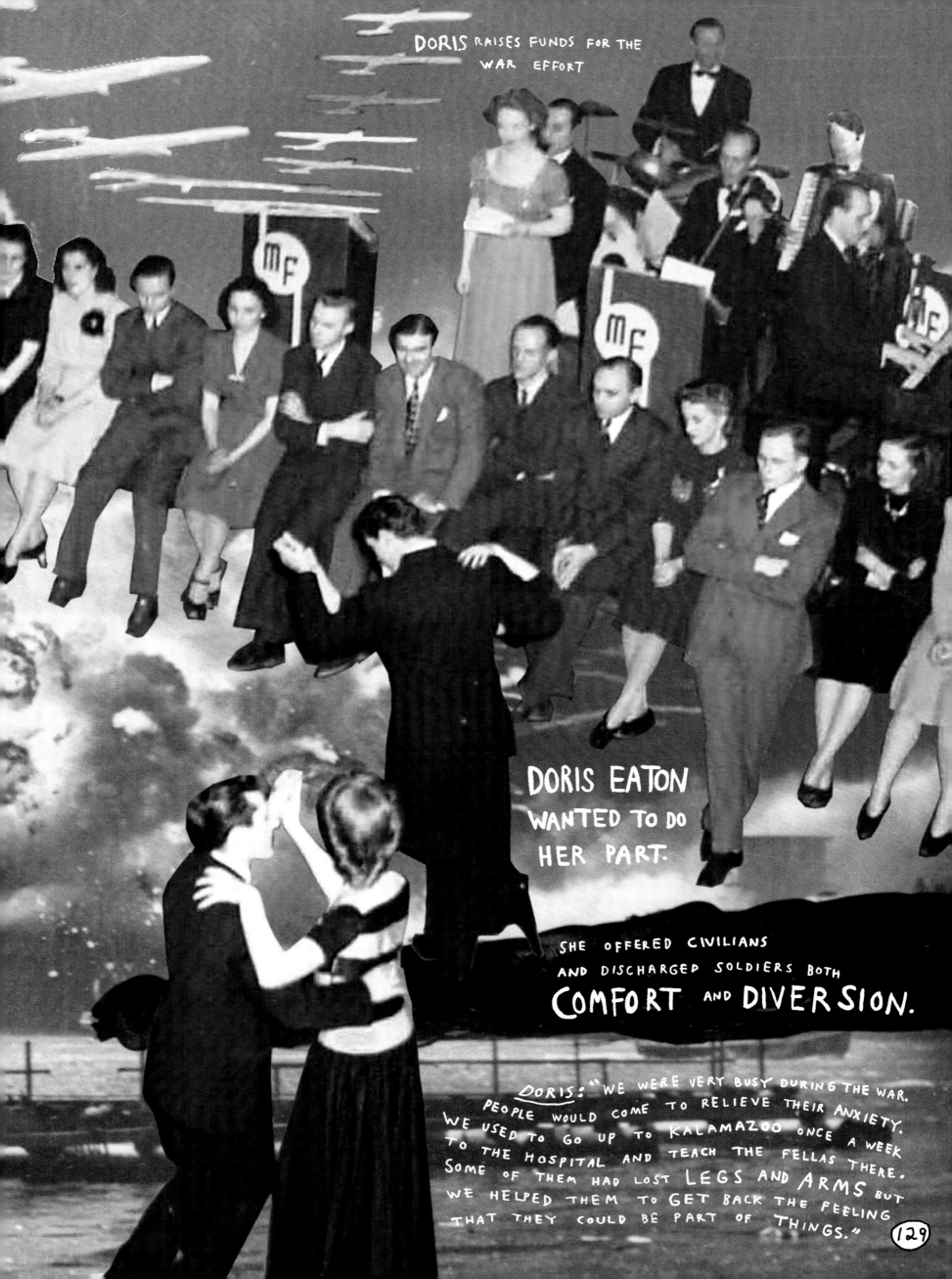

DORIS RAISES FUNDS FOR THE WAR EFFORT

DORIS EATON WANTED TO DO HER PART.

SHE OFFERED CIVILIANS AND DISCHARGED SOLDIERS BOTH COMFORT AND DIVERSION.

DORIS: "WE WERE VERY BUSY DURING THE WAR. PEOPLE WOULD COME TO RELIEVE THEIR ANXIETY. WE USED TO GO UP TO KALAMAZOO ONCE A WEEK TO THE HOSPITAL AND TEACH THE FELLAS THERE. SOME OF THEM HAD LOST LEGS AND ARMS BUT WE HELPED THEM TO GET BACK THE FEELING THAT THEY COULD BE PART OF THINGS."

129

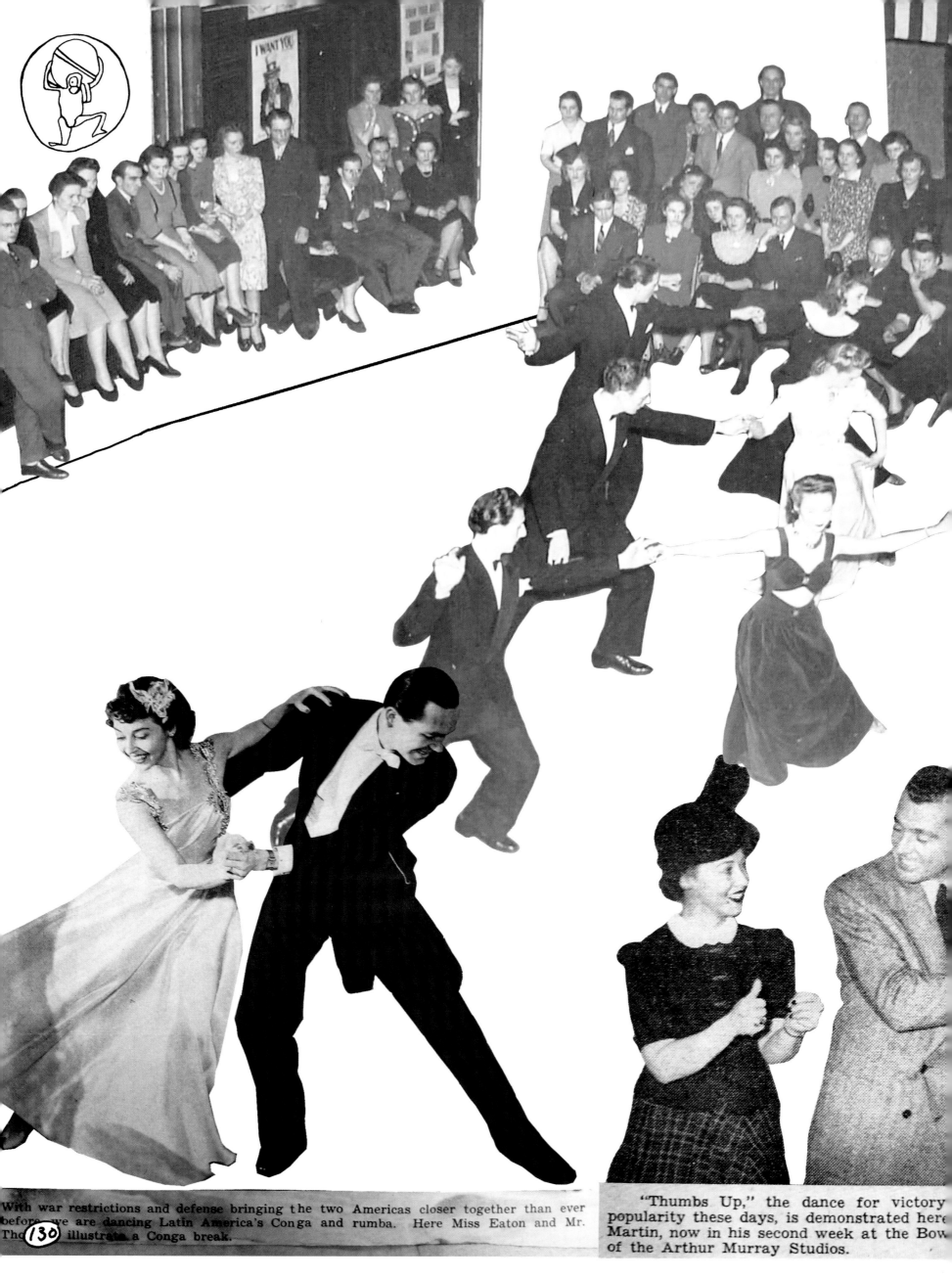

With war restrictions and defense bringing the two Americas closer together than ever before we are dancing Latin America's Conga and rumba. Here Miss Eaton and Mr. Tho illustrate a Conga break.

"Thumbs Up," the dance for victory popularity these days, is demonstrated here Martin, now in his second week at the Bow of the Arthur Murray Studios.

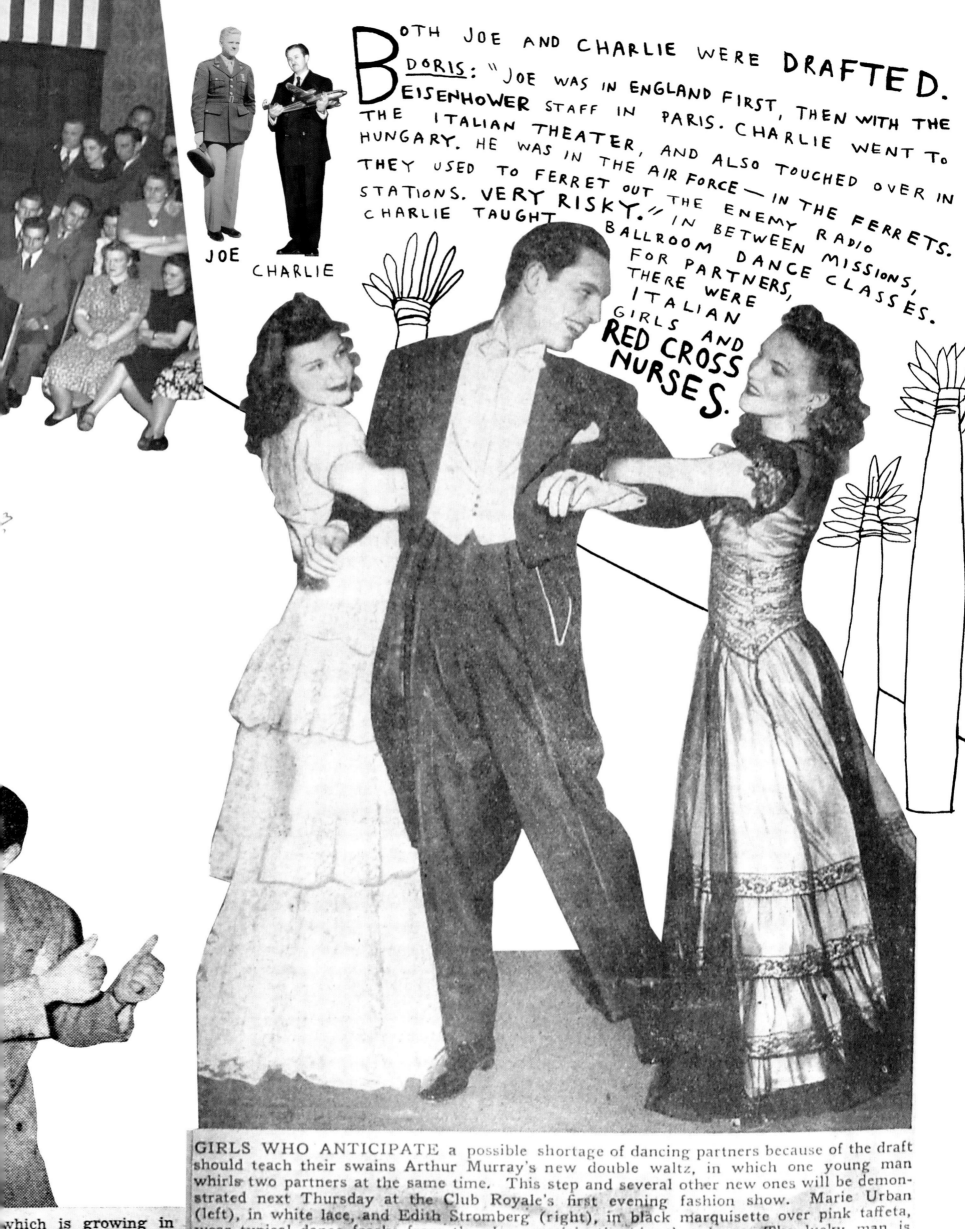

BOTH JOE AND CHARLIE WERE **DRAFTED.**
DORIS: "JOE WAS IN ENGLAND FIRST, THEN WITH THE EISENHOWER STAFF IN PARIS. CHARLIE WENT TO THE ITALIAN THEATER, AND ALSO TOUCHED OVER IN HUNGARY. HE WAS IN THE AIR FORCE — IN THE FERRETS. THEY USED TO FERRET OUT THE ENEMY RADIO STATIONS. VERY RISKY." IN BETWEEN MISSIONS, CHARLIE TAUGHT BALLROOM DANCE CLASSES. FOR PARTNERS, THERE WERE ITALIAN GIRLS AND RED CROSS NURSES.

JOE CHARLIE

GIRLS WHO ANTICIPATE a possible shortage of dancing partners because of the draft should teach their swains Arthur Murray's new double waltz, in which one young man whirls two partners at the same time. This step and several other new ones will be demonstrated next Thursday at the Club Royale's first evening fashion show. Marie Urban (left), in white lace, and Edith Stromberg (right), in black marquisette over pink taffeta, wear typical dance frocks from the shop participating in the show. The lucky man is Jimmie Howle.

which is growing in by singing star, Tony ry, and Doris Easton,

For further information call The Detroit News, Randolph 2000, line 555, between 9 a. m. and 5 p. m.

BY THE TIME THE FREE WORLD HAD BEEN SECURED FROM FASCISM, DORIS HAD EXPANDED HER **DANCE EMPIRE,** EVENTUALLY ESTABLISHING 18 STUDIOS. WHEN JOE AND CHARLIE WERE RELEASED FROM THE SERVICE, SHE HAD CIVILIAN JOBS WAITING FOR THEM. SHE GAVE JOE A STUDIO IN TOLEDO TO MANAGE. THERE, HE **FELL IN LOVE** WITH BROWN-EYED MURRAY INSTRUCTOR LUCILLE CASEY FROM BAY CITY AND THEY MARRIED. A SON, JOE EATON, JR., WAS BORN IN 1948 AND A DAUGHTER, DIANE, NOT LONG AFTER. CHARLIE ALSO FOUND AN ARTHUR MURRAY TEACHER TO **ROMANCE...**

↓

...A SMOLDERING BRUNETTE NAMED JEANNIE WINTERS. ACCORDING TO FRIEND HELEN SABO BROAD: "SHE WAS ABSOLUTELY GORGEOUS, A LITTLE SPANISH BARBIE DOLL. WELL, SHE WASN'T SPANISH, SHE JUST LOOKED SPANISH."

DORIS, HAVING BEEN BURNED TWICE IN LOVE, WAS CAUTIOUSLY OPTIMISTIC ABOUT NEW **ENTANGLEMENTS.**
DORIS: " MR. MURRAY GAVE US A LIST OF PUPILS THAT HAD TAKEN LESSONS IN NEW YORK OR ON DANCE CRUISES SO WE COULD LET THEM KNOW THEY COULD FINISH THEIR LESSONS IN DETROIT. SO I'M GOING DOWN THE LIST AND I COME TO THE NAME **PAUL H. TRAVIS.** I DIAL THE PHONE NUMBER AND A VOICE ON THE OTHER END SAYS, HELLO! I SAY, 'IS THIS MR. TRAVIS?'

PAUL TRAVIS: "YES."

DORIS EATON: "MR. TRAVIS, THIS IS MISS EATON CALLING. I WANTED TO LET YOU KNOW WE ARE OPENING...

...AN ARTHUR MURRAY STUDIO HERE."
PAUL: "YESSS...?"
DORIS: "I'D LIKE FOR YOU TO COME DOWN AND SEE THE STUDIO AND POSSIBLY YOU'D LIKE TO FINISH YOUR COURSE."

PAUL: "I THINK I OUGHT TO MEET YOU FIRST AND THEN I'LL KNOW IF I WANT TO COME TAKE A LESSON."

DORIS: "NO, MR. TRAVIS. I THINK IT'D BE AWFULLY NICE FOR YOU TO COME TO THE STUDIO."

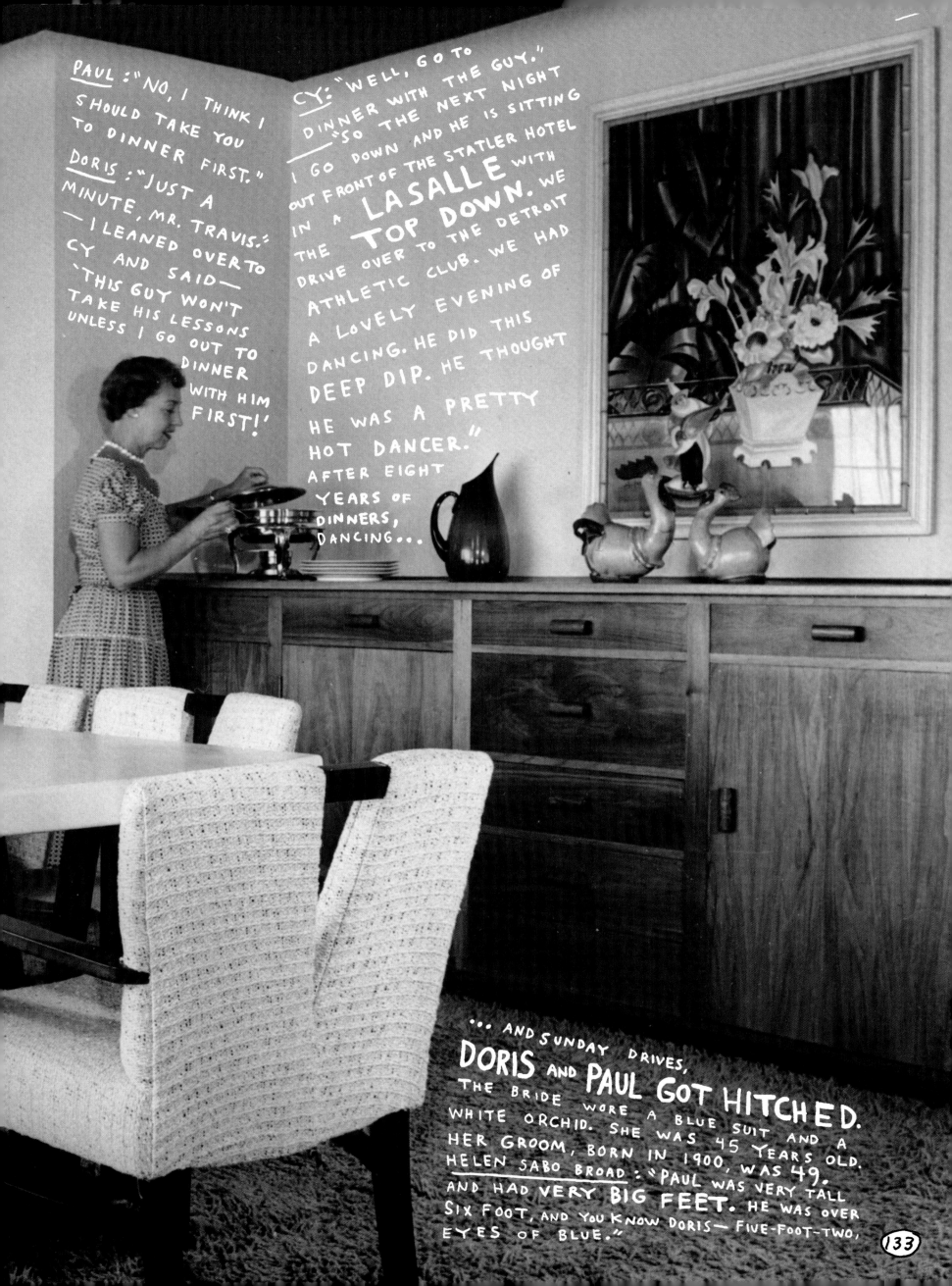

PAUL: "NO, I THINK I SHOULD TAKE YOU TO DINNER FIRST."

DORIS: "JUST A MINUTE, MR. TRAVIS." — I LEANED OVER TO CY AND SAID — "THIS GUY WON'T TAKE HIS LESSONS UNLESS I GO OUT TO DINNER WITH HIM FIRST!"

CY: "WELL, GO TO DINNER WITH THE GUY." "SO THE NEXT NIGHT I GO DOWN AND HE IS SITTING OUT FRONT OF THE STATLER HOTEL IN A **LASALLE** WITH THE **TOP DOWN.** WE DRIVE OVER TO THE DETROIT ATHLETIC CLUB. WE HAD A LOVELY EVENING OF DANCING. HE DID THIS **DEEP DIP.** HE THOUGHT HE WAS A PRETTY HOT DANCER." AFTER EIGHT YEARS OF DINNERS, DANCING...

... AND SUNDAY DRIVES, **DORIS** AND **PAUL GOT HITCHED.** THE BRIDE WORE A BLUE SUIT AND A WHITE ORCHID. SHE WAS 45 YEARS OLD. HER GROOM, BORN IN 1900, WAS 49. HELEN SABO BROAD: "PAUL WAS VERY TALL AND HAD VERY **BIG FEET.** HE WAS OVER SIX FOOT, AND YOU KNOW DORIS — FIVE-FOOT-TWO, EYES OF BLUE."

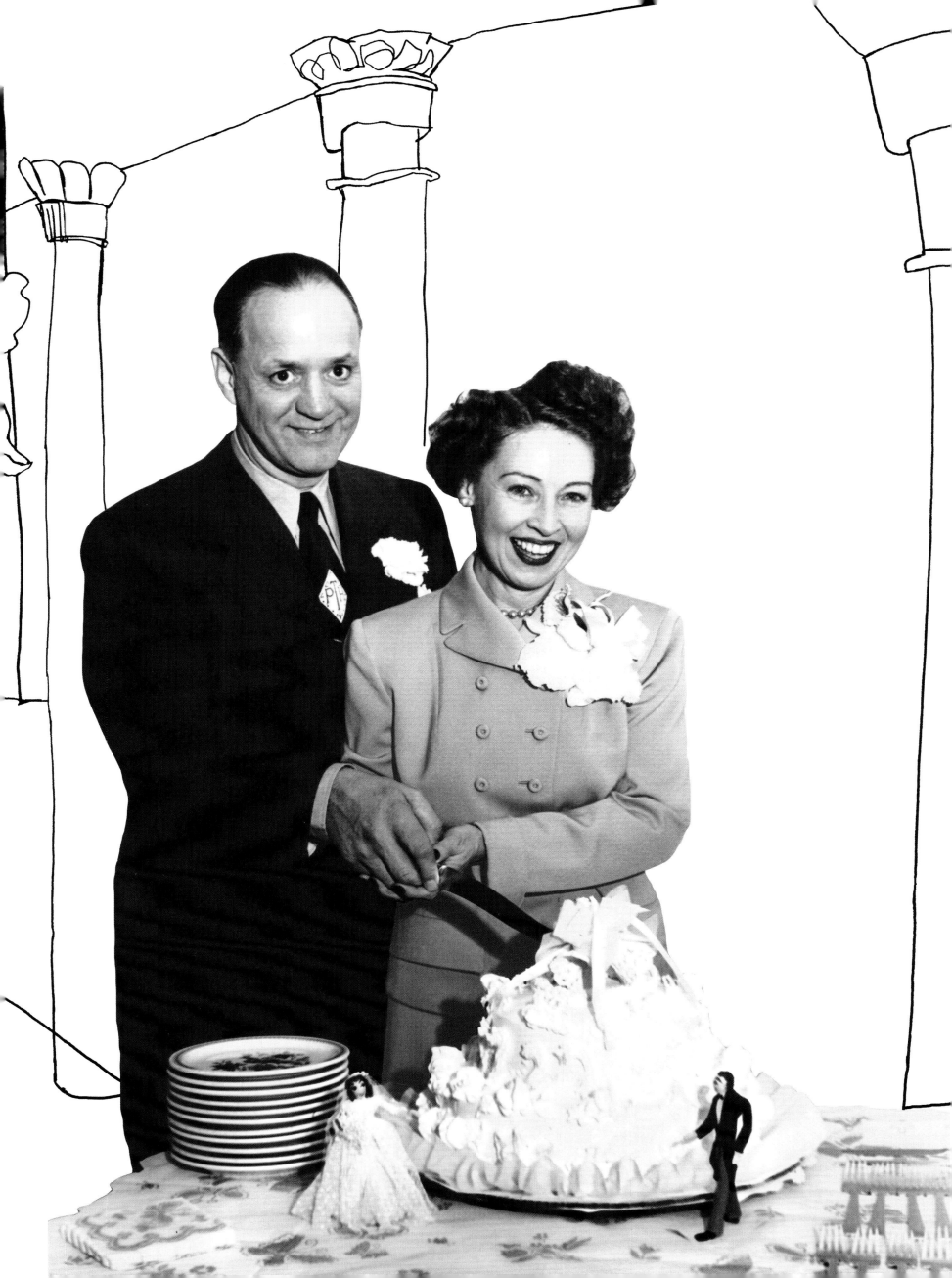

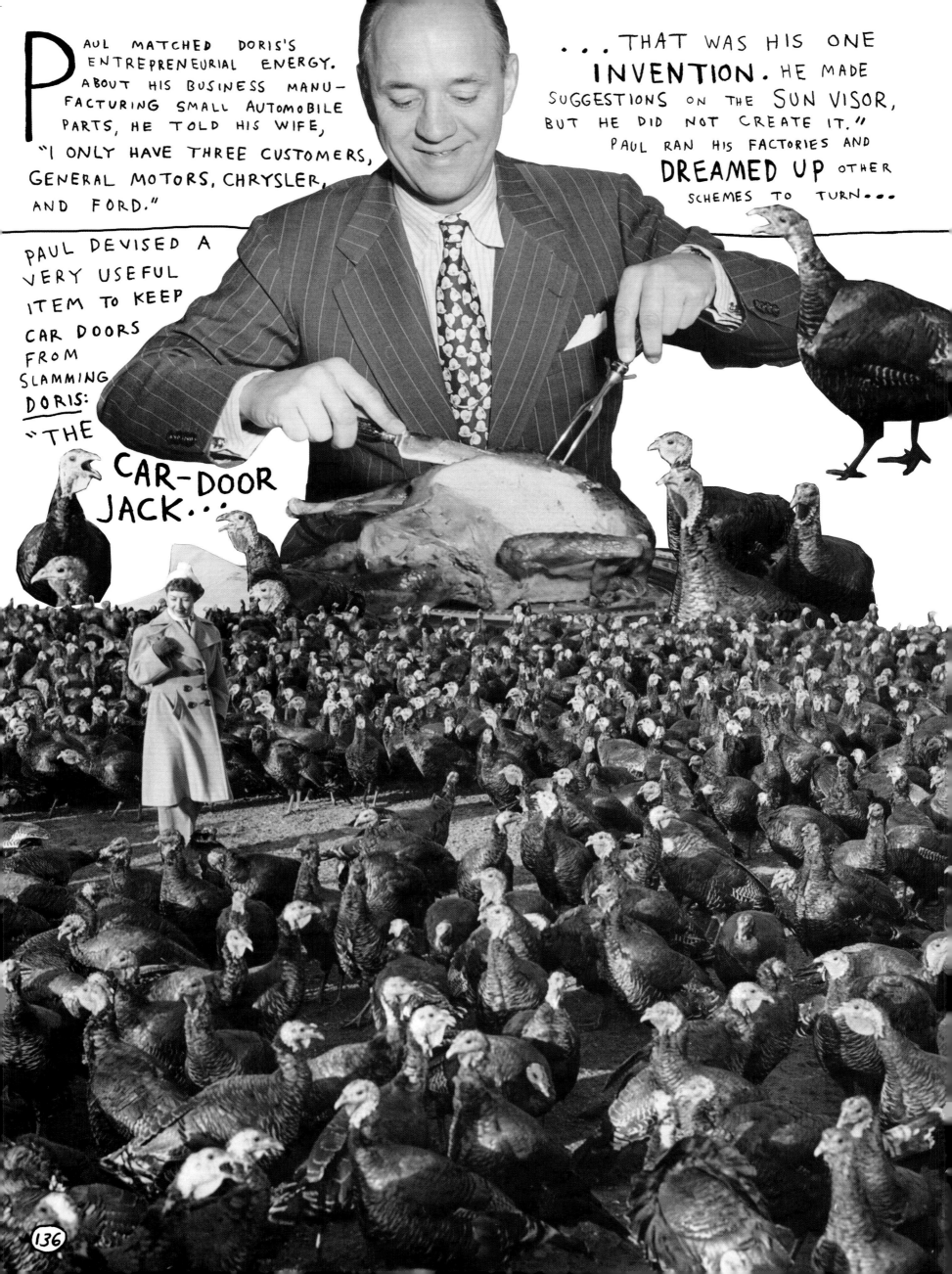

PAUL MATCHED DORIS'S ENTREPRENEURIAL ENERGY. ABOUT HIS BUSINESS MANUFACTURING SMALL AUTOMOBILE PARTS, HE TOLD HIS WIFE, "I ONLY HAVE THREE CUSTOMERS, GENERAL MOTORS, CHRYSLER, AND FORD."

PAUL DEVISED A VERY USEFUL ITEM TO KEEP CAR DOORS FROM SLAMMING DORIS: "THE CAR-DOOR JACK...

...THAT WAS HIS ONE **INVENTION**. HE MADE SUGGESTIONS ON THE SUN VISOR, BUT HE DID NOT CREATE IT." PAUL RAN HIS FACTORIES AND **DREAMED UP** OTHER SCHEMES TO TURN...

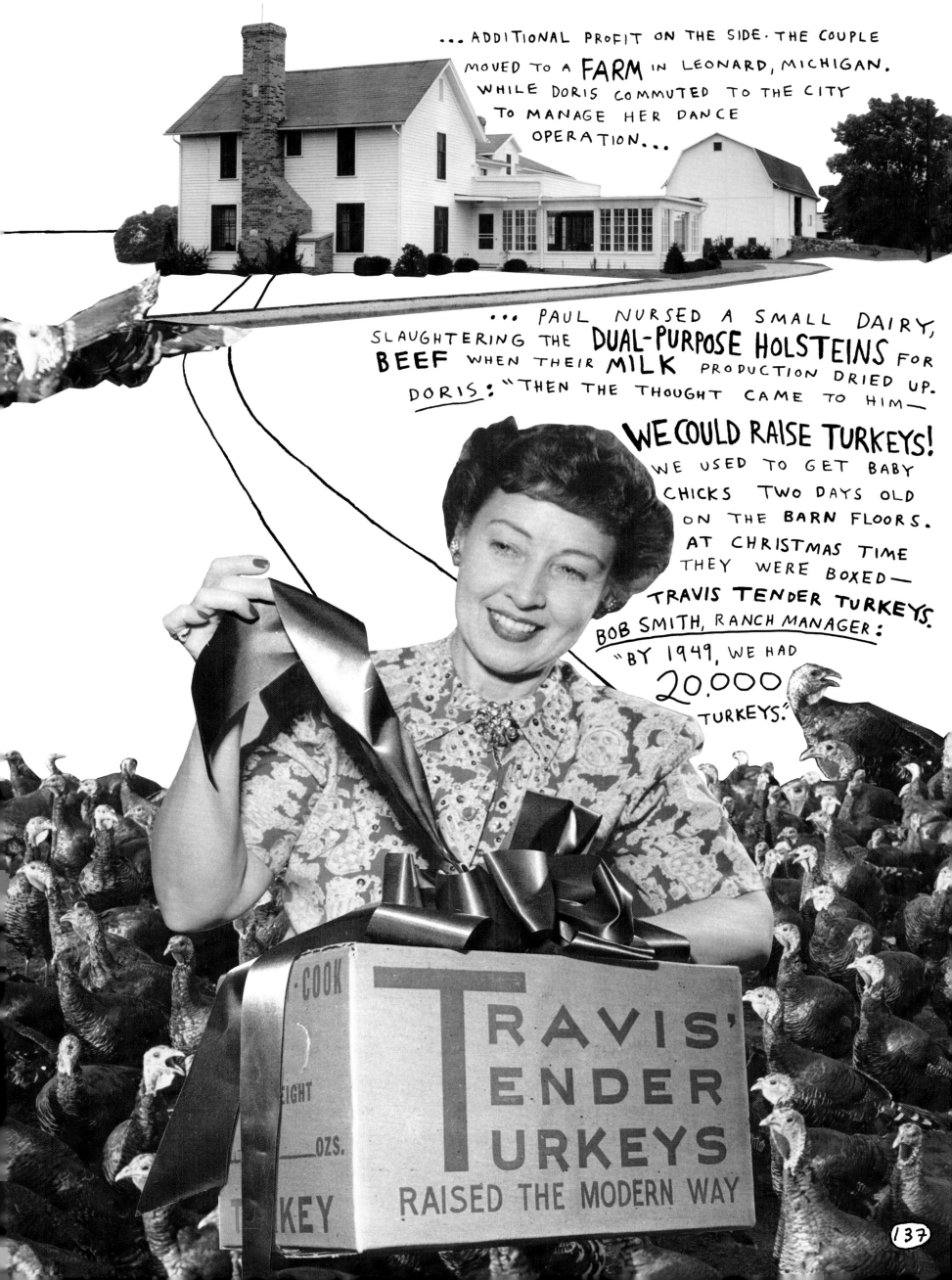

...ADDITIONAL PROFIT ON THE SIDE. THE COUPLE MOVED TO A **FARM** IN LEONARD, MICHIGAN. WHILE DORIS COMMUTED TO THE CITY TO MANAGE HER DANCE OPERATION...

...PAUL NURSED A SMALL DAIRY, SLAUGHTERING THE **DUAL-PURPOSE HOLSTEINS** FOR **BEEF** WHEN THEIR **MILK** PRODUCTION DRIED UP. DORIS: "THEN THE THOUGHT CAME TO HIM—

WE COULD RAISE TURKEYS! WE USED TO GET BABY CHICKS TWO DAYS OLD ON THE BARN FLOORS. AT CHRISTMAS TIME THEY WERE BOXED— TRAVIS TENDER TURKEYS. BOB SMITH, RANCH MANAGER: "BY 1949, WE HAD **20,000** TURKEYS."

TRAVIS' TENDER TURKEYS RAISED THE MODERN WAY

· COOK

EIGHT

OZS.

TURKEY

(137)

THOUGH NOW MARRIED WITH A GROWING FLOCK, DORIS DID NOT FEEL LIKE SETTLING DOWN.

DORIS: "I TOOK MY BROTHER CHARLIE AND WE WENT TO RIO AND STUDIED THE SAMBA. WE WENT TO ARGENTINA AND STUDIED THE TANGO. WE STOPPED IN CUBA AND STUDIED THE RUMBA. WE'D GO TO NIGHTCLUBS OR DANCE HALLS AND WE'D GET UP ON THE FLOOR AND THE CUBANS WOULD MAKE A CIRCLE AROUND US. THEY WERE AMAZED AMERICANOS COULD DO THEIR DANCING."

CHARLIE HAD THE IDEA TO HOST ARTHUR MURRAY DANCE VACATIONS IN HAVANA. BY THE SUMMER OF 1950, THE PROGRAM WAS UP AND RUNNING OUT OF HAVANA'S HOTEL NACIONAL.

THE HOTEL, AN ELEGANT McKIM, MEAD & WHITE BUILDING WITH VIEWS OF THE STRAITS OF FLORIDA, WAS A STATELY PARLOR FOR CUBAN DICTATOR FULGENCIO BATISTA IT LENT A...

...TOUCH OF REFINEMENT TO HIS MEETINGS WITH AMERICAN MOBSTERS SUCH AS MEYER LANSKY AND LUCKY LUCIANO.

OTHER FAMOUS GUESTS INCLUDED ERNEST HEMINGWAY, AVA GARDNER, AND WINSTON CHURCHILL. CHARLIE EVEN BUMPED INTO HIS OLD FRIEND **JOHN WAYNE**.

DORIS: "JOHN SAID, 'CHARLIE, WHAT THE HECK ARE YOU DOING HERE?' AND CHARLIE ASKED HIM, 'YOU WANT TO LEARN TO RUMBA?'"

ARTHUR MURRAY INSTRUCTOR HELEN SABO BROAD: "WE MET **ERROL FLYNN** AND HIS SON, DOWN AT THE POOL."

WHILE CUBA UNDER BATISTA WAS DUBBED A 'LATIN LAS VEGAS,' POST-WAR AMERICA ALSO PLACED A GREATER EMPHASIS ON RECREATION, ALBEIT WITH A SELF-CONSCIOUSLY WHOLESOME BENT. TELEVISION WAS QUICKLY BECOMING A DOMINANT CULTURAL FORCE, WITH PROGRAMMING THAT PORTRAYED A PICTURE OF VIRTUE AND PRESCRIBED NORMALITY. LASSIE, FATHER KNOWS BEST, AND THE ADVENTURES OF OZZIE AND HARRIET, WERE AMONG THE SHOWS SETTING THE TONE.

SOCIAL DANCING PARTNERED EASILY WITH THIS AGENDA. THE ROLES OF MEN AND WOMEN WERE STRICTLY DEFINED, AND EACH MOVEMENT FELL IN LINE WITH A FAMILIAR PATTERN.

IT WAS ONLY NATURAL FOR DORIS EATON, WITH HER PERFORMANCE BACKGROUND AND CURRENT POSITION AS PROMINENT DIRECTOR OF MORE THAN A DOZEN DANCE STUDIOS, TO HOST HER OWN BROADCAST. DORIS: "I HAD MY OWN TELEVISION SHOW FOR SEVEN YEARS. IT WAS HALF AN HOUR, ONCE A WEEK, BEGINNING IN 1952."

hurl Stu Erwin into hilarious confusion, 7 . . .
6:45—Perry Como's solos include "Sweetheart of All My Dreams" and "Black Moonlight," 2.
7:00—A new series of Arthur Murray dance parties start with Emsee Doris Eaton Travis interviewing members of the Detroit Fashion Group, 4. "Mama" celebrates "Citizenship Day," 2.

Louis-Marciano bout, 4.
9:00—Jimmy Bivins vs. Cole heavyweight bout, 4. "Po an Alabama detective spru convicts, 2.
9:45—Dwight D. Eisenhower from Kansas City, 4.
10:00—"Black Spider"—"Ch Chinese Cat," 7.

Back on TV Channel 4 Tonight at 7

"At Arthur Murray's"

Doris Eaton Travis, Emcee,

Will Interview Mary Morgan, Regional Director of the Fashion Group, and Some of Her Famous Members. You'll Learn the Newest Tango Steps!

Be Sure to See the First Show of a New Series Featuring the Finest Social Dancing!

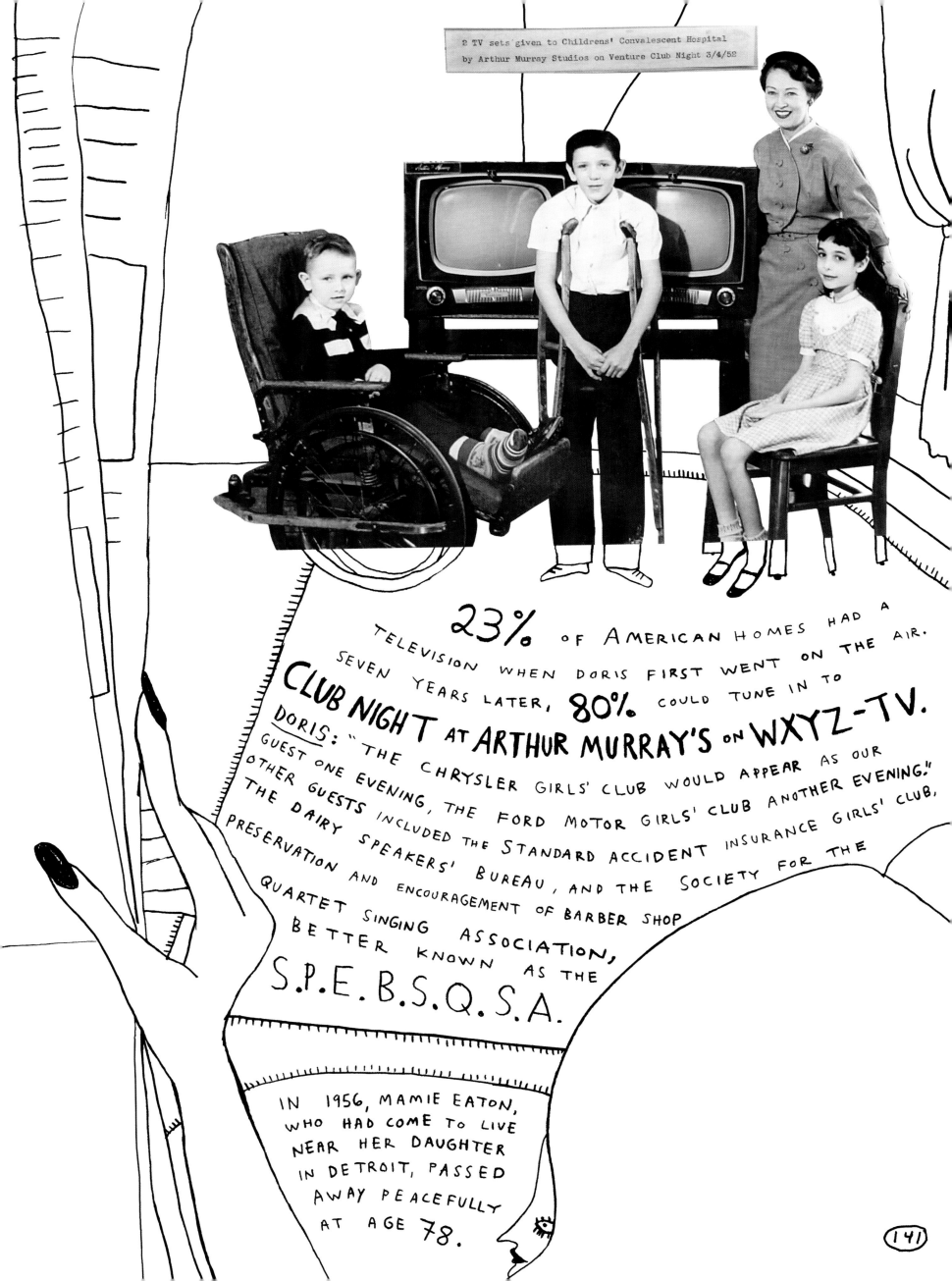

23% OF AMERICAN HOMES HAD A TELEVISION WHEN DORIS FIRST WENT ON THE AIR. SEVEN YEARS LATER, 80% COULD TUNE IN TO

CLUB NIGHT AT ARTHUR MURRAY'S ON WXYZ-TV.

DORIS: "THE CHRYSLER GIRLS' CLUB WOULD APPEAR AS OUR GUEST ONE EVENING, THE FORD MOTOR GIRLS' CLUB ANOTHER EVENING." OTHER GUESTS INCLUDED THE STANDARD ACCIDENT INSURANCE GIRLS' CLUB, THE DAIRY SPEAKERS' BUREAU, AND THE SOCIETY FOR THE PRESERVATION AND ENCOURAGEMENT OF BARBER SHOP QUARTET SINGING ASSOCIATION, BETTER KNOWN AS THE

S.P.E.B.S.Q.S.A.

IN 1956, MAMIE EATON, WHO HAD COME TO LIVE NEAR HER DAUGHTER IN DETROIT, PASSED AWAY PEACEFULLY AT AGE 78.

141

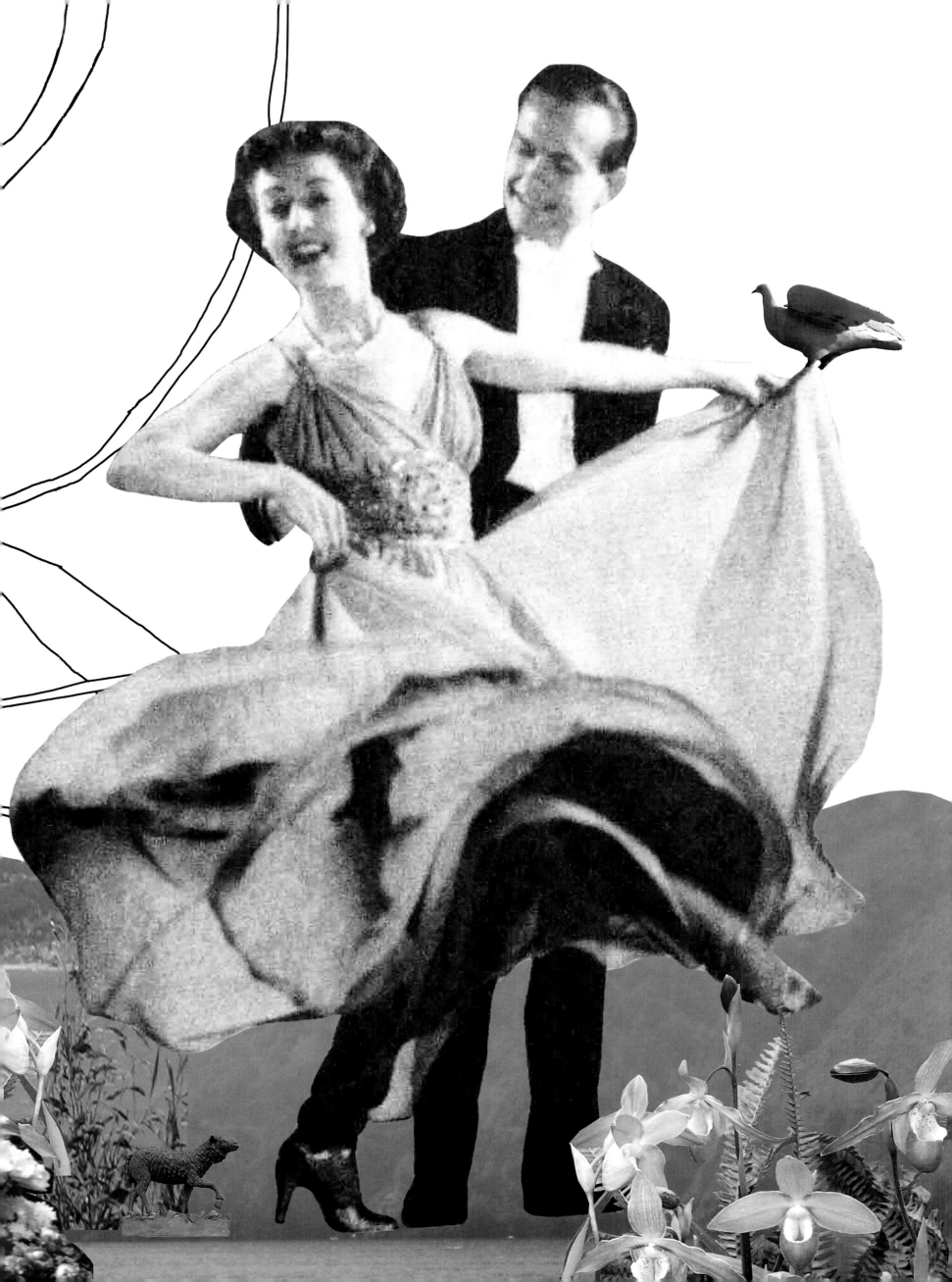

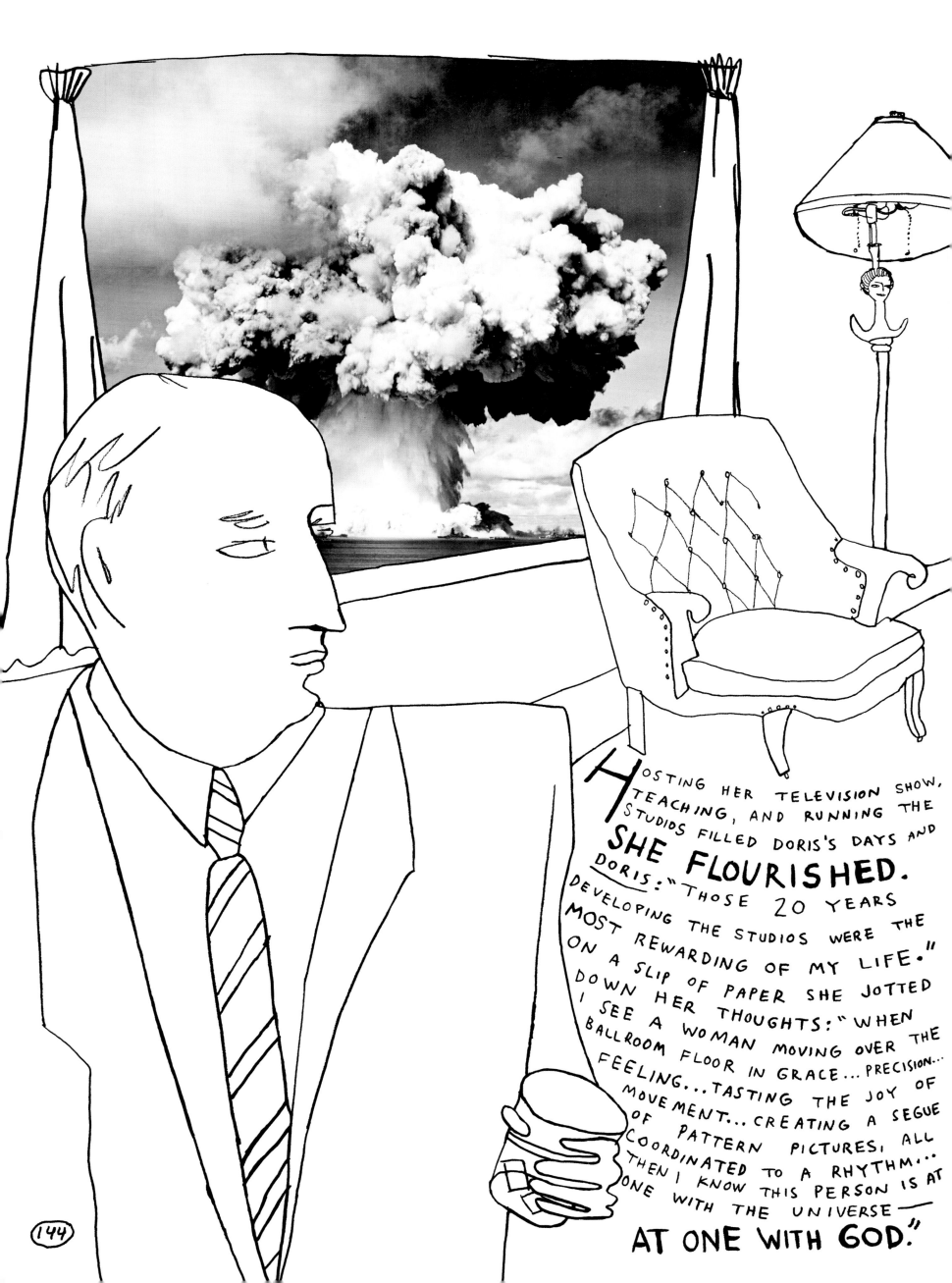

Hosting her television show, teaching, and running the studios filled Doris's days and **SHE FLOURISHED.** DORIS: "THOSE 20 YEARS DEVELOPING THE STUDIOS WERE THE MOST REWARDING OF MY LIFE." ON A SLIP OF PAPER SHE JOTTED DOWN HER THOUGHTS: "WHEN I SEE A WOMAN MOVING OVER THE BALLROOM FLOOR IN GRACE...PRECISION... FEELING...TASTING THE JOY OF MOVEMENT...CREATING A SEGUE OF PATTERN PICTURES, ALL COORDINATED TO A RHYTHM... THEN I KNOW THIS PERSON IS AT ONE WITH THE UNIVERSE— **AT ONE WITH GOD."**

DORIS THREW LAVISH GALAS, ARRANGED DANCE CRUISES TO SOUTH AMERICA AND EUROPE, AND OVERSAW BEAUTY PAGEANTS.

BUT THE PARTY WAS INTERRUPTED.

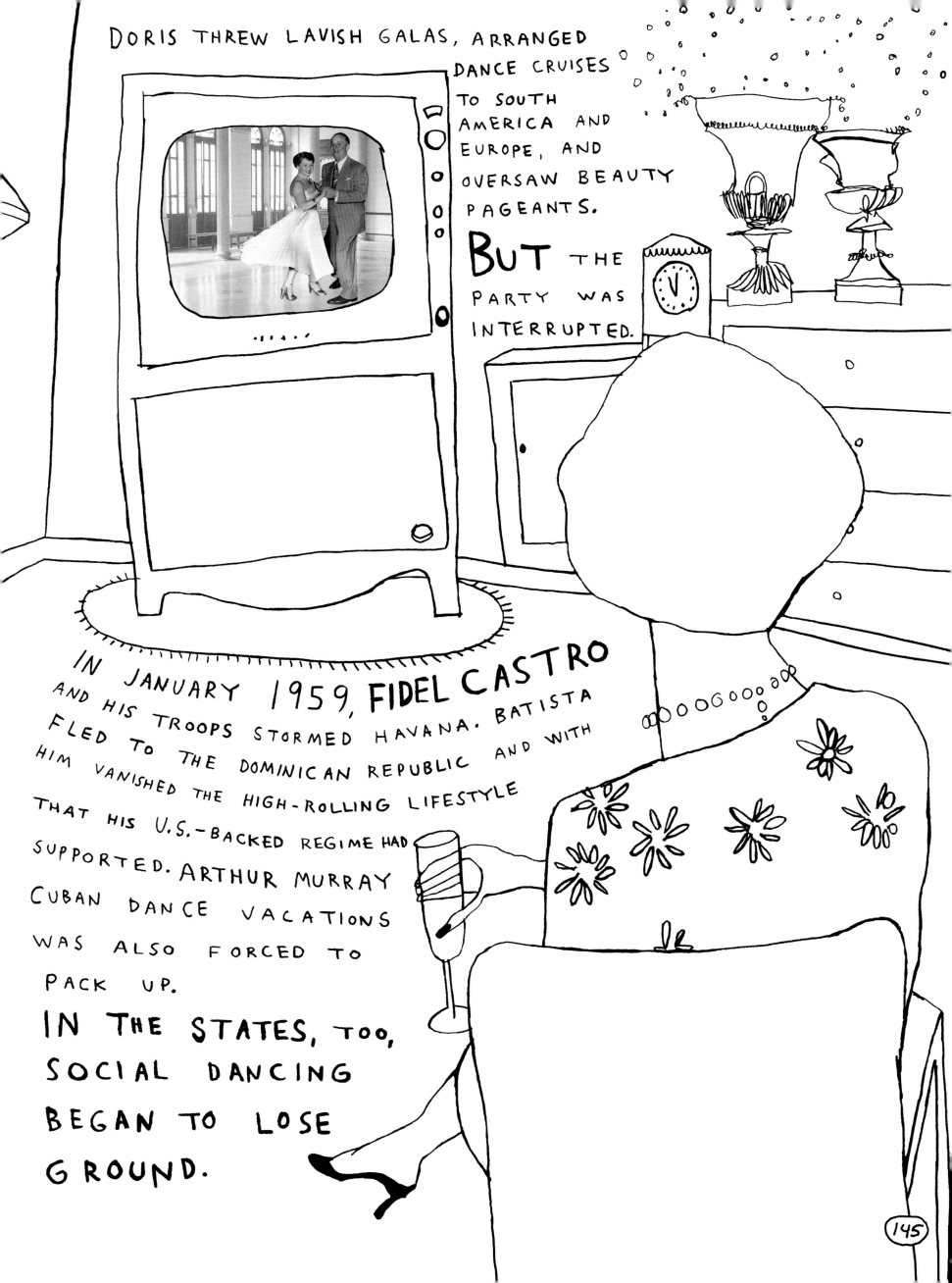

IN JANUARY 1959, FIDEL CASTRO AND HIS TROOPS STORMED HAVANA. BATISTA FLED TO THE DOMINICAN REPUBLIC AND WITH HIM VANISHED THE HIGH-ROLLING LIFESTYLE THAT HIS U.S.-BACKED REGIME HAD SUPPORTED. ARTHUR MURRAY CUBAN DANCE VACATIONS WAS ALSO FORCED TO PACK UP.

IN THE STATES, TOO, SOCIAL DANCING BEGAN TO LOSE GROUND.

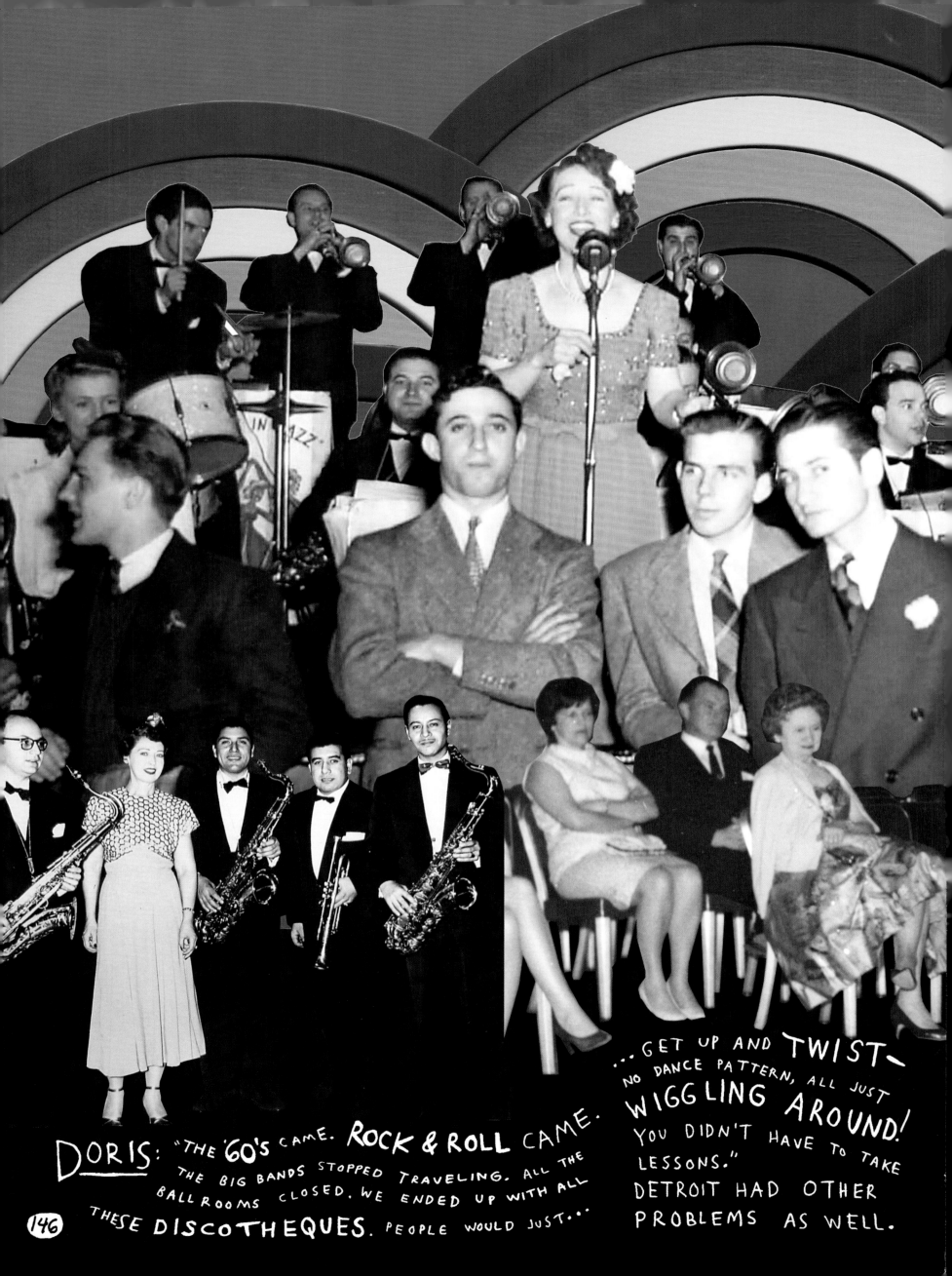

DORIS: "THE '60's CAME. ROCK & ROLL CAME. THE BIG BANDS STOPPED TRAVELING. ALL THE BALLROOMS CLOSED. WE ENDED UP WITH ALL THESE DISCOTHEQUES. PEOPLE WOULD JUST... GET UP AND TWIST— NO DANCE PATTERN, ALL JUST WIGGLING AROUND! YOU DIDN'T HAVE TO TAKE LESSONS." DETROIT HAD OTHER PROBLEMS AS WELL.

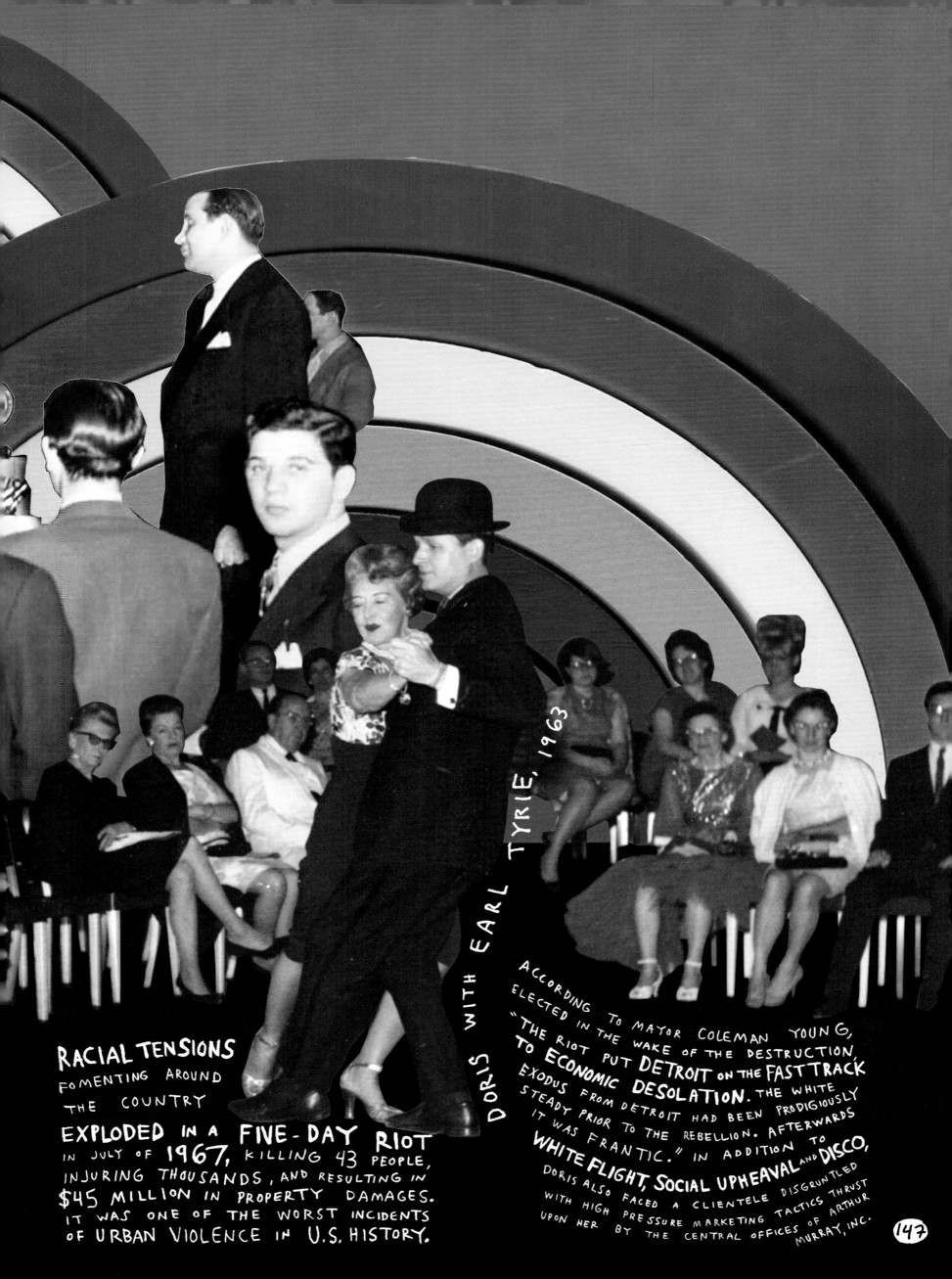

DORIS WITH EARL TYRIE, 1963

RACIAL TENSIONS FOMENTING AROUND THE COUNTRY EXPLODED IN A FIVE-DAY RIOT IN JULY OF 1967, KILLING 43 PEOPLE, INJURING THOUSANDS, AND RESULTING IN $45 MILLION IN PROPERTY DAMAGES. IT WAS ONE OF THE WORST INCIDENTS OF URBAN VIOLENCE IN U.S. HISTORY.

ACCORDING TO MAYOR COLEMAN YOUNG, ELECTED IN THE WAKE OF THE DESTRUCTION, "THE RIOT PUT DETROIT ON THE FAST TRACK TO ECONOMIC DESOLATION. THE WHITE EXODUS FROM DETROIT HAD BEEN PRODIGIOUSLY STEADY PRIOR TO THE REBELLION. AFTERWARDS IT WAS FRANTIC." IN ADDITION TO WHITE FLIGHT, SOCIAL UPHEAVAL AND DISCO, DORIS ALSO FACED A CLIENTELE DISGRUNTLED WITH HIGH PRESSURE MARKETING TACTICS THRUST UPON HER BY THE CENTRAL OFFICES OF ARTHUR MURRAY, INC.

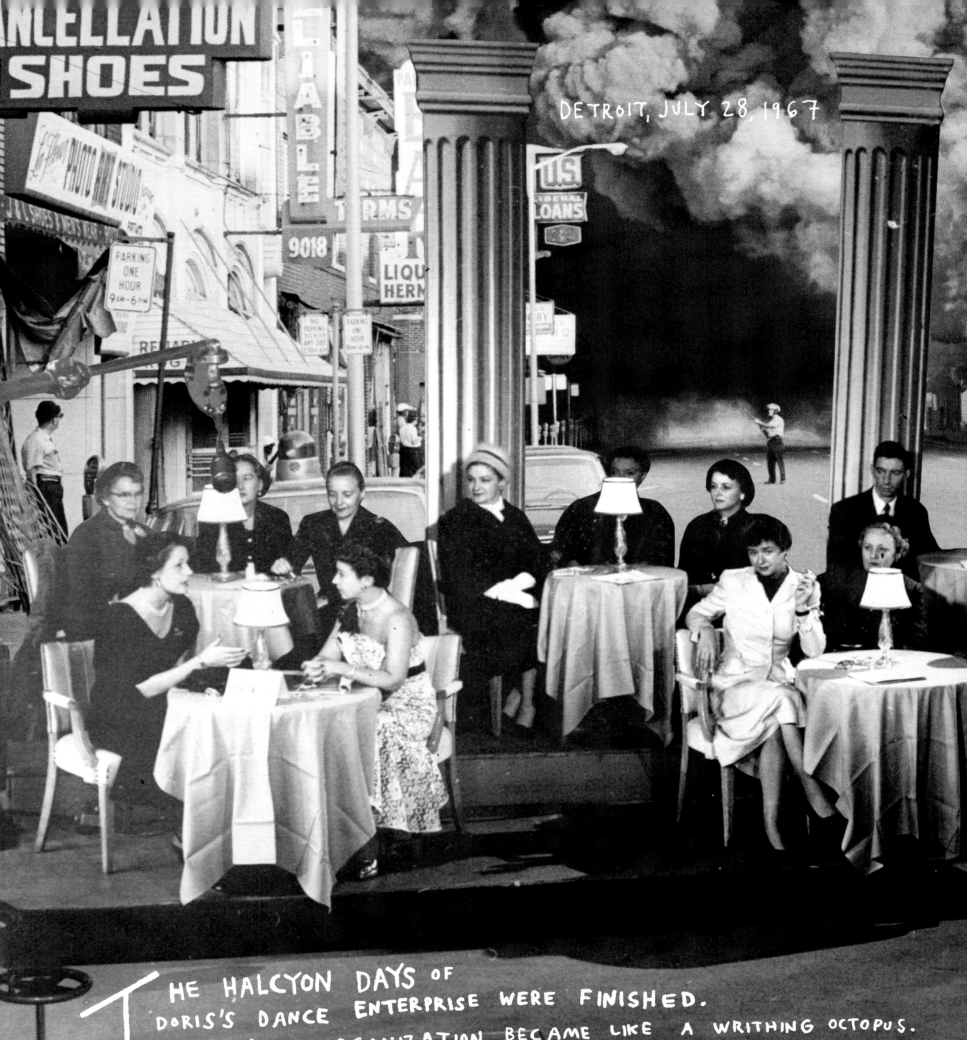

DETROIT, JULY 28, 1967

THE HALCYON DAYS OF DORIS'S DANCE ENTERPRISE WERE FINISHED. DORIS: "THE ORGANIZATION BECAME LIKE A WRITHING OCTOPUS. I NO SOONER GOT ONE ARM FROM AROUND MY NECK THEN ANOTHER WRAPPED AROUND. I WAS IN A LOSING BATTLE." PAUL LENT HER $250,000 AND SHE EXTRICATED HERSELF, SETTLING LAWSUITS AND BEGINNING TO SELL OFF HER STUDIOS. AT 63 YEARS OLD, DORIS EATON WAS YET AGAIN STARTING OVER.

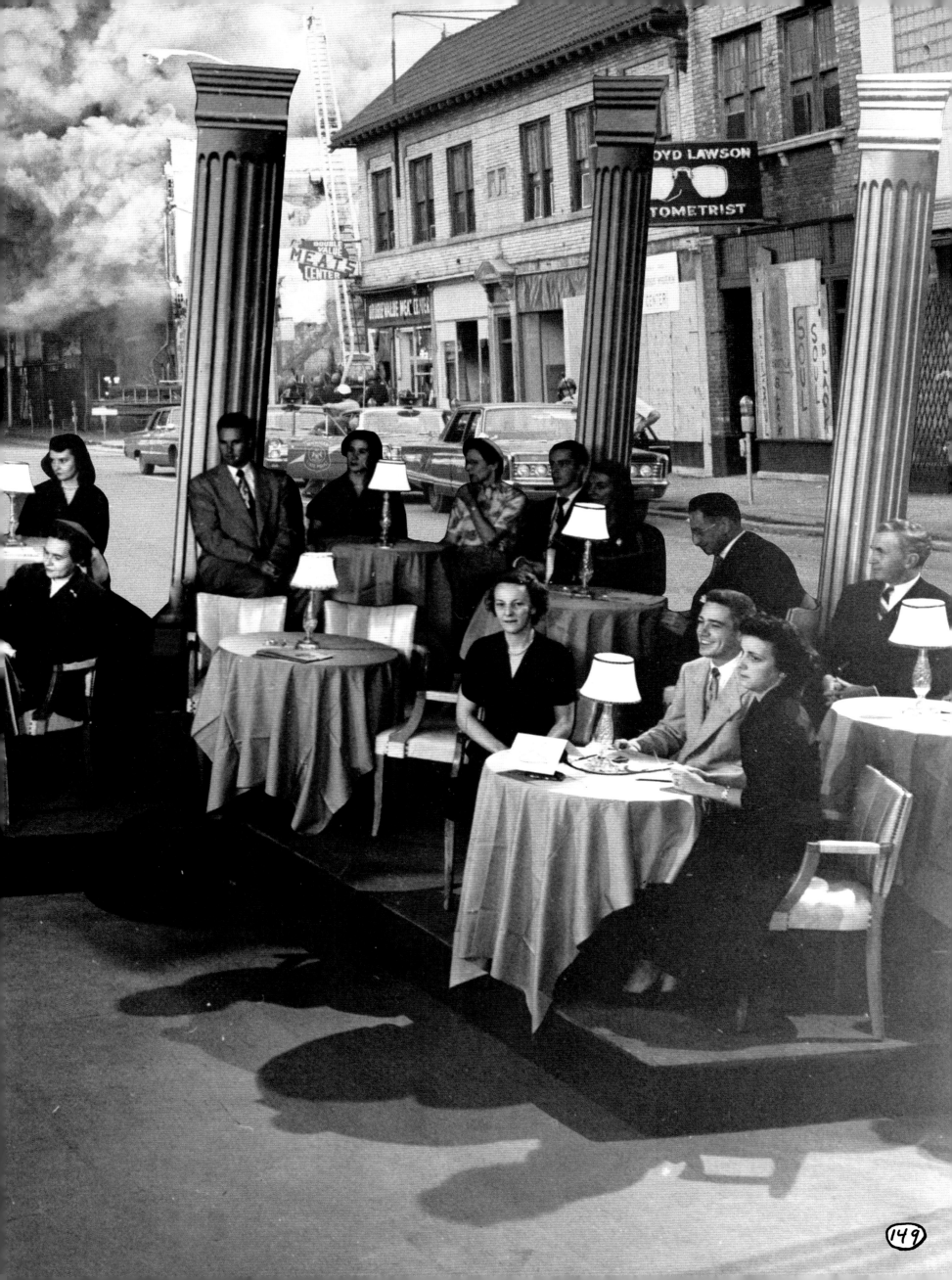

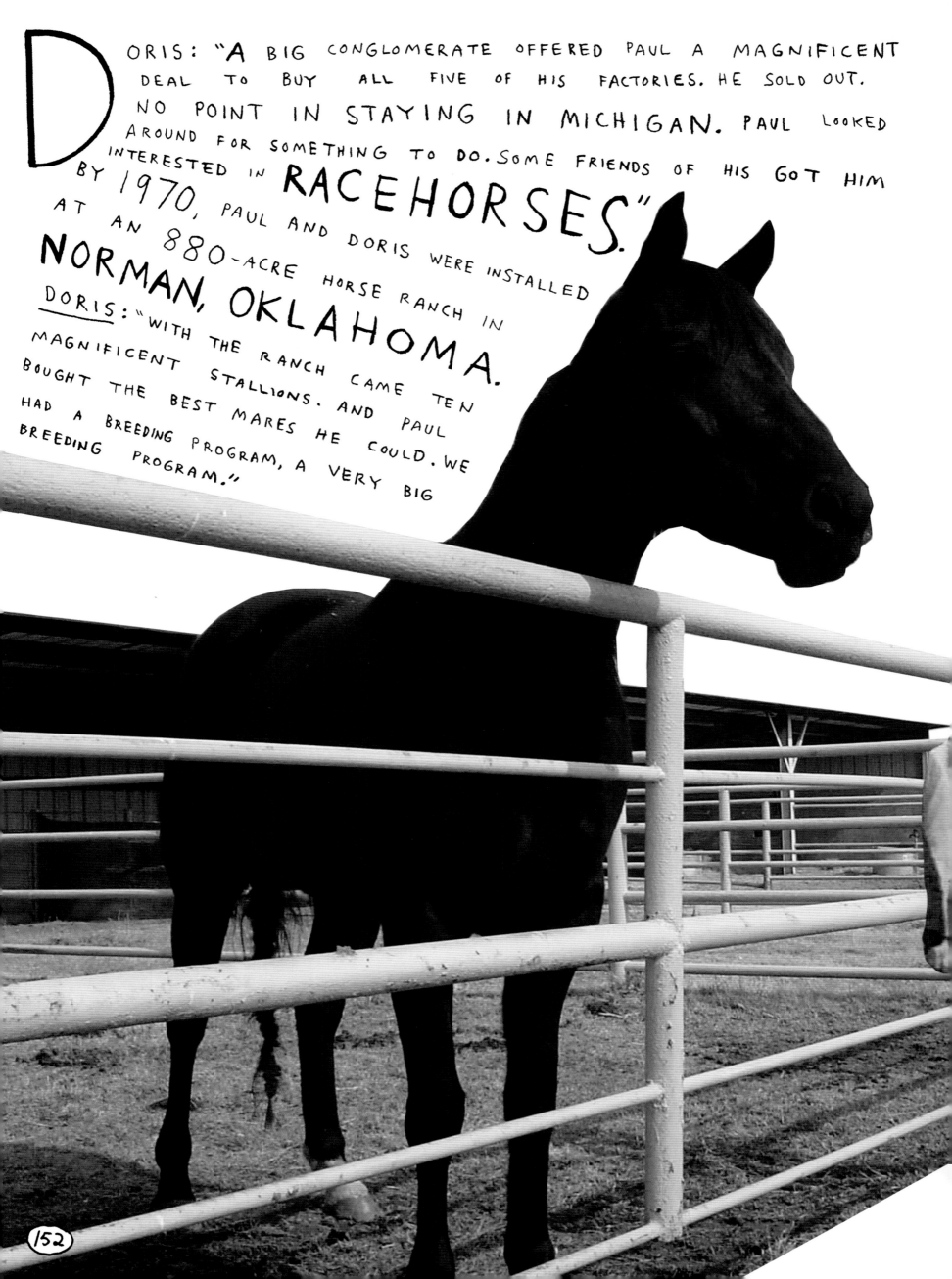

DORIS: "A BIG CONGLOMERATE OFFERED PAUL A MAGNIFICENT DEAL TO BUY ALL FIVE OF HIS FACTORIES. HE SOLD OUT. NO POINT IN STAYING IN MICHIGAN. PAUL LOOKED AROUND FOR SOMETHING TO DO. SOME FRIENDS OF HIS GOT HIM INTERESTED IN RACEHORSES."

BY 1970, PAUL AND DORIS WERE INSTALLED AT AN 880-ACRE HORSE RANCH IN NORMAN, OKLAHOMA.

DORIS: "WITH THE RANCH CAME TEN MAGNIFICENT STALLIONS. AND PAUL BOUGHT THE BEST MARES HE COULD. WE HAD A BREEDING PROGRAM, A VERY BIG BREEDING PROGRAM."

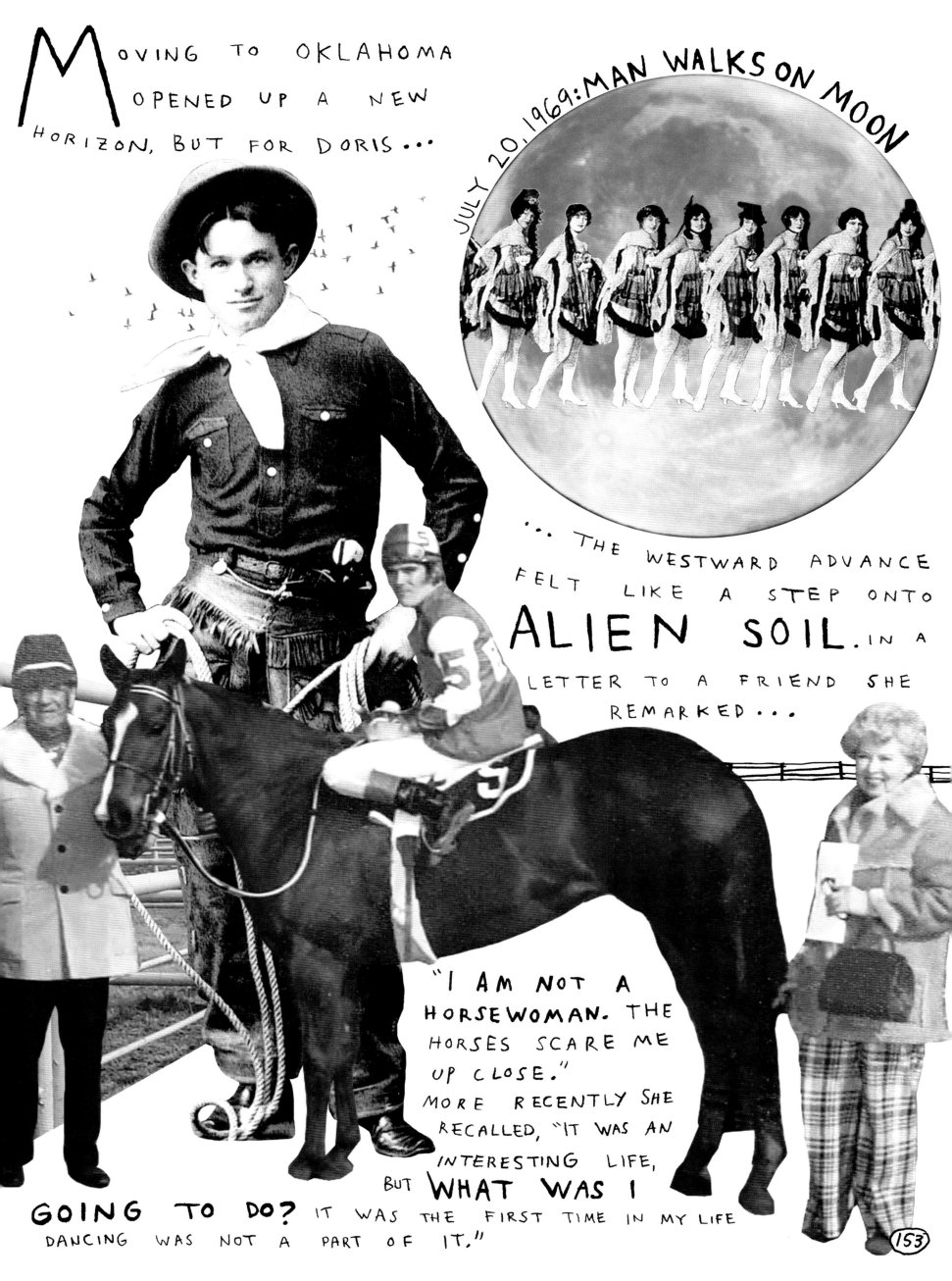

Moving to Oklahoma opened up a new horizon, but for Doris...

JULY 20, 1969: MAN WALKS ON MOON

... THE WESTWARD ADVANCE FELT LIKE A STEP ONTO ALIEN SOIL. IN A LETTER TO A FRIEND SHE REMARKED...

"I AM NOT A HORSEWOMAN. THE HORSES SCARE ME UP CLOSE." MORE RECENTLY SHE RECALLED, "IT WAS AN INTERESTING LIFE, BUT WHAT WAS I GOING TO DO? IT WAS THE FIRST TIME IN MY LIFE DANCING WAS NOT A PART OF IT."

Losing dancing and financial independence contributed to Doris's ambivalence about life in Oklahoma. Despite the trappings of domestic contentment, a certain malaise hung over her. Just a few years earlier BETTY FRIEDAN had identified this "ACHING DISSATISFACTION" among married women as a "PROBLEM THAT HAS NO NAME" in her groundbreaking 1963 book THE FEMININE MYSTIQUE.

IN 1969, FRIEDAN'S OWN MARRIAGE CRUMBLED. PAUL AND DORIS FALTERED, TOO. PAUL WAS ANGRY ABOUT THE COLLAPSE OF DORIS'S STUDIOS, AND, THOUGH SHE REPAID HIM, RESENTFUL ABOUT THE LARGE SUM HE HAD LOANED HER. PAUL COOLED TO HIS WIFE, FILLING HER WITH LONGING AND DISQUIET. ON A SCRAP OF PAPER SHE WROTE PAUL A NOTE HE WOULD NEVER SEE:

"DEAR, I KNOW I AM NOT THE IMAGE THAT USED TO STAND BEFORE YOU— FRESH LOOKING— IN THE PRIME OF MY WOMANHOOD PHYSICALLY... MY ARMS FALLEN IN FLESHY LOOPS FROM THE BONE, THE ROSY-CHEEKED, MILK-WHITE COMPLEXION ON WHICH I USED TO BE SO COMPLIMENTED— IT WAS LIKE MY MOTHER'S— IS NOW A PALE BEIGE. BUT I HAVE LEFT MY ENTHUSIASM FOR YOUR COMPANY. MY ENERGY IS UNFADING, MY MENTAL ABILITY STILL SHARP. AND THAT IS WHY IT HURTS SO TO THINK ABOUT US CHANGE SO DAMNABLY. SO ALL I CAN DO NOW WHEN WE GO OUT DANCING IS TO HOPE THE MUSIC AND THE DANCING, WHICH IS QUITE...

"...AS DELIGHTFUL AS IT EVER WAS, WILL ENCHANT YOU SUFFICIENTLY THAT YOU MIGHT ONCE AGAIN **IMAGINE AS I DO.** BUT FOR **THE WAY IT WAS.**"

THE "WAY IT WAS" REVOLVED AROUND THE DANCE FLOOR, SO DORIS LOOKED IN NORMAN FOR PLACES WHERE THEY COULD AGAIN STEP OUT.

<u>DORIS</u>: "WE LEARNED THE COUNTRY WESTERN DANCES — THE DUCHESS, SLAPPIN' LEATHER, COTTON-EYED JOE."

DESPITE THE TENSION, DANCING KEPT DORIS AND PAUL NEVER MORE THAN AN ARM'S LENGTH APART PREVENTING COMPLETE ESTRANGEMENT, AND EVEN BEGINNING TO

REBUILD THEIR RELATIONSHIP.

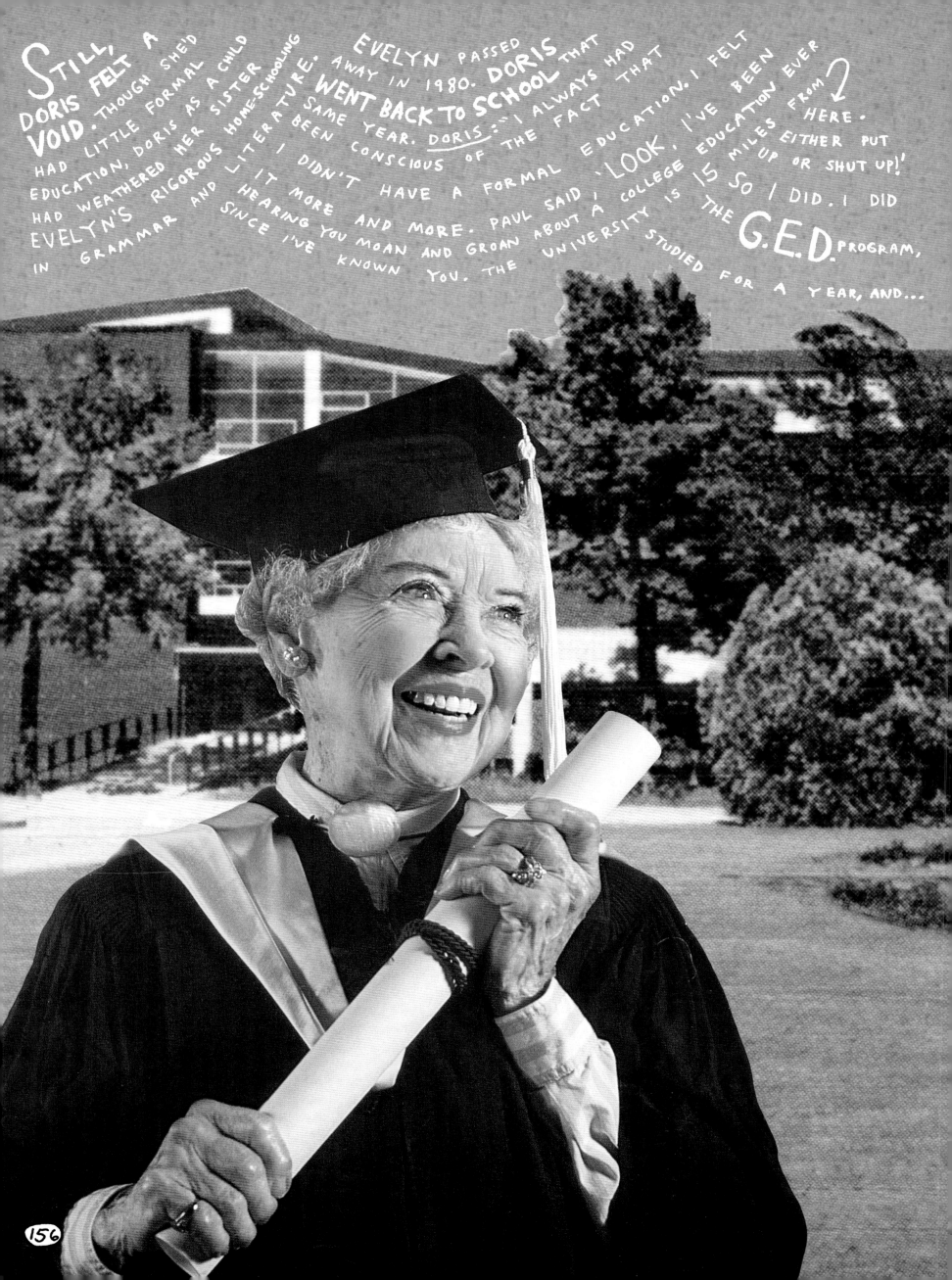

Still, Doris felt a void. Though she'd had little formal education, Doris as a child had weathered her sister Evelyn's rigorous homeschooling in grammar and literature. Evelyn passed away in 1980. Doris went back to school that same year. Doris: "I always had been conscious of the fact that I didn't have a formal education. I felt it more and more. Paul said, 'Look, I've been hearing you moan and groan about a college education ever since I've known you. The university is 15 miles from here. So I did. I did either put up or shut up!' So I did. I did the G.E.D. program, studied for a year, and...

156

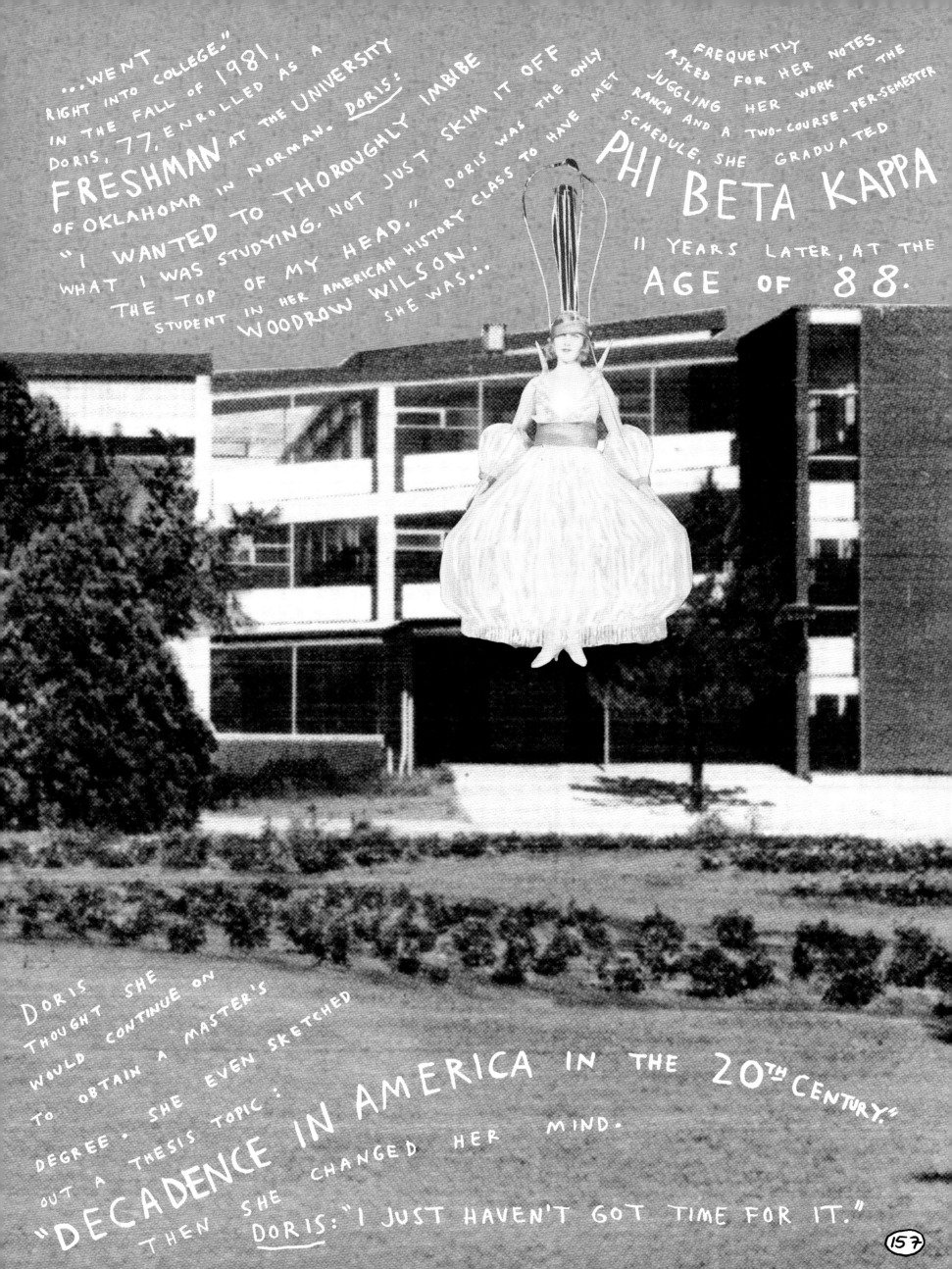

...WENT RIGHT INTO COLLEGE." IN THE FALL OF 1981, DORIS, 77, ENROLLED AS A FRESHMAN AT THE UNIVERSITY OF OKLAHOMA IN NORMAN. DORIS: "I WANTED TO THOROUGHLY IMBIBE WHAT I WAS STUDYING, NOT JUST SKIM IT OFF THE TOP OF MY HEAD." DORIS WAS THE ONLY STUDENT IN HER AMERICAN HISTORY CLASS TO HAVE MET WOODROW WILSON. SHE WAS... FREQUENTLY ASKED FOR HER NOTES. JUGGLING HER WORK AT THE RANCH AND A TWO-COURSE-PER-SEMESTER SCHEDULE, SHE GRADUATED PHI BETA KAPPA 11 YEARS LATER, AT THE AGE OF 88.

DORIS THOUGHT SHE WOULD CONTINUE ON TO OBTAIN A MASTER'S DEGREE. SHE EVEN SKETCHED OUT A THESIS TOPIC: "DECADENCE IN AMERICA IN THE 20TH CENTURY." THEN SHE CHANGED HER MIND. DORIS: "I JUST HAVEN'T GOT TIME FOR IT."

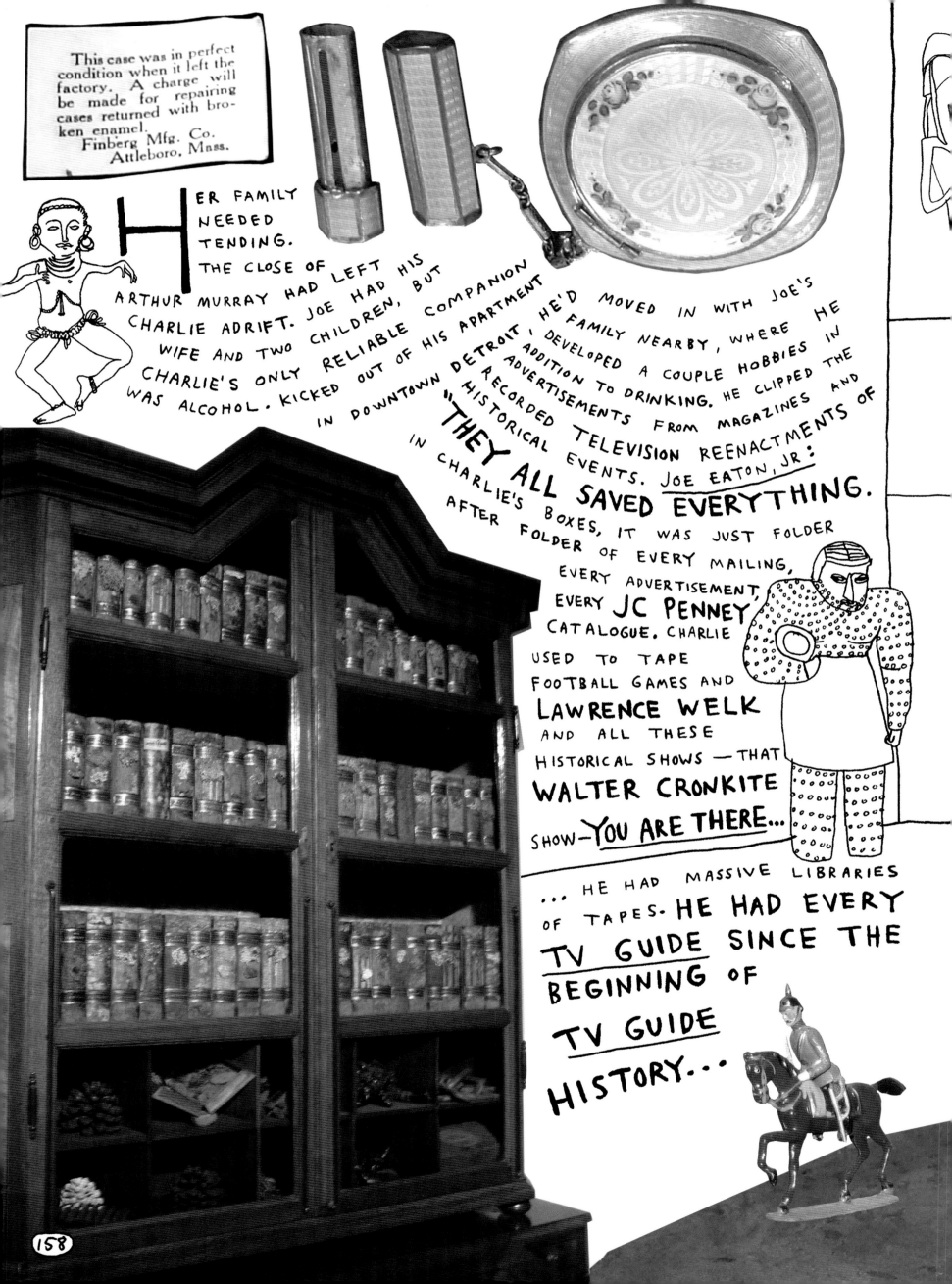

HER FAMILY NEEDED TENDING. THE CLOSE OF ARTHUR MURRAY HAD LEFT CHARLIE ADRIFT. JOE HAD HIS WIFE AND TWO CHILDREN, BUT CHARLIE'S ONLY RELIABLE COMPANION WAS ALCOHOL. KICKED OUT OF HIS APARTMENT IN DOWNTOWN DETROIT, HE'D MOVED IN WITH JOE'S FAMILY NEARBY, WHERE HE DEVELOPED A COUPLE HOBBIES IN ADDITION TO DRINKING. HE CLIPPED THE ADVERTISEMENTS FROM MAGAZINES AND RECORDED TELEVISION REENACTMENTS OF HISTORICAL EVENTS. JOE EATON, JR:

"THEY ALL SAVED EVERYTHING. IN CHARLIE'S BOXES, IT WAS JUST FOLDER AFTER FOLDER OF EVERY MAILING, EVERY ADVERTISEMENT, EVERY JC PENNEY CATALOGUE. CHARLIE USED TO TAPE FOOTBALL GAMES AND LAWRENCE WELK AND ALL THESE HISTORICAL SHOWS — THAT WALTER CRONKITE SHOW — YOU ARE THERE...

... HE HAD MASSIVE LIBRARIES OF TAPES. HE HAD EVERY TV GUIDE SINCE THE BEGINNING OF TV GUIDE HISTORY...

"... THERE COULD BE TWO OR THREE MISSING, BUT KNOWING HIM, IT'S UNLIKELY."

IN 2000, DORIS...

...BROUGHT CHARLIE TO LIVE ON TRAVIS RANCH. SHE BUILT HIM A SUITE ATTACHED TO THE HOUSE.

159

RED SILK KERCHIEFS
12-PR, RED L&R PRESS - BEIGE NET
PR, SATIN - PINK - TIGHTS

A Nekoosa Paper

duraflame
ONE FIREPLACE LOG FLAMES 2
CONTENTS 4 LOGS

duraflam

FRAGILE
HANDLE WITH CARE
DO NOT CRUSH

WALT DISNEY
FIGURINES
SMALL SHEEP
BUNNIES

MISC.

160

Mary Lee

Easter Greetings

Easter Greetings

MISC. CHICKENS
+ BUNNIES

conforming hat:

lipstick cal

Old Trinke

TRINKETS

mic COACHES

Daniel Green
COMFY
MADE IN U.S.A.

(161)

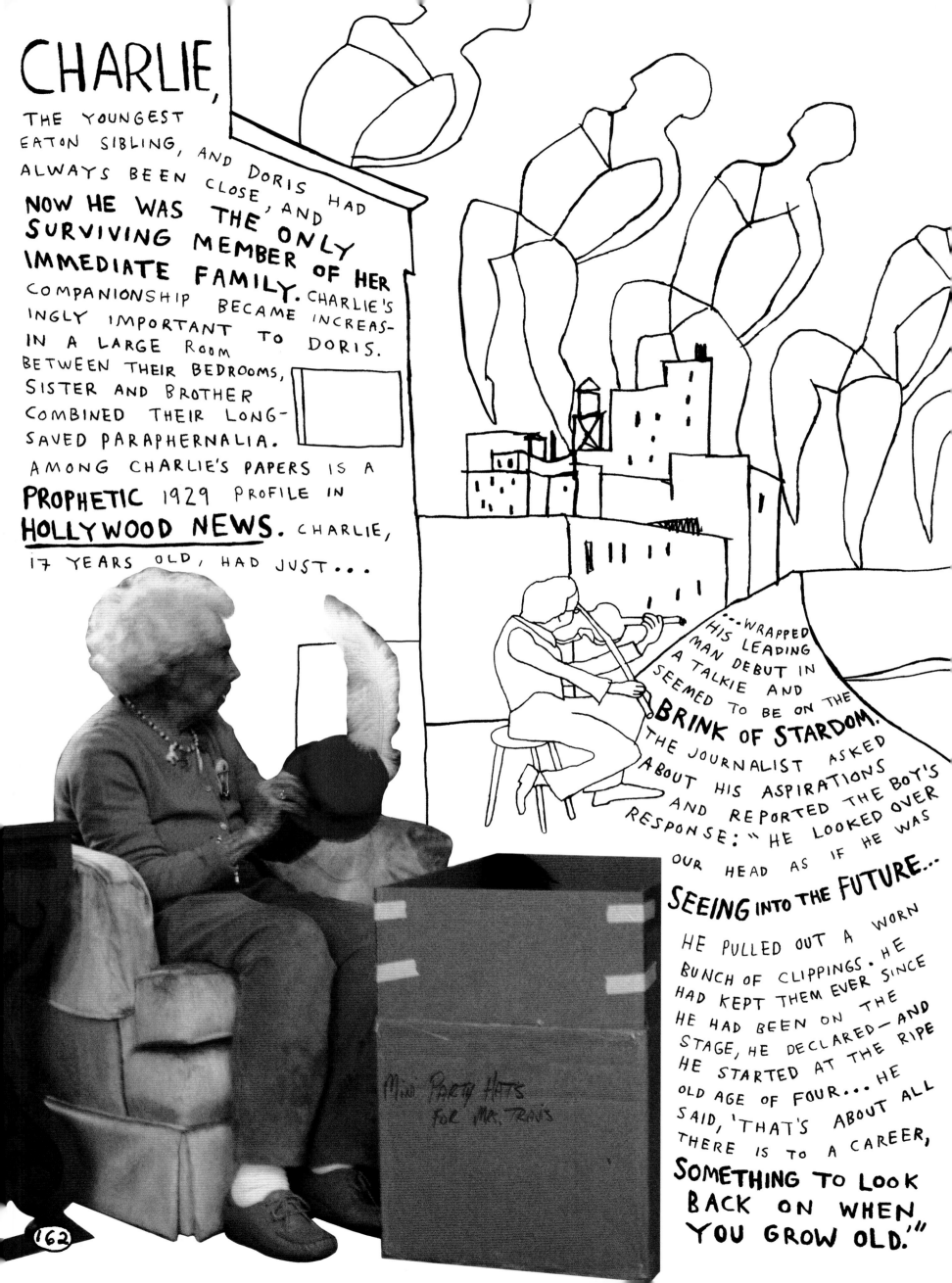

CHARLIE, THE YOUNGEST EATON SIBLING, AND DORIS HAD ALWAYS BEEN CLOSE, AND NOW HE WAS THE ONLY SURVIVING MEMBER OF HER IMMEDIATE FAMILY. CHARLIE'S COMPANIONSHIP BECAME INCREASINGLY IMPORTANT TO DORIS. IN A LARGE ROOM BETWEEN THEIR BEDROOMS, SISTER AND BROTHER COMBINED THEIR LONG-SAVED PARAPHERNALIA. AMONG CHARLIE'S PAPERS IS A PROPHETIC 1929 PROFILE IN HOLLYWOOD NEWS. CHARLIE, 17 YEARS OLD, HAD JUST...

...WRAPPED HIS LEADING MAN DEBUT IN A TALKIE AND SEEMED TO BE ON THE BRINK OF STARDOM. THE JOURNALIST ASKED ABOUT HIS ASPIRATIONS AND REPORTED THE BOY'S RESPONSE: "HE LOOKED OVER OUR HEAD AS IF HE WAS SEEING INTO THE FUTURE...

HE PULLED OUT A WORN BUNCH OF CLIPPINGS. HE HAD KEPT THEM EVER SINCE HE HAD BEEN ON THE STAGE, HE DECLARED—AND HE STARTED AT THE RIPE OLD AGE OF FOUR... HE SAID, 'THAT'S ABOUT ALL THERE IS TO A CAREER, SOMETHING TO LOOK BACK ON WHEN YOU GROW OLD.'"

Mini Party Hats for Mr. Travis

162

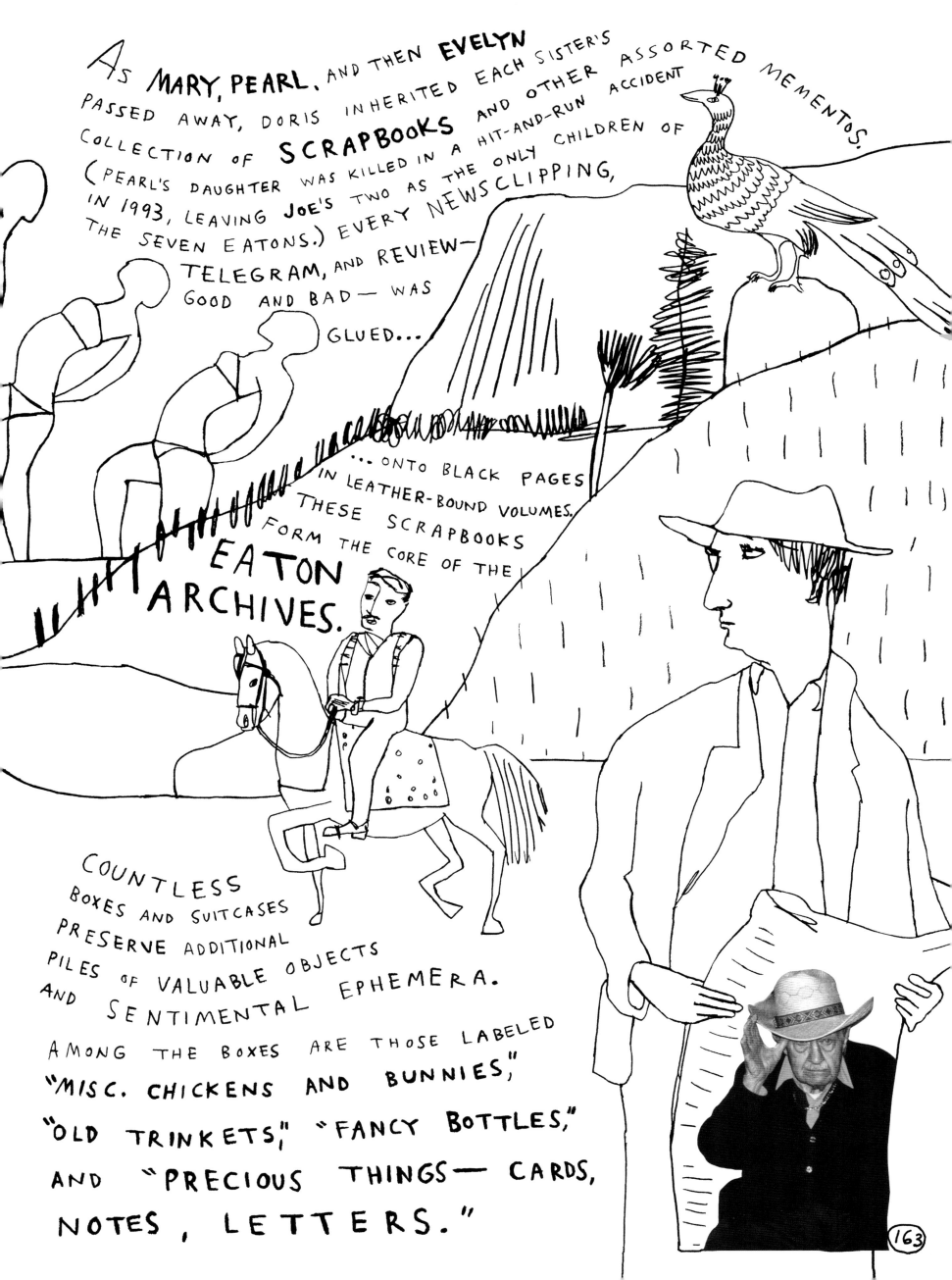

As MARY, PEARL, AND THEN EVELYN PASSED AWAY, DORIS INHERITED EACH SISTER'S COLLECTION OF **SCRAPBOOKS** AND OTHER ASSORTED MEMENTOS. (PEARL'S DAUGHTER WAS KILLED IN A HIT-AND-RUN ACCIDENT IN 1993, LEAVING **JOE'S** TWO AS THE ONLY CHILDREN OF THE SEVEN EATONS.) EVERY NEWSCLIPPING, TELEGRAM, AND REVIEW— GOOD AND BAD— WAS GLUED...

...ONTO BLACK PAGES IN LEATHER-BOUND VOLUMES. THESE SCRAPBOOKS FORM THE CORE OF THE **EATON ARCHIVES.**

COUNTLESS BOXES AND SUITCASES PRESERVE ADDITIONAL PILES OF VALUABLE OBJECTS AND SENTIMENTAL EPHEMERA.

AMONG THE BOXES ARE THOSE LABELED "MISC. CHICKENS AND BUNNIES," "OLD TRINKETS," "FANCY BOTTLES," AND "PRECIOUS THINGS— CARDS, NOTES, LETTERS."

163

Stacks of souvenirs could not save Charlie from dementia. Age and alcoholism caught up with him, and he needed full-time care. Doris dubbed his room "CLUB CARLOS," and hung the walls with photos of his early days in show business, shots of doing the mambo in Havana, lead former flame Jeannie Winters in formation on the shelves. Doris looked after his health and his dignity, and made sure he had companionship.

EARL TYRIE: "I went out there in 2000 to be around Charlie and talk about the old times, to be a reminder of the old days, Havana, the night clubs we would go to — the TROPICANA, the SANS SOUCI, CLUB BAMBOO. Sometimes I would sing a little to bring back...

... things that he would remember — 'ESTOY TAN ENAMORADO CON LA NEGRA TOMASA.'"

DORIS'S husband, PAUL, was declining, too.

DORIS: "HE HAD A KNEE REPLACEMENT. WHEN HE WAS JUST BEGINNING TO WALK AGAIN BY HIMSELF, HE SLIPPED ON HIS SOCK AND BROKE HIS ANKLE. I FOUND HIM FLAT ON HIS BACK IN THE FOYER HERE, WITH ONE SHOE ON AND ONE SHOE OFF. FROM THEN ON IT WAS JUST DOWNHILL..."

"...ANYWAY, THOSE ARE THE THINGS YOU HAVE TO SEE YOURSELF THROUGH. THEY CANCELED THE COUNTRY WESTERN BAND AT THE CLUB. GRADUALLY WE SOLD OFF THE HORSES. SO YEAR AFTER YEAR IT DEPLETED UNTIL WE ENDED UP WITH ONE HORSE. FINALLY WE SOLD THAT TO SOMEONE UP IN CANADA.=

PAUL PASSED AWAY IN 2000. HELEN SABO BROAD WAS VISITING THE RANCH AT THE TIME. HELEN:

"WE DIDN'T EXPECT IT BUT WE KNEW IT WAS GOING TO HAPPEN...

...WHEN THEY TOOK HIM OUT IN THE GURNEY, IN THE AMBULANCE, DORIS STOOD AT THE DOOR. THERE WERE A COUPLE OF HORSES DOWN BY THE RAILING. THE CORONER'S LIMO JUST DROVE OFF AND THE HORSES LOOKED AT HER AND SHE WATCHED IT 'TIL THE END OF THE ROAD."

DORIS: "THE PASTURES WERE BEAUTIFUL AND WELL KEPT.

I DECIDED TO OPEN THE RANCH UP FOR BOARDING. I CALL IT TRAVIS RANCH NURSING HOME FOR HORSES."

165

JUST WHEN TIME SEEMED TO HAVE STOLEN THE LAST TRACE OF GLAMOUR FROM DORIS'S LIFE, THE TELEPHONE RANG AT TRAVIS RANCH.

DORIS EATON, ZIEGFELD GIRL

WAS WANTED BACK ON BROADWAY. DORIS: "THE NEW AMSTERDAM THEATRE HAD BEEN THROUGH RACK AND RUIN. THEN WALT DISNEY— THAT COMPANY— TOOK IT OVER AND RECONDITIONED IT." AFTER FOUR YEARS' LABOR AND SOME $36 MILLION INVESTED, THE HOME OF THE ZIEGFELD FOLLIES FROM 1913 TO 1927 WAS RESTORED TO ITS ORIGINAL RAZZLE-DAZZLE, GOLD-LACED, ALLEGORICAL FRIEZES, MOLDED-PLASTER PEACOCKS, AND CARVED OAK WAINSCOTTING WERE . . .

... RESURRECTED FROM THE RUBBLE OF NEGLECT AND DISREPUTE OF TIMES SQUARE'S PEEP SHOW DAYS. FOR THE OPENING GALA, OFFICIALS WANTED TO AUTHENTICATE THEIR METICULOUS WORK WITH ONE FINAL FLOURISH—ZIEGFELD GIRLS. OF THE HUNDREDS WHO HAD PERFORMED FOR FLORENZ ZIEGFELD, ONLY FIVE WERE STILL LIVING AND ABLE TO TO ATTEND. ON APRIL 2, 1997, 41ST STREET, FROM THE STAGE DOOR TO THE END OF THE BLOCK, WAS LAID WITH RED CARPET AND NEW YORK CITY MAYOR RUDOLPH GIULIANI INTRODUCED THE FORMER FOLLIES GIRLS, ALL IN THEIR 90'S.

DORIS: "I WAS THE ONLY ONE THAT COULD DANCE. SO I DID THE ROUTINE I DID IN 1919. IT WAS JUST UNBELIEVABLE THAT SUCH A THING WAS HAPPENING. I THOUGHT ABOUT IT—

'HERE I AM AGAIN, RIGHT WHERE I STARTED.'"

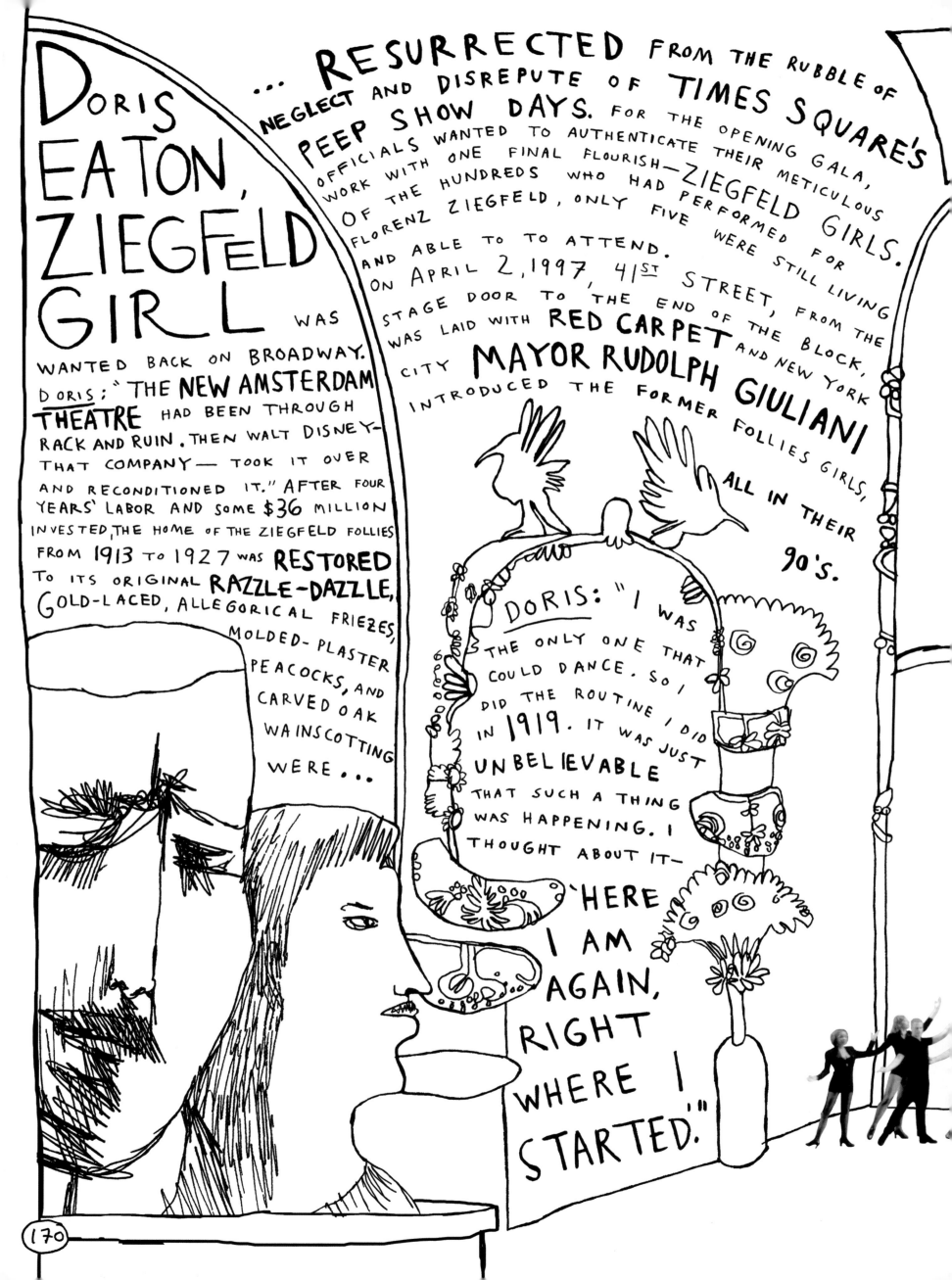

DORIS, 94 YEARS OLD, PERFORMED "MANDY," A SOFT SHOE TO MUSIC AND...

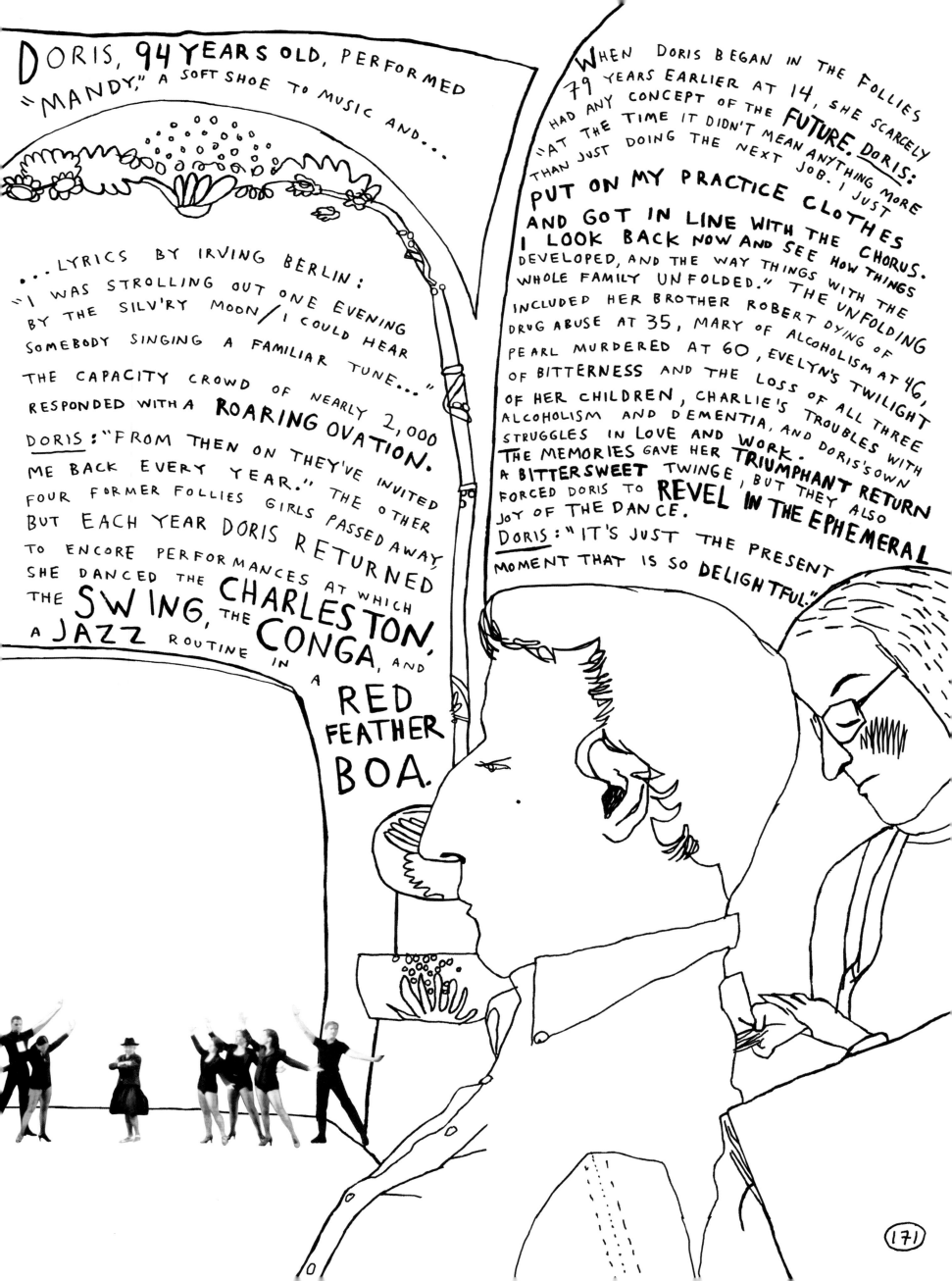

...LYRICS BY IRVING BERLIN: "I WAS STROLLING OUT ONE EVENING BY THE SILV'RY MOON / I COULD HEAR SOMEBODY SINGING A FAMILIAR TUNE..." THE CAPACITY CROWD OF NEARLY 2,000 RESPONDED WITH A ROARING OVATION. DORIS: "FROM THEN ON THEY'VE INVITED ME BACK EVERY YEAR." THE OTHER FOUR FORMER FOLLIES GIRLS PASSED AWAY, BUT EACH YEAR DORIS RETURNED TO ENCORE PERFORMANCES AT WHICH SHE DANCED THE CHARLESTON, THE SWING, THE CONGA, AND A JAZZ ROUTINE IN A RED FEATHER BOA.

WHEN DORIS BEGAN IN THE FOLLIES 79 YEARS EARLIER AT 14, SHE SCARCELY HAD ANY CONCEPT OF THE FUTURE. DORIS: "AT THE TIME IT DIDN'T MEAN ANYTHING MORE THAN JUST DOING THE NEXT JOB. I JUST PUT ON MY PRACTICE CLOTHES AND GOT IN LINE WITH THE CHORUS. I LOOK BACK NOW AND SEE HOW THINGS DEVELOPED, AND THE WAY THINGS WITH THE WHOLE FAMILY UNFOLDED." THE UNFOLDING INCLUDED HER BROTHER ROBERT DYING OF DRUG ABUSE AT 35, MARY OF ALCOHOLISM AT 46, PEARL MURDERED AT 60, EVELYN'S TWILIGHT OF BITTERNESS AND THE LOSS OF ALL THREE OF HER CHILDREN, CHARLIE'S TROUBLES WITH ALCOHOLISM AND DEMENTIA, AND DORIS'S OWN STRUGGLES IN LOVE AND WORK. THE MEMORIES GAVE HER TRIUMPHANT RETURN A BITTERSWEET TWINGE, BUT THEY ALSO FORCED DORIS TO REVEL IN THE EPHEMERAL JOY OF THE DANCE. DORIS: "IT'S JUST THE PRESENT MOMENT THAT IS SO DELIGHTFUL."

171

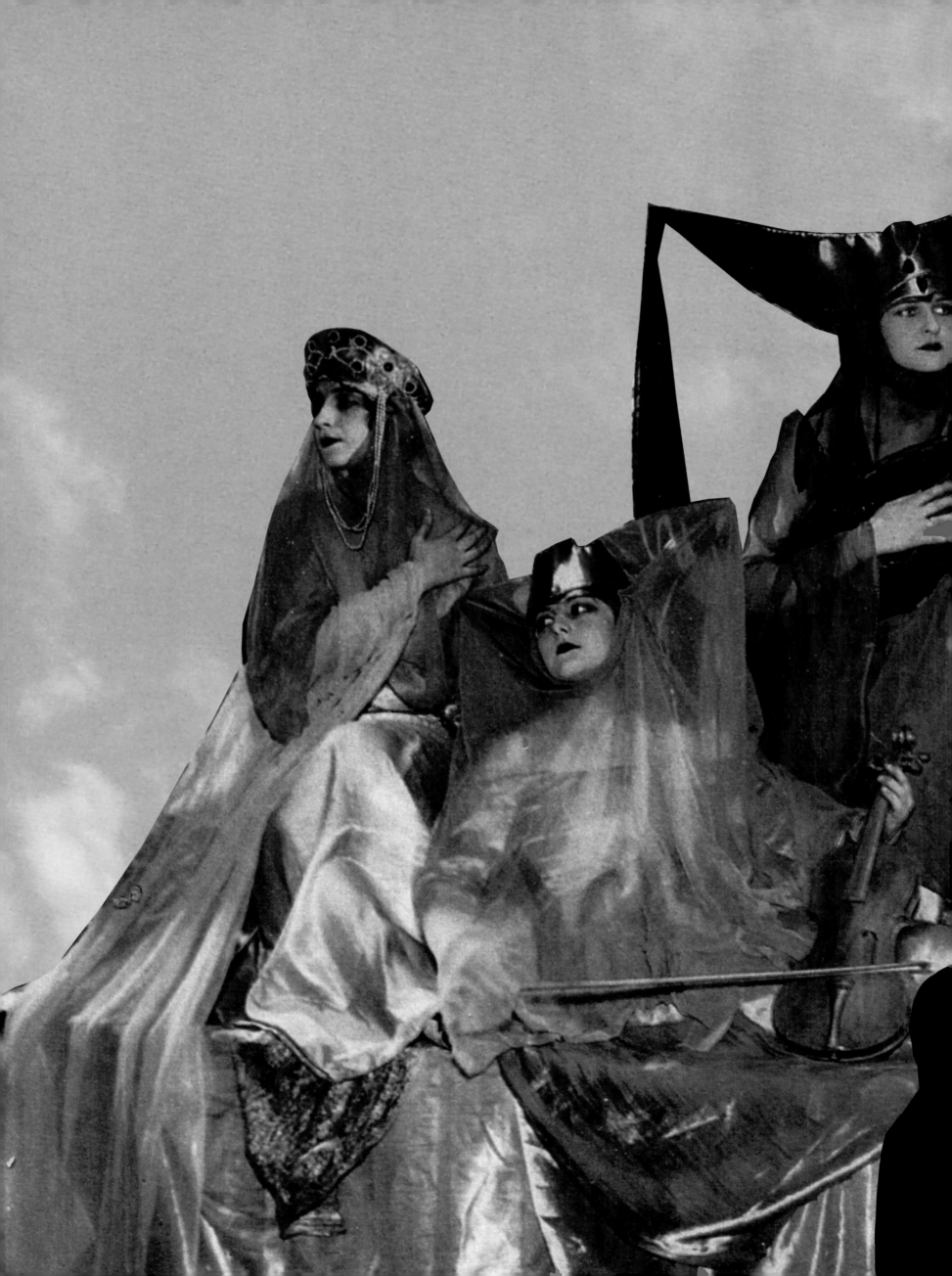

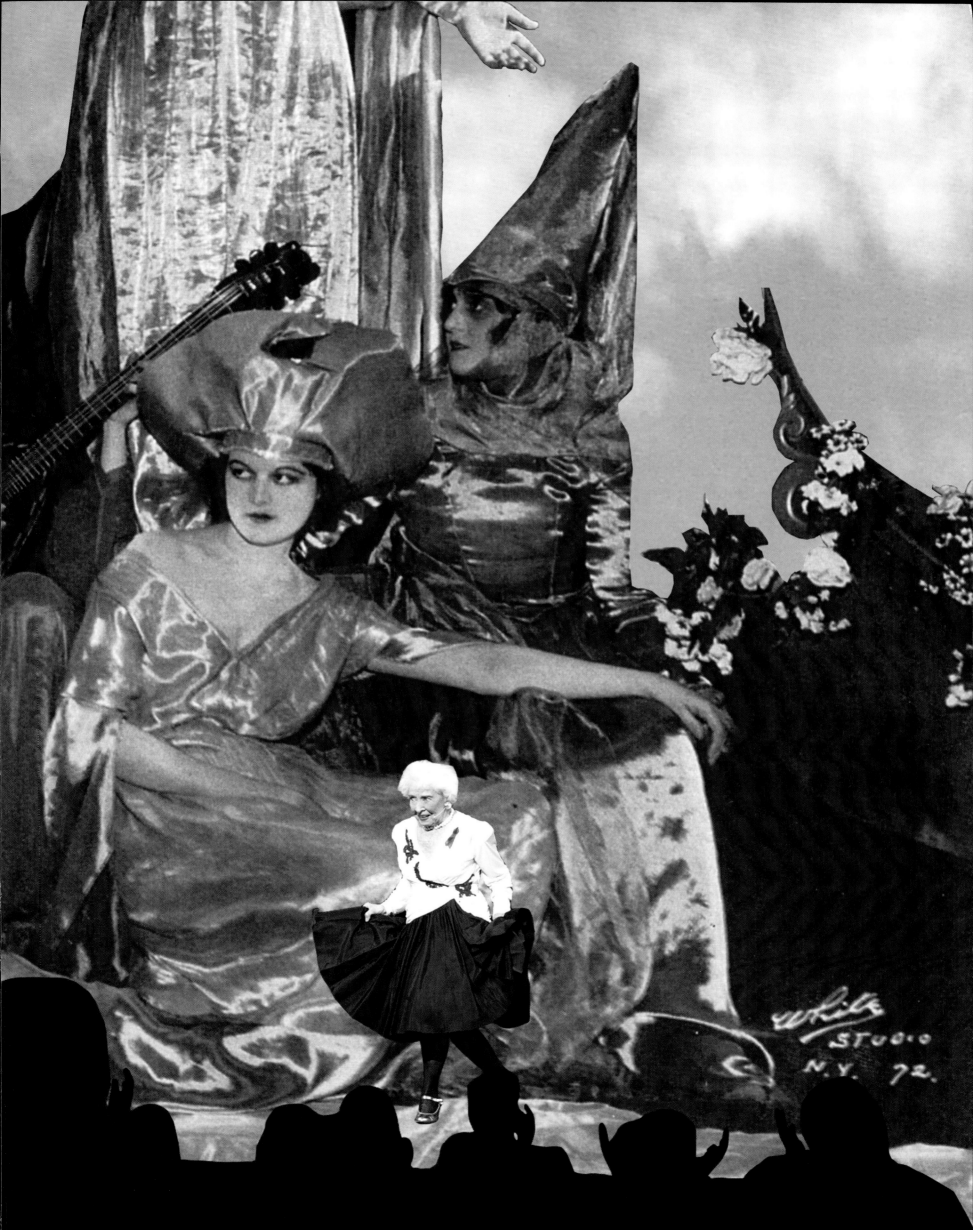

WITH EACH PASSING YEAR, THE NOVELTY OF DORIS'S AGE INCREASED. GOOD MORNING AMERICA, THE TODAY SHOW, CNN, PBS, THE NEW YORK TIMES THE NEW YORK POST, THE DAILY NEWS...

...USA TODAY, NATIONAL PUBLIC RADIO, AND NATIONAL GEOGRAPHIC WERE AMONG THOSE CLAMORING TO PROFILE THE IMPROBABLY VITAL DORIS EATON TRAVIS. IN 1998, TALK SHOW HOST

ROSIE O'DONNELL SAW DORIS DANCE AND INVITED HER TO BE A GUEST ON THE PROGRAM. DORIS: "RIGHT AFTER THAT, THEY GOT IN TOUCH WITH ME TO SEE IF I WOULD DO THIS PART IN A JIM CARREY MOVIE." OSCAR-WINNING DIRECTOR MILOS FORMAN WANTED DORIS FOR HIS UPCOMING FILM, MAN ON THE MOON. DORIS: "I WAS SUPPOSED TO BE AN ELDERLY MOVIE ACTRESS WHO HAD RETIRED...

"...THE FIRST REHEARSAL WE HAD, I CAME ON TO DO MY PART. AFTER I DID IT THE FIRST TIME, THE DIRECTOR SAID TO ME, 'DORIS, YOU ARE SUPPOSED TO BE AN OLD WOMAN, WOULD YOU PLEASE WALK LIKE ONE?' SO I SLOWED DOWN A LITTLE BIT." (175)

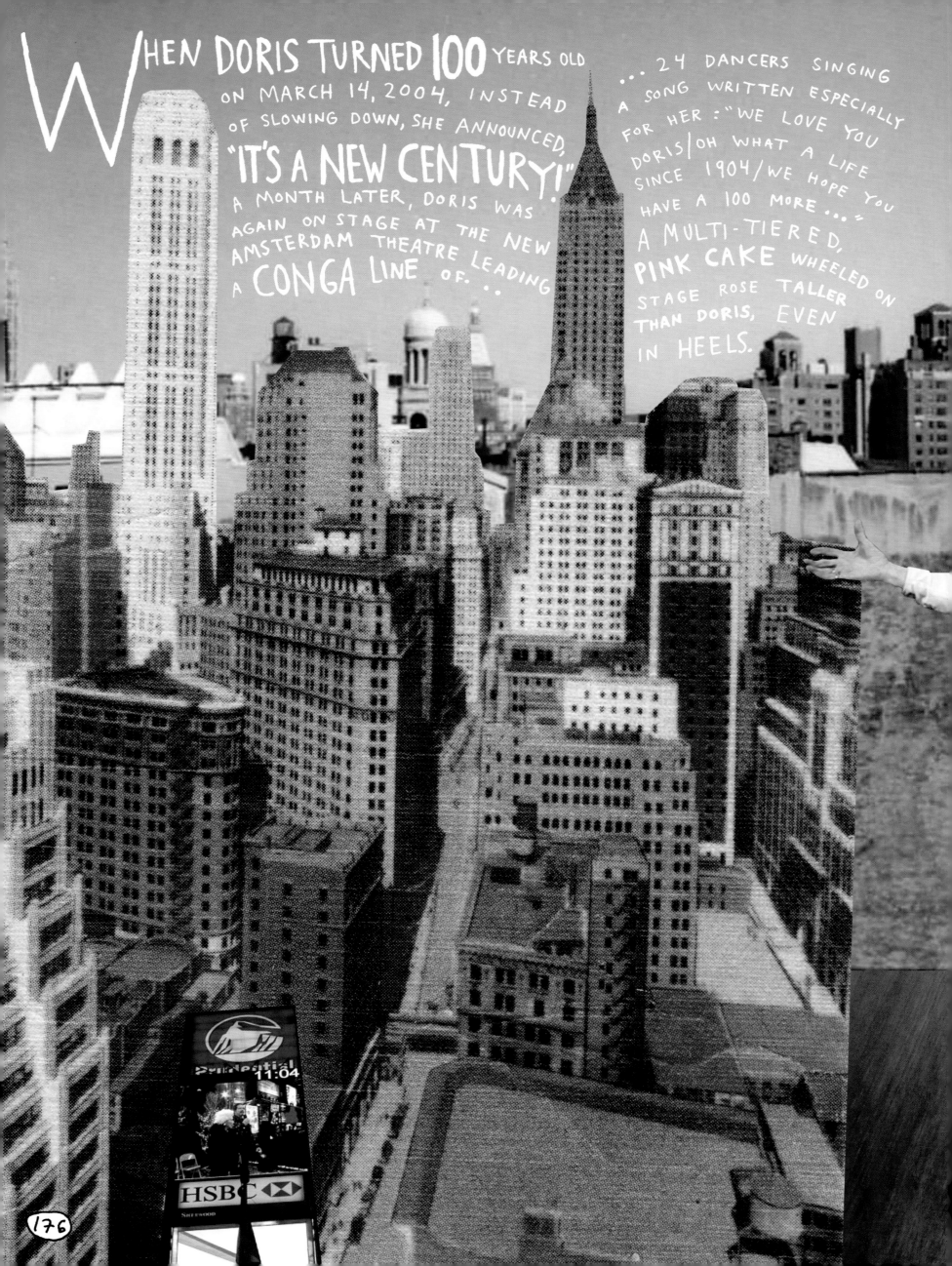

WHEN DORIS TURNED 100 YEARS OLD ON MARCH 14, 2004, INSTEAD OF SLOWING DOWN, SHE ANNOUNCED, "IT'S A NEW CENTURY!" A MONTH LATER, DORIS WAS AGAIN ON STAGE AT THE NEW AMSTERDAM THEATRE LEADING A CONGA LINE OF... ...24 DANCERS SINGING A SONG WRITTEN ESPECIALLY FOR HER: "WE LOVE YOU DORIS/OH WHAT A LIFE SINCE 1904/WE HOPE YOU HAVE A 100 MORE..." A MULTI-TIERED, PINK CAKE WHEELED ON STAGE ROSE TALLER THAN DORIS, EVEN IN HEELS.

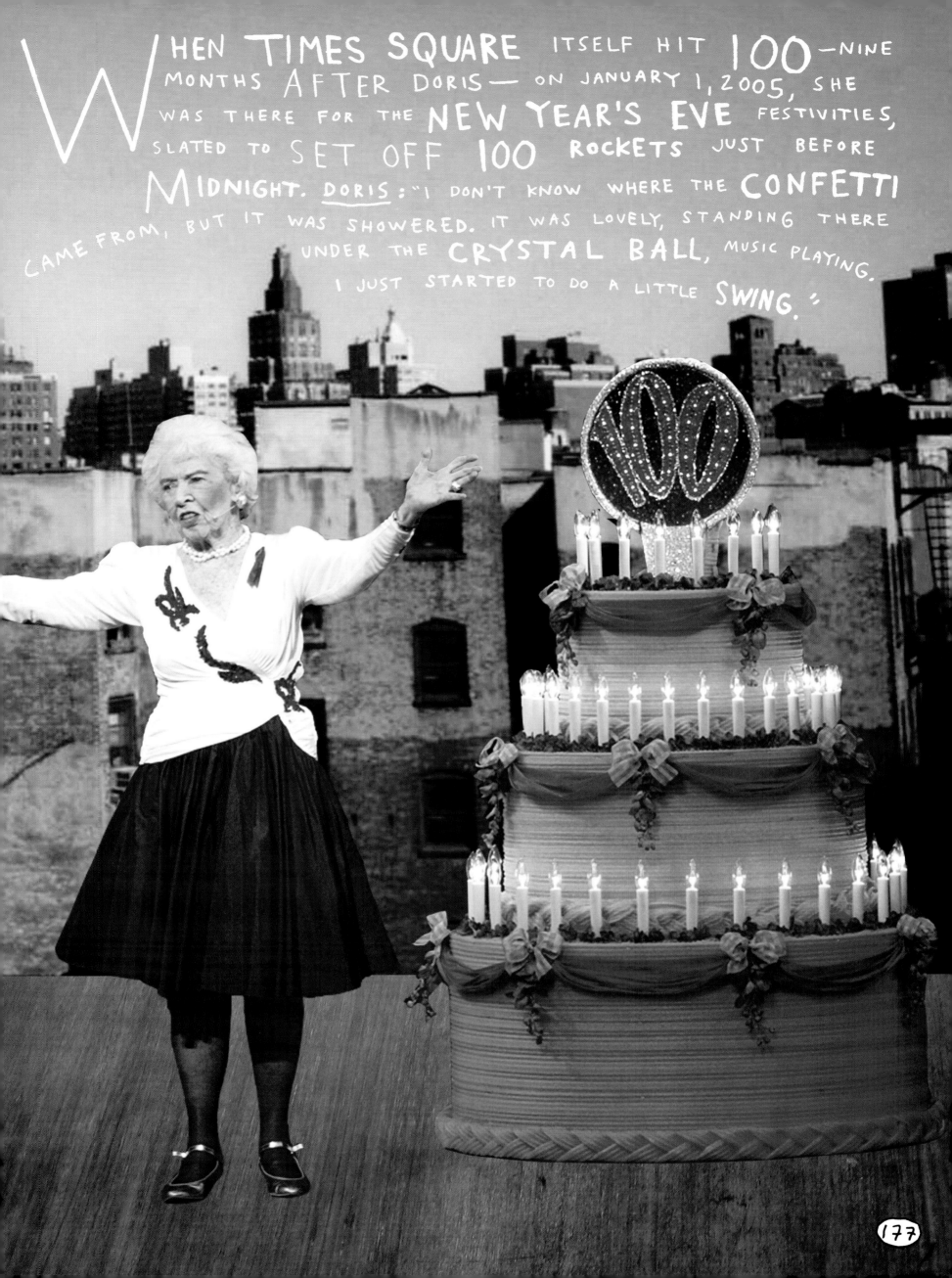

WHEN TIMES SQUARE ITSELF HIT 100—NINE MONTHS AFTER DORIS— ON JANUARY 1, 2005, SHE WAS THERE FOR THE NEW YEAR'S EVE FESTIVITIES, SLATED TO SET OFF 100 ROCKETS JUST BEFORE MIDNIGHT. DORIS: "I DON'T KNOW WHERE THE CONFETTI CAME FROM, BUT IT WAS SHOWERED. IT WAS LOVELY, STANDING THERE UNDER THE CRYSTAL BALL, MUSIC PLAYING. I JUST STARTED TO DO A LITTLE SWING."

T WAS NOT LONG AFTER THE NEW YEAR THAT DORIS RECEIVED A LETTER FROM OAKLAND UNIVERSITY INVITING HER TO RECEIVE AN **HONORARY DOCTORATE.** WITH HER 100TH BIRTHDAY BEHIND HER AND A **PHD** IN HER POCKET, DORIS WAS READY TO THROW A PARTY. THE INVITATIONS WENT OUT, REQUESTING THAT THE GUESTS SPORT **FEATHERED HEADGEAR.**

DORIS HIRED A BAND. SHE RECRUITED HER NEPHEW JOE EATON JR., HER ASSISTANT BILL GEORGE, AND FORMER ARTHUR MURRAY TEACHER EARL TYRIE AS DANCE PARTNERS. SIX WEEKS IN ADVANCE, THEY BEGAN REHEARSING DANCES TO PERFORM. EARL PARTNERED DORIS IN THE **CUBAN BOLERO.** EARL: "IT'S A BIT SENSUAL, JUST ENJOYING THE FEEL OF THE **RHYTHM** AND THE **MOVEMENT** OF THE **HIPS...**

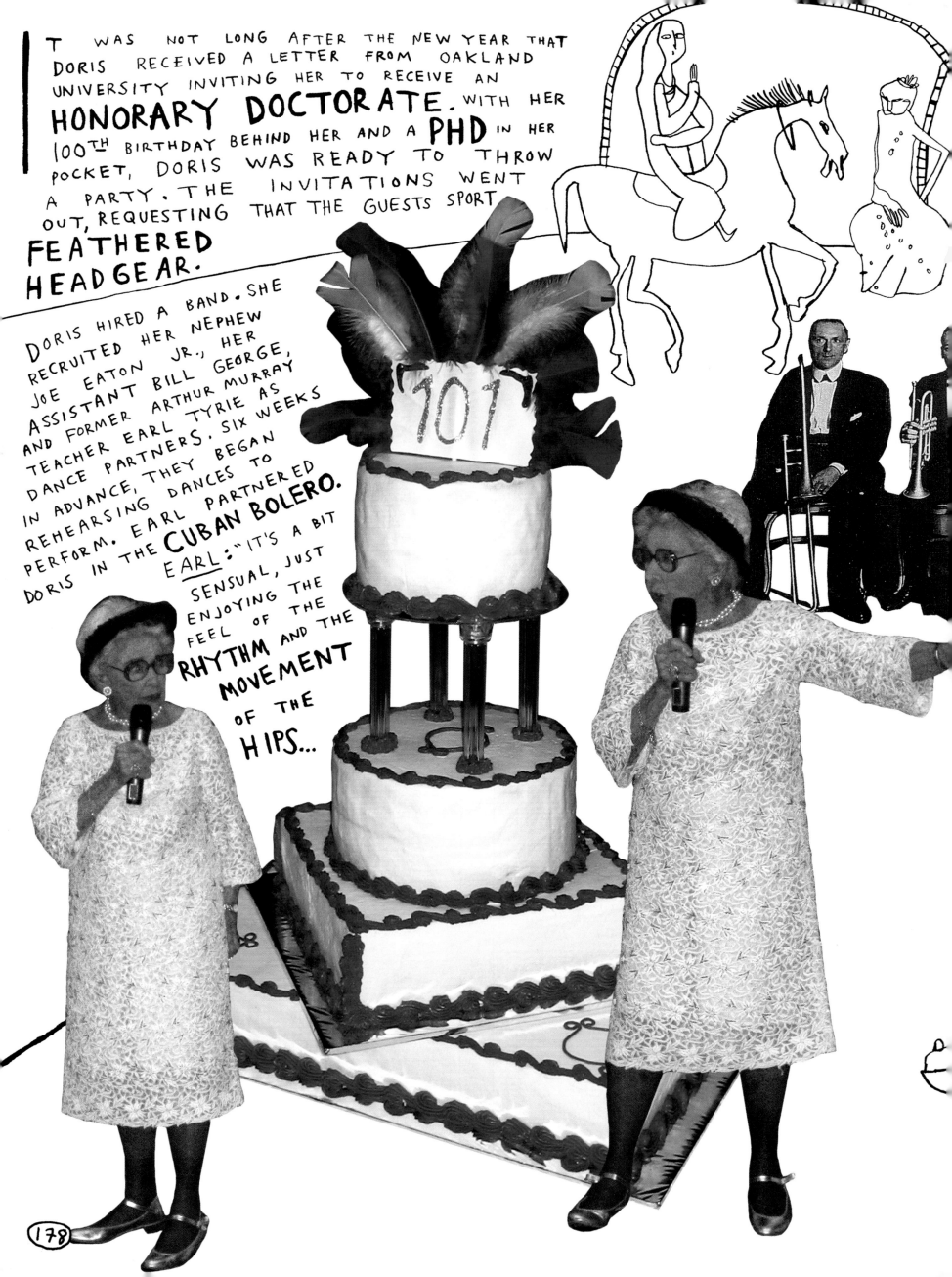

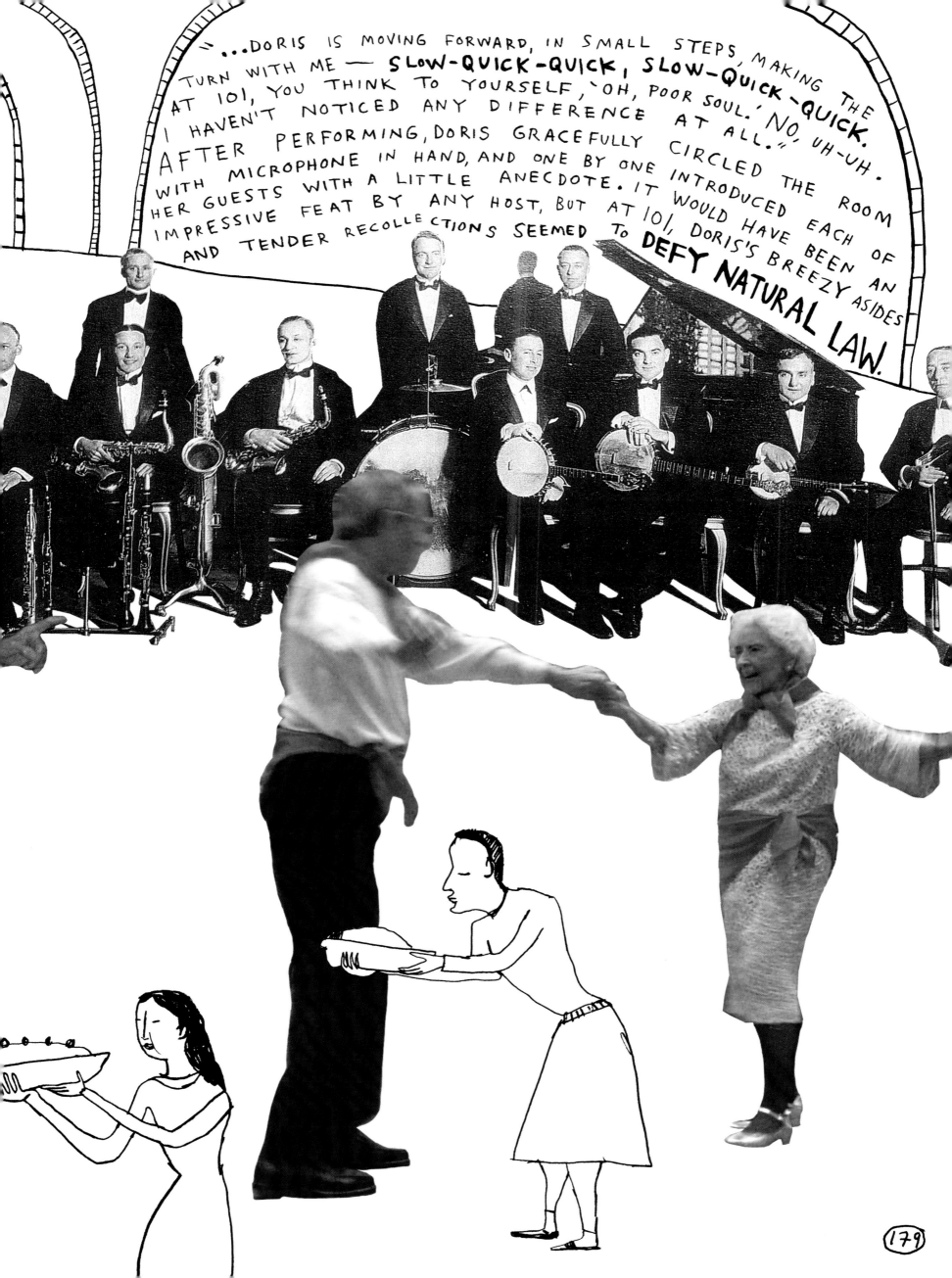

"...DORIS IS MOVING FORWARD, IN SMALL STEPS, MAKING THE TURN WITH ME — **SLOW-QUICK-QUICK, SLOW-QUICK-QUICK.** AT 101, YOU THINK TO YOURSELF, 'OH, POOR SOUL.' NO, UH-UH. I HAVEN'T NOTICED ANY DIFFERENCE AT ALL." AFTER PERFORMING, DORIS GRACEFULLY CIRCLED THE ROOM WITH MICROPHONE IN HAND, AND ONE BY ONE INTRODUCED EACH OF HER GUESTS WITH A LITTLE ANECDOTE. IT WOULD HAVE BEEN AN IMPRESSIVE FEAT BY ANY HOST, BUT AT 101, DORIS'S BREEZY ASIDES AND TENDER RECOLLECTIONS SEEMED TO **DEFY NATURAL LAW.**

(179)

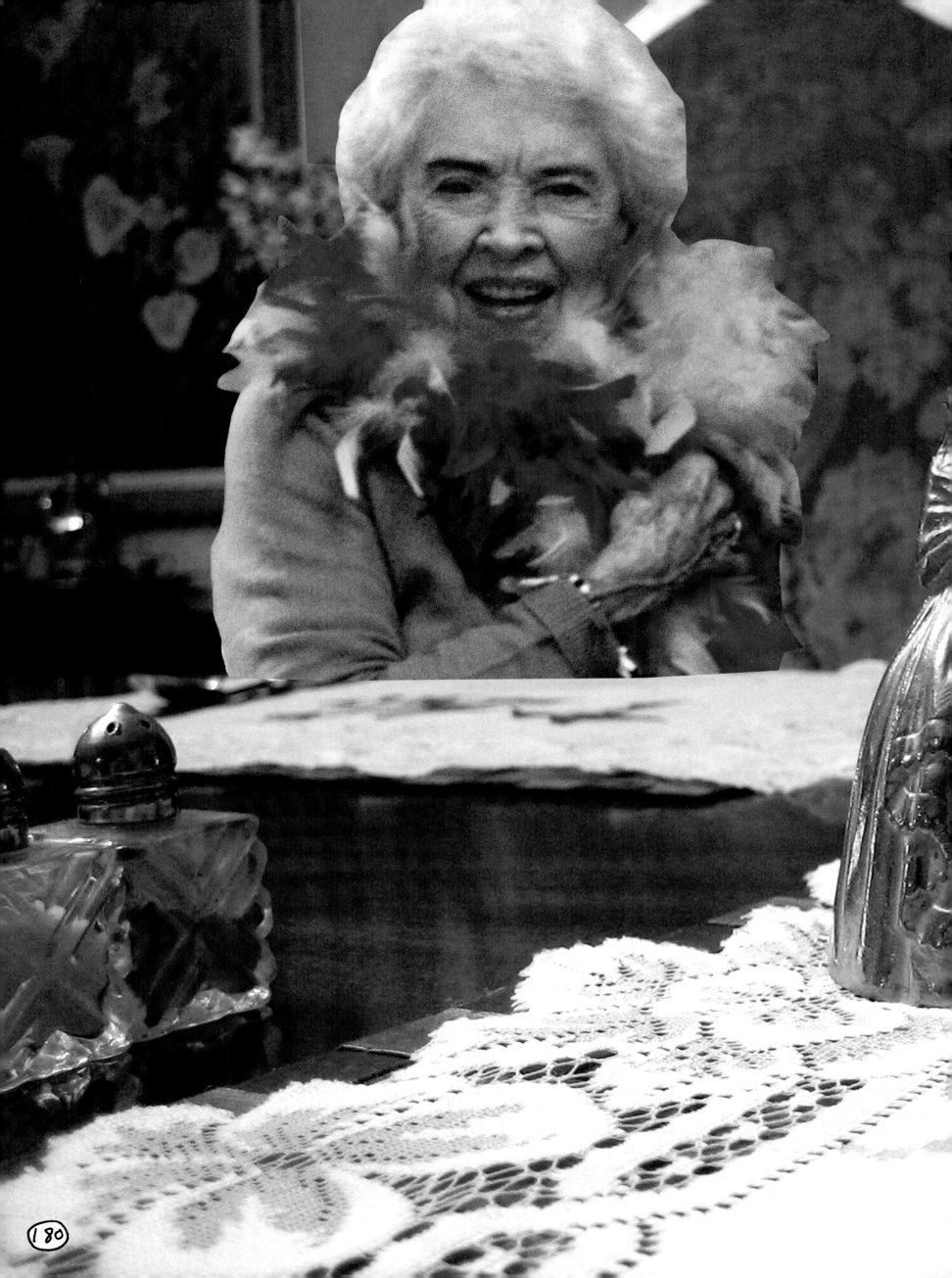

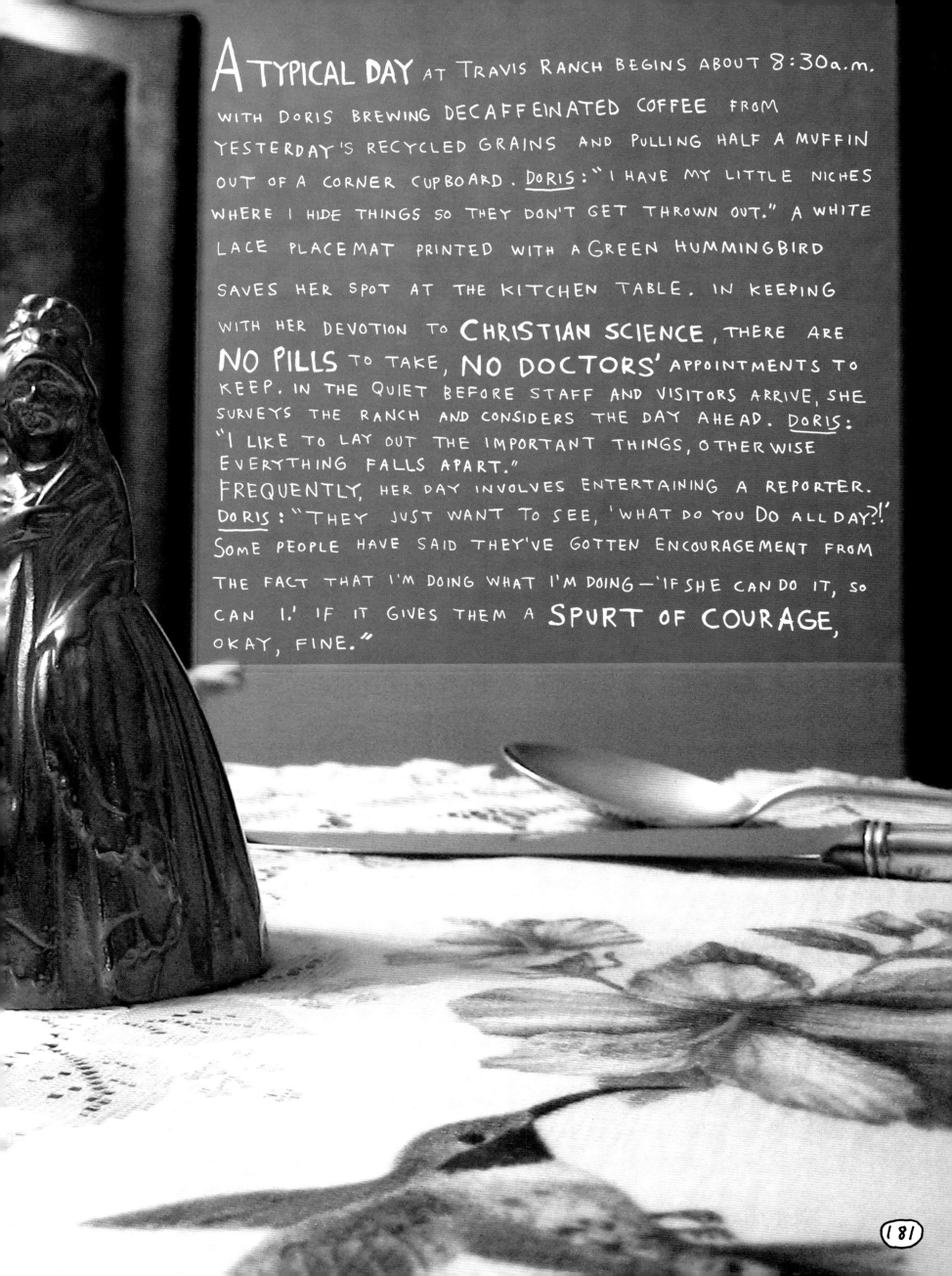

A TYPICAL DAY AT TRAVIS RANCH BEGINS ABOUT 8:30a.m. WITH DORIS BREWING DECAFFEINATED COFFEE FROM YESTERDAY'S RECYCLED GRAINS AND PULLING HALF A MUFFIN OUT OF A CORNER CUPBOARD. DORIS: "I HAVE MY LITTLE NICHES WHERE I HIDE THINGS SO THEY DON'T GET THROWN OUT." A WHITE LACE PLACEMAT PRINTED WITH A GREEN HUMMINGBIRD SAVES HER SPOT AT THE KITCHEN TABLE. IN KEEPING WITH HER DEVOTION TO **CHRISTIAN SCIENCE**, THERE ARE **NO PILLS** TO TAKE, **NO DOCTORS'** APPOINTMENTS TO KEEP. IN THE QUIET BEFORE STAFF AND VISITORS ARRIVE, SHE SURVEYS THE RANCH AND CONSIDERS THE DAY AHEAD. DORIS: "I LIKE TO LAY OUT THE IMPORTANT THINGS, OTHERWISE EVERYTHING FALLS APART."

FREQUENTLY, HER DAY INVOLVES ENTERTAINING A REPORTER. DORIS: "THEY JUST WANT TO SEE, 'WHAT DO YOU DO ALL DAY?!' SOME PEOPLE HAVE SAID THEY'VE GOTTEN ENCOURAGEMENT FROM THE FACT THAT I'M DOING WHAT I'M DOING—'IF SHE CAN DO IT, SO CAN I.' IF IT GIVES THEM A **SPURT OF COURAGE**, OKAY, FINE."

"I GET THE IMPULSE TO MOVE. I GUESS YOU'D CALL IT DOING MY OWN THING. THAT'S WHAT THEY CALL IT THESE DAYS. YOU SEE, RIGHT NOW EVERYBODY THINKS OF ME AS GETTING OLD. FIRST THING EVERYONE SAYS IS 'HOW DO YOU FEEL?' MEANING, 'YOU STILL WALKING AROUND?' SO I HAVE TO MEET THAT THOUGHT EVERY DAY. I SAY, 'NO! I'M STILL DOING THINGS!' I DON'T HAVE TO DO BACKBENDS AND NIP-UPS AND CARTWHEELS ANYMORE, BUT I AM VERY ACTIVE."

JOE EATON JR. ASSISTS HIS AUNT WITH ONE CURRENT ACTIVITY, CATALOGUING THE ARCHIVE ROOM.

JOE JR.: "WE GATHERED ONE SMALL BAG OF STUFF, AND EVEN THEN, WE ASSIGNED IT TO A CORNER TO GO THROUGH LATER. NOW WE HAVE SEVERAL LEVELS OF STUFF. NOTHING WENT INTO THE TRASH. I HAD THE FEELING THAT WE WERE TAKING EVERYTHING IN THE ROOM AND MOVING IT ONE TABLE TO THE LEFT."

DORIS:

"YOU SEE YOUR LIFE UNFOLDING IN PIECES BEFORE YOU. THE MEMORIES ARE THERE, AND THEY ARE VERY SHARP. AND TENDER..."

182

"... I'M THE LAST OF SEVEN CHILDREN. MY HUSBAND IS GONE. I AM ALONE. CHARLIE AND MY HUSBAND ARE BURIED RIGHT OUT HERE. THAT'S WHERE I'M GOING TO BE BURIED. GOING TO STAY ON TRAVIS RANCH.

I'M NOT THE LEAST BIT MORBID ABOUT IT.

WHEN WE WERE IN THE FOLLIES AND TRAVELING ON THE ROAD, NOT GETTING AN EDUCATION, OUR FRIEND JANE LOCKER WOULD LAY OUT A READING PROGRAM FOR US. MOSTLY AMERICAN LITERATURE.

WE WOULD BE IN A HOTEL ROOM, MARY AND I WOULD FIND A COMFORTABLE CHAIR, AND MAKE SURE MAMA HAD A COMFORTABLE CHAIR, TOO. I LOVED THE NEW ENGLAND POETS AND MEMORIZED SOME OF THEIR VERSES...

... WHO WAS THE LAWYER WHO WROTE 'THE CHAMBERED NAUTILUS'? OLIVER WENDELL HOLMES. YOU KNOW WHAT THE CHAMBERED NAUTILUS DOES— IT BUILDS A NEW SHELL AND CASTS OFF THE OLD ONE...

... THIS LAST VERSE STAYED WITH ME:

'BUILD THEE MORE STATELY MANSIONS, O MY SOUL, AS THE SWIFT SEASONS ROLL! LEAVE THY LOW-VAULTED PAST! LET EACH NEW TEMPLE, NOBLER THAN THE LAST, SHUT THEE FROM HEAVEN WITH A DOME MORE VAST, TIL THOU AT LENGTH ART FREE, LEAVING THINE OUTGROWN SHELL BY LIFE'S UNRESTING SEA.'"

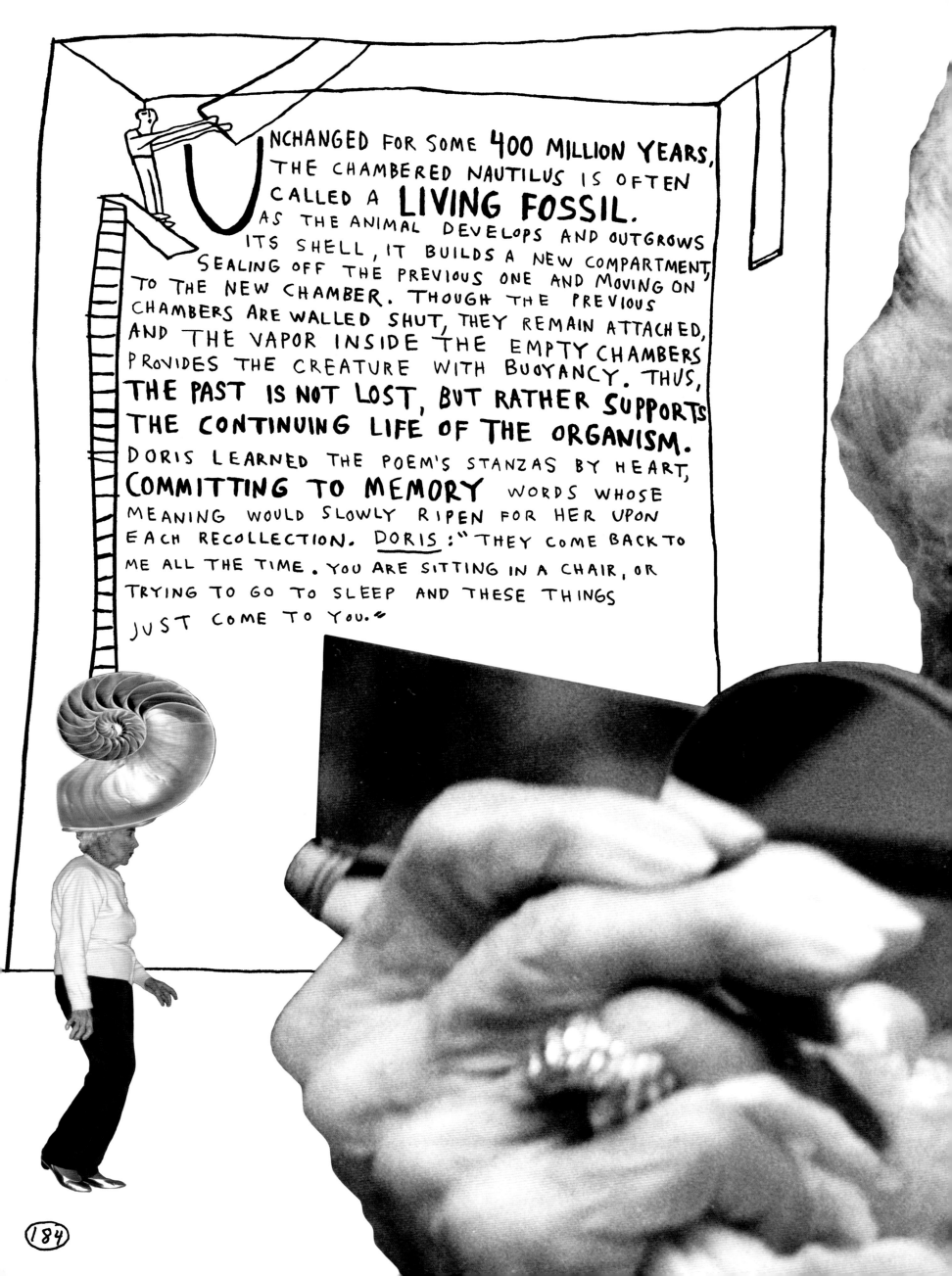

UNCHANGED FOR SOME 400 MILLION YEARS, THE CHAMBERED NAUTILUS IS OFTEN CALLED A **LIVING FOSSIL.** AS THE ANIMAL DEVELOPS AND OUTGROWS ITS SHELL, IT BUILDS A NEW COMPARTMENT, SEALING OFF THE PREVIOUS ONE AND MOVING ON TO THE NEW CHAMBER. THOUGH THE PREVIOUS CHAMBERS ARE WALLED SHUT, THEY REMAIN ATTACHED, AND THE VAPOR INSIDE THE EMPTY CHAMBERS PROVIDES THE CREATURE WITH BUOYANCY. THUS, **THE PAST IS NOT LOST, BUT RATHER SUPPORTS THE CONTINUING LIFE OF THE ORGANISM.** DORIS LEARNED THE POEM'S STANZAS BY HEART, **COMMITTING TO MEMORY** WORDS WHOSE MEANING WOULD SLOWLY RIPEN FOR HER UPON EACH RECOLLECTION. <u>DORIS</u>: "THEY COME BACK TO ME ALL THE TIME. YOU ARE SITTING IN A CHAIR, OR TRYING TO GO TO SLEEP AND THESE THINGS JUST COME TO YOU."

185

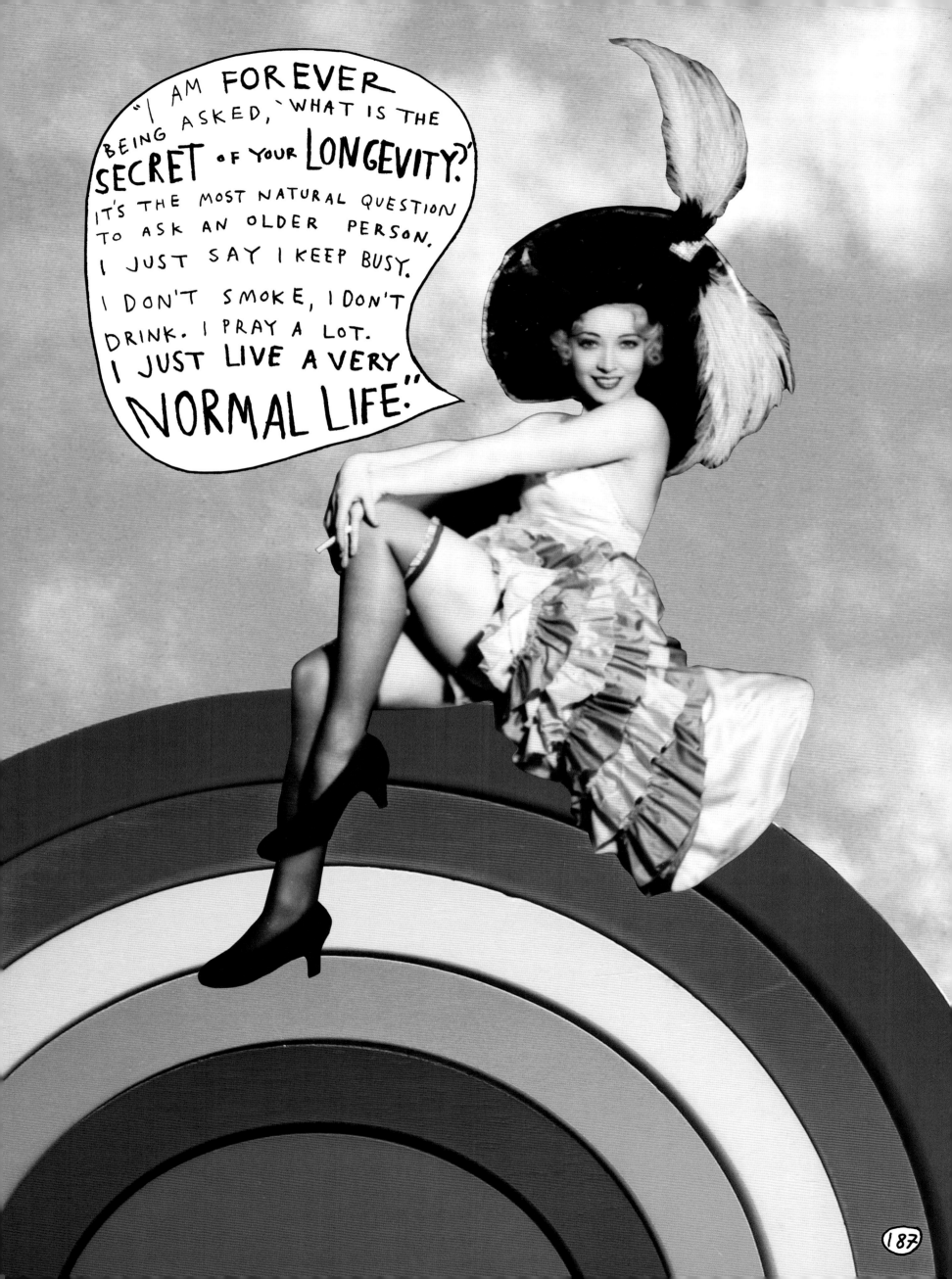

NOTES

I.

2-3. "WITH THE REST OF THE FAMILY SLEEPING": COLLIERS WEEKLY, JULY 25, 1925.

"I HAD ALREADY MADE UP MY MIND": COLLIERS WEEKLY, JULY 25, 1925.

5. "TOSS OF DRY LEAVES": DORIS EATON TRAVIS, THE DAYS WE DANCED (NORMAN: UNIVERSITY OF OKLAHOMA PRESS, 2003), p.16.

8. "A SEAT FOR $1.50": NEW YORK TIMES, ADVERTISEMENT, JUNE 30, 1907.

"OFFICERS JOINED IN THE FINALE CAN-CAN": CHICAGO DAILY TRIBUNE, AUGUST 4, 1907.

10. "THE TWO SISTERS DEMONSTRATED": BALTIMORE EVENING STAR, DECEMBER 22, 1914.

12. "THE SHUBERTS HEARD": PEARL EATON, UNPUBLISHED WRITINGS.

20. "JOE EATON LIKED TO BRAG": TELEPHONE INTERVIEW WITH JOE EATON, JR.

II.

28. "AN ENGAGING MORSEL OF A DANCER": NEW YORK TIMES, JUNE 26, 1916.

"PENNINGTON WAS NOT FIVE FEET TALL": RICHARD AND PAULETTE ZIEGFELD, THE ZIEGFELD TOUCH (NEW YORK: HARRY N. ABRAMS, 1993), p.308.

"THIS INTERESTING FIELD": NED WAYBURN, THE ART OF STAGE DANCING (NO PUBLISHER NOTED), 1926; REPRINTED BY BELVEDERE (NEW YORK, 1980), p.58.

30. "TICKET-SEEKERS LINED UP": WASHINGTON POST, JUNE 30, 1918.

"A VISION IN GORGEOUSNESS"... "EMBODIMENT OF A NEW MOVEMENT": NEW YORK TIMES, OCTOBER 27, 1903.

"ELECTRIFIED FLOORS": ZIEGFELD, THE ZIEGFELD TOUCH, p.244.

"PAINTED BACKDROPS": RANDOLPH CARTER AND ROBERT COLE, JOSEPH URBAN: ARCHITECTURE, THEATRE, OPERA, FILM (NEW YORK: ABBEVILLE PRESS, 1992).

31. "SPREAD THEM ON YOUR NOSE": NEW YORK TIMES, DECEMBER 23, 1923.

"AN OSTRICH, HORSES, ELEPHANTS": TELEPHONE INTERVIEW WITH PATRICIA ZIEGFELD, DAUGHTER OF FLORENZ ZIEGFELD.

35. "THE CURVE, THE DIMPLE": CHICAGO DAILY TRIBUNE, FEBRUARY 17, 1918.

36. "ZIEGFELD TRACED THE BLOODLINES": PICTORIAL REVIEW, MAY 1925.

"BLUE-BLOOD AMONG THE REVUES": NEW YORK TIMES, JUNE 6, 1922.

"OPENING NIGHT": NEW YORK HERALD, JUNE (DATE OBSCURED) 1920.

"THE SIGHING SOUND OF LIPS UNSATISFIED": LADY ("LUCILE") DUFF-GORDON, DISCRETIONS AND INDISCRETIONS, p.66.

37. "THAT SUPREME PERSONAL CHARM": ELINOR GLYN, ROMANTIC ADVENTURES (NEW YORK: E.P. DUTTON, 1936); QUOTED IN MUSEUM AT FIT CATALOGUE: DESIGNING THE IT GIRL.

38. "SANDOW'S MUSCLED SHOULDERS AND 58" CHEST": ATLANTA CONSTITUTION, JULY 9, 1893.

39. "THE CIRCUMFERENCE OF THE CALF": ASSOCIATED PRESS, WASHINGTON POST, JULY 24, 1932.

40. "I LOOKED LIKE A ROSE UNFURLING": DORIS EATON TRAVIS, UNPUBLISHED WRITINGS.

"THE FOLLIES ARE UPON US": CHICAGO DAILY TRIBUNE, DECEMBER 22, 1918.

42. "CONDUCTOR FRANK DARLING OPENED": NEW YORK HERALD, JUNE 19, 1918.

46. "APARTMENT 10-41": NILS HANSON, ZIEGFELD DIVA, UNPUBLISHED MANUSCRIPT, 2006.

47. "CHICKENS, HALF A DOZEN GOATS... THREE TIMES DAILY": STEVEN GAINES, NEW YORK MAGAZINE, "THE ANSONIA: THE BUILDING OF THE UPPER WEST SIDE," MAY 16, 2005.

48. "A SERIES OF MEETINGS": NEW YORK TIMES, JULY 22, 1921.

49. "A DAWN ON APRIL 17, 1929": WASHINGTON POST, APRIL 18, 1929.

54. "$5,000 A WEEK": PEARL EATON, UNPUBLISHED WRITINGS.

"SHE STOOD OUT ABOVE ALL THE OTHERS": NEW YORK HERALD, JUNE (DATE OBSCURED) 1920.

56. "YOUNG, MIDDLE AGED, MARRIED, SINGLE": PEARL EATON, UNPUBLISHED WRITINGS.

60. "THEY LIKE TO TAKE US TO RITZ": ATLANTA CONSTITUTION, MAY 19, 1920.

61. "FROM 8 O'CLOCK UNTIL UNCONSCIOUS": ATLANTA CONSTITUTION, MAY 19, 1920.

"THERE ARE NO MORE DANGERS": PUBLIC LEDGER, n.d.

63. "THE FLAPPERS BEGAN [THE TREND]": LOS ANGELES TIMES, APRIL 16, 1924.

67. "EVEN DRY NIGHTCLUBS": FRANCINE DU PLESSIX GRAY, "DIRTY DANCING: THE RISE AND FALL OF AMERICAN STRIPTEASE," THE NEW YORKER, FEBRUARY 28, 2005.

"GOOD MORNING, JUDGE": CHICAGO DAILY TRIBUNE, NOVEMBER 19, 1933.

"GUINAN'S IN NEW YORK WAS WETTER THAN THE ATLANTIC": CHICAGO DAILY TRIBUNE, MARCH 4, 1951

70. "IN ROME THE POPE CONDEMNED": NEW YORK TIMES, NOVEMBER 13, 1927.

"CHICAGO COURTS DELIBERATED": NEW YORK TIMES, NOVEMBER 21, 1921.

"HOBOKEN POLICE": WASHINGTON POST, AUGUST 30, 1925.

"DR. EDWIN CRAW WARNED": WASHINGTON POST, JANUARY 10, 1926.

72. "MAKES YOUR HAIR LIE DOWN": DAILY NEWS, ADVERTISEMENT, JUNE 8, 1926.

76. "THIS LOVE-MAKING MUST STOP": "TELL YOUR CHILDREN" PUBLICITY MATERIALS, GAUMONT CO., LTD BRITISH FILM ARCHIVES.

79. "SPLASHED WITH ORANGE BLOSSOMS": LOS ANGELES TIMES, JANUARY 9, 1923.

"GORHAM UNDER ARREST": LOS ANGELES TIMES, JANUARY 9, 1923.

81. "AT 3:30 P.M. ON JULY 2": WIRELESS AGE, AUGUST 21, 1921.

"THE GREAT ARENA WHERE 90,000 PERSONS": WIRELESS AGE, AUGUST 21, 1921.

86. "IT WAS A STRENUOUS DANCE": HOLLYWOOD NEWS, DECEMBER 27, 1926.

"LIVELY AS A BARNACLE SUFFERING WITH SLEEPING SICKNESS IN THE DEAD SEA": LOS ANGELES EXAMINER, ADVERTISEMENT, n.d. 1926.

93. "THEY MOB THE CHURCH": DETROIT NEWS, SEPTEMBER 6, 1929.

96. "THE VERY IDEA INTRODUCES": ATLANTA CONSTITUTION, NOVEMBER 24, 1929.

102. "I'M THROUGH": ZIEGFELD, THE ZIEGFELD TOUCH, p. 154.

104. "IN 25 YEARS": WASHINGTON POST, OCTOBER 9, 1935.

105. "THE HARDEST KIND OF LABOR": LOS ANGELES TIMES, APRIL 22, 1923.

"THE GIRL 'KNEW TOO MUCH'": WASHINGTON POST, JANUARY 4, 1934.

III.

113. "AS THE DEPRESSION DEEPENED": NEW YORK TIMES, MARCH 4, 1991.

114. "ARTHUR MURRAY'S OPERATION": NEW YORK TIMES, MARCH 4, 1991.

"VERY FIRST FRANCHISE LICENSE": TELEPHONE INTERVIEW WITH GEORGE THEISS, PRESIDENT OF ARTHUR MURRAY, INC. JANUARY 25, 2006.

124. "CHILD PART IN SHOWBOAT": THE MORNING TELEGRAPH, SEPTEMBER 15, 1932.

"SEVERE METAMORPHOSIS OF THE LIVER": TRAVIS, THE DAYS WE DANCED, p. 218.

125. "PHOTOGRAPHS SNAPPED AT THE CRIME SCENE": PHOTOS FROM DORIS EATON TRAVIS ARCHIVES.

128. "92%... BY THE WAR'S END": DAVID LEE POREMBA, DETROIT: A MOTOR CITY HISTORY
(CHARLESTON: ARCADIA PUBLICATIONS, 2001), p. 123.

"THE SINGLE EFFORT OF ONE INDIVIDUAL": FRANKLIN D. ROOSEVELT, LEND-LEASE SPEECH, MARCH 15, 1941.

141. "23%... 80%": JIB FOWLES, WHY VIEWERS WATCH (LONDON: SAGE PUBLICATIONS, 1992), p. 13.

144. "WHEN I SEE A WOMAN": DORIS EATON TRAVIS, UNPUBLISHED WRITINGS.

147. "FIVE-DAY RIOT...": POREMBA, DETROIT, A MOTOR CITY HISTORY, p. 131.

"THE RIOT PUT DETROIT ON THE FAST TRACK": http://en.wikipedia.org/wiki/12th_Street_Riot.

"MARKETING SCHEMES": NEW YORK TIMES, MARCH 4, 1991.

IV.

162. "HE LOOKED OVER OUR HEAD": HOLLYWOOD NEWS, MARCH 12, 1929.

V.

170. "AFTER 4 YEARS": MARK C. HENDERSON, THE NEW AMSTERDAM, THE BIOGRAPHY OF A BROADWAY
THEATRE (NEW YORK: HYPERION, 1997), p. 127.

"RED CARPET AND NEW YORK CITY MAYOR": INTERVIEW WITH NILS HANSON.

PHOTOGRAPH CREDITS

(WHEN PART OF A COLLAGE, INDIVIDUAL PHOTOS ARE SPECIFIED IN PARENTHESES.)

PHOTOGRAPHS BY RIVKA KATVAN : 171, 173, 177, 185

PHOTOGRAPH BY MICHAEL MYERS : 119, 153 (FULL MOON)

OTHER IMAGES : 19 (WOODROW WILSON), PRINCETON UNIVERSITY LIBRARY; 36-37 (LADY DUFF-GORDON PHOTO & SKETCH), COLLECTION OF RANDY BRYAN BIGHAM; 78 (TRUE EXPERIENCES COVER), DORCHESTER MEDIA LLC; 84 (CHARLES LINDBERGH), LINDBERGH PICTURE COLLECTION, MANUSCRIPTS & ARCHIVES, YALE UNIVERSITY, (MARY), COLLECTION OF DAVIE LERNER; 85 (COUPLE DANCING THE CHARLESTON), GETTY IMAGES, (DORIS & PARTNER DANCING NEAR PHONOGRAPH), DETROIT FREE PRESS; 90 ("COCOANUT GROVE" NEWS-PAPER CLIPPING), LOS ANGELES TIMES; 114 ("DANCE TO SLENDERNESS" CLIPPING), DETROIT NEWS; 117 (DETAIL FROM PHOTO OF HENRY & CLARA FORD, FROM THE COLLECTIONS OF THE HENRY FORD); 120-121 ("ON YOUR TOES" COLUMNS) DETROIT NEWS; 128-129 (USS EXPLODING AT PEARL HARBOR), BETTMANN/CORBIS; 130 (DORIS DANCING IN NEWSPAPER CLIPPINGS), DETROIT FREE PRESS ; 131 ("PARTNER SHARING DANCE"), DETROIT NEWS ; 144 (2ND ATOMIC BOMB TEST), NATIONAL MUSEUM OF HEALTH & MEDICINE, ARMED FORCES INSTITUTE OF PATHOLOGY; 148-149 (BLACK SMOKE FROM FIRE COVERS STREET), BETTMANN/CORBIS ; 156 (DORIS GRADUATES), SOONER MAGAZINE / J. PAT CARTER; 175 (DORIS BEING INTERVIEWED), JAMES HERB & CARLOS MIRANDA; 176 (DORIS ON JUMBOTRON), JAMES HERB & CARLOS MIRANDA; 183 (DORIS), NILS HANSON

ADVERTISEMENTS COURTESY OF ARTHUR MURRAY, INC.: 118, 140

PHOTOGRAPHS BY LAUREN REDNISS: VARIOUS PHOTOS OF TRAVIS RANCH, OBJECTS IN DORIS EATON TRAVIS'S ARCHIVES, SUPPORTING COLLAGE MATERIALS, AND OTHERWISE UNCREDITED RECENT PHOTOS OF DORIS EATON TRAVIS.

AUTHOR'S NOTE

ALL EFFORTS HAVE BEEN MADE IN RESEARCHING THIS BOOK AND ACKNOWLEDGING SOURCE MATERIALS. ON OCCASION, PHOTOGRAPHS OR NEWSPAPER CLIPPINGS FROM DORIS EATON TRAVIS'S ARCHIVES HAD NO IDENTIFICATION. I APOLOGIZE FOR NOT BEING ABLE TO CREDIT THESE MATERIALS, AND FOR ANY OTHER OVERSIGHT. I WELCOME ANY ADDITIONAL INFORMATION, WHICH I WOULD BE HAPPY TO INCORPORATE IN A FUTURE EDITION.
UNLESS OTHERWISE NOTED, QUOTES FROM DORIS EATON TRAVIS AND OTHERS ARE FROM INTERVIEWS I CONDUCTED IN PERSON IN NORMAN, OKLAHOMA, NEW YORK CITY, OR ON THE TELEPHONE.

— LAUREN REDNISS, APRIL 2006

THANK YOU!!

JUDITH REGAN • SETH REDNISS
MELIK KAYLAN • ANNA BLISS
RICHARD LJOENES • KURT ANDREWS • CASSIE JONES
ADRIENNE MAKOWSKI • BRIAN WEAVER
CHASE BODINE • GREGG SULLIVAN

DORIS EATON TRAVIS

NILS HANSON • JOE EATON, JR. • BILL GEORGE
LAWRENCE WESCHLER • JIMMY IACOBELLI
BRIAN REA • PETER BUCHANAN-SMITH • SUZANNE WICKHAM
WADE SCHUMANN • MIA FINEMAN • TCTDNSIN
JEDEDIAH PURDY • ANNE LESTER • HUONG HUANG
RIVKA KATVAN • MAIRA KALMAN • LEON FRIEDMAN
ISAAC MIZRAHI • SID GOTTLEIB • RANDY BIGHAM • JOSH PRAGER
JAMES HERB • CARLOS MIRANDA • MICHAEL MYERS
MICHAEL RHODE • MOLLY SORKIN • RICHARD GOLUB
ILAN ARBOLEDA • NOAH ROSS • SCOTT MILSTEIN • SOURCERY
RUTHIE ABEL • LISA BEBCHICK • CHARLOTTE HERSCHER
AMY GRAY • RICHARD MCGUIRE • TINA SCHNEIDER
MATTHEW HAIMES • UTA TACHI BANA • URSULA COOPER
ESTHER GOLUB • CLAIRE REDNISS • DAVIE LERNER
☆ ROBIN & RICHARD REDNISS ☆ ✶ ☆

HARPER COLLINS BOOKS MAY BE
PURCHASED FOR EDUCATIONAL,
BUSINESS, OR SALES PROMOTIONAL
USE. FOR IMFORMATION PLEASE
WRITE:
SPECIAL MARKETS DEPARTMENT
HARPER COLLINS PUBLISHERS, INC.
10 EAST 53RD STREET
NEW YORK, NY 10022

FOR EDITORIAL INQUIRIES, PLEASE CONTACT:

REGAN
10100 SANTA MONICA BLVD., 10TH FLOOR

LOS ANGELES, CA 90067

A GENERAL TRADE EDITION OF THIS BOOK WAS PUBLISHED IN
NOVEMBER 2006 BY REGAN, AN IMPRINT OF HARPERCOLLINS PUBLISHERS.
PRINTED ON ACID-FREE PAPER
LIBRARY OF CONGRESS CATALOGING-IN-PUBLICATION DATA HAS BEEN APPLIED FOR.

ISBN 10: 0-06-124150-4 (LIMITED EDITION)
ISBN 13: 978-0-06-124150-5

06 07 08 09 10 SC 10 9 8 6 7 5 4 3 2 1

LAUREN REDNISS GRADUATED FROM BROWN UNIVERSITY AND
RECEIVED HER MFA FROM THE SCHOOL OF VISUAL ARTS.
SHE IS A FREQUENT CONTRIBUTOR TO THE OP-ED PAGE OF
THE NEW YORK TIMES, WHICH NOMINATED HER WORK FOR
THE PULITZER PRIZE. SHE TEACHES AT THE PARSONS
SCHOOL OF DESIGN AND LIVES IN NEW YORK CITY.

TO RECEIVE NOTICE OF AUTHOR EVENTS AND NEW BOOKS BY
LAUREN REDNISS, SIGN UP AT WWW.AUTHORTRACKER.COM

COVER DESIGN BY LAUREN REDNISS
AUTHOR PHOTO BY DAVID SMITH

HOUSE NOTES.

Ladies and gentlemen recovering articles lost in this theatre will kindly return them to the house manager, who will make every effort to restore them to their owners.

Water filtered by the Centadrink Filters Co.

Perfect sanitary conditions are maintained at this theatre by the use of the disinfectants and disinfecting appliances of the West Disinfecting Company, New York.

Physicians who anticipate being called can be summoned by leaving their names and seat numbers with the treasurer.

Electrical bridges on the stage and elevators in building by the Marine Engine & Machine Company.

This theatre is cleansed by the Kenney Vacuum Sweeping System.